8

The Lady
Ratcliffe

III

9

a Lady

III

10

The Lady
Vaux

III

11

The Lady
Lester

III

Lucretia
a large Pictu...

19

The Lady
Parker

III

20

Edward Prince
of Wales

III

21

Reshemer
Gent. of
Cornwall

III

22

The Lady
Meutas

III

28

Christ. a Madona

29

Fitz Williams
Earl of Southampt...

III

35

Sr John
Godsalve
Kt

III

36

Nine small
Pictures

...small
...tures

K
64

44

L
65

M
66

N
67

O
68

21 small Heads

P
69

45

11 Pictures

Q
70

...eads

Looking Glass

54

Madona

QUEEN CAROLINE

PUBLISHED FOR THE PAUL MELLON CENTRE FOR STUDIES IN BRITISH ART

YALE UNIVERSITY PRESS · NEW HAVEN AND LONDON

QUEEN CAROLINE

Cultural Politics at the Early Eighteenth-Century Court

Joanna Marschner

Designed by Sophie Sheldrake

Printed in Malaysia

LIBRARY OF CONGRESS CATALOGING-IN-PUBLICATION DATA

Marschner, Joanna.
 Queen Caroline : cultural politics at the early eighteenth-century court / Joanna Marschner.
 pages cm
 ISBN 978-0-300-19777-8
1. Caroline, Queen, consort of George II, King of Great Britain, 1683–1737--Art patronage. 2. Arts--Political aspects --England--London. 3. Arts, English--England--London --18th century. I. Title.
 NX701.2.c365M37 2014
 709.2--dc23
 2013028626

ENDPAPERS
Hanging plan of a Wall of the Queen's Closet, Kensington Palace, after George Vertue, a plate from W. Bathoe, *A Catalogue of the Pictures, Drawings. . . etc, at Kensington in the Queen Caroline's Closet. . .*, London, 1758. British Library (detail of fig. 94).

TITLE-PAGE
'*Richmond Ferry as it was*' by J. B. C. Chatelain after Marco Ricci, engraving, published by J. Groupy, c. 1725. Orleans House, London (detail of fig. 31).

NOTE ON DATES
In 1752 the Julian Calendar was replaced by the Gregorian Calendar in which the day from which a new year was calculated was moved from 25th March back to 1st January. In this book, dates before 1752 follow the Gregorian system so that those in the months of January, February and March are given in the year we would use today.

for

JILL AND MAX MARSCHNER

'The Queen talked to me at least half an hour upon my collection of printed Heads, Dr Couraye, the history of France, gardening, painting, flattery and divers political and moral subjects.'

John Perceval, Lord Egmont, 31st December, 1734

CONTENTS

ACKNOWLEDGEMENTS

I would like to thank HM The Queen for graciously allowing me to consult the many rich sources of information held about the royal collections in the early eighteenth century.

I owe many thanks to the staff of the Royal Collection, the Royal Archives, the Royal Library, and the Royal Collection's Photographic Service and Conservation Department, past and present. So many people have been extremely generous with their advice and support. In particular I would like to thank Jonathan Marsden, Sir Hugh and the Hon. Lady Roberts and the late Sir Geoffrey de Bellaigue and Lady de Bellaigue. I would also like to record my debt to the late Sir Oliver Millar and the late Sir Robin Mackworth Young.

Historic Royal Palaces has kindly supported this research. In particular I would like to thank, most sincerely, John Barnes, Dr Edward Impey, Dr Lucy Worsley and Nigel Arch. There is also a special thank you for Jasmeet Barker, who so efficiently helped me track down the illustrations that were the trickiest to find. The curatorial team at Kensington Palace has been very patient with the demands this research has made on occasion, and I would like to thank Jenny Lister, Victoria Norton, Beatrice Behlen, Deirdre Murphy, Alexandra Kim and the team of valuable volunteer assistants.

Thanks are also due to Peter Day at Chatsworth House, the late Peter Thornton, Margaret Richardson, Tim Knox and Susan Palmer at Sir John Soane's Museum, Mark Handley at the Royal Botanic Gardens, Kew, Neil Bingham at the RIBA and the staff at Northampton County Record Office. The staff of the following institutions have been unfailingly helpful: The Bodleian Library, The British Library, The British Museum,

Opposite
A Performance of 'The Indian Emperor or The Conquest of Mexico by the Spaniards' by William Hogarth, oil on canvas, 1732–35. Private Collection (detail of fig. 142)

The Guildhall Library, The London Library, The National Art Library, The National Portrait Gallery, The National Archives and The Witt Library.

I have been assisted and encouraged by many colleagues abroad. In Italy I would like to thank Dr Kirsten Aschengreen Piacenti (Museo Stibbert, Florence); in Germany Professor Dr Hans Ottomeyer (Deutscheshistorisches Museum) and Dr Winfried Bacr (Stiftung Preussisches Schlösser und Garten Berlin-Brandenburg) in Berlin, Dr Lorenz Seelig and Dr Nina Gockerel in Munich (Bayerisches Nationalmuseum), Dr Uta Löwenstein in Hesse, Dr Alheidis von Rohr in Hanover (Historisches Museum am Hohen Ufer, Hannover), Dr Jutta von Bloh and Dr Dirk Syndram in Dresden (Staatliche Kunstsammlungen, Dresden); in Denmark Dr Mogens Bencard, Katia Johansen, Jørgen Hein and Peter Kristiansen (De Danske Kongers Kronologiske Samling på Rosenborg); and in the Netherlands Dr Wies Erkelens, Dr Elco Elzinger and A. D. Renting (Paleis Het Loo) and Martin Loonstra, Mr L. J. A. Pennings, Claudia Maartense van Ham, Mr Harm Roord (Koninklijk Huisarchief).

There are many other individuals who have helped in a myriad of ways. They have, variously, passed on valuable research, kindly read parts of the text and provided the most delightful company on field trips. I wish here to record my immense gratitude to Raphael Bernstein, Carlotta del Bianco, Adam Bowatt, Julius Bryant, the late Anne Buck, Margaret and Richard Davies, Diana Dethloff, Caroline Elam, Karen Finch, Dr Peter Gaunt, Professor Paul Gifford, Philippa and Gordon Glanville, John Hardy, Avril Hart, the late Helena Haywood, Richard Hewlings, Eve Higgs, Mark Hinton, the late Dr Oliver Impey, Amin Jaffer, Victoria and Jonathan Brunskill, Carol Jones, Simon Keynes, Santina Levey, Jane Marschner, Amaia Menchaca and Michael Field, Anne and Philip Mitchell, David Mitchell, Dr Tessa Murdoch, the Earl of Wemyss, Sheila O'Connell, Lucy Peltz, Hugo Penning, the late Professor Roy Porter, Charles Truman, Adelheid Rasche, Professor Aileen Ribeiro, Treve Rosoman, Dr Ann Saunders, Professor Stephen Taylor, Lady Willoughby de Eresby, Janet Wood, and Katherine and Ashley Wyatt.

Professor Helen Weston and Professor David Bindman, at University College, London, were supervisors of the PhD which formed the starting point for this book. For their thoughtful and patient support I must record a big thank you.

Clarissa Campbell Orr very kindly read through the book as it came together. Her thoughtful advice was invaluable, and I am very grateful for this generosity.

At Yale University Press I must thank Sally Salvesen, Sophie Sheldrake and Elizabeth Drury most sincerely for their part in bringing the book into being. It would not be as gloriously illustrated as it is without the very generous support of the Paul Mellon Centre and for this I am grateful to Professor Mark Hallett, Martin Postle, Amy Meyers and Professor Brian Allen.

Finally I must thank my parents Max and Jill Marschner, who, like me, were intrigued by Queen Caroline from the very beginning, followed the research enthusiastically, and were always sure it would work out well in the end.

To all true Britons, lovers of Liberty, and the present Succession,
THIS PLATE IS DEDICATED.

INTRODUCTION

Caroline of Ansbach, the wife of King George II, has no rival among England's queen consorts in the scale and range of her cultural patronage. Her projects, which touched on art, architecture, gardens, literature, science and natural philosophy, individually might be seen simply as a reflection of her interests, but when assessed together they form a considerable programme based in Renaissance notions of princely responsibility. This would have been introduced to her at the culturally resplendent courts of Saxony, Brandenburg and Hanover where she spent her early years.

On her arrival in London in 1714, following the accession to the English throne of her father-in-law, the Elector of Hanover, as King George I, Caroline used her schemes imaginatively and politically; through them she forged important bonds between the Hanoverian monarchy and English society. She enticed many of the great minds who were shaping the political and cultural landscape of early eighteenth-century England to take part in her debates, her salons and her conferences. This allowed her to enter their worlds, visit their houses, and by this help to promote and legitimize the new dynasty (fig. 1).

In 1734 Sir Robert Walpole addressed Caroline: 'Madam without you I can do nothing . . . you, Madam, are the sole mover of this Court'; the philosopher Gottfried Wilhelm Leibniz called her 'a princess so accomplished and so spiritual'; and the essayist Voltaire wrote: 'she was born to encourage the whole circle of the arts'.[1] Politicians, courtiers, and those who sought the Queen's protection, might be accused of flattery, but contemporary satirists were quick to identify her as the power behind the throne: 'You may strut, dapper George but 'twill all be in vain; We know 'tis Queen Caroline, not you, that

Opposite
The Hanoverian Succession
by Johann Sebastian Müller,
etching and engraving,
published 20th January, 1752.
The Royal Collection
(detail of fig. 12)

1

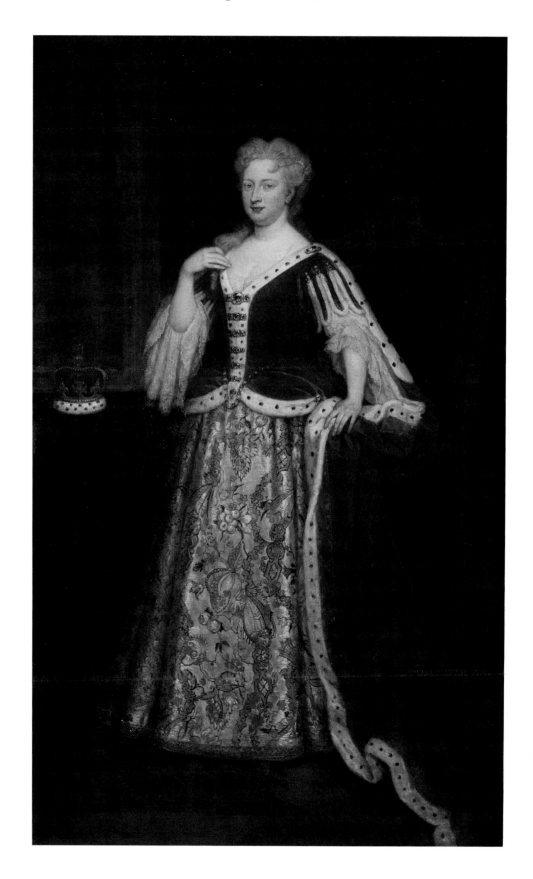

1 *Caroline of Ansbach
as Princess of Wales* by
Sir Godfrey Kneller,
oil on canvas, 1716.
The Royal Collection

reign.'[2] When she died an epitaph was pinned up anonymously at the Royal Exchange in London which read: 'O Death, where is thy sting, to take the Queen and leave the King?'[3]

Caroline has largely escaped the attention of historians. Visitors to Hampton Court Palace today may admire her state bed which still dominates the Queen's Bedchamber, and some may recall that she played an important part in the laying out of Kensington Gardens and what would later become the Royal Botanic Gardens at Kew. Most of us, however, would have difficulty untangling her history from that of Caroline of Brunswick, the spouse of King George IV.

Caroline of Brandenburg-Ansbach was born on 1st March, 1683.[4] She was the daughter of John Frederick, Margrave of Brandenburg-Ansbach, by his second wife, Eleonore Erdmuthe Louisa of Saxe-Eisenach. Caroline's pedigree was distinguished. Her father belonged to a junior branch of the Hohenzollern dynasty, whose main line were electors of Brandenburg, making Caroline third cousin to Frederick William, Elector of Brandenburg and Duke of Prussia, known as the 'Great Elector'. Caroline's mother was the daughter of John I, Duke of Saxe-Eisenach, whose family belonged to the senior, Ernestine branch of the House of Wettin; the junior, Albertine branch had the electorship of Saxony. A few years after Caroline's father died in 1686, her mother was married again to a distant kinsman, John George IV, Elector of Saxony.

With a wealth of natural resources Saxony was prosperous. In the splendid palace which sat at the heart of the city of Dresden, Eleonore would have discovered rich collections of paintings, sculpture and curiosities which had been accumulated since the time of Duke Moritz, inaugurated as Elector of Saxony in 1547. Caroline and her younger brother William Frederick would not experience these delights immediately. Before settling into her new home their mother sent them to Berlin to live with Frederick III, Elector of Brandenburg and Duke of Prussia, son of the Great Elector, and they were educated there alongside his son Frederick William (figs 2 and 3).[5]

By the time Caroline and her brother joined their mother in Dresden in 1692 Eleanore's marriage was in trouble. Even though she was described by Baron von Pöllnitz, a German adventurer, traveller and commentator on many of the European courts he visited, as 'a Princess, whose excellent accomplishments gain'd a great veneration, and beautiful person

2 *Ansbach* by Wenceslaus Hollar from *The Town Atlases*, etching, c. 1630. British Museum, London

3 *John Frederick, Margrave of Brandenburg-Ansbach* by Richard Tompson after ?Willem Wissing, mezzotint, 1678–79. British Museum

the admiration of all who saw her,' her new husband preferred to spend his time with his mistresses.[6] After two years of humiliation, Eleonore retired to a dower house at Pretzsch, in Saxony. Just a few months later she was left a widow again when John George caught smallpox from his official mistress Magdalena Sybilla von Neidschütz, the '*Favoritin*'. Eleonore and her family continued to live under the protection of the new elector, John George's younger brother, known as 'Augustus the Strong', until her death in 1696.[7] Thirteen-year-old Caroline and eleven-year-old William Frederick, now orphans, were taken back to Ansbach by their half-brother George Frederick, the young margrave, one of the children of Caroline's father by his first wife.[8]

It was not long before the Elector Frederick III of Brandenburg, with whom Caroline and her brother had lodged as small children, suggested that she return to live with him, his second wife, Sophie Charlotte of Brunswick-Lüneburg, and their son. His kind words – 'I will never fail as your guardian, to espouse your interests, and to care for you as a loving father, and pray your Highness to have me in the same confidence as your mother always

had' – encouraged Caroline to accept his offer, and in 1696 she took up residence in the household of Sophie Charlotte in Berlin (fig. 4).[9]

Caroline's wit, intelligence and beauty – she had thick blonde hair and blue eyes – was immediately noticed by visitors to the Court in Berlin and, in the autumn of 1703 when she was twenty, she received two letters while on a visit to Freiburg in Saxony. The first letter came from the Bishop of Vienna, who introduced himself as one of her mother's friends and suggested she should go immediately to visit Fredericka Elisabeth of Saxe-Eisenach, Duchess of Saxe-Weissenfels, a distant relative. The second letter explained that when she arrived in Weissenfels she would find someone there who was anxious to meet her. The mystery visitor was the Archduke Charles, the second son of the Habsburg emperor Leopold I, who was considering taking Caroline as his wife. This was an extraordinary honour. The Elector Frederick William, the father of Frederick III and Caroline's 'guardian', had had ambitious plans to increase the power of, and respect for, the House of Brandenburg-Prussia, perceiving it had potential as a lever in French and Austrian politics, but until the late seventeenth century it could still only be seen as a moderately important state in the Holy Roman Empire, without particular geographical or economic assets worth exploiting. Caroline's family connections to the industrially progressive states of Saxony and Ansbach, though, made her an attractive proposition. Charles's aide-de-camp wrote afterwards to say that the 'most happy and delightful meeting had filled him [the Archduke] with the liveliest admiration.'[10] However for this alliance to have any future it was imperative that Caroline, brought up Lutheran, convert to Catholicism.

After many hours of discussion with Father Ferdinand Orban, the Jesuit priest sent to Berlin to supervise her religious conversion, Caroline still had doubts. While Frederick (proclaimed King in Prussia in 1701) assured her that the marriage would bring glory to the House of Brandenburg and was anxious for it to proceed, his wife Sophie Charlotte believed that Caroline should make her own decision. It was following her advice that Caroline decided to reject the proposal from the Archduke.[11]

4 *'Carolineum Augustum, sive Palatium Regium civitatis Carolinensis vulgo Charlottenburg'* by Johann Christoph Böcklin after Eosander de Göthe, engraving, c. 1705. The Royal Collection

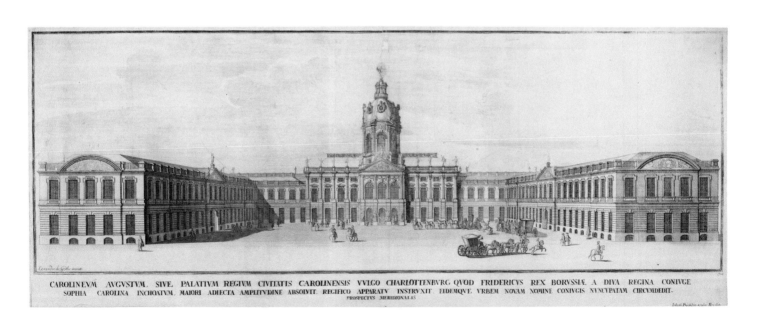

CAROLINEVM AVGVSTVM. SIVE. PALATIVM REGIVM CIVITATIS CAROLINENSIS VVLGO CHARLOTTENBVRG QVOD FRIDERICVS REX BORVSSIÆ A DIVA REGINA CONIVGE SOPHIA CAROLINA INCHOATVM. MAIORI ADIECTA AMPLITVDINE ABSOLVIT. REGIFICO APPARATV INSTRVXIT EIDEMQVE VRBEM NOVAM NOMINE CONIVGIS NVNCVPATAM CIRCVMDEDIT. PROSPECTVS MERIDIONALIS

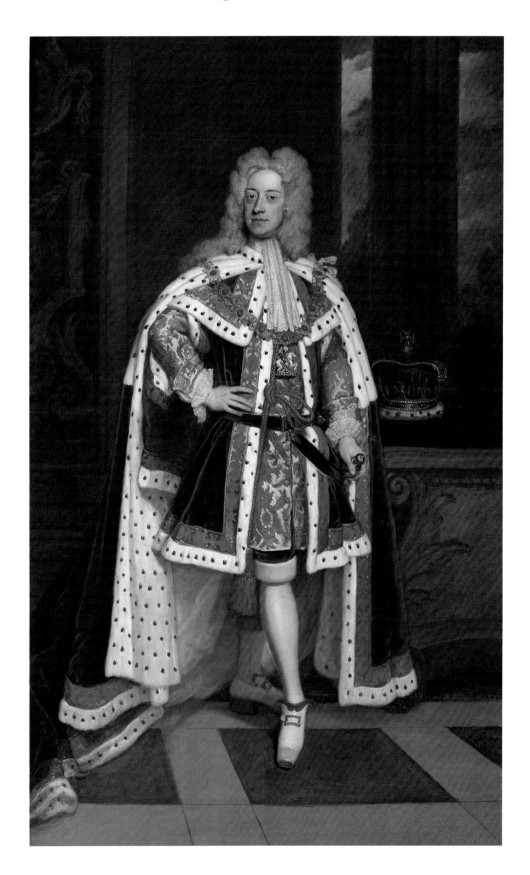

5 *George II as Prince of Wales*
by Sir Godfrey Kneller,
oil on canvas, 1716.
The Royal Collection

Early in June 1705, while staying with her half-brother at Triesdorf, a summer residence in Ansbach, recovering not only from this upsetting episode but also from the news that Sophie Charlotte had died suddenly at the age of thirty-seven, her life took another turn. Two strangers arrived, introducing themselves as Baron von Eltz and Monsieur de Busch. Monsieur de Busch, who was especially attentive as they sat playing cards together, was in fact George Augustus of Brunswick-Lüneburg, the son of George Louis, Elector of Hanover. George Augustus was the nephew of Sophie Charlotte and grandson of Sophia Charlotte's mother, the Electress Sophia. Caroline had been so fulsomely praised by Sophia that when he heard rumours that the King in Prussia was brokering a marriage for his son Frederick William to Caroline he hastened to make her acquaintance with a view to making her his own wife.

A few days later Baron von Eltz revealed to Caroline the identity of the mysterious Monsieur de Busch and requested her hand for George Augustus. With her half-brother's agreement a settlement was drawn up and they married in September 1705. The Dowager Electress Sophia – her husband Ernest Augustus had died in 1698 – was delighted, writing to Frederick: 'I have made no secret of loving the princess from the first moment I set eyes on her, or of desiring her for one of my grandsons.'[12] The House of Hanover was a relative upstart within the Austro-German political arena. The unification of its scattered lands had not been achieved until the late seventeenth century and electoral status was not conferred until 1693. Caroline, a Hohenzollern princess, brought to the family both prestige and political connections. Her public affirmation of the Protestant faith was another reason for making her acceptable in Hanoverian eyes. This was because of an extraordinary turn in the fortunes of the House of Hanover (fig. 5).

In England, in 1700, the troubled House of Stuart lost its only proper chance of retaining the throne. In 1694 Queen Mary had died, childless, of smallpox. By the terms of the Bill of Rights, which had brought William III and Mary II to the throne in 1689, the succession was to pass on the death of the last of them to Mary's heirs, to Mary's sister Anne and her heirs, and then to any children William might have by any later marriage, in that order. Of the seventeen children born to Anne and her husband Prince George of Denmark just one boy, Prince William Henry, Duke of Gloucester, survived infancy. Much loved and carefully nurtured, the health of the little prince was desperately precarious and on 30th July, 1700, just five days after his eleventh birthday, he died. Anne had no expectation of more children, her health having suffered greatly in child-bearing, and William, widowed at the age of forty-four, had not been inclined to take a second wife. It was therefore imperative that a plan be made to secure the succession, and Parliament considered the claims to the throne of various family members.

There were important criteria to be satisfied. At the top of the list was the requirement for the next monarch to be Protestant; the Bill of Rights, as well as limiting the power of the sovereign, and reaffirming Parliament's claim to control taxation and legislation, had provided guarantees against the abuses of power which James II and the other Stuart kings had committed. The bill stated: 'it hath been found by experience that it is inconsistent with the safety and welfare of this protestant kingdom to be governed by a papist prince.' The sovereign would be required in the coronation oath to swear to maintain the Protestant religion.

Of Catholic claimants there was no shortage. From 1688 James II lived in exile at St Germain-en-Laye in France and, after James's death in 1701, his son by Mary of Modena, Prince James Francis Edward Stuart – the 'Old Pretender' – pursued his claim with vigour. But Parliament considered the securing of a Protestant succession so important that it declared invalid not only the claims of the Jacobites but also those of some fifty other Catholic near-relatives. The Act of Settlement, passed in 1701, nominated the Lutheran Dowager Electress Sophia of Hanover, a granddaughter of James I of England, and her Protestant heirs as successors to the throne of England.

Queen Anne, despite the Electress Sophia's lobbying, had not encouraged any involvement from the Hanoverians in British affairs. Dealing with the internal political situation as well as with the War of the Spanish Succession occupied her energies. The Court of the exiled Stuarts at St Germain-en-Laye, was already a worrying focus for the discontented, and the presence of a Hanoverian court in London could easily have become another. Nevertheless, conscious of her husband's destiny, Caroline used her years as a young wife in Hanover to good advantage.

She was fortunate in having a strong relationship with her husband. The couple rejoiced in the birth of their children. Frederick Louis was born in January 1707, Anne followed in 1709, and then Amelia Sophia Eleanor in 1711 and Caroline Elizabeth in 1713 (fig. 6). The temperaments of the pair proved remarkably complementary. Caroline's intelligence and even temper proved a counter-balance and foil to George's energy and his frustration at

6 *Princesses Anne, Amelia and Caroline* by Martin Maingaud, oil on canvas, 1721. The Royal Collection

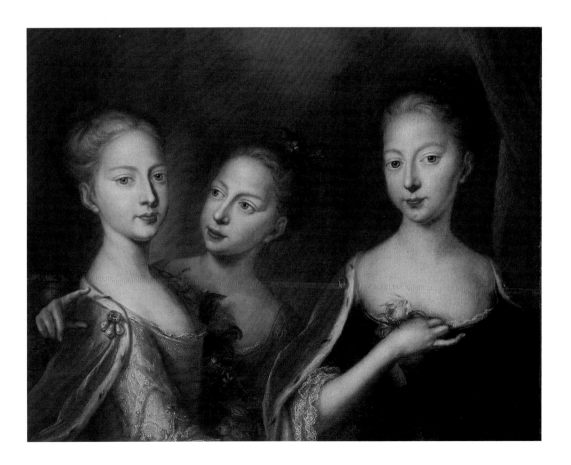

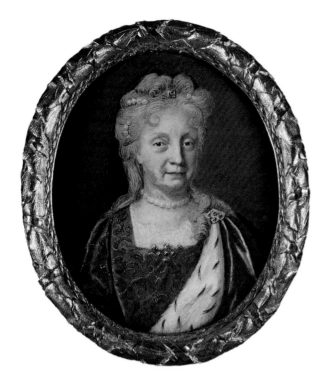
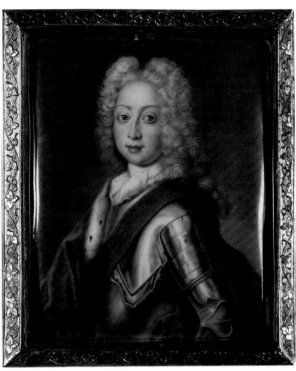

the narrowness of their lives. They both studied English and being naturally inclined to be sociable greeted visitors from London with enthusiasm, through them seeking to gain a knowledge of British politics, society and customs. By 1714 they had met several members of the British political élite, including the Duke of Marlborough, the Earl of Sunderland, the Earl of Halifax and James Craggs the younger, all of whom had attempted to further their careers by forging bonds with the coming regime. Among the secretaries and officials who formed their entourages were artists and architects, and members of the British intellectual community such as Sir John Vanbrugh, Joseph Addison and John Gay.

In June 1714 the Electress Sophia (fig. 7) died unexpectedly, while walking in her garden at Herrenhausen. When Queen Anne died in London two months later, by the terms of the Act of Settlement Sophia's son George Louis was proclaimed king as George I of Great Britain. On 20th September the King arrived in London in the company of his son Prince George Augustus, the newly created Prince of Wales. Caroline (now Princess of Wales), with their three little daughters, joined her husband on 11th October, taking up residence in St James's Palace in time for the coronation a week later. Frederick, the eldest son of George Augustus and Caroline, was left in Hanover as a sign to the electorate that the family would continue to honour its responsibilities there (fig. 8).

In England a precarious situation had to be faced. The Act of Union of 1707, which united Scotland with England and Wales under the Protestant faith and a common legislature, had, in part, made the Hanoverian succession possible. Designed to prevent a separate Scottish foreign policy, it had lessened the chances of the significant body of Stuart supporters establishing a rival base. However, the Jacobite threat to the Hanoverians remained serious. Expeditionary forces supporting James Stuart, the Old Pretender – the

7 *Sophia, Electress of Hanover*, German School, watercolour on vellum laid on card with a gessoed back, c. 1700. The Royal Collection

8 *Frederick Prince of Wales as a Child* by Charles Boit, 1724, miniature. The Royal Collection

young, glamorous Roman Catholic son of James II – had landed in Scotland in 1708 and would again in 1715. And there would be further scares in 1717, 1719 and 1720. It was essential that George I and his family played their part in providing a dependable Protestant leadership.

In England the Court had much ground to regain. By the early eighteenth century new centres of power had developed in the busy and prosperous business community in the City of London as well as in Parliament. Parliament, which allowed every part of the country its representative in the running of the nation, had, since 1688, met much more regularly over several months each year. The new ruler would need to see this position adjusted – the Court needed to be revitalised and made a place of fashionable assembly once again. However, the turbulent history of Britain during the seventeenth century – which included the fact that there had been seven monarchs in the previous one hundred years – meant there had been little time or impetus to invest in the development of any of the royal homes, to serve as their centre of operations. Whitehall Palace, the rambling collection of apartments, courtyards, galleries and offices located close to Westminster Hall, which had been used by a succession of monarchs since the sixteenth century, had burned down in 1698. William and Mary had begun modernising Hampton Court Palace, but Mary's sudden death in 1694 interrupted the work and the project was still incomplete in 1702 when William died. Queen Anne, though she conscientiously maintained the cycle of court gatherings in the modest apartments at St James's Palace (fig. 9) and Kensington Palace, suffered such ill-health she had little energy to initiate expensive plans for either the rebuilding of Whitehall or the completion of the plan for Hampton Court. As a result

9 *'The Royal Palace of St James's'* by Johannes Kip after Leonard Knyff, a plate from *Britannia Illustrata*, 1707. British Museum

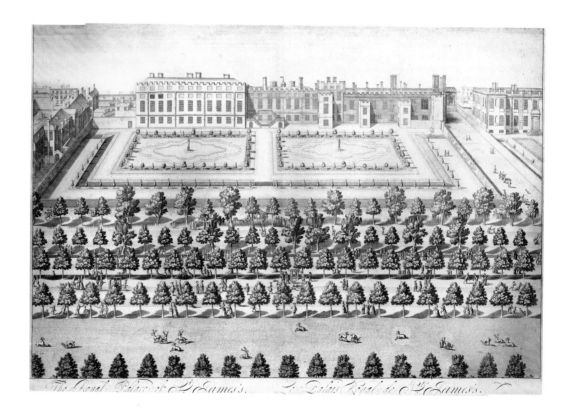

there was no centre of court culture to rival France's Versailles, in which Louis XIV had invested so considerably.

 George I was an unlikely monarch to address these challenges. He was plain, already in his fifties and lacking in charm (fig. 10). While he understood and spoke English, he preferred much of the official business with his ministers to be conducted in French and Latin. For the British he had little appeal beyond his Protestant faith. Long estranged from his wife Sophia Dorothea of Celle, whom he had banished to Ahlden in 1694 after she was discovered in an adulterous relationship with Count Philipp Christoph von Königsmarck, he travelled to London in the company of his mistress Melusine von der Schulenburg, their children and his half-sister Sophia Charlotte von Kielmansegg. This was a situation the English found curious and confusing.

 On arrival in England Caroline's first contribution to the smooth integration of the new regime was to provide a strong female presence at Court. While her English was peppered with German and French idioms, she was young, attractive and outgoing, and dealt elegantly with the court duties which fell to her.[13] After careful study of the local etiquette respecting her position in the royal household, she early elected, as the senior royal female, to follow the protocol that would be accorded a queen consort.[14] If some observers thought this presumptuous, her dignified and friendly manner won them over, especially when, unlike other members of the royal family, she appointed an entirely English staff. Her position as wife to the heir to the throne was unambiguous, and very soon the couple found themselves at the centre of a lively circle.

10 *George I* by Georg Wilhelm Lafontaine, oil on canvas, c. 1720–27. The Royal Collection

Caroline provided some new and much needed glamour to court occasions, though as Princess of Wales with a relatively modest income for her household of between £8000 and £10,000 each year from her husband's Civil List allowances, and an additional £8000 allocated for her private expenses (rising to £100,000 when she was queen), her choices might be described as stately rather than lavish. Mantuas, close-fitting dresses extending to a train behind and left open down the front to reveal a decorative petticoat, were her preferred style of dress.[15] They were made of luxurious textiles such as 'brown flower'd silk', 'white and gold armoz' and 'white and gold estoff manto'; 'armoz' (armoisin) and 'manto' (mantua) were terms used for grades of woven silk.[16] The dresses were worn over 'long hoop petticoats' made in crimson linen, each shaped by up to three pounds of whalebone. On less formal occasions Caroline elected to wear a sultan, a practical, neat, close-fitting dress with a full gathered skirt but no train, or a sack, a dress characterised by its 'sack back', or deep pleats set into the back of the neckband and falling loose to create an elegant fullness down the entire back of the dress, and sometimes extending into a little train. Her choice of textile for these was usually fine, plain silk in green, blue or purple, serving to set off the English or French lace worn around the neck and as ruffles for the sleeves.

The size of Caroline's headwear was a source of mirth among her circle. She favoured 'a strange coarse gauze' according to Mary Pendarves (born Mary Glanville, later Mrs Delany), or substantial caps, hoods, heads or mobs made or trimmed with lace.[17] The lace bills would be among the largest in Caroline's private account books. For a single 'compleat head of Brussels point' she paid the lace merchant John Denay as much as a hundred guineas in 1733, though a 'head' could have represented more than ten metres of lace. On her feet Caroline seems to have preferred wearing slippers, a simple type of shoe without backs, rather than other, fashionable and more substantial styles. They were made in silk and often decorated with metal braids, but this did not prohibit even the most energetic activity. Lady Cowper, one of Caroline's Ladies of the Bedchamber, reported that 'she danced in slippers very well at the Prince's Birthday' in 1714.[18] In 1727, perhaps reflecting on her choices, Caroline asked Lady Lansdowne if she could send from Paris a fashion doll dressed by the milliner to the French princesses.[19] Little seemed to change, however, and Caroline's choice of dress would remain elegant if restrained, and on occasion just a little idiosyncratic.

Adopting an appropriate style on court occasions was just a small part of creating a role for herself and establishing relationships at Court. There were many more challenges and dangers for someone in her position. There were few models that Caroline, as Princess of Wales, could look to. Mary II, though she ruled as joint monarch with her husband William III between 1689 and 1694, had assumed a role which was in reality much nearer that of queen consort, both in her actions and interests, content to defer to him in matters of political or military policy. Moderately well educated, energetic, and having established a good rapport with her husband, Mary's opportunity to arrange and manage her situation within the framework of the Court was auspicious, and all started well. Her first significant contribution was to spearhead the campaign to improve the quality of royal accommodation at all the royal palaces, a project which extended to the overseeing of new building work at Kensington Palace and Hampton Court Palace and the establishment of new gardens. There was a political dimension to Mary's patronage as she consciously drew in Protestant artists and craftsmen, recently exiled from France, to manage the fitting-out and

furnishing of the new apartments – a gesture to demonstrate affiliation with the anti-French power bloc in Europe which saw Protestant William as its champion. She was quick to exploit the fruits of early colonisation and overseas trading alliances as she filled her rooms with Indian textiles and ceramics from China and Japan.[20] She delighted in the treasures she discovered in the royal collections and made efforts to assess the state of the royal libraries. But her reign was brief; childless, she died suddenly aged thirty-two. Her legacy was a myriad of incomplete projects. Any sense of a programme or philosophy behind her patronage was lost.

From an earlier generation Caroline may have considered the example provided by Catherine of Braganza. Catherine had arrived in London to marry Charles II in 1662 and did not return to her native Portugal until 1692, after the death of her husband. During this time the single important fact that dictated the course of her life as queen consort was that she remained childless. This severely limited her influence at Court, a situation which she sought to ameliorate with her cultural patronage. To counterbalance the French faction which built up around the King's mistress, the young and beautiful Louise de Kérouaille, she invited distinguished Italian musicians to London to provide the music for her chapel and patronised Italian painters. Catherine's plan was to an extent successful. The reputation of this Italian artists' community eventually extended well beyond the confines of the Court into fashionable society, with the Queen identified as its champion.[21] However, at its heart, this was a programme grounded in the need for the Queen to play off one of the King's mistresses against another. Caroline's situation in 1714 was far more fortunate.

Caroline, immediately identified as 'a princess of the brightest character', was confident that the existence of her young and healthy offspring, a key requirement of any queen consort, already gave her a special status as 'Mother of the Nation' – a role eulogized by William Talbot, the Bishop of Oxford, at the coronation of George I. She immediately introduced her pretty young daughters into ceremonial life at Court in a way which was comfortable and reassuring.[22] The two eldest accompanied their mother to see their father installed in the House of Lords in 1715.[23] She was also in the happy – and, for the Hanoverians, unusual – position of knowing her husband saw her as his helpmate and confidante.

Their marriage would receive a significant test shortly after George Augustus and Caroline arrived in London. They settled into St James's Palace with George Augustus's father, George I. Their sadness at leaving their son Frederick in Hanover must have been offset to some degree by excitement at the thought of the challenges that lay ahead. However, following the burning down of Whitehall Palace in 1698, accommodation for three generations of the royal family was severely limited. Crammed together into St James's, or in the relatively informal and hardly more commodious apartments at Kensington Palace, jealousies and tensions were inevitable. It did not help that George Augustus was quick to criticise his father for his aloofness and about his special friendships with those who advised him on his German policy. When it came to military matters they were impossibly competitive.[24] In July 1716, when the King returned to Hanover, the situation boiled over. He insisted that George Augustus dismiss the military general the 2nd Duke of Argyll who had served as his Groom of the Stole since 1714. Argyll had been given this appointment as a reward for his commitment to the House of Hanover but he had recently fallen from favour after his actions rebuffing a Jacobite invasion in Scotland had nearly resulted in a

defeat. Angry at losing his position as Commander-in-Chief, the Duke had become quarrelsome and therefore a dangerous person to occupy a key position in the household of the heir to the throne and those who opposed the King. George Augustus initially resisted his father's demand. In response the King threatened to bring his brother Ernest Augustus from Hanover to act as 'Guardian and Lieutenant of the Realm' in his absences instead of entrusting the responsibility to his son.[25]

The humiliation resulted in George Augustus dismissing Argyll but, despite the upset, he resolved with Caroline to enjoy being at the centre of court life while the King was away. They took themselves to Hampton Court for the summer, where they entertained in style, dined in public, organised public entertainments and sought to make friends across political divides. When George I returned to London in January 1717, the popularity of the young couple aroused his jealousy and political battle lines were drawn up once again.

Since the mid seventeenth century the terms 'Whig' and 'Tory' had been used to describe the major political groupings in the House of Commons. The parties had drawn together to support the Glorious Revolution which saw the accession of Protestant William and Mary in 1689, but, during the negotiations for the Act of Settlement in 1701 to decide who should be the successor to the Stuart monarchs, it had had been the Whigs who had most actively supported the Hanoverian claim. Over the summer of 1716, with the King away, concern grew that he was adopting a foreign policy that favoured Hanoverian interests rather than those of England, and this led to serious splits in the Whig support. Viscount Townshend, Secretary of State for the North, and Robert Walpole, Secretary of State for the South, declared their allegiance to George Augustus, leaving James Stanhope, Second Secretary, and the Earl of Sunderland, the Lord Privy Seal, as the King's principal supporters. An already tense situation deteriorated even further in 1717 when Caroline gave birth to another son.

The safe arrival of the little prince should have been the occasion for great celebration as Caroline's baby the previous year had been stillborn. George Augustus proposed that his father George I, Ernest Augustus (George I's brother) and Sophia Dorothea, Queen of Prussia (George Augustus's sister) should stand as godparents to the infant, whom they wished to name Louis. His father objected. The child should be called George William, and he insisted that the Duke of Newcastle, the Lord Chamberlain, be included in a revised list of godparents. Despite attempts at a compromise the King had his way. After the ceremony there was an angry spat between George Augustus and Newcastle, during which Newcastle understood he had been challenged to a dual by the Prince. When news of this reached the King, George Augustus was summoned, arrested and then banished from St James's. Caroline was given the option to follow her husband but, if she did, the King decreed that as wards of the Crown her three young daughters and the newborn son would remain in his charge.

Caroline, though devastated at the thought of being parted from her children who were already in England, would not consider leaving her husband.[26] The couple retreated together to the house of Lord Grantham, the Prince's Lord Chamberlain and, when all efforts at reconciliation with the King failed, they decided they would purchase a house of their own. They settled on Leicester House, a two-storeyed mansion, with an elegant courtyard in front and a small formal garden at the rear, which was in Soho, just a short walk from St James's Palace (fig. 11).[27]

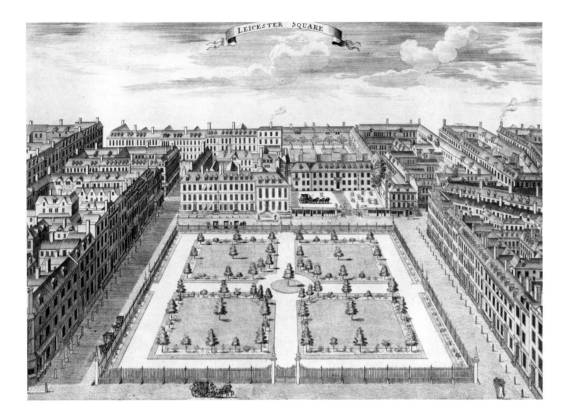

The estrangement between father and son – a situation not uncommon in the case of royal families – meant George I would dictate the manner of the upbringing of the three princesses, Anne, Amelia and Caroline, as well as supervising the education of Prince Frederick, who had been left in Hanover. Under his charge the girls were provided with apartments at Kensington Palace arranged around what became known as 'Princesses Court'. The Countess of Portland, the clever niece of Sir William Temple, advisor to William III, was appointed their governess. Six of Anne's school books, which have been preserved as part of the Royal Collection in The Netherlands, provide evidence of the ambitious programme of academic study followed by the girls.[28] One contains extracts written in French taken from Plutarch, Heroditus and Thucydides, amongst other classical authors. Another contains a long transcription in Italian of the history of the Roman Empire and a third has theological texts written in German. Philippe Mercier was engaged to give art lessons and Handel provided their music tuition.

The shock that reverberated around the Court when Prince George William died aged three months while in the King's charge ensured that Caroline would be allowed regular access to her daughters again, although they were still not allowed to live with their parents. Letters which passed between family members, and remarks overheard, testify that the arrangement continued to cause great distress. Anne was heard to say: 'we have a good father and good mother and yet we are like charity children,' and when asked whether her grandfather, the King, visited, replied: 'Oh no, he does not love us enough for that.'[29] According to Lady Cowper, in 1720, Caroline wrote to Robert Walpole: 'You will hear from me and my complaints every day and hour, and in every place if I have not my children

11 *Leicester Square* by Sutton Nicholls from *London Described*, 1720–30. British Museum

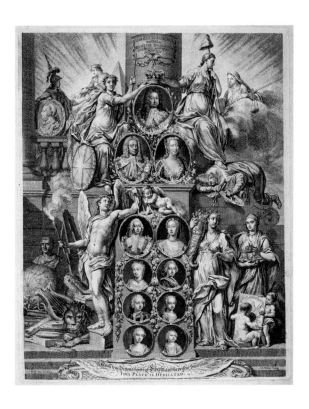

again.'[30] Anne's description of the daily timetable Lady Portland devised for her charges indicates a strict though balanced schedule. The Princesses rose at seven in the morning. After prayers, breakfast and a walk they worked at their lessons until their main meal at one o'clock. The afternoon started with another walk or, if the weather was bad, a period to 'talk of sensible things'. After this there would be dancing, riding and music lessons. They would see their mother and more rarely their father for an hour in the evening before retiring to bed.[31] While Caroline seems to have been able to build a loving relationship with her daughters, their father commented later that he had found it difficult to relate to his children when they were young and only came to enjoy their company as they became young adults.[32]

George Augustus and Caroline went on to have another son, William Augustus (fig. 15), who was born in 1721, and two more daughters: Mary (fig. 13), born in 1723, and Louisa (fig. 14), in 1724. These younger children were allowed to remain in the charge of their parents, and it became a much tighter and more affectionate family unit. Their education was a matter that Caroline took very seriously: to raise and educate the next generation of a royal family, in a way that fitted them for their future roles in life, was one of the preeminent responsibilities of any queen consort and vitally important in providing stability for the royal family. Having initially been distanced from the schoolroom of her older children, her involvement in organising the timetable for her younger children must have been seen as a very precious charge. Caroline gained a reputation as the exemplary parent. Stephen Philpot in *An Essay on the Advantage of a Polite Education*, published in 1747, commended her particularly for attending so many of her children's lessons and for her care in checking their academic progress with their teachers.[33]

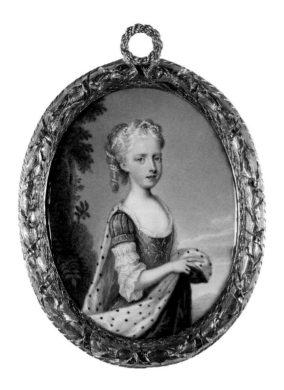

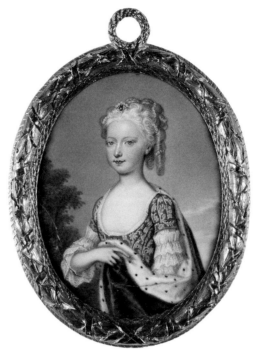

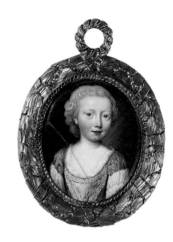

The academic syllabus she devised for William Augustus when he was ten years old and had been provided with his own establishment was very ambitious. Stephen Poyntz, an intelligent if retiring diplomat, was appointed his governor, with William Wyndham of Felbrigg his assistant. Jenkins Thomas Philipps, an able classical scholar, served as principal tutor, though Sir Andrew Fountaine, Caroline's Vice-Chamberlain and a noted connoisseur of art, provided tuition too, and the Prince also attended lessons with Robert Freind, the headmaster of Westminster School.[34] Freind was a Tory High Churchman, but a great friend of Dr Thomas Sherlock, Caroline's chaplain and from 1728 to 1734 Bishop of Bangor; perhaps Caroline sought to expose her son to a variety of religious opinion, given that the majority of the clergy within her circle were Low Churchmen or Latitudinarians (men who wished to emphasise or encourage a latitude, or liberalness, in matters of doctrine, liturgical practice and ecclesiastical organisation within the Church of England). Lessons in law, constitutional history, modern history and geography were provided by Nicholas Hardinge and Philip Zollman. Mr Hawksbee travelled from Woolwich Academy to teach ballistics, and instruction in shipbuilding came from Sir Jacob Acworth, Surveyor to the Navy. Henry Flitcroft was asked to instruct the young prince in the principles of architecture (fig. 15).

Mary Howard, who had joined the royal household as a Maid of Honour to Caroline on her arrival in London in 1714, married Mr Wyndham in 1734 after the death of her first husband, the Earl of Deloraine. She was governess from about 1730 to the two youngest princesses, Mary and Louisa, though they also shared several of their brother's tutors, including Wyndham, Jean Palairet, who taught all the younger children French, German and Italian, and Jenkins Thomas Philipps, who gave Latin lessons.[35] Bernard Lens replaced

13 *Princess Mary* by Christian Friedrich Zincke, miniature, c. 1731. The Royal Collection

14 *Princess Louisa, later Queen of Denmark, when Young* by Christian Friedrich Zincke, miniature, 1730. The Royal Collection

15 *Prince William Augustus, Duke of Cumberland, as an Infant* by Christian Friedrich Zincke, miniature, c. 1724. The Royal Collection

Philippe Mercier as the tutor in painting and drawing to the younger children, and Mr Weidman succeeded Handel as music teacher.[36]

Leicester House soon took on the role of a rival court, and Caroline's Drawing Rooms assumed the nature of a salon: a gathering to which she invited artists, writers, theologians, philosophers and scientists. She had set up these occasions initially in St James's Palace immediately on her arrival there in 1714 but, after the royal rift, the participants – with little hesitation – followed her to her new home. By the mid-seventeenth century well-born women were beginning to realise the deficiencies in their education and the concept of the salon emerged in Paris. It was an occasion when they could meet in small groups, often in the home, to discuss literature, theology and new scientific discoveries. The meetings may not have had any official, public or academic role, but attendance provided access to the world of letters and allowed women a part in the contemporary cultural, scientific as well as political debate. They provided an incentive for preparatory reading and an opportunity to practise conversational skills, thereby improving their understanding of, and engagement with, the world.[37]

Caroline had experienced such gatherings when she was young, sitting at the feet of Sophie Charlotte in Berlin and the Electress Sophia in Hanover. But, unlike in Brandenburg or Hanover – where the Court was central to the cultural and intellectual life of the State, with the salon playing its part – in England they had largely existed, since the mid-seventeenth century, in aristocratic circles and at universities. Caroline's plan was to encourage the Court to be once again the promoter and encourager of the arts and sciences. The salon would allow the Court to be seen to be aligned with communities whose reputation for creativity and intellectual achievement already had an international reputation. It would bring her contact and information about local preoccupations and taste, as well as providing an opportunity for her to present to a lively and vocal community the benefits brought by the new reign.

The people who were invited to Caroline's salons were those who could support the Hanoverian dynasty in some way. There was always a scattering of clerics. Having refused an imperial crown for her religion, she was proud to claim a role as a Protestant heroine, a role that could serve the new ruling house to some advantage. She rebuffed the approach made by John Robinson, Bishop of London and Dean of the Chapel Royal, 'to satisfie her in any doubts or scuples she cd. have in regard to our Religion & to explain anything to her, wch she did not fully comprehend', saying. 'he is very impertinent to suppose yt I who refused to be Empress for ye sake of the Protestant Religion don't understand it.'[38] Amongst the eclectic throng were High Churchmen such as Dr Thomas Sherlock, Joseph Butler, rector of Stanhope and later Caroline's chaplain, and William Wake, the Archbishop of Canterbury, her spiritual adviser, as well as the Latitudinarians Benjamin Hoadly, Bishop of Salisbury, Robert Clayton, later Bishop of Clogher, and Dr Samuel Clarke, the rector of St James's, Piccadilly.[39]

Caroline was anxious to bring Sir Isaac Newton into her circle despite her long-standing friendship with his great rival, Gottfried Wilhelm Leibniz. Newton achieved status as a national hero in England in his own lifetime, and his brilliance would provide distinction and credibility to the gatherings. Newton's friends Zachary Pearce and the astronomer Edmond Halley were invited too. Amongst the writers who attended from the earliest days were Alexander Pope, John Gay and Thomas Tickell. Jonathan Swift, one of the literary

lions of the day, took longer to coax into the throng. He received his invitation through Henrietta Howard (later Lady Suffolk), one of Caroline's Women of the Bedchamber, who explained that Caroline 'loved to see odd persons, and having sent for a wild boy from Germany, had curiosity to see a wild Dean from Ireland.'[40] After nine royal summonses Swift finally agreed to attend.

The salons were just one of Caroline's remarkable initiatives, and it is evident that much more remains to be said about this extraordinary woman – hence this book. It does not set out to be the definitive biography; it is Caroline's remarkable cultural policy and its dynastic dimension which will be explored. Caroline's European background had introduced her to the Renaissance notion that the Court should be a civilising influence on society at large and, as the senior female, she assumed for herself the traditional role of champion of the arts and sciences – the polite and pious counterpart of the male role to administer justice and defend the honour and liberties of the nation. In the chapters which follow Caroline will emerge as a figure determined to fulfil the traditional requirements laid on a queen consort as well as endeavouring to re-establish the Court as an intellectual and cultural hub for the nation. The task would not be easy. The social and cultural climate in England was very different. The dramatic spectacle of court procedure practised in many European palaces would need to be aligned to the needs of an English parliamentary monarchy, where ostentation and show were not so welcome. However, if Caroline could achieve success in this, it would make an important contribution to the legitimizing and embedding of the fragile new dynasty during those dangerous times – the threat of a Jacobite invasion was ever present.

In recent years historians have begun to re-evaluate the early Hanoverian period, and two major avenues of research have been explored. The first has been a re-appraisal of the role of the Court, embracing its social and political as well as its cultural functions. John Beattie's *The English Court in the Reign of George I* published in 1967, and Ragnhild Hatton's *George I: Elector and King* which followed in 1978, established a solid body of new information on which others such as Barbara Arciszewska, Robert Bucholz and Hannah Smith have built subsequently. But in none of these works has Caroline emerged with a distinct identity and role.[41] The two volumes edited more recently by Clarissa Campbell Orr, which have explored the nature of queenship within the court culture of Britain and Europe, have provided more pertinent information. They contain essays by Christine Gerrard and Andrew Hanham which touch on Caroline, but Gerrard chose to compare the approach Caroline took to her role generally in comparison to that taken by her daughter-in-law, Augusta of Saxe-Gotha, and Hanham explored how Caroline's engagement with the political and ecclesiastical frameworks within her new homeland can be seen as a contribution towards the anglicization of the Hanoverians.[42] Elsewhere, Stephen Taylor has written an important essay about the relationship between the Hanoverian court and the Church, a subject in which Caroline had a pivotal role.[43] While Caroline begins to take her place in the make-up of the early Hanoverian court through these works, her management of its cultural politics is still not clear.

Building on Linda Colley's work, which explores the developing sense of a British national identity in the eighteenth century, a second avenue of research has concerned the impact that the union of Britain and Hanover contributed to the forging of a modern British monarchy.[44] The most recent anthology of essays, edited by Brendan Simms and

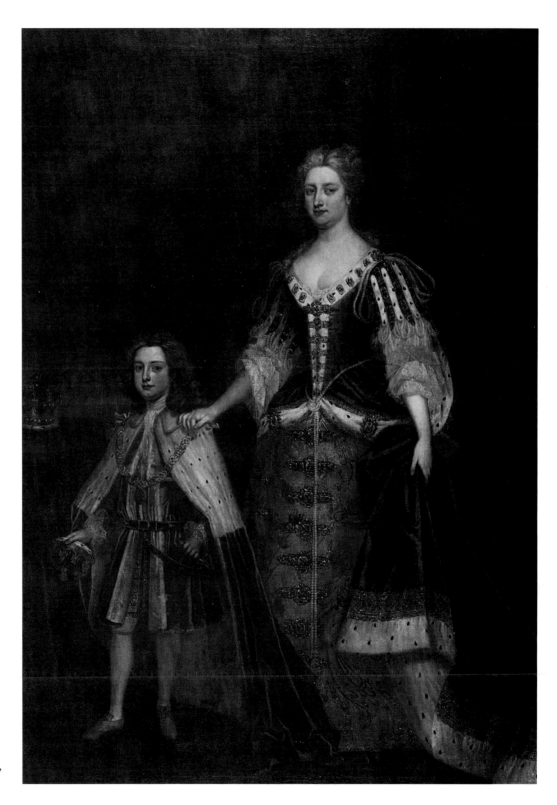

16 *Queen Caroline with her Son Prince William Augustus, Duke of Cumberland* by Charles Jervas, oil on canvas, 1729. The Royal Collection

Torsten Riotte, which contributes to this strand, makes no attempt, however, to cover the cultural aspects of the Court.[45] Andrew Thompson's biography of George II does much to establish the European context which conditioned the foreign and, to a certain extent, the domestic policy followed in England in the first half of the eighteenth century, but again there is scant mention of Caroline and how her projects fell into this construct.[46]

There is also no useful biography of Caroline which might usefully fill in the many gaps. The most recent piece of research to cover her life history was compiled by Stephen Taylor for the *Oxford Dictionary of National Biography*, but this is of necessity brief and wide-ranging. There are three earlier biographies, all written many decades ago: the first, by W. H. Wilkins, was published in 1901, those by Peter Quennell and R. L. Arkell in 1939. All these works concentrate on chronicling the troubled family politics of the first three generations of Hanoverians in more or less detail.[47] The work by Arkell is the most comprehensive, making use of archive resources in Berlin, Hanover and London, with footnotes to help the reader, but while it describes some of Caroline's cultural initiatives this is in no great detail and without context. There are many contemporary historians, including John Walters, Kimerly Rorschach and Frances Vivian, who have suggested that Caroline's eldest son, Frederick, was the first member of the Hanoverian family fully to explore the power of cultural politics, but Caroline, with her own steely resolve, was there before him, setting her own agenda and providing a model and inspiration for his programmes which followed (fig. 16).[48]

There is a wealth of documentary references to map Caroline's projects, as well as a considerable and extraordinary trail of material evidence – a garden, paintings, sculpture, artefacts from her cabinet of curiosities – which survives into our own times and illustrates the considerable breadth of her involvement with the worlds of art and science. While there is rarely a single source to document each of her many schemes, the references in letters, diaries, inventories and business accounts allow one to build up a framework for each venture, and then to fill this in with an extraordinary level of detail about its scope and ambition.

Caroline's artistic projects initiated as Princess of Wales continued after she became queen consort in 1727. To achieve her ambitions Caroline would form links with individuals, organisations and institutions. Her interests and involvement extended from the salon into the wider court circle and beyond, into cultural communities in London and its environs. This brought her into contact with the world of the gardener, the architect, the sculptor and artist, the philosopher and natural philosopher. Caroline emerges not just as a powerful individual responsible for the shaping of the eighteenth-century monarchy in Britain but as a force in the early English Enlightenment.

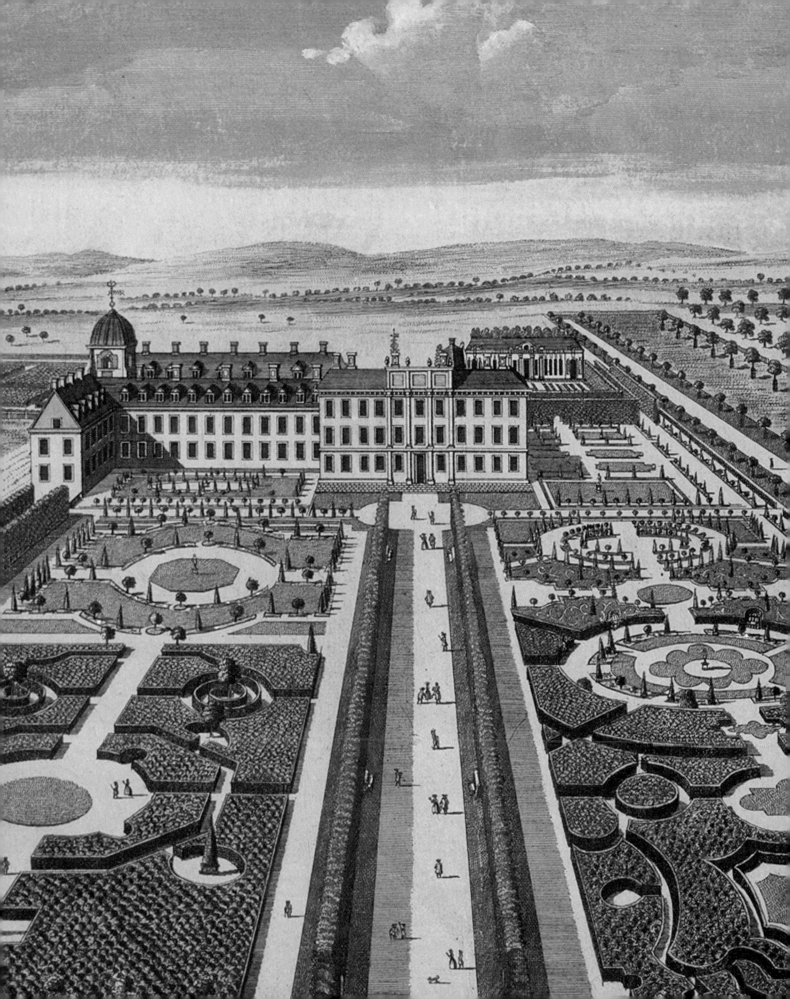

1

CAROLINE
and the *Gardeners*

During the first two decades of the eighteenth century, in a debate within cultured circles in Britain led by the Earl of Shaftesbury, the Whig philosopher, it was suggested that one of the benefits of the Hanoverian succession might be a renaissance in the arts. Jonathan Richardson, a painter and author of *An Essay on the Theory of Painting* in 1715, commented: 'If our nobility and gentry were lovers of Painting and connoisseurs, a much greater treasure of paintings would be drawn up and antiques would be brought in, which would contribute abundantly to the raising and ameliorating of taste, as well as the improvement of our artists.'[1] But for those in the cultural community who anticipated a flood of new building projects and art commissions after George I's accession in 1714, the King would be a remote, inaccessible figure. George Augustus, the Prince of Wales, if more energetic and articulate, declared without embarrassment, 'I care nothing for Bainting or Boetry' and admitted to 'extreme ignorance in painting'.[2] Those who made their way to the salon Caroline established immediately on arriving in London found that she was approachable and enthusiastic, and would be key to a revival of interest in the arts.

The circle admitted to Caroline's salon in the drawing room at Leicester House was small, but an opportunity to draw up a programme which would touch a greater number of people emerged in 1719 when George Augustus acquired Ormonde Lodge in Richmond as a country seat.[3] The plan she devised in the wake of this would bring her into contact with the wider artistic community in London and in particular, since the project was the creation of a new garden, with a group of pioneering English garden theorists and

Opposite
'The Royal Palace of Kensington' by Johannes Kip after Leonard Knyff, a plate from *Britannia Illustrata*, 1707 (detail of fig. 20)

practitioners. Through the new garden Caroline would explore contemporary notions of Englishness – it was the first time she attempted to pursue her political agenda by means of art patronage.

The new house, which was promptly renamed 'Richmond Lodge', was located in the park surrounding the remains of Henry VIII's great Richmond Palace on the south bank of the Thames. Although both William III and the Duke of Ormonde, Ranger of Richmond Park, who had taken over the lease on William's death in 1702, had enlarged and improved the building, the red-brick house was small, its new pedimented façade concealing an irregular room plan.[4] For George Augustus and Caroline, however, any perceived disadvantages were offset by the desirable intimacy it afforded; for Caroline it became a semi-private province which she could make her own (fig. 17).

The greatest opportunity Richmond offered to Caroline related to the park. This extended to some hundred acres along the south bank of the Thames, from Richmond to the hamlet of Kew, and included most of the site of the modern Royal Botanic Gardens. There was already a formal garden surrounding the lodge, which had been established by William III with the help of his gardener George London. It was planted with alleys of trees framing the north-facing façade of the house and extending down to the river.[5] Ormonde had contributed a terrace walk along the river bank and two small summer-houses.

Caroline's enthusiasm for embarking on a garden project comes as no surprise given her background. In 1697 her first mentor, Sophie Charlotte (fig. 18), the wife of her guardian

17 *'A Prospect of the Royal House at Richmond'* by J. B. C. Chatelain after Marco Ricci, engraving, published by J. Groupy, c. 1725. Orleans House, London

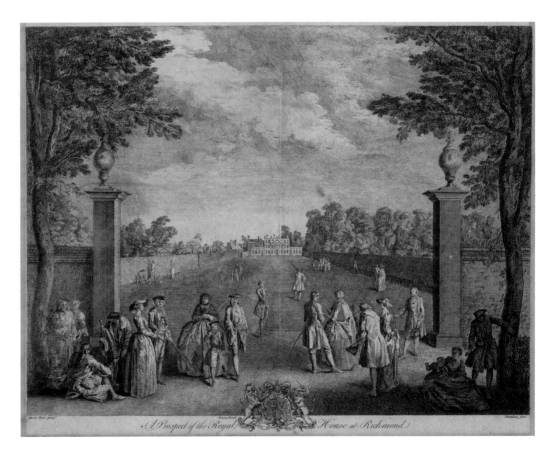

A Prospect of the Royal House at Richmond

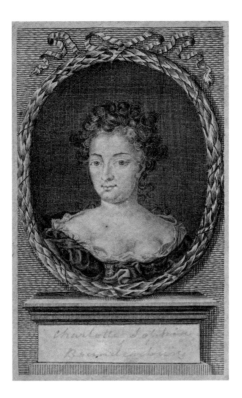

the Elector Frederick III, had initiated plans for a garden at Lützenburg – now called 'Charlottenburg' – where she employed Siméon Godeau, a pupil of the eminent French gardener André Le Nôtre, to provide the design.

Sophie Charlotte, who had married the then-widowed Elector Frederick III of Branden-burg in 1684 at the age of sixteen, sought solace at Lützenburg, a royal estate just outside Berlin, when she realised that her relationship with her husband was unlikely to thrive. As part of Frederick's ambitious campaign to provide the state with the trappings of a princely court, he had developed a plan to aggrandise the Stadtschloss in central Berlin, and perhaps his young wife felt the making of a new house and garden would give them a common interest.[6] Built between 1695 and 1699, to designs by the architect Johann Arnold Nering, Lützenburg was remodelled in 1701 to reflect Sophie Charlotte's new status after Frederick declared himself 'King in Prussia'.[7] During Caroline's years in Berlin she would have seen Godeau's garden laid out, the formal parterres with clipped box hedges planted and the newly laid lawns embellished with gilded statuary. A pool cut at its centre had a harbour for gondolas imported from Venice.[8]

Sophie Charlotte's mother, the Dowager Electress Sophia, who presided over the Court in Hanover, was Caroline's second role model, for she too had created important gardens. Born in 1630, Sophia was the twelfth child of Frederick V, Elector Palatine, and Elizabeth, the 'Winter Queen', who was the daughter of King James I of England and VI of Scotland and his wife Anne of Denmark.

Elizabeth's marriage had seemed auspicious. Frederick V was regarded as the foremost Protestant prince in Germany, holding land in the Upper and Lower Palatinate of immense strategic value. However, all of this was lost after an ill-advised attempt to seize the crown,

18 *Sophie Charlotte of Brunswick-Lüneburg, Wife of Frederick III, Elector of Brandenburg*, Anon., stipple and line engraving, early eighteenth century. National Portrait Gallery, London

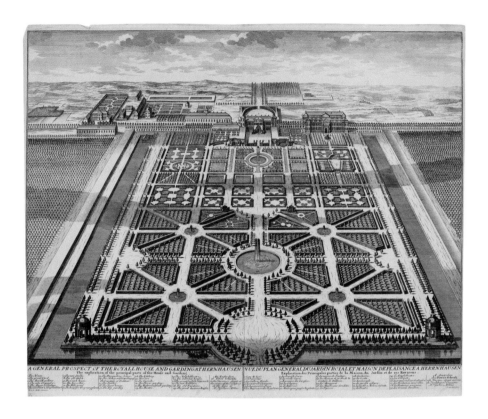

19 *'A General Prospect of the Royall House and Garding at Hernhausen'* by Joost van Sasse after Johann Jakob Möller, engraving, 1720. The Royal Collection

and annex the territories of Bohemia, part of the preserve of the Austrian Habsburgs. Defeated, he was eventually given asylum, with his family, in The Hague in The Netherlands. Despite the change in their fortunes, both Frederick and Elizabeth felt a deep pride in their ancient lineage and had ambitions for their family. Their daughter Sophia was exceptionally well educated, following a programme designed by her father which included theology, mathematics, history and jurisprudence as well as Latin and Greek.[9] Every Wednesday and Sunday professors from Leiden University were invited for dinner at the Prinsenhof, the nursery palace established for Sophia and her brothers and sisters.[10]

In 1658, at the age of twenty-six, Sophia married Ernest Augustus, the youngest of the four sons of George, Duke of Brunswick-Lüneburg. After her husband became the secular Bishop of Osnabrück in 1661, she had her first opportunity to become involved in an architectural project when she supervised the architects and artists undertaking the remodelling and returnishing of the Bishop's Palace. Martin Charbonnier, also a pupil of Le Nôtre, was invited from France to provide a design for this, her first garden.

Sophia's second opportunity to make a garden occurred in 1680, after Ernest Augustus inherited the land and titles of his two older brothers and moved with Sophia and their family into the Leineschloss, the town palace in Hanover.[11] Finding their new home cramped and old-fashioned, she promptly planned to restore another palace a short distance away at Herrenhausen. Having travelled extensively in Italy with her husband, she selected Giacomo Quirini, an architect from Venice, to assist with the project. Charbonnier returned to create its impressive garden (fig. 19). There were avenues and parterres embellished with statuary, bordered on three sides with canals along which gondolas drifted at

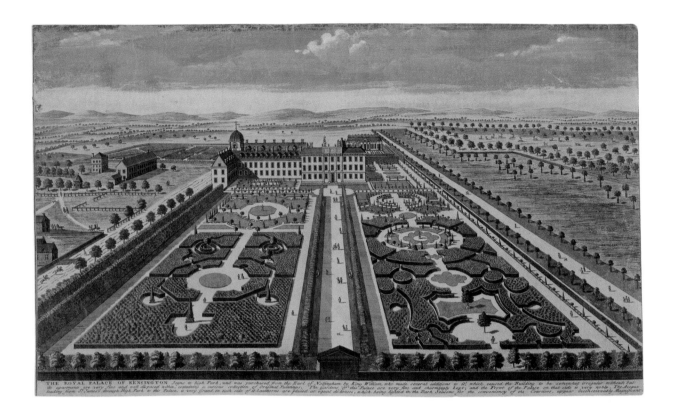

appointed times during the day. After the death of Ernest Augustus in 1698, their son George Louis invested considerable funds in embellishing this scheme, employing the English architect William Benson to give advice on hydraulics; the new fountains rivalled those set up by Louis XIV in France.[12] Caroline here had yet another example of how court culture could spill from a palace and claim the landscape.

The royal gardens at Hampton Court Palace and Kensington Palace (fig. 20), which Caroline had explored on her arrival in London, had been laid out for William and Mary by George London and Henry Wise. London had been apprenticed in the 1670s to John Rose, the royal gardener at St James's Park, who in his turn had been trained by Le Nôtre. The partnership between London and Wise had begun in 1687, and together they owned Brompton Park nursery. The style of garden developed by London and Wise is typified by their work for the Duke of Devonshire at Chatsworth – a mixture of French-derived canals and bosquets, parterres in the Dutch manner and Italian-inspired high cut hedges, statuary and terracing. London and Wise both continued to work for Queen Anne, and Wise was given the contract to manage the royal gardens by George I.

Although her past experience was in the Le Nôtre school of garden design, and she had easy access in London to gardeners working in his tradition, Caroline was aware that new, radical ideas about the design of gardens were being debated by English architects and thinkers, and she was determined to explore them in the design of her new venture.

Since the Glorious Revolution of 1688, the Whig party in opposition had associated itself with the philosophies of the Earl of Shaftesbury, Sir William Temple and Joseph Addison, as well as the work of the poet John Milton, in their creation of a vision for a

new nation. Each of these men had conjured up his own theories about the world and the bond existing between man and nature, and they explored how this might be expressed through the nurturing or creation of the landscape. This was a powerful metaphor and it could be realised in a physical way. Shaftesbury, grandson of the 1st Earl of Shaftesbury, the founder of the Whig party, wrote *The Moralists: A Philosophic Rhapsody* in 1709 in which the protagonists, Theocles, the teacher, and Philocles, the disciple, proclaim nature 'supremely Fair and sovereignly Good' as the best guide for the moral, liberty-loving Briton.[13] Temple published *Upon the Gardens of Epicurus* in 1685 in which he discussed the merits of a new, informal and uncontrived approach to garden design as practised in China and Japan which he had discovered by examining imagery found on imported ceramics and lacquer goods. The Whig journalist Addison wrote a series of essays for *The Tatler*, *The Spectator* and *The Guardian*, between 1709 and 1716, elaborating on the ideas of Shaftesbury and Temple, conjuring up a vision for the land in which the whole variety of nature would be embraced and honest farmland could break into the garden. Milton's description of the Garden of Eden in *Paradise Lost* provided the Whigs with a vision of a relaxed British Arcadia of gentle rolling countryside punctuated with temples, echoing the paintings of Claude Lorrain and Nicolas Poussin.

The first architect and gardener to take up these new ideas and reflect them in his work was Sir John Vanbrugh, who in 1699 was commissioned by the Earl of Carlisle, a leading Whig politician and great admirer of the works of Temple, to design Castle Howard, a country palace in Yorkshire. Carlisle employed George London to provide advice on the laying out of formal parterres in the manner of Le Nôtre, but when it came to Wray Wood, a forty-acre plantation near the house, it is likely that Vanbrugh or possibly Carlisle himself conceived the 1705 design which left the woodland in a relatively natural state, with a sequence of discreetly interspersed statues and rustic seats.[14] For the garden theorist Stephen Switzer, Wray Wood was the first great example of nature untamed, replacing the notion of nature disciplined.[15] Amongst members of the Kit Kat Club, a group of men which included Carlisle and Vanbrugh that had met since the last years of the seventeenth century – ostensibly to discuss business and literature but who also had a common political agenda to endorse the Hanoverian succession – this approach to gardening quickly gained an association with those who supported George I and his family.[16]

By 1716 Vanburgh was working for Richard Temple (later 1st Viscount Cobham), a Whig and also a member of the Kit Kat Club, at Stowe in Buckinghamshire. Temple had already started work to enliven the irregular park surrounding his house, planting new woods and establishing avenues, and ultimately investing it with political messages with the assistance of the gardener Charles Bridgeman. In the first phase a canal was cut on the main axis of the garden, and mounts were constructed from the spoil to allow visitors to take in the prospect. The construction of a ha-ha allowed the still relative formality of the park to blend seamlessly into the surrounding natural landscape. In the next three years Vanbrugh's Rotondo, an amphitheatre called the 'Queen's Theatre', Nelson's Seat and a little brick temple, later called the 'Temple of Bacchus', and an obelisk were constructed to provide a sequence of dramatic features for those touring the garden, punctuating the landscape and framing the views (figs 21 and 22).

The Vanbrugh-Bridgeman partnership was consolidated in about 1717 when the team was employed to transform the humble Chargate House in Esher into a home worthy of

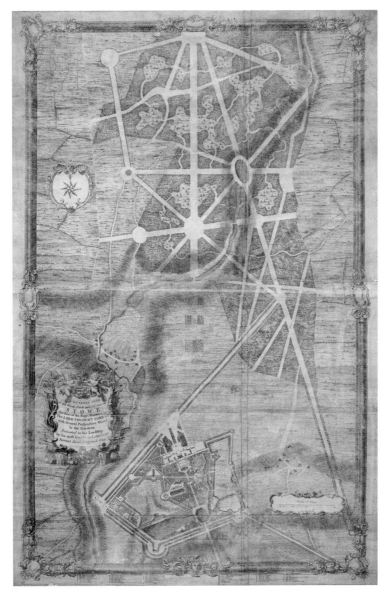

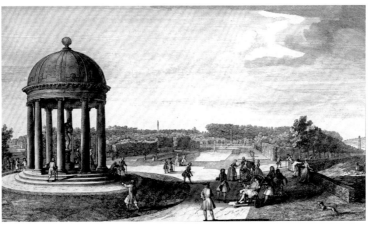

21 *Stowe, Buckinghamshire.
Plan of House, Woods, Park
and Gardens* by Bernard
Baron after Jacques Rigaud,
an engraved plate from Sarah
Bridgeman, *A General Plan
of the Woods, Park and Gardens
of Stowe*, 1739. RIBA, London

22 *Stowe, Buckinghamshire:
the Queen's Theatre from the
Rotunda, with Lord Cobham
and Charles Bridgeman* by
Bernard Baron after Jacques
Rigaud, a plate from Sarah
Bridgeman, *A General Plan
of the Woods, Park and Gardens
of Stowe*, 1739. RIBA, London

the Duke of Newcastle, a Whig and future prime minister. Newcastle renamed the house 'Claremont'. Vanbrugh himself had owned this property in 1709 but had taken little account of the dramatic possibilities of the site. The new work made the most of the natural hill directly behind the house. A wood was planted by Bridgeman, interlaced with winding paths and topped by Vanbrugh's romantically Gothick Belvedere.

Caroline's introduction to the new thinking came through three men who followed in the train of Carlisle, Cobham and Newcastle. The first was the Earl of Burlington, whom Caroline is likely to have met for the first time when he stopped off in Hanover in 1714 during the Grand Tour (fig. 23). On the accession of George I he was appointed to the Irish Privy Council and, by 1715, had been appointed Vice-Admiral of the County of York, Lord Lieutenant of the East and West Ridings and *Custos rotulorum* of the North and East Ridings, as well as Lord High Treasurer of Ireland. He later served as George II's Vice-Chamberlain. In 1721 he married Lady Dorothy Savile, who became Caroline's Lady of the Bedchamber. She was an intelligent amateur artist who followed her husband's work with great interest, contributed significant funds to allow his projects to proceed and played a lively part in the circle of artists he drew into his orbit. She would have been in an excellent position to support her husband's ventures and pass on information about them to her royal mistress.

In 1716 Burlington started work on the remodelling of the garden surrounding the house at Chiswick which he had inherited in 1704, when he was just ten.[17] He planted new

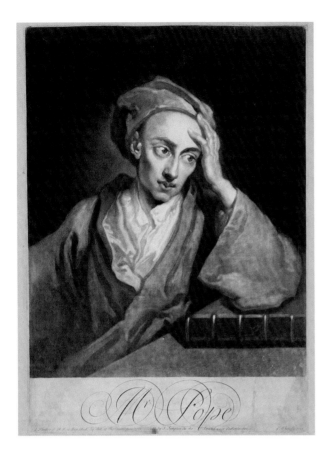

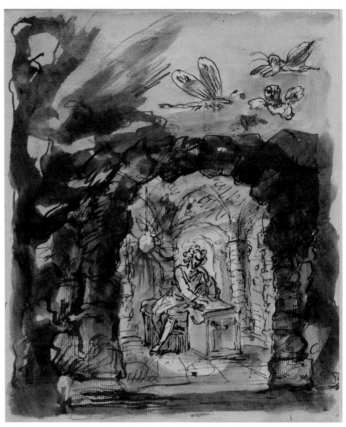

avenues to form a *patte d'oie*, or 'goose foot', following the traditional French model, and then theatrically introduced small pavilions – the domed and pedimented Pagan Building by James Gibbs and then the Bagnio, to a design he conceived himself with the help of Colen Campbell – and began to create something which was entirely new.

It was probably Lord Burlington who introduced Caroline to Alexander Pope. One of the great literary lions of the early eighteenth century, author of the universally acclaimed *Rape of the Lock* and *Windsor-Forest*, and the translator of Homer's *Iliad* into English verse, his company was eagerly sought by the rich and influential (figs 24 and 25). In 1711 Pope had set out his own ideas about the relationship between landscape and the garden in his poem 'An Essay on Criticism', and this was followed, in 1713, with an essay for *The Guardian* in which he extolled the virtue of 'unadorned nature', which he claimed was 'the taste of the ancients in their gardens'.[18]

Until 1719, when Pope purchased the lease of land for a house of his own on the banks of the Thames at Twickenham, he had little opportunity to put his ideas into practice though from 1718, as the great friend of Lord (later Earl) Bathurst, he had advised on the creation of Bathurst's new forest garden on his estate at Cirencester. Caroline was intrigued and invited him to her salon at Leicester House.

The third person who proved an inspiration to Caroline was Sir Andrew Fountaine, who enjoyed a reputation as a connoisseur, collector and conversationalist. During the Grand Tour he had established friendships with both Cosimo III de' Medici, Grand Duke of

24 *'Mr Pope'* by George White after Sir Godfrey Kneller, mezzotint, 1722. The Royal Collection

25 *Alexander Pope in his Grotto* by William Kent, pen and brown wash over pencil, c. 1730. Devonshire Collection, Chatsworth, Derbyshire

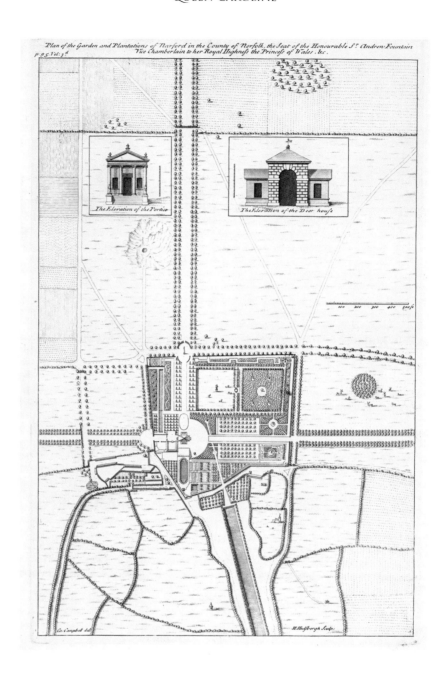

Plan of the Garden and Plantations of Narford in the County of Norfolk, the Seat of the Honourable S. Andrew Fountain *Vice Chamberlain to her Royal Highnef the Princefs the Princefs of Wales &c.*
p. 95. Vol: 3.ᵈ

The Elevation of the Portico

The Elevation of the Deer house

C. Campbell del. H. Hulsbergh Sculp.

26 *'Plan for the gardens and plantations of Narford, the Seat of the Honourable Sir Andrew Fountaine, with elevations of the portico (garden temple) and deer house'* by H. Hulsbergh after C. Campbell, a plate from Colen Campbell, *Vitruvius Britannicus*, vol. III, 1725

Tuscany, and with the philosopher Leibniz, one of Caroline's first heroes. Having accompanied the Earl of Macclesfield to Hanover to deliver the Act of Settlement to the Electress Sophia, in 1701, he already stood on good terms with the new regime, and, with their friendship with Leibniz and Burlington in common, Caroline was immediately drawn to him and appointed him her Vice-Chamberlain in 1723.[19] She rated his intellect and experience so highly that she later asked him to be a tutor to her youngest son, William Augustus.[20]

On his return to Britain in 1706 Fountaine had started making improvements to the garden at Narford, his estate in Norfolk. It soon had a pool framed with an exedra in the

Roman style, as well as Palladian temples. Within the seventeenth-century Dutch-inspired compartments, which made up the rest of the garden, new wiggly walks were cut, and statuary and single large trees were placed as eye-catchers to enhance the views. Spaces were opened up where deer could graze – all in line with Addison's new gardening theories (fig. 26).

By the early eighteenth century the making of a garden had become a fashionable occupation in England. This was something that Caroline could use to her advantage: her plan to create a garden herself would be one with which many could identify and it would make a connection with members of the English aristocracy whose company she enjoyed and who might usefully serve as her supporters. The fact that a garden could be invested with a political message provided her with another dimension to explore. When gardens were later created with messages critical of the government – by 1730 Lord Cobham's garden at Stowe had become increasingly politically charged after he quarrelled with the Prime Minister Sir Robert Walpole – having appropriated the medium and turned it to her own use, she could defuse their ambition to some extent.[21] There was just one concern: unlike many of her gardening compatriots Caroline, as Princess of Wales, had only about £18,000 a year to spend, and for the most part this was subject to public scrutiny. Any commission would have to be placed with care.

This led Caroline to open up a discussion at a gardening conference rather than simply taking advice from the gardeners in her immediate circle. Her conference was held in September 1719, and all the leading garden theorists and practitioners were invited. The guest list does not survive, but Alexander Pope, who attended, provided some clues as to the identities of the other participants. He wrote to his patron Lord Bathurst: 'That this letter be all of a piece, I'll fill the rest with an account of a consultation lately held in my neighbourhood, about designing a princely garden. Several criticks were of several opinions: One declared he would not have too much Art in it; for my notion (said he) of gardening is, that it is only sweeping nature: Another told them that Gravel walks were not of a good taste, for all the finest abroad were of loose sand: A third advis'd peremptorily there should not be one Lyme-tree in the whole plantation: A fourth made the same exclusive clause extend to Horse-chestnuts, which he affirmed not to be Trees, but Weeds: Dutch Elms were condemned by the fifth; and thus half the trees were proscribed, contrary to the Paradise of God's own planting, which is expressly said to be planted with *all trees*. There were some who could not bear Ever-greens and call'd them Never-greens; some, who were angry at them only when cut into shapes, and gave the modern Gardeners the name of Ever-green Taylors; some, who had no dislike to Cones and Cubes, but would have them cut in forest trees; and some who were in a passion against any thing in shape, even against clipt hedges, which they call green walls.'[22]

One can be almost certain that Pope is recording the views of the gardeners Henry Wise and his new partner, James Carpenter, who still worked in the formal French/Dutch tradition characterised by its use of hedges and topiary, as well as those of Charles Bridgeman, who advocated a more unstructured approach to landscape. Lord Burlington missed the conference. He was in Italy and did not arrive home until November.

In the end it was Bridgeman who won Caroline's commission to work at Richmond. His credentials were impressive: he had served an apprenticeship under Wise at the Brompton Park nursery and in 1709 had been invited to join his master in the team working on the Baroque garden for the Duke and Duchess of Marlborough at Blenheim Palace.

27 *Charles Bridgeman*
by Sir James Thornhill,
pencil on paper, c. 1730.
Private Collection

He had also worked with Vanbrugh on gardens in the new Arcadian style for Richard Temple and the Duke of Newcastle (fig. 27).

In its first phase of development Bridgeman's ideal landscape for Caroline at Richmond contained plenty of old-fashioned features. A series of tree-lined avenues were planted; two viewing mounts were constructed, one giving views over the Thames, the other in the woods; there was a canal and duck pond of strict rectangular plan. The riverside terrace, newly planted with elms, was extended to reach the village of Kew. (fig. 28) There was a snailery, which so intrigued George I that he sent his Master Joiner and Master Carpenter there to make notes about its construction in order that a similar feature could be introduced into the garden he had started to create at Kensington.

However, in other parts of the garden Caroline followed hard on the heels of Lord Bathurst in ensuring that it merged with the landscape. Bridgeman planted 'morsels of a forest like appearance', irregular copses of trees to the northeast of the villa and five new wildernesses, laced through with serpentine walks. There was the Forest Oval – a circular grassy glade cut in a copse of trees – and an amphitheatre, one of Bridgeman's signature features. This was set within a copse of elms, a much more subtle variation of the turf-covered terraces of the Queen's Theatre he constructed concurrently at Stowe. The fields which lay beside Love Lane, the public road which formed the eastern boundary of the garden, were retained and planted with corn. While they provided a useful hunting ground for George Augustus, they would be singled out for special comment by Horace Walpole in his *Anecdotes of Painting* for according so well with Addison's prescription for achieving variety in the landscape (fig. 29).[23] A visitor in 1724 looked to European models and

described it as a 'perfect Trianon', comparing it with Louis XIV's great garden at Versailles where the Grand Trianon, a garden palace built there to a design by the architect Jules Hardouin-Mansart, and set in elegant grounds, had been completed in 1687.[24] In fact, Caroline's garden-park was beginning to resemble rather more closely a *ferme ornée*; it would be many years before Philip Southcote created his much-admired ornamental farm at Wooburn, near Chertsey in Surrey.

The Richmond garden became a desirable destination for the fashionable and those with social aspirations. As an oasis from the bustle and noise of city life it had much to offer. A day out at Richmond was relaxing and fun. According to Lady Mary Wortley Montagu, it was an elegant place for *fêtes galantes* and in 1723 she described festivities 'by land and water' at which members of the Court of the Prince and Princess would play at living the pastoral life in masquerade dress.[25] There was horse racing in the grounds and boat races on the river. In August 1719 Caroline had invited the actor-manager William Penkethman to look into the possibility of building a theatre there. It all served to show that George Augustus and Caroline wished to be involved in local life.

28 *'An Exact Plan of the Royal Palace Gardens and Park at Richmond'* by John Rocque, engraving, 1754. British Library

29 *Design for Part of the Gardens at Richmond* by Charles Bridgeman, pen and ink on paper, c. 1720–30. The National Archives, Kew

Many people made their way to the garden. John Perceval (afterwards Viscount Perceval and from 1733 Earl of Egmont), a Member of Parliament for County Cork in Ireland and later a Member of the House of Commons in London, noted in his diary that he took his family there to enjoy the new walks, and to dine in 1730.[26] Jean Baptiste-Claude Chatelain's engraving *'Veue de la Maison Royale de Richmond'* of 1736 provides a glimpse into the rarified world that had been created. Based on Jean-Antoine Watteau's work *Le pélerinage à l'île de Cythère*, which had been exhibited at the French Academy in 1717, Chatelain's version depicts Caroline's garden viewed from the Middlesex bank of the Thames as the backdrop for a group of visitors (fig. 30). Wearing tastefully rustic dress, they disembark from boats and stroll along the riverside in the foreground.[27]

On June 11th, 1727, George I died at Osnabrück after suffering a stroke during one of his regular visits to Hanover. Sir Robert Walpole rushed with the news to Richmond Lodge where George Augustus and Caroline were staying. They promptly returned to Leicester House through cheering crowds of well-wishers. Four days later they established their new court at St James's Palace. The date for the coronation was set for 11th October. George II and his consort walked in procession between Westminster Hall and Westminster Abbey; Caroline in her velvet robes and borrowed diamonds strode out in front of her canopy so that she might better be seen.

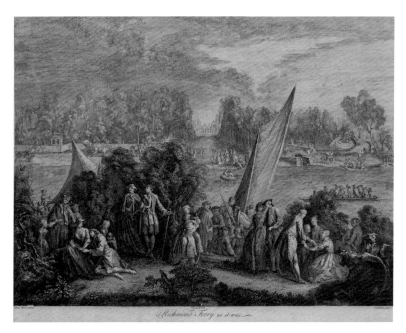

The accession brought Caroline the opportunity to make a second garden. She now had several new sites to explore, and much greater funds to support her projects after Sir Robert Walpole steered a generous Civil List settlement through the House of Commons. Caroline was allocated £100,000 a year for her household as well as the use of Somerset House and Richmond Lodge. Her ambition turned first to Kensington Palace. There already was a formal garden with parterres and low clipped hedges to the south, a wilderness with meandering paths, a mock mound made up of trees of graduated heights and a sunken garden to the north, and a park of nearly one hundred and fifty acres to the east. This had been established by Queen Anne many years earlier and was ripe for remodelling.[28]

Caroline inherited a partly worked scheme for refashioning these gardens initiated by George I. In 1725 he had decided to make improvements to the large open paddock which lay to the east of the palace, with the intention of transforming it from a traditional hunting ground in which horses, deer and elk could roam at will, into a more exotic wildlife park. By 1726 three tigers and a pair of civet cats had been added to the collection and given iron 'dens'.[29] At the King's request a snailery was to be constructed and there were plans to introduce 'East Indian' and 'outlandish' birds.[30] The project was in the hands of Henry Wise (fig. 31) and his partners – James Carpenter until Carpenter's death in 1726, and thereafter Charles Bridgeman.

The paddock was laid out to provide a series of enclosures, or 'quarters', divided one from another with new gravel walks. Some of the quarters were filled with native and foreign trees; others were left open as lawns. Those allocated to the collection of animals were enclosed by fences. The rectangular pond next to the palace was enlarged and the chain of muddy ponds created by the River Westbourne to the west of the paddock were cleared with the intention of turning them into a single clearly defined lake.

30 '*Richmond Ferry as it was*' by J. B. C. Chatelain after Marco Ricci, engraving, published by J. Groupy, c. 1725. Orleans House, London

31 *Henry Wise* by Sir Godfrey Kneller, oil on canvas, c. 1715. The Royal Collection

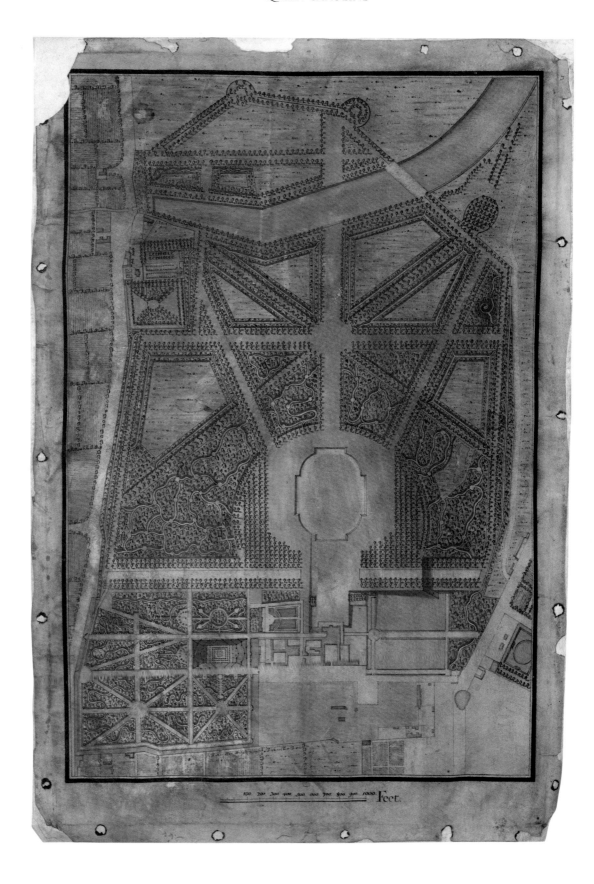

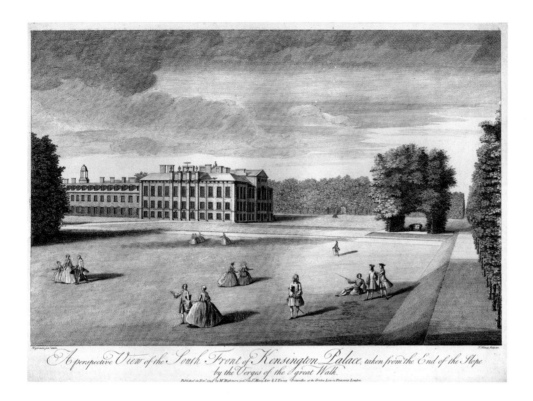

A perspective View of the South Front of Kensington Palace, taken from the End of the Slope by the Verges of the great Walk.

But if George I had intended to create a park though which visitors could walk to observe exotic animals, Caroline had plans for a grander, more cohesive garden. In 1727 she entered into negotiations to enlarge the park by purchasing land called the 'Bayswater Garden', at the north end of the Westbourne ponds, which had previously been leased by William III to the Earl of Jersey.[31] By the end of the year the tigers and civet cats had found a new home in the menagerie at the Tower of London and nothing more is heard of the snailery (fig. 32).[32]

Caroline's choice as gardener for the Kensington project was again Bridgeman – the elderly Wise had been pensioned off in 1728. Bridgeman decided to retain some of some of the earlier proposals – the walks would be completed but their width increased, and the clearing of the Westbourne ponds and the digging of the new 'Great Basin' would be finished – but he made many changes too. The formal gardens to the south of the palace would be cleared completely to give uninterrupted views across the 'great circular lawn' which surrounded the Great Basin and down the central east-west avenue leading to the new Serpentine Lake. Trees were to be lifted from some of the existing quarters to create 'a Berceau or walk of shade' in 'spinneys next the boundary walls', thereby better defining the garden perimeter.[33] Bridgeman's estimate of the cost prepared in 1728 amounted to just over £5000, and he believed the work could be completed by 1730 (fig. 33).[34]

By Michaelmas 1728 the Grand Walk, now called the 'Broad Walk', had been laid down. The following year saw the setting out of the 'Great Bow' of trees to mark the perimeter of the circular lawn, and the shady 'Berceau' was established along the north and south boundary walls. In the end it was not until late in 1731 that the three new great avenues radiating from the Great Basin had been planted and work on the Serpentine Lake was

32 *Plan of Kensington Gardens* by Charles Bridgeman, pen, ink and coloured wash, 1733. Huntington Library, San Marino, California

33 *'A Perspective View of the South Front of Kensington Palace taken from the End of the Slope by the Verges of the great Walk'* by John Tinney after Anthony Highmore, engraving, 1744. British Museum

far enough advanced for *The London Evening Post* to report that two royal yachts had been launched there.[35]

Climbing the winding path through leafy shrubs to the top of a viewing mount constructed in the southeast corner of the garden, visitors would be able to contemplate Caroline's contribution to the redesigned gardens. The 'quarters' now appeared as woody groves cut through by avenues radiating from the great circular lawn. The lawn which framed the eastern façade of Kensington Palace had the Great Basin set at its centre. On the further bank of the Serpentine Lake a ha-ha had been cut which allowed uninterrupted views over the pastures beyond. The thickets planted along the perimeter walls ensured that visitors remained unaware of the busy roads to the north and south.

The gardens at Kensington were never described with the hyperbole that runs through accounts of Caroline's garden at Richmond. Baron Pöllnitz, the German commentator whose travels had brought him to London, visited in the early 1730s as the final elements of the new layout fell into place, and suggested: 'Kensington Gardens would be very fine for a private person but for a King, methinks I could wish them to be somewhat more magnificent.'[36] But one should remember that the new works there were implemented many years after the construction of the Richmond garden and planting takes time to

mature. It would not be long before the garden became another oasis, even nearer the busy metropolis, which was open to visitors when the King was not in residence, and as long as they were neatly dressed. *The Gentleman's Magazine* was determined that both the garden, and Caroline who had championed its creation, should receive all due applause. In April 1733 it published a poem in celebration:

On the Queen's Mount at Kensington

Still shall the Lyre for *Richmond's* Grot be strung,
And *Kensington's* fair Mount be left unsung?
Leave for a while sublimer Themes, and tell
How much Her [Caroline's] taste in Gard'ning does excell:

In that Retreat (blessed with the summer Court)
Where Citizens on *Sunday* Nights resort,
A Royal Mount, erects its verdant head;
Rais'd by that Hand, by which are Thousands fed;
Here, free from the Fatigues of State, and Care,
Our Guardian Queen ofts breaths the Morning Air:
From hence surveys the Glories of her Isle,
While Peace and Plenty all around her smile.

Descend we from the Mount, lo! all beneath,
Alike delight, alike fresh Odours breath:
Pleas'd, and amaz'd, each fair Design I view,
And gradually the verdant Course pursue;
At ev'ry Step, new Scenes of Beauty rise,
Here, well judg'd Vistos meet th'admiring Eyes:
A River there waves thro' the happy Land,
And ebbs and flows, at *Caroline's* Command.
No costly Fountains, with proud Vigour rise,
Nor with their foaming Waters lash the Skies;
To such false Pride, be none but Louis prone,
All she lays out in Pleasure is her own.
Here nothing is profuse, nor nothing vain;
But all is noble, and yet all is plain:
So happily do Art and Nature joyn,
Each strives which most shall add to the Design,
In such a State, were our first Parents plac'd,
And *Eve* like *Caroline* the Garden grac'd:
Had she such Constancy of mind possest,
She had not fell, but we had still been blest.[37]

By 1767 *The London and Westminster Guide* described the 'Beautiful and extensive gardens, to which the public have now uninterrupted access.' On the death of George II in 1760 door bells would be installed at each of the garden gates making entry even easier.[38] When Sophie von la Roche visited in 1786 she wrote: 'My whole soul was gladdened at the beauty and peace I found there . . . Many other people were strolling in the spacious gardens, daily open to all, by the King's good grace. Here one may wander between tall trees and lovely shrubs, or by the pond over hilly ground, or across meadows . . .'.[39]

The choice to make a garden, the adoption of a particular style and the choice of monuments could all signal a message about social status, cultural interests and political allegiance. However, Caroline contrived to remain relatively neutral in her politics. She was influenced by the writings of Tory Lord Bathurst but made numerous visits to look at the gardens made by prominent Whig politicians. For her, political benefit would be derived in other ways. The making of the gardens did indeed serve her well, but as a means of engaging with the world of the artist and the literati. By drawing together some of the great English garden theorists to inform her own garden philosophy she was able to form a bond with her new compatriots. Her conversations later were peppered with references to new and innovative English garden fashions. In Lord Egmont's diary is recorded a discussion he overheard between Caroline and Sir John Rushout. Caroline, delighted with her success at Richmond, claimed: 'I think I may say that I have introduced that, in helping nature, not losing it to art.'[40] Once the gardens were completed they provided useful places for social gatherings too. From the early 1720s, for those disenchanted with or barred from the Court of George I, Richmond Lodge and its beautiful grounds, where George Augustus and Caroline as Prince and Princess of Wales welcomed visitors and entertained generously, was a honey-pot to which they would gravitate.

Caroline's garden at Richmond and the garden she went on to create at Kensington Palace deserve far more attention than they have received from modern historians who have explored the rise of the landscape garden in the early eighteenth century.[41] The absence of any serious appraisal may result from the fact that Caroline as an individual remains shadowy compared with Richard Temple at Stowe, Lord Burlington at Chiswick and the Duke of Newcastle at Claremont, as well as Alexander Pope at Twickenham, whose histories are far better recorded. Caroline's gardens were still being developed when she died so it is hard to evaluate them as complete schemes. It did not help that at this period, when ideas in garden design moved at such extraordinary speed, the plans she conceived with her friends and advisors were quickly overtaken by those working on other garden projects. It was not long before the garden at Richmond was dismantled and remodelled by her son Prince Frederick (fig. 35) and his wife Augusta.

Yet Caroline's gardens occupied very significant sites, and were more accessible to visitors than many. Even though as Princess of Wales and later as queen consort her funds were limited, there was still enough to allow her to work on an ambitious scale. Her husband would bluster and chastise her for her extravagance yet he quietly paid her debts. This ensured that both garden theorists and the most adventurous gardeners sought her company and patronage, and Caroline in her turn was generous in her commissions. At the time of their construction her gardens attracted considerable public attention.

Caroline's access to increased funds in 1727 would have considerable importance for the garden at Richmond as well as that at Kensington. It would allow her to look again at her

projects there, and re-order them on a far more ambitious scale. Her new works saw not only another manipulation of the landscape but also the insertion of an intriguing collection of garden buildings.

35 *Frederick, Prince of Wales* by Christian Friedrich Zincke, miniature, 1729. The Royal Collection

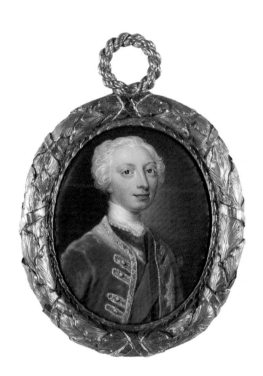

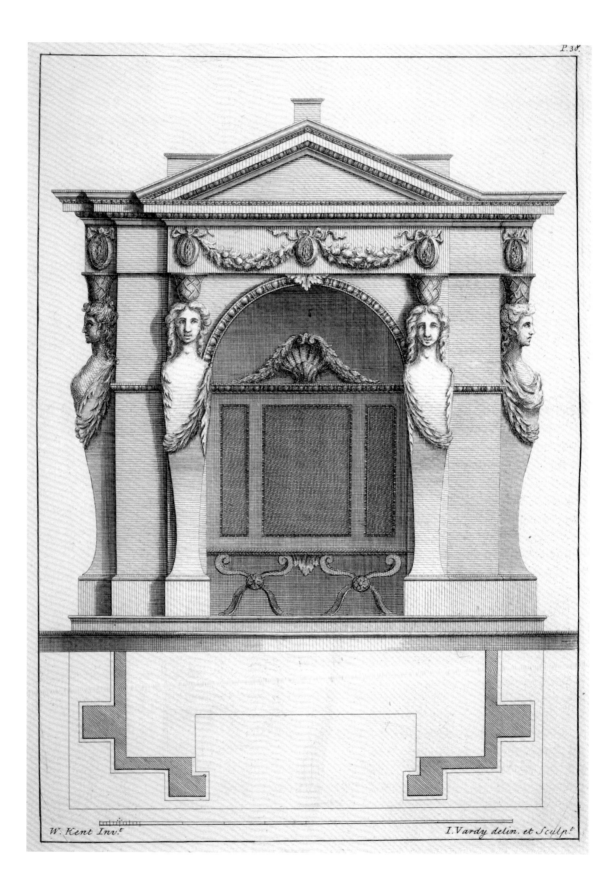

W. Kent Inv.t I. Vardy delin. et Sculp.t

2

CAROLINE
and the Architects

On the accession of George II in 1727, the dynamic between the royal residences changed. After Whitehall Palace was destroyed by fire in 1698, St James's Palace had become the monarch's principal London home, and the new king and queen moved there immediately after receiving the news of the death of George I. However, by the 1720s – although St James's Park and Green Park lay to the south and west – the palace had been more or less absorbed into the sprawling suburb of Piccadilly. Numerous London guides in the eighteenth century noted not only the overcrowding in this part of the City of Westminster but also its many 'epidemical distempers.'[1] The palace itself, with its origins in a fifteenth-century ecclesiastical foundation, was rambling and inconvenient, and it was not long before George and Caroline were exploring all the other royal homes in and around London to assess whether they might be more congenial. There were many functions any new base should fulfil, including providing Caroline with a base for her cultural programmes. There was no reason why, as queen consort, she would abandon the purpose and the pleasures that the salon and her garden had provided.

If there was an English Valhalla it was Windsor Castle. Built in the eleventh century, at its heart was the College of St George with St George's Chapel, the lodging and the spiritual home of the knights of the Order of the Garter – Britain's oldest and most venerable order of chivalry. However, despite its pedigree and its dramatic setting, the castle was a day's journey from Westminster so could not be considered a practical base for the Court.

Opposite
Design for a Revolving Seat,
Kensington Gardens by
William Kent, a plate from
John Vardy, *Some Designs of
Mr Inigo Jones and Mr Wm
Kent,* 1744 (detail of fig. 49)

Notwithstanding the growing bureaucratisation and professionalism of government it was important for the monarch to stay in close contact with Parliament during its increasingly lengthy sessions.

Hampton Court Palace, created by Cardinal Wolsey and King Henry VIII on the banks of the Thames in the sixteenth century, had been spectacularly remodelled in recent years by William III and was arguably the grandest of the royal homes available to the royal family. However, it was hardly more conveniently located than Windsor since river travel on the royal barges had been largely abandoned.

There remained a very limited number of royal buildings in proximity to Westminster. Inigo Jones's Banqueting House, the last remnant of Whitehall Palace, was far too small and could only be considered suitable for ceremony or entertaining, which left Kensington Palace as the most convenient and pleasant compromise between the city and the countryside. This would be the palace adopted by Caroline as her headquarters when George II appointed her regent in 1729, 1732, 1735 and 1736.

George I had already identified the need for a more appropriately splendid building that would serve as his base and enhance the image of the Hanoverian monarchy and, from 1714, the peace which followed the Spanish War of Succession had potentially freed up money for a building project. He had settled on Kensington, but, for those who had anticipated the new reign would bring a new bright future for the arts and architecture, his plans proceeded disappointingly cautiously. In April 1718 a number of designs for remodelling the palace had been laid before him. The grandiose plan submitted by Sir John Vanbrugh for a new Baroque edifice on the scale of Blenheim was immediately rejected.[2] Two other designs simply to rebuild the fragile early seventeenth-century portion of the palace, prepared by the Office of Works, presided over the elderly Sir Christopher Wren and his assistant Nicholas Hawksmoor, were much more modest. These were vetoed too. The plan which eventually found favour was probably the work of Colen Campbell, and was for a very limited rebuilding and redecoration of just the oldest part of the palace in the Palladian style.

Important to the choice of this architectural style and probably this architect was Lord Burlington, a great admirer of Palladio and a keen amateur architect himself, who considered Campbell his mentor. There were other architects, such as William Talman, the Honourable Roger North and William Benson, who had explored the Palladian style, but it was Burlington's court appointments from 1714 which brought him regularly right into the heart of the royal circle and afforded him the opportunity to champion his particular favourites. His own architectural projects in the manner of Palladio were begun at Chiswick in 1716 with the construction of James Gibbs's Pagan Building, followed in 1717 by the Bagnio. George I would have found comfort in this choice too, since it was the style of architecture studied and practised at the Court in Hanover by the previous two generations of the Hanoverian family. It epitomised an ideal of order, restraint and politeness. The other notable architectural commission made by George I, for White Lodge in Richmond Park, in 1726, from the architect Roger Morris and Henry Herbert (later Earl of Pembroke), was also in this style.[3] It would become a style associated by the Whig party, and the Hanoverians. The Baroque style was more usually associated with the defeated Stuart regime and, by extension, the Jacobites and Catholicism – an uncomfortable reminder to the Guelf family of the fragility of their hold on power.

The work at Kensington was supervised by William Benson, who inherited Wren's post as Surveyor of the King's Works and was familiar with George I's building projects undertaken earlier, while Elector of Hanover and before he became King of England. Benson proved himself to be an inept manager, however, and was quickly replaced by Sir Thomas Hewett, who completed the project. From 1722 the new state apartments were redecorated in a new, visually striking and luxurious style. Caroline would build on this legacy.

With her older children lodged for the most part at Kensington Palace during the years they lived in their grandfather's charge, Caroline would have visited regularly during the period when the building renovation was being undertaken. It is very likely that this provided her with the first opportunity to meet the architect and designer William Kent. According to George Vertue, the art historian, engraver and antiquary, Kent was first introduced to George I by Thomas Coke, the King's Vice-Chamberlain, in about 1722, though one can be confident Lord Burlington had a hand in the affair. An estimate submitted by William Benson and the Serjeant Painter Sir James Thornhill for the decoration of the new Cupola Room at Kensington Palace was considered overpriced: 'Being by Vice Chamberlain Coke thought too extravagant and so represented to the King – he without more ado takes Mr Kent to Kensington and ask'd what he would have for the same painting to be done'.[4] The price Kent suggested was, of course, pitched lower and he was awarded the commission (fig. 36).

Having completed the Cupola Room scheme to everyone's satisfaction, Kent was awarded a series of contracts for decorating the other rooms which had recently been remodelled. The work embraced not only the decorative painting of ceilings and walls, but also the designing of furniture and picture frames. Eventually it extended to the design of the curtains and other soft furnishings, establishing overall colour schemes, the detail of the picture hangs and the arrangement of the spaces. His enthusiasm and easy manner, his imaginative approach to his work and his powerful patrons ensured that Kent's career flourished. He was officially appointed royal Master Carpenter in 1726 (fig. 37).

William Kent was born in Bridlington, Yorkshire, in 1686. His family seems to have been of modest means but his talent as an artist, which was apparent from his earliest years, meant that in this small community he attracted patrons from amongst the prosperous landowners and burgesses. They in turn provided introductions to Yorkshire men living and working in London such as the politician Sir William Hustler, whose family came from Bridlington. These early patrons contributed funds to send Kent to Italy in 1709 in the company of the young architects John Talman, and Daniel Locke. The visit was planned so that not only could Kent further his own studies but also make purchases of statuary and pictures on their behalf. He was able to prolong his time in Italy when additional financial support was provided in 1712 by the Lincolnshire landowner Burrell Massingberd, who, with his friend Sir John Chester of Chicheley Hall in Buckinghamshire, became his next patron. Another champion, Thomas Coke, heir to Holkham in Norfolk, Kent encountered en route. Coke was probably the first person to encourage Kent, the artist, to look with new eyes at the architectural heritage of northern Italy, offering to fund Kent's tour to Siena, Florence, Bologna, Ravenna, Venice and Padua.[5]

Lord Burlington would be Kent's last and greatest patron, and pivotal to his success at Court. It is probable that they met for the first time in 1714 when Burlington, then a wealthy twenty-year-old, arrived in Rome during his first Grand Tour. The encounter must have been brief; Burlington was ill and returned shortly afterwards to London. It was not until 1719, during Burlington's second tour, that they saw each other again, this time in Genoa, where Burlington was studying architecture. His original promoters and backers found themselves gradually ignored and, on his return to London Kent moved straight into Burlington House on Piccadilly; he would remain a member of Burlington's extended family circle until his death and became a great friend of Burlington's wife Dorothy. This would serve him well as Dorothy, Lady of the Bedchamber to Caroline from 1727, could champion Kent's interests in discussions as she undertook her duties.

Kent would, in fact, become Caroline's own architect, her advisor in all matters artistic and her friend. On the accession of George II, Kent's position as Master Carpenter was re-confirmed, and in addition he was appointed Surveyor and Examiner of His Majesty's Paintings. He became known in the intimate royal circle as 'Il Signor' or 'Kentino'; Lady Burlington wrote in 1733: 'Tuesday . . . if the Signor is with you pray tell him that I saw last night a book published by I Ware with Ripley's name to his designs upon the Queen's table in the Gallery', suggesting that Caroline took a close and personal interest in his ideas.[6] Even as Lord Burlington's engagement with the Court waned in the 1730s Caroline remained faithful to Kent and, by 1735, he had been promoted to the position of Master Mason and Deputy Surveyor. Under Burlington's wing, Kent built up a large client base among the wealthy and landed, designing new houses and gardens for them, or re-styling

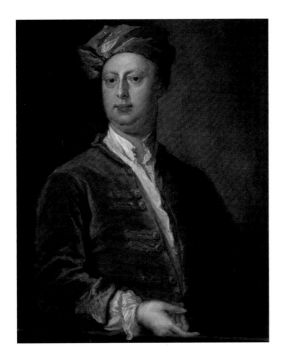

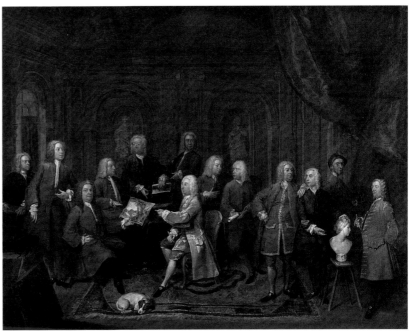

their existing ones. His royal appointments ensured Caroline could remain privy to information about innovative architectural projects and brought a means of contact with a host of other contemporary artists and designers. Gawen Hamilton's painting *A Conversation of Virtuosis at the King's Arms* shows a group of friends, all of whom were united in their support of Sir Robert Walpole (fig. 39). It includes portraits of George Vertue, antiquary and engraver, Michael Dahl, painter, James Gibbs, architect, Joseph Goupy, painter and etcher, John Wootton, painter, Charles Bridgeman, gardener, and John Michael Rysbrack, sculptor. William Kent sits right at the heart of this band. Kent's work between 1727 and 1737, the ten years Caroline enjoyed as queen consort, has been discussed by several distinguished historians of today, but the importance of Caroline's patronage in his oeuvre has largely escaped attention.[7]

The first work that Kent undertook for George II and Caroline was as a result of their inspection of the various royal homes. In the report drawn up by the Board of Works on the state of the wall paintings on the west wall of St George's Hall at Windsor Castle illustrating the Black Prince's triumphs, it was noted that they were badly disfigured by 'salts in the lime of the wall'. Others near the King's Great Staircase and in the Communication Gallery there were found to be 'so decay'd and defaced that if they be not soon repaired it will be impossible to restore them'. Kent was asked to manage their conservation.[8] Attention next turned to St George's Chapel in the castle precinct and he received an order in 1732 to 'clean and beautify' the altarpiece.[9]

At Hampton Court, Kent made a survey of the Queen's Staircase which was in a poor state of repair, with its decoration only partially worked. Once the damage had been surveyed, he was asked to undertake repairs and to complete the painted scheme (fig. 39).[10] The royal tour of the Banqueting House had revealed the delicate state of the magnificent ceiling canvases painted by Peter Paul Rubens which had been installed in 1636.

37 *William Kent* by ?Bartholomew Dandridge, oil on canvas, c. 1736. National Portrait Gallery

38 *A Conversation of Virtuosis at the King's Arms* by Gawen Hamilton, oil on canvas, 1735. National Portrait Gallery

39 The Queen's Staircase, Hampton Court Palace, with painted decoration completed by William Kent, 1735

A programme of conservation was promptly devised which took until 1734 to complete. Both Caroline and George later climbed the scaffolding tower 'forty foot high' to admire Kent's conservation work.[11]

With much of the work to remodel the State Apartments at Kensington Palace complete by 1727, Caroline found a more rewarding arena for her architectural ambition in the palace garden. She must have been inspired by the many innovations in garden design pioneered in the 1720s by Burlington and Pope, both members of her circle. Since 1719, when Pope moved into his new villa at Twickenham, he had worked to create a garden there which broke new boundaries. The grounds were originally so modest that within a year he had purchased five acres of agricultural land on the other side of the Hampton Court road running behind the villa. This he linked to his original river-side estate with a tunnel which was transformed into a grotto. The garden he eventually established, though never large, was bound to be influential: Pope had been a friend of Charles Bridgeman ever since they had met at Caroline's gardening conference, and he had played an important part in the thinking behind the gardens laid out for Lord Cobham at Stowe and Lord Bathurst at Cirencester. Pope's own garden would be designed as a piece of theatre, full of cleverly controlled perspectives and contrived illusions. The visitor passed from the gloomy grotto

into a bright, tree-lined avenue. Shady groves gave way to sunny lawns. The whole was punctuated with a number of dramatic episodes – a mount, a shell temple or a statue. With the help of his long-time collaborator, the architect James Gibbs, optical tricks were designed. Mirrors were installed in the grotto to enable visitors in the garden to see a distant view of the Thames, and the reflection of the natural spring covered the walls. It is not known whether Caroline visited the garden herself but she was certainly instrumental in its development. In 1725 she supplied 'a detachment of His workmen from the Prince's, all of a stroke, & it is yet unpayd for . . .' to assist in the digging of the 'Bridgemannic Theatre' – an amphitheatre which framed its furthest reach. She was certainly influenced by its design (figs 40 and 41).

40 *View of Pope's Garden with his Shell Temple* by William Kent, pen, ink and wash, 1725–35. British Museum

41 '*A Plan of Mr Pope's Garden as it was left at his death*' by John Serle, published by R. Dodsley, 1745. British Library

Burlington had continued to develop the garden at Chiswick. With the introduction of temples into his *patte d'oie* from about 1716 he had already broken new ground – the first temples at Stowe were not constructed until 1719; by then Burlington had moved on and was already exploring new ideas. Colen Campbell, his architectural mentor, continued to encourage his passion for the architecture of Palladio, and Burlington returned to Italy to continue his studies there, not only visiting Palladio's finest work but also the antique Roman models which Palladio had taken as his inspiration. When he came home, he brought with him a collection of Palladio's drawings purchased in Venice (fig. 42).

Between 1724 and 1729, though most of Burlington's time and money was spent on the building of a new villa to abut the old family home, the garden received attention too. Two basins inspired by descriptions found in texts by the younger Pliny were set within exedras of clipped yew hedges, leavening the otherwise rather formal plan (fig. 43). The new features brought with them a political message – radical Whig theorists advocated that a new English society should be modelled on that of the Roman Republic.[12]

Rather than convening a second colloquium to discuss the latest developments in garden design theory, Caroline decided that she would prefer to see some of the new gardens for herself. Her husband had little understanding or sympathy with this plan – he complained to Lord Hervey, Caroline's Vice-Chamberlain: 'she may stay at home as I do. You do not see me running into every puppys house to see his chairs and stools ... what matter that she sees a collection or not'.[13] But Caroline was not deterred. She decided to plan her visits for the months when George II would be in Hanover, and she was left in London as regent.

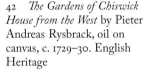

42 *The Gardens of Chiswick House from the West* by Pieter Andreas Rysbrack, oil on canvas, c. 1729–30. English Heritage

Charles Bridgeman, who had continued to supervise Caroline's garden at Richmond, must have facilitated the programme as the visits were exclusively to locations in which he had had some involvement. In 1726, she travelled by water with her children to Henrietta Howard's new estate at Marble Hill.[14] In 1729 the destination was Cliveden, where Bridgeman had recently created a new amphitheatre for the soldier-politician the Earl of Orkney.[15]

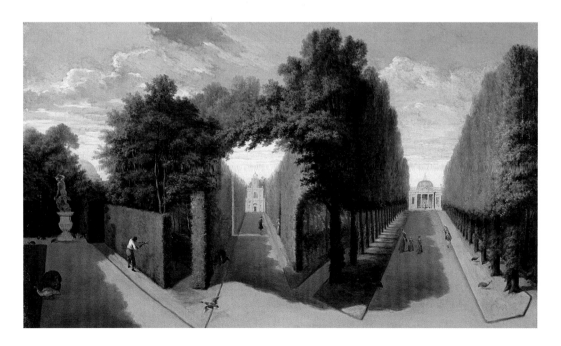

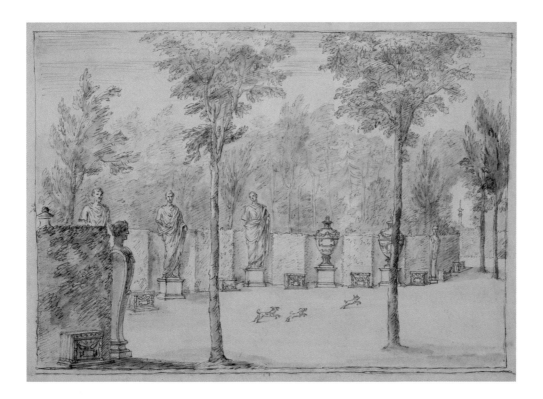

It followed the turf-covered terraced model he had pioneered at Stowe rather than repli-cating the design set amongst elms that he had created earlier for Caroline. At Claremont, which she visited two months later, he had built an even more ambitious and spectacular example, on a massive scale, for the Duke of Newcastle, taking full advantage of its hilly site. In 1732 she paid visits to Esher Place, the Surrey home and garden of the Honourable Henry Pelham, Newcastle's brother, and to Gubbins, near St Alban's, the home of Sir Jeremy Sambrooke .[16] At Gubbins she inspected the forest park punctuated with statuary and decorative buildings, including a folly arch in the Gothic style, dovecote and grotto which Bridgeman had created, again working with his architect friend James Gibbs.[17] She viewed Burlington's work on his new villa and its garden at Chiswick in 1735 (figs 44, 45 and 46).[18]

Caroline, while content to retain the services of Bridgeman for gardening commissions, was not minded to draw his friend Gibbs into her plans and instead made William Kent her choice of architect. Bridgeman and Kent had in fact already worked together in Burlington's garden. The Orangery garden, completed in 1728, comprised a terraced amphi-theatre with a pond and obelisk at its centre. While its design was close to a model found in Bridgeman's gardens at Stowe and Cliveden, there is a drawing by Kent which indicates that he too may have had a hand in its layout, particularly in the design of the temple which presided over it all. Kent and Bridgeman had also been employed together by New-castle to remodel parts of the garden at Claremont.[19]

In about 1734 the building of two pavilions, to designs by William Kent, was underway in the remodelled Kensington Gardens.[20] The first was the Queen's Temple on the banks of the Serpentine Lake. Each of its three bays had an arched opening to frame the view.[21]

43 *View into the Exedra at Chiswick* by William Kent, pen, ink and brown wash over pencil, 1736. Devonshire Collection, Chatsworth

44 *'Plan of the Gardens and Park at Claremont, one of the Seats of the Duke of Newcastle, with Views'* by John Rocque, engraving, 1738. British Library

45 *'Plan du Jardin et Vue des Maisons de Chiswick'* by John Rocque, 1736. Devonshire Collection, Chatsworth

Opposite, above
46 *A Survey of the House, Gardens and Park at Claremont* by Antoine Aveline after John Rocque, engraving, 1738. The Royal Collection

Opposite, below
47 *'An Exact Plan of the Royal Palace Gardens and Park at Richmond'* by John Rocque, engraving, 1734. British Library

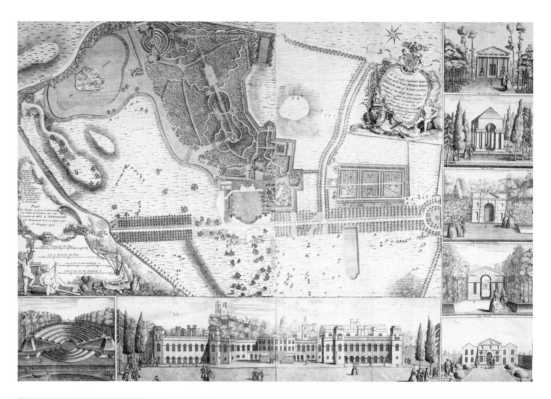

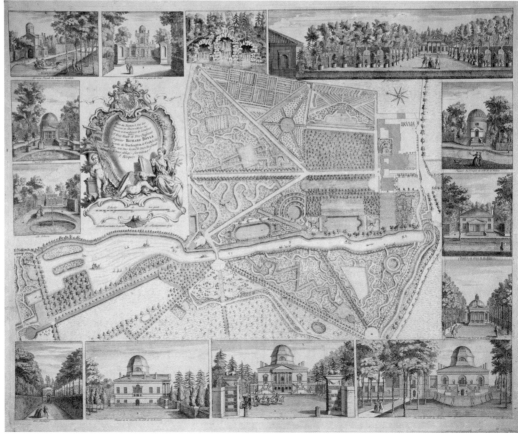

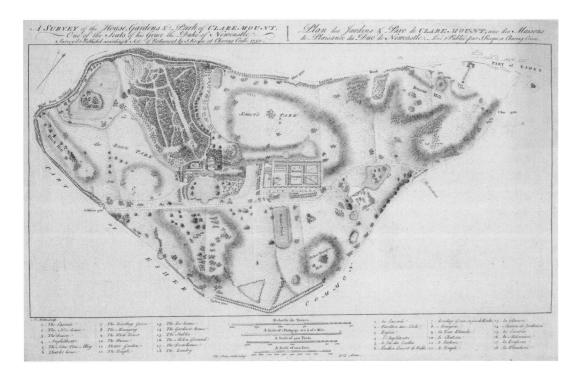

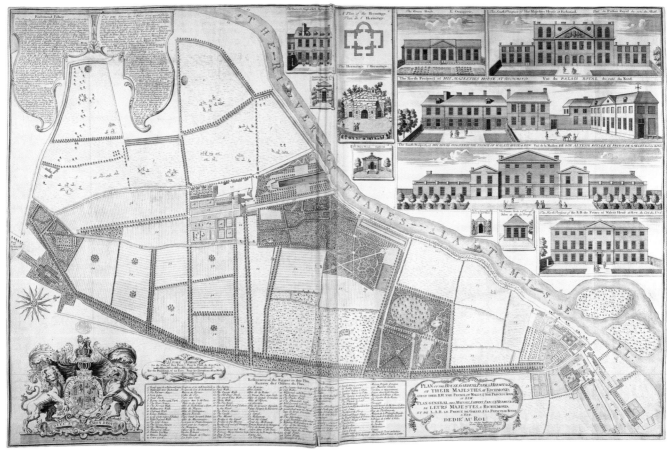

The second was the revolving seat, or 'pleasure house', intended to catch the eye as well as to allow visitors to view the prospect from the top of the mount in the south-east corner of the garden (fig. 49).[22] It took the form of a small pedimented temple of just one bay.[23] The arch-topped central opening was flanked with wreathed caryatids and a second pair stood at each end. In 1755 the author of *London in Miniature* extolled the beauty of the 'artificial Mount . . . planted with sweet shrubs and has a seat upon it that turns round with great Ease and Pleasure' to give views in every direction.[24] It was still there in 1761 when Count von Kielmansegg explored the gardens and was struck by the 'hillock, on which a covered seat was so arranged that it could be turned round accordingly to the direction of the wind. The mount is surrounded by a small wood of evergreen trees, and has fine views towards the south and west'.[25]

But it was Richmond Lodge which continued to serve Caroline as her special retreat. At the accession, the lodge had been allocated to her to serve as one of her dower houses in the event of George II's death. Peter Wentworth, one of her Grooms of the Bedchamber, described how on occasion he was instructed to arrange transport from Kensington to Richmond for six o'clock in the morning 'to be kept a great secret' so that Caroline and her daughters could breakfast there from cherries they had picked themselves from the trees.[26] With the accession bringing the new and discrete Civil List allowance, she could begin the second phase of work on its garden with even greater ambition. It would be her own creation, unlike Kensington where a predecessor's work conditioned the layout, and she evidently felt this allowed her to experiment with bolder new ideas. This garden, which had become a honey-pot for the young and fashionable, and a useful early cultural hub for the new regime, would be given an additional political agenda. In her campaign to promote the Hanoverian dynasty, the garden would play its part by celebrating the dignity and antiquity of the English royal line (fig. 47).

Caroline started the embellishment of her garden with the introduction of a series of buildings, following the fashion established by Burlington, and which had been employed to even greater effect at Stowe. The first addition was the Queen's Pavilion, which was constructed in the woods in 1729. This was followed by an ornamental dairy which took the form of a pedimented classical temple of three bays located at the head of the canal very near the lodge. A domed temple with Tuscan columns set on a mount by the river was completed shortly afterwards. However, the most impressive of the new edifices would be the Hermitage and Merlin's Cave.[27]

The Hermitage, situated towards the north of the garden, is first mentioned in November 1730 and was arguably the first garden building to be designed by Kent. Its construction started before that on the Temple of Modern Virtue, the Temple of Venus and the little Hermitage of similar design at Stowe.[28] The Richmond Hermitage no longer survives, but there are a number of drawings which provide information about its design, the interior layout and its decoration.[29] The building was constructed from rough-hewn stones and had a triple-arched façade with a central pediment supported by voussoirs. To the left side there was a small attic. In the arches on either side of the centre doorway were cusped quatrefoil windows set over low bench seats, according to a drawing by William Kent in Sir John Soane's Museum, though a contemporary illustration for the Hermitage by Bernard Lens shows these as doors.[30] Spear-topped railings ran across the front (figs 51–3).

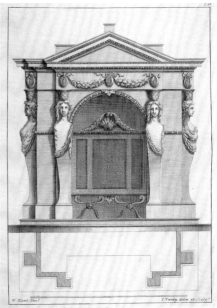

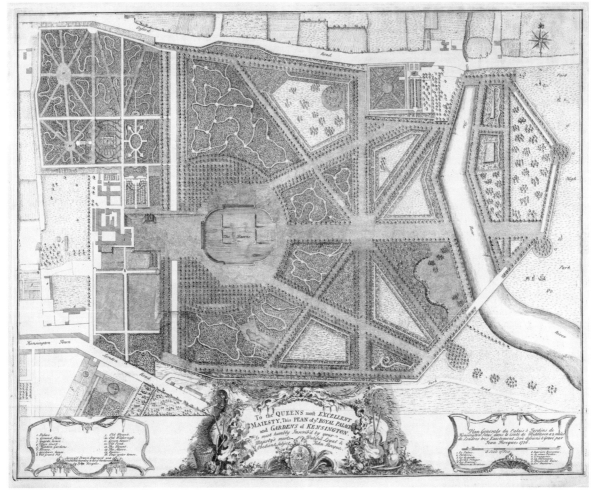

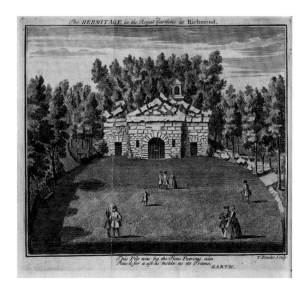

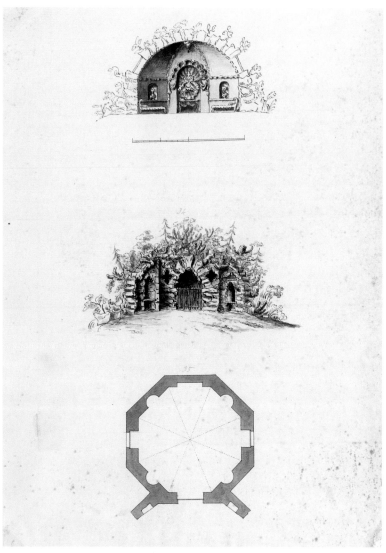

51 *'The Hermitage in the Royal Gardens at Richmond'* by T. Bowles after Bernard Lens, a plate from Edmund Curll, *The Rarities of Richmond: Being Exact Descriptions of the Royal Hermitage and Merlin's Cave, with his Life and Prophesies,* 1736

52 *A Plan of the Hermitage at Richmond,* a detail from John Rocque, *'An Exact Plan of the Royal Palace Gardens and Park at Richmond'*, engraving, 1734. British Museum

Kent set up an imaginative juxtaposition between the rustic exterior elevation and the classically proportioned interior. The drama and surprise which resulted may have been calculated to give a greater force to the messages conveyed by the furnishings inside and to induce a state of contemplation in the visitor. As the poem 'Richmond-Gardens' concluded:

The sylvan scene with more than nature drest,
Involves the thoughts of the admiring guest.

Behind the façade there was a small transverse lobby with apsidal ends. Passing across this, a central octagonal room, sixteen feet in diameter, was entered, which had a deep exedra at the back lit by a central lantern let into the vaulted ceiling. The room had arched niches set above the dado, and the room was furnished with day beds.[31] The altar placed against

the back wall of the exedra was decorated with a dramatic corona of gilded scalloped rays.[32] Either side of the central space were small square rooms, lit again from lanterns let into the ceilings, but here having rich Rococo decoration. The left-hand room was filled with large bookcases, while the right-hand one had an elaborate canopied bed. The decoration of the vaulted ceilings with stalactites introduced a little picturesque Gothick detail.

Henry Flitcroft was the architect who supervised the building project (fig. 54), with help from Andrews Jelfe, the Master Mason. Flitcroft had been one of Burlington's favourites since 1720, when he was injured during the building of Burlington House, and Burlington had later been instrumental in his appointment as Clerk of the Works at Whitehall, Westminster and St James's, as well as Richmond. The Hermitage was completed in April 1732 at an official cost of £1141. 1s. 4¼d. Caroline had in fact added a massive £2028. 0s. 10d. from her private Privy Purse funds and later spent £115. 2s. 6d. on books for the library which she established there.[33]

By 1735 Merlin's Cave had been constructed to a design by William Kent to the south of the Duck Pond, just three hundred yards away from the Hermitage.[34] It was rather misleadingly called a 'cave' as it was in fact a thatched cottage in an almost playful Gothic style (fig. 55). Passing though the ogee-shaped doorway, flanked by Gothic buttresses, one entered a large vaulted circular room, the walls covered with blind tracery into which niches were set. On either side of the main room there were octagonal pavilions furnished with bookcases. The central room and the two pavilions each had its own dramatic beehive-shaped roof thatched by Henry Stallard.[35]

Merlin's Cave has also not survived, but its design is recorded in an engraving used to illustrate Dryden's *Merlin: or, the British Inchanter: and King Arthur, the British Worthy*

Opposite, right
53 *Design for Queen Caroline's Hermitage, Richmond* by William Kent, pen and wash over pencil, c. 1730. Sir John Soane's Museum

54 *Henry Flitcroft* attributed to Bartholomew Dandridge, oil on canvas, c. 1740. RIBA, London

55 *'Merlin's Cave in the Royal Gardens at Richmond'* by T. Bowles a plate from Edmund Curll, *The Rarities of Richmond*, 1736

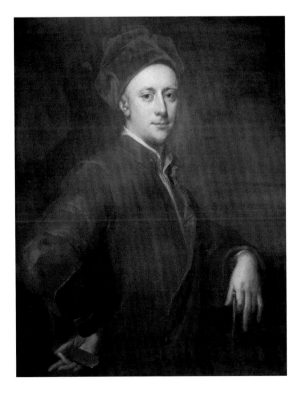

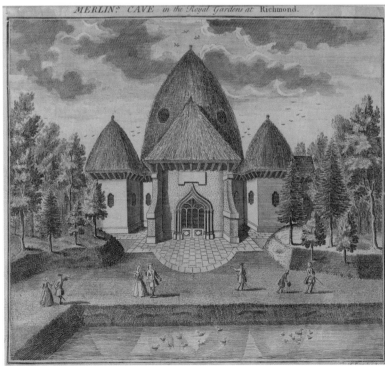

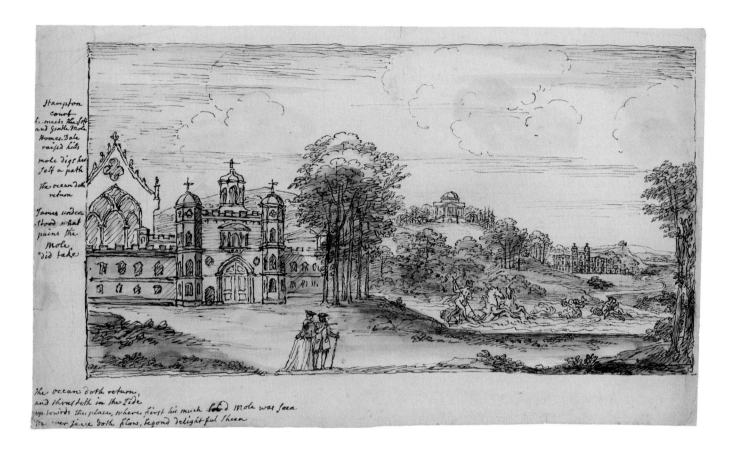

*Hampton
court
he meets the soft
and gentle Mole
Homer-Dale
raised hills*

*mole digs he
self a path*

*The ocean doth
return*

*James under
stood what
pains the
Mole
did take*

*the ocean doth return,
and thrusteth in the Tide
up towards the place, where first his much lov'd mole was seen
the river since doth flow, beyond delightful Sheen*

56 *Landscape Capriccio with Hampton Court, Esher and River Scene with Triton* by William Kent, pen and wash over pencil, 1730–40. British Museum

published by Edmund Curll in 1736 and also incorporated in John Rocque's map of Richmond Gardens which was widely published (fig. 47).[36] There are just two illustrations which record the interior arrangements. A drawing by Kent is included in John Vardy's *Some Designs of Mr Inigo Jones and Mr Wm Kent* and there is a second anonymous engraving showing a variation on this layout, which was used as an illustration to *The Rarities of Richmond* by Edmund Curll published in 1736.[37]

Work on Merlin's Cave started shortly after Kent had received a request as Master Carpenter to rebuild the east range of Clock Court at Hampton Court Palace. For that project, according to Horace Walpole, he had first toyed with a design in the classical idiom but in 1731, encouraged by Sir Robert Walpole, he reverted to a Gothic style which would blend more sympathetically with the rest of the palace.[38] The opportunity this work provided for the study of sixteenth-century architecture proved crucial for the projects which followed. It is probably the reason why the first Palladian-inspired plan which Kent produced for the Honourable Henry Pelham for Esher Place was abandoned and Kent decided instead to design the new house in a Gothic style. As at Hampton Court there was a historical legacy – a gatehouse built in the late fifteenth century by Cardinal Wolsey, now called 'Waynfleet's Tower', which survived from the first house which had occupied the site.[39] Kent's revised design not only included the tower, but the main façade shows the influence of the entrance façade of Hampton Court (fig. 56).[40]

Kent's commission for Pelham also extended to the creation of an Arcadian landscape peppered with a range of garden pavilions. As well as a grotto with a façade in the Tuscan

order and a hermitage tucked behind a classical arch, there was a third little building which had significance for the Merlin's Cave project which followed. It was a cottage with a high-pitched roof covered with thatch anticipating the Cave's thatched beehive-shaped roofs.[41] Having first visited Newcastle's estate in 1729, Caroline returned in 1732 and would have had the opportunity of viewing the work in progress. Amongst a group of drawings by Kent preserved at Rockingham Castle, Northamptonshire, there is an image of a tented pavilion decorated with the royal arms which he may have designed for this royal visit (fig. 57).[42]

However, Flitcroft and his colleague Andrews Jelfe, who were responsible for building the Cave, may have brought their own contribution to the project too. While the exotically shaped roofs may simply have been Kent's romantically Gothick conceit, both Flitcroft and Jelfe had a serious interest in contemporary archaeology and had encountered the archaeologist and antiquary William Stukeley earlier in their careers. For Flitcroft, this had been during his employment with Burlington. For Jelfe, it was back in 1719 when, as 'Architect and Clerk of the Works' for 'garrisons, forts, castles . . . belonging to the Office of Ordnance', he was sent to Scotland to survey a building with a high domed roof called Arthur's 'O'on', or Oven, located on the banks of the Carron river near Falkirk. It was in fact a domed Roman shrine but with traditional, if spurious, Arthurian associations. Stukeley was so impressed by Jelfe's work that he chose to have his drawings of the O'on engraved, and they are preserved today in the Bodleian Library.[43] Caroline's Merlin's Cave was not dissimilar in style, and she would certainly have delighted in the connection with King Arthur. This was the first imaginative way of introducing an English promotional

57 *'A plan of the garden and view of ye buildings of ye Rt Honble Henry Pelham Esq at Echa in the county of Surry'* by John Rocque, engraving, c. 1730. British Library

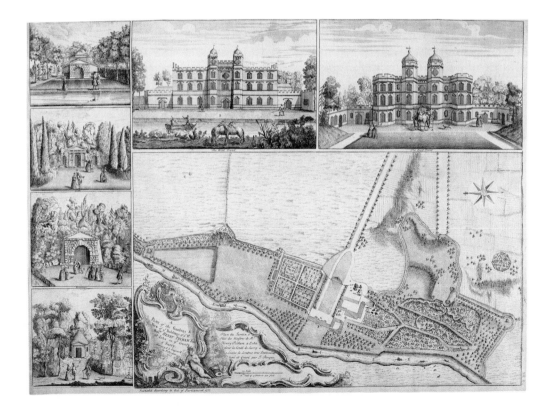

58 *'The Chief Druid from a Statue'*, an illustration from *Mona Antiqua Restaurata* by Henry Rowland, 1723

agenda into the endeavour. She was familiar with Stukeley's archaeological research, too, owning a copy of his book *Itinerarium Curiosum, or an Account of the Antiquitys and Remarkable Curiositys in Nature or Art, Observ'd in Travels thro' Great Britain* about the archaeology of Avebury and Stonehenge – a major contribution to the contemporary debate concerning the origins of the British nation.[44]

It is also possible that the design of Merlin's Cave was informed by contemporary research into 'primitive' structures associated with the Druids. This was another connection which could be seen as promoting all things English. Antiquarian interest in this religion can be traced back to the late sixteenth century and, by about 1620, the Druids were presented as the ancient priests of Britain. In the seventeenth century they acquired a consistent visual identity: bare footed, with long hair topped with a leafy garland, a long beard and wearing a long, shaggy robe. These illustrations sometimes include depictions of their dwellings, which took the form of small circular huts topped with high conical roofs covered with thatch, very like the unusual roofs of Merlin's Cave. Stukeley may have again proved the catalyst. Even though he completed his notable work on the history of the Druids after Caroline's death, his research must have been well advanced at the time when she conceived the plan for Merlin's Cave with Kent, Flitcroft and Jelfe. It was probably an influence on the work of John Wood the Elder, another contemporary architect.[45] Caroline may have had her own reason for empathy with this style. As a teenager she had met John Toland, who had researched these ancient peoples when he formed part of the intellectual circle supported by Sophie Charlotte in Berlin (fig. 58).[46]

Whether Caroline and Kent saw their little building as a Druidical structure, one associated with King Arthur or simply one that referred to a venerable Gothic past we may never know, but it is interesting to speculate as to whether Caroline had consciously set up the

dual reference. What was important was that the choice of architectural style adopted for both Merlin's Cave, and for the Hermitage, was an appropriate complement to the political message carried by sculptural programmes set up in the interiors. Caroline's sculpture commissions will be discussed in the next chapter.

Kent's work in Caroline's garden contributed to the creation of a stage on which the joys of rustic English life could be celebrated. The garden already contained some of the elements characteristic of the *ferme ornée*, but evolved to become a *trianon* – a landscape full of temples and little buildings including the dairy with its collection of creamware dishes. There was a dancing lawn in front of Merlin's Cave.[47] This was in line with Caroline's ambition to encourage all that was old and English. As Princess of Wales in 1715, she had presided over a rural sports day at Hampton Court at which local boys and girls competed in running races for prizes of smocks, petticoats and hoods. She quickly learnt how to dance traditional country dances, such as the Hemp Dressers, which she introduced into court celebrations.[48]

Kent and Bridgeman manipulated the landscape to provide a series of dramatic settings for Caroline's pavilions. They chose a thicket of pine trees, opening on to a circular lawn to frame the Hermitage, and a woody enclosure for Merlin's Cave. The façade of the Cave was reflected in the Duck Pond cut just in front. While this was all fashionably 'picturesque', in line with a formula advocated in *New Principles of Gardening* by Batty Langley, it was also as if each of the buildings was given its own stage too.[49] It hardly comes as a surprise to find a drawing by Kent of an Arcadian scene in which a satyr bows before a shepherdess, in front of a hermitage very close in design to that at Richmond, as if in a stage set.[50] Perhaps the shepherdess represents Caroline herself (fig. 59).

59 *Stage Setting with Arcadian Hermitage* by William Kent, pen, ink and wash, 1730–40. Sir John Soane's Museum

Kent brought a new approach to the management of the landscape. Horace Walpole claimed: 'He leapt the fence, and saw that all nature was a garden'.[51] However J. G. Wynn, writing in *London and Westminster Improved*, added that he still 'needed the practical experience and abilities of Bridgeman to help him translate his ideas into reality – his landscapes exist only as sketches which he presumably left to others to recast as measured drawings.[52] Kent's involvement in Caroline's garden improvements did indeed bring about a relaxing of the formality present in Bridgeman's work, a trend which continued as they worked again as a team at Chiswick and Stowe.

Fashionable visitors continued to flock to Richmond and, entering by the gate near Richmond Green, they were able to make a tour of the garden. This would take them past the Dairy to the Tuscan Temple and then on to the Queen's Temple, where they could elect to follow the terrace along the river or take the winding path into the woods which took them to the amphitheatre, the Hermitage and Merlin's Cave. On summer nights the riverside terrace would always be crowded.[53] Within the woods, the visitor would happen by surprise on the pavilions and temples. All were described enthusiastically – the Hermitage generally in melancholy terms as a retreat 'like a shallow cave by nature made'.[54] Edmund Curll found it 'very grotesque, being a Heap of Stones, thrown together in very artful disorder and curiously embellished with moss and shrubs to represent rude nature.'[55] 'The stones of this building appear as if laid by accident,' claimed Walter Hanson. Lord Egmont returned to the garden with his wife and daughter, describing their day out in his diary: 'The most curious parts of the garden are Merlin's Cave, before which there is a good piece of water; the Grotto which is very solitary and romantic, a walk planted two miles and a half long, and the Terrace to the Thames. The rest consists of divers other walks, some of them close and winding in the woods, others quite open.'[56]

Caroline's ambition for Richmond was not restricted to the development of the garden; as her financial situation improved she harboured plans for Richmond Lodge too. In the early years of the new reign Sir Edward Lovett Pearce, the Surveyor General of Ireland, drew up a set of plans and elevations for a new 'royal lodge' to replace the small inconvenient building.[57] Pearce died in 1733, but Caroline was eager not to let her plan drop and in 1735 a design for the new palace was devised by Kent. A pearwood model of this was made up by Mr Marsden, a cabinet-maker of Vine Street in Westminster, and then set up in one of the Richmond summer-houses for inspection.[58] The building as proposed had just two

60 Model for a new palace at Richmond made for William Kent, boxwood, 1730–40. The Royal Collection

storeys but extended for twenty-seven bays, probably with a dome at its centre and a squat octagonal tower at each corner. The design was ambitious and probably just too expensive, and by 1735 Caroline found she had other preoccupations (fig. 60).[59]

On his accession to the throne, George I had considered it essential that his eldest grandson remained in Hanover to represent the family interests there. During his periodic residences back in the electorate he managed to maintain a friendly relationship with Frederick, but there was no contact between the young prince and his parents. It is probable that during this time they approached the King with a proposal regarding the royal succession, suggesting that Frederick should remain in Hanover to succeed as elector, allowing their new British-born son, William Augustus, to inherit the British throne. George I seems to have had sympathy with this plan. However, while he may have appreciated that the needs of Hanover and Britain were very different, he would know this was not a decision in his gift; such a radical adjustment in the line of succession would need to be carefully negotiated with both the College of Electors and with Parliament in London. He also required that Frederick's views on the matter be taken into account. George I died before any of these discussions were even brokered. Eventually, in 1728, George Augustus and Caroline decided Frederick should be brought to London. This was to save diplomatic embarrassment after he tried, against advice, to broker marriage with his cousin Wilhelmine in Prussia. As the eldest son and Prince of Wales, he took his seat in the House of Lords and immediately achieved a measure of political clout after establishing a particular rapport with the politicians who represented the forty-four seats of his duchy of Cornwall. In the eyes of the people he was the undisputed heir. His parents realised any earlier dynastic plans were thwarted.

This was an inauspicious introduction to his family. Even though during the first few months Frederick, aged twenty-one, was provided with elegant accommodation, accompanied Caroline and his brother and sisters on their visits to the houses and gardens of courtiers and politicians, and joined in their music-making, Frederick's reversionary interest in his father's position created great tension. George II was increasingly worried when Frederick, having taken his seat in the House of Lords, was courted by members of the political opposition, and feared that this could result in a challenge to his own position. Arthurian imagery with its promise of a rosy royal future, so recently accorded to him and used by Caroline to further dynastic agendas, was being linked increasingly with his rebellious son. Echoing the treatment received from his father, George II retaliated by preventing Frederick from setting up his own establishment, restricting his allowance and for many years frustrating any marriage plans. It was not until 1735 that George indicated that Princess Augusta of Saxe-Gotha might be considered a suitable bride. The marriage, which took place in April 1736, did little to improve relations. Frederick failed to make an appearance at court events and went to Parliament behind George's back seeking an increase to his income. Worst of all, in July 1737, in his determination that his heir should not be born under his father's roof, he rushed his pregnant wife from Hampton Court Palace to St James's, not only putting the lives of mother and child in jeopardy but also ensuring that the birth of their child was not witnessed. Lack of witnesses to the birth potentially allowed an element of doubt to surround the legitimacy of the heir to the throne, and this had serious implications for the line of succession. For Caroline, Frederick had become 'That wretch! – That villain!'[60]

An additional concern for Caroline was that her husband had, over the years, taken his pleasure with a sequence of mistresses which she tolerated reluctantly as the lot of a royal wife. With the adventuress Henrietta Howard, who had caught George's eye in about 1717, she was able to maintain her superiority through the politics of the royal household where Henrietta was employed as one of her Women of the Bedchamber. Henrietta was trapped in an abusive marriage and dependant on the security her royal office provided.[61] Lady Deloraine (governess to the younger princesses), who replaced Henrietta in the King's affections in 1734, proved a passing fancy. In 1735 Caroline, by now in her fifties and in indifferent health, found she had a far more dangerous rival. This was Amelia Sophia de Walmoden, whom George had met during a sojourn in Hanover. He sent lengthy, explicit letters back to Caroline extolling her virtues and on his return his bad temper, and the regular humiliation she endured at his hands, led Caroline for the first time to feel that their strong interdependent relationship might be in peril. When George returned to Hanover the following year to meet again with Amelia, who had just given birth to their child, Caroline took action.[62] She wrote to George suggesting that he bring his mistress back to St James's to serve in her household. Having her rival near to hand would give her back some control over the situation. Plans for Richmond were put to one side as Caroline agreed to clear rooms at St James's Palace where she stored books so that a new apartment could be created for Amelia, and an idea for another project seems to have emerged. In 1736 Caroline decided to build a new library at St James's Palace.[63]

On her arrival in London Caroline's love of reading was immediately evident to the new countrymen she encouraged into her salon. Although she established book collections at Kensington Palace as well as at Richmond, from a practical point of view the royal family spent a great part of the year at St James's Palace, still the principal ceremonial and diplomatic centre for the monarchy. By choosing this location for a new library she could maintain the book collection conveniently near to hand, and the library would acquire prestige by its association with the seat of government, lifting it out of Caroline's private sphere.

The library, designed by William Kent, was a single-storey building sixty feet long and thirty wide located on the west side of St James's Palace where the Office of Works had its yard.[64] There is no record of its exterior elevation, but designs survive to show that, although conceived as an addition to the great complex of sixteenth- and seventeenth-century buildings which comprised St James's Palace, the new library was designed in the classical idiom (fig. 61). Caroline like other neo-Palladians had come to eulogise Inigo Jones as a great master and star royal architect of a previous era. Her library already contained Colen Campbell's *Vitruvius Britannicus* as well as Kent's compendium of drawings by Palladio, Inigo Jones and John Webb from Burlington's collection, *Designs of Inigo Jones with some Additional Designs* published in 1727. This choice of style would have been considered appropriate and patriotic.

There was evidently much debate about the final design details for the interior. Initially Kent seems to have envisioned the room decorated in the Palladian manner, with a giant order and a cross-vaulted ceiling based on the design of Roman baths, but he went on to produce a great variety of detailed drawings for alternative designs.[65] The final scheme had arch-topped windows arranged along one long wall overlooking Green Park, balanced on the wall opposite with arched recesses containing bookshelves. Bookshelves projected out

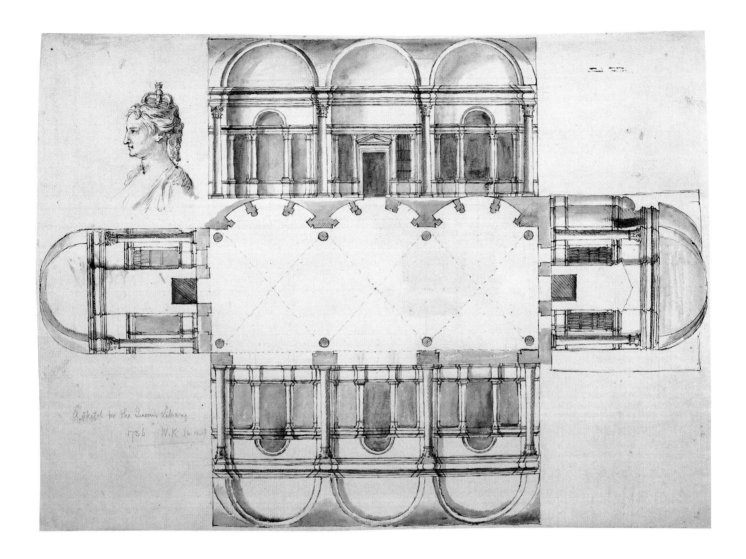

of the walls at right angles on both long walls and were built into the recesses which flanked the chimneypieces and doors at the ends of the room.[66] The ceiling was divided into three fields above an elaborately carved cornice and deep cove.[67] The central field contained an elaborately carved cartouche with Mannerist embellishment in the manner of Giulio Romano.[68] The building work was supervised by Andrews Jelfe, had worked earlier on the construction of the Hermitage and Merlin's Cave.[69] The two views of the interior of the library showing it in use, one a watercolour by Charles Wild, the other a drawing by him, were both made in the early nineteenth century, many decades after Caroline's death.[70] Although by this time many of the fittings had been removed, the illustrations show that the Queen's Library was on a much grander scale than any of Kent's other library projects. He also built libraries at Holkham for Thomas Coke, at Houghton for Sir Robert Walpole, at Devonshire House for the Duke of Devonshire and, lastly, at Rousham for General James Dormer-Cotrell.

Any discussion of Caroline's involvement with fashionable architecture in the 1730s begs a debate about the relationship between her projects and those initiated by her eldest son,

Frederick, Prince of Wales. In 1730 Frederick sought a way out of his difficult family situation by taking over the lease of Kew House. This was located less than a mile from Richmond Lodge and close to the Dutch House, which Caroline had earlier leased for use by her elder daughters, Anne, Amelia and Caroline, suggesting that Frederick at this time was concerned to maintain some contact with his family.

Kent must have just prepared his designs for the Hermitage at Richmond for Caroline when Frederick asked him to enlarge and embellish Kew House, which he renamed the 'White House'. While it is just possible that Frederick had already met Kent as he started working on projects in the various royal homes in 1729, Lord Burlington was the likely catalyst. There was an immediate empathy between the two which turned on matters of art and architecture. Not only did Burlington introduce his stable of artists and craftsmen to the young prince but when in 1732 Frederick purchased a second house, Carlton House in Pall Mall, from Burlington's mother, the Dowager Countess of Burlington, Burlington himself worked up a design – never executed – for its remodelling.

In 1732, the year that saw the final bills for the Hermitage paid, as well as work beginning on Merlin's Cave and the two little pavilions constructed for Caroline in Kensington Gardens, William Kent was appointed architect to Prince Frederick and embarked on an ambitious plan to transform his White House. The work there was largely complete in 1735, just as Merlin's Cave opened to visitors. Perhaps galvanised by envy at the scale of Frederick's project, Caroline embarked on her plan to build a new library at St James's (fig. 62).

The garden which William Kent created for Frederick at Carlton House from 1734 would prove ultimately more pioneering and influential than Caroline's at Richmond. However,

62 *'View of the Gardens at Carlton House'* by William Woollett, engraving, 1750–60. The Royal Collection

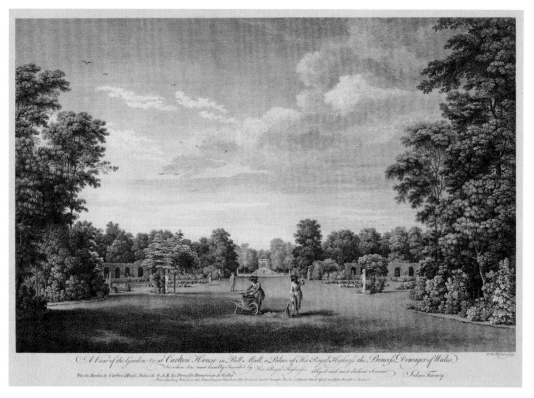

one has to remember that it was Caroline who drew the royal family into the English circle of gardening theorists and designers and, as early as 1719, began to experiment with new ideas which exploded the formality that had characterised English gardens of an earlier generation. Frederick's first excursion into garden design came after he had had the opportunity to travel with Caroline to view Bridgeman's achievements at Claremont, Cliveden and Gubbins, and had seen the re-styling of parts of her garden at Richmond. It was not until 1736, following his first visit to Alexander Pope's garden at Twickenham, that Frederick started the embellishment of the grounds surrounding his White House (fig. 63).

After Caroline's death, Kent's work for the royal family tailed off dramatically. He continued to work for the Crown however, and produced magnificent designs for the rebuilding of the Palace of Westminster and Horse Guards in Whitehall. The Royal Mews was a project left unfinished when Kent died in 1748 and was eventually completed by his associate John Vardy.

For her countrymen, who hoped the Hanoverian succession would bring a flood of new architectural commissions, Caroline's contribution must have seemed modest. However, the Hermitage, Merlin's Cave and the Queen's Library at St James's, which Kent designed for her, excited debate and interest, not least because through them she sought to embed and champion the new regime and celebrate the distinction of the dynasty. This would be achieved not just through choice of architectural style and setting, but also in the imaginative embellishment and decoration of the buildings. This brought her into contact with the community of sculptors in working in London.

63 *The Gardens at Kew* by Johan Jacob Schalch, oil on canvas, c. 1760. The Royal Collection

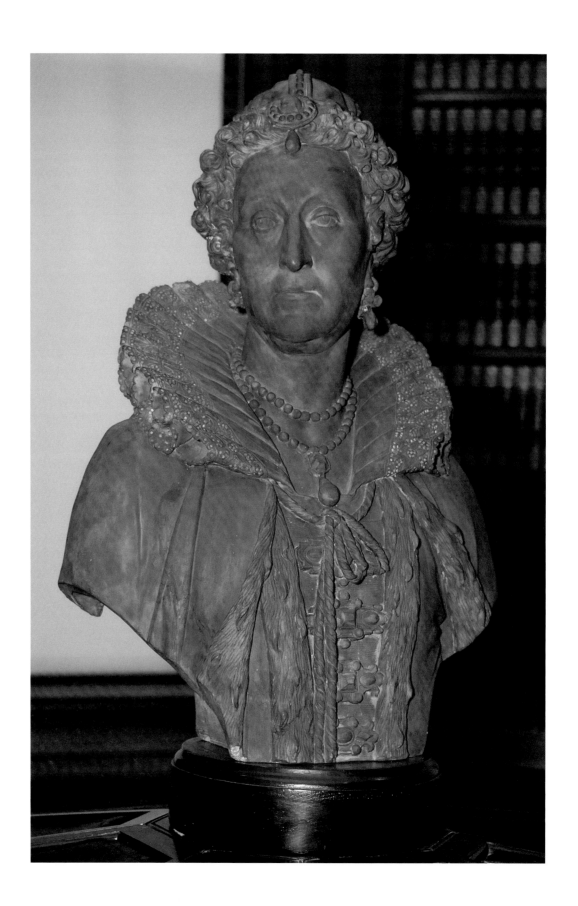

3

CAROLINE
and the Sculptors

Caroline's decision to furnish her architectural projects with sculpture was much discussed and applauded by the cultural élite and in the popular press. *The Gentleman's Magazine* notes that Caroline had brought honour to the English court by taking 'statuary into her protection.'[1] It occupied a completely legitimate and established place within the contemporary canon of artistic representation, and Caroline was considered to have embraced it, on behalf of the House of Hanover, in an honourable way.

Sculpture was commissioned for both the Hermitage and Merlin's Cave, and also for the new library at St James's. At each of them the work was used to put across her message. In her role as the champion of the arts and sciences Caroline set up the Hermitage as a tribute to Newtonian science, as well as to explore her own ideas about Latitudinarian theology. At Merlin's Cave she celebrated the pedigree of the new Hanoverian dynasty and its connection with the mythical history of the British nation. The sculptural programme commissioned for the library allowed Caroline, as a historian, to explore in a different way the history and the role of monarchy in Britain.

The Hermitage in the garden of Richmond Lodge was the first of Caroline's temples to be set up as a pantheon decorated with portrait busts. The first mention of the commission for four busts for 'the Queens [building] at Richmond' was made by George

Opposite
Queen Elizabeth I by John Michael Rysbrack, terracotta, 1737–38. The Royal Collection (detail of fig. 87)

71

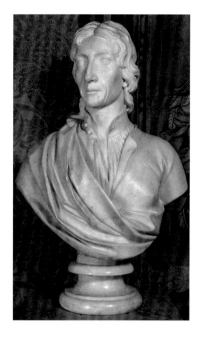

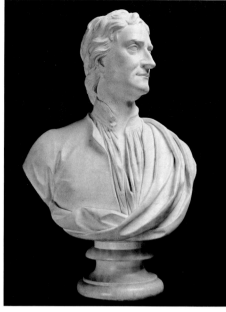

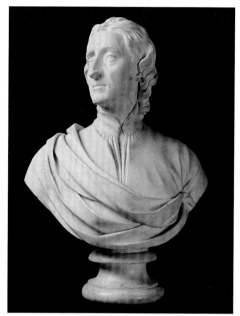

64 *Sir Robert Boyle*
by Giovanni Battista Guelphi,
marble, 1732. The Royal Collection

65 *Sir Isaac Newton*
by Giovanni Battista Guelphi,
marble, 1731. The Royal Collection

66 *John Locke*
by Giovanni Battista Guelphi,
marble, 1731. The Royal Collection

Opposite, left
67 *Dr Samuel Clarke*
by Giovanni Battista Guelphi,
marble, 1731. The Royal Collection

Opposite, right
68 *William Wollaston*
by Giovanni Battista Guelphi,
marble, 1731. The Royal Collection

Vertue in 1731. These commemorated great scientists, theologians and philosophers of the
late seventeenth and early eighteenth centuries. A fifth bust was delivered to complete the
collection in 1732.[2] The sculptor selected by Caroline for the project was Giovanni Battista
Guelphi, a Roman by birth, who had been encouraged to decamp to London in about 1719
by Lord Burlington to work on projects at Burlington House and Chiswick.[3] The white
marble busts, which remain part of the Royal Collection, have long, slightly horsey faces,
boldly modelled and framed with trailing locks of rather lank hair, all hallmarks of
Guelphi's style (figs 64–68).[4]

The busts were placed in the niches in the central room of the Hermitage. The bust of the scientist Sir Isaac Newton, with his head turned to the right, was balanced by that of the philosopher John Locke, turned to the left.[5] The Reverend Dr Samuel Clarke was turned to balance the bust of his fellow cleric William Wollaston. The bust of the chemist, physicist and philosopher Robert Boyle, wearing a pleated shirt and loosely falling coat, which, as *The Gentleman's Magazine* noted: 'stands higher . . . on a pedestal, in the inmost, and as it were, the most sacred Recess of the Place; behind his Head, a large Golden Sun, darting its wide spreading Beams all about, and towards the others, to whom his Aspect is directed.' He presided over the pantheon, and embodied the marriage between natural philosophy and Newtonian science which linked all the worthies together.[6] The author of a poem published in *The Flowers of Parnassus: Or the Ladys Miscellany, for the Year* MDCCXXXV declared:

> *Wisdom* and *Piety* their Beams unite
> To shine in Boyle with all convections light,
> Which thro' the various walks of Nature shews
> God, the Prime Source, whence all Perfection flows (fig. 69).[7]

69 '*A Section of Merlin's Cave in the Royal Gardens at Richmond*' by William Kent, a plate from John Vardy, *Some Designs by Mr Inigo Jones and Mr Wm Kent,* 1744

Caroline had been introduced to the work of Newton by Leibniz at the Court of Sophie Charlotte in Berlin. Leibniz's contact with the British natural philosopher had started with an exchange of letters in 1676, but their initial respect and admiration for each other evaporated in 1705 when both claimed to have invented the theory of fluxions. Despite their estrangement, Caroline's own spirit of enquiry meant she was concerned to honour them both. She made contact with Newton shortly after her arrival in London with the intention of enticing him into her circle; his pupil, William Whiston, was an easier proposition and was amongst the first group of clerics who hastened to her salon. Her persistence with Newton paid off and by 11th February, 1716, Lady Cowper recorded that she was entertaining him with Dr Samuel Clarke so they could 'explain Sir Isaac's System of Philosophy' to her.[8] A careful selection of his publications had already begun to find its way into her collection of books.[9] In fêting Newton, Caroline would have been seen as aligning herself with many others who regarded him as a great English hero. His ordered, providentially guided, but mathematically regulated, world was seen as a model for a stable and prosperous society controlled by men as well as by God. As such it was a philosophy in tune with that of the Latitudinarians, free-thinkers and other Low-Church clerics. It was soon appropriated by them and preached from their pulpits. It also accorded with the social and political theories of members of the Whig party who had championed the Hanoverian succession.[10]

Samuel Clarke, Newton's companion at the philosophical debate in 1716, was regarded as the foremost English metaphysician in early eighteenth-century London. After being invited to give two of the prestigious annual Boyle lectures – established in 1692 under the terms of the will of the eminent natural scientist-philosopher Robert Boyle to discuss the existence of God – he was appointed Chaplain in Ordinary to Queen Anne and was presented with the living of St James's Piccadilly.[11] Caroline had no difficulty attracting his attention; in 1714 he hurried to St James's Palace very shortly after her arrival to present her with copies of his books.[12] She read them immediately and just two days later Lady Cowper reported that her mistress had declared: 'Dr Clarke shall be one of my favourites; his writings are the finest things in the world.'[13] Her admiration was enduring. At her instigation he entered into a correspondence with Leibniz between 1715 and 1716. Their discussion was eventually published in 1717 as *A Collection of Papers which Passed between the Late Learned Mr Leibnitz and Dr Clarke in the Years 1715 and 1716 Relating to the Principles of Natural Philosophy*. Caroline's library contained this and many other titles by Clarke, often in multiple editions.[14] When he died in 1729, Lord Egmont reported that Caroline commissioned a copy to be made of his portrait by Charles Jervas and had this hung in Kensington Palace, accompanied by a fulsome epitaph written by Benjamin Hoadly, Bishop of Salisbury.

William Wollaston was a disciple of Clarke, and author of *The Religion of Nature Delineated*. Wollaston had struggled to attract interest in his ideas and his book was initially printed privately in 1722. However, it soon became hugely popular: in 1724 ten thousand copies were sold, and by 1750 there had been seven new editions. His residence in London should have allowed him the opportunity to encounter Caroline both as Princess of Wales and as queen.

The other worthies selected by Caroline for celebration in the Hermitage, the philosopher metaphysician Robert Boyle and philosopher John Locke, had died in 1691

and 1704 respectively, before Caroline had a chance to meet them. However, in Berlin, when she was young, she had become aware of Locke's ideas after Sophie Charlotte entered into a lengthy discussion of Locke's *Essay Concerning Human Understanding* with Leibniz. Henriette-Charlotte von Pöllnitz, a member of the Prussian household, reported to Leibniz that Caroline had just written to say that she too was reading Locke's works.[15] Her admiration for him as well as for Robert Boyle can be judged by the number of their books she had in her library.

Caroline's interest in Boyle and Locke and their inclusion in her pantheon had a particular import in an English context. Like Newton, both Boyle and Locke had acquired status as British heroes particularly with the late seventeenth-century Whig opposition. Both had stressed the fundamentals of Christianity while showing impatience with the politics and divisions within the established Church, and this had endeared them to the Latitudinarians. The universities of Oxford and Cambridge vied for fame by association with their achievements, and Boyle's work underpinned the reputation of the Royal Society. By revealing her admiration of them so obviously Caroline showed that she was aware of the considerable English contribution to the greater European scientific debate.[16] When questioned about her choice, Caroline remarked diplomatically and neutrally to Lord Egmont: 'There is a satisfaction to see the portraits of eminent persons dead and gone, but 'tis melancholy to reflect how soon their great actions are forgotten and that their glory terminates in a sheet of paper.'[17]

On the accession of George II, the salons which Caroline had held at Leicester House were largely abandoned and she withdrew somewhat from such active participation in academic and literary debate.[18] As queen it would have been hard to keep such gatherings

70 Temple of British Worthies, Stowe, the monument designed by William Kent, completed c. 1735

apolitical, and to continue with them could be dangerous both for her and for her husband. As her power of patronage increased, she probably became aware that her openness could be abused, and she chose to promote the interests of humbler, less politically sensitive recipients. Some of those with whom she had particularly enjoyed debating, such as Newton and Clarke, would be honoured, privately, in her pantheon.

In choosing who should be commemorated Caroline was not swayed in her choice by Lord Burlington or Sir Andrew Fountaine, who were powerful influences on other aspects of her patronage. While Burlington and Fountaine had both selected their heroes from classical antiquity, her architect William Kent and her garden designer Charles Bridgeman could keep Caroline abreast of Lord Cobham's scheme, set up only very recently in his great garden at Stowe, and which in the end most nearly echoed her own. Between 1729 and 1730, in Bridgeman's west garden, James Gibbs's Temple of Fame had been embellished with portrait busts by Michael Rysbrack of Milton, Shakespeare, Bacon, Elizabeth I, William III and John Hampden, as well as Caroline's favourites, Newton and Locke.[19] These were the individuals Cobham considered his men (and one woman) 'of action'. The ensemble included those who had championed Protestantism and upheld the honour of the nation in the military and cultural spheres (fig. 70).

Caroline's adoption of a national iconography fell easily into this fashion, and the worthies programme in the Hermitage met with almost universal approval. *The Gentleman's Magazine* even devised a poetry competition in its honour and published the eleven winning entries.[20] Though this project fell within Caroline's personal orbit and therefore left her a free choice in choosing her heroes, she had selected an exclusively British list which found immediate favour with commentators.[21] *The Gentleman's Magazine* noted in her choice 'her peculiar Affection to this Country and the Natives of Great Britain' and added pointedly 'her own Leibnitz is not allowed a Place there.' *The London Journal* commented: 'when Her Majesty consecrated these dead heroes … she built herself a temple in the hearts of the People of Britain who will by this instance of her love of liberty and public virtue, think their interests safe in the hands of the Government as their own'.[22]

For visitors to the garden at Richmond, the relationship Caroline had engineered between the Hermitage and its environment was commended very favourably too. The poem 'On the Royal Grotto' about the Hermitage, published in *The Gentleman's Magazine* in 1735, emphasises the fact that Caroline's 'temple sacred to honour and virtue', dedicated to men who were the 'glory of their country', was given suitable dignity. Nature untamed was seen as being an appropriate setting for the celebration of virtuous endeavour and the contemplation of the great. It was a landscape considered worthy testimony to the immanence of the divine.

The message in Merlin's Cave was quite different. It was designed to celebrate the mythical and mystical origins of the English nation and was part of Caroline's campaign to endorse the Hanoverian regime by identifying a common ancestry between the House of Guelph, which the Hanoverians saw as their ancestors, and the medieval English kings. This was achieved in a startling and dramatic way through a tableau composed of six life-size waxworks, each connected in some way with the legend of King Arthur. Kent's atmospheric depiction of the interior, as well as descriptions found in *The Gentleman's Magazine* and in Edmund Curll's *Rarities of Richmond*, suggest that these were arranged around a table placed in the central room (fig. 71).[23]

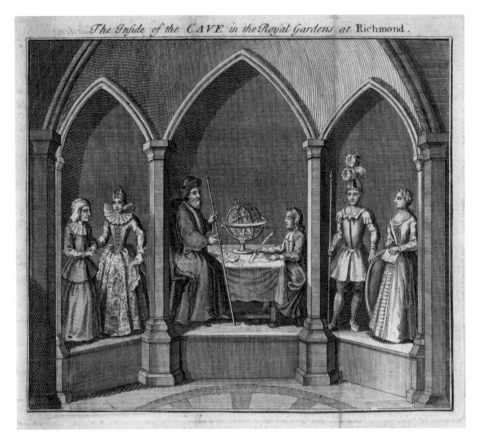

The wax figures had been made by Mrs Mary Salmon, or her assistant Thomas Benière, at Mrs Salmon's popular waxworks exhibition, located at the sign of the Golden Salmon at St Martin's in Aldersgate.[24] The exhibition was described by Zacharias Conrad von Uffenbach in 1710: 'we drove also in the neighbourhood of St Martin le Grand, to a certain Mistres Samons, who is famed throughout England for her skilful wax modelling, she showed us six rooms full of all kinds of wax figures, mostly life-size and representing ancient tales, especially English ones, though there is no need to describe them here in any detail. Suffice it to say that the work is tolerable ... this woman appears to work only with moulds but we could see that the work is very accurate from the figure of the Queen as well as one of herself. She has represented herself holding a child in her lap.'[25] Perhaps it was because of Mrs Salmon's history of making figures to represent 'ancient tales' that Caroline chose her over her rival Mrs Goldsmith, another, more famous artist in wax working in early eighteenth-century London. It was Mrs Goldsmith who had been commissioned to make the death masks of Mary II, William III and Queen Anne's son, the eleven-year-old William, Duke of Gloucester, and probably she was the maker of the full-length wax portraits of Mary II, William III and Queen Anne which survive today as part of the 'Ragged Regiment' display of English monarchs in Westminster Abbey (fig. 72).[26]

The iconographic programme selected by Caroline was obscure and confused even to contemporary commentators. Visitors to the Cave were in agreement that Merlin sat at the table with a book open before him and surrounded with mathematical instruments,

71 *'The Inside of the Cave in the Royal Gardens at Richmond'* by T. Bowles, a plate from Edmund Curll, *The Rarities of Richmond*, 1736

72 *Frances, Duchess of Richmond and Lennox* by Mrs Goldsmith, waxwork, 1702. Westminster Abbey, London

and that he was accompanied by his secretary. Edmund Curll reported that Merlin's book was called '*The Life and Predictions of the Late Celebrated Duncan Campbell*' and contained prophesies made by Campbell, a deaf and dumb labourer who had travelled to London in 1694. By 1720 he had been adopted not just by fashionable society but even at Court as a latter-day Merlin with the ability to identify future brides or bridegrooms. He so impressed Daniel Defoe that Defoe wrote *The History of the Life and Adventures of Mr Duncan Campbell*.[27]

The figure of Queen Elizabeth I which stood nearby was easy to recognise. She was accompanied by a smaller, older figure, in more informal dress. Some identified her as Mother Shipton, who, *The Gentleman's Magazine* explained, was a witch or female Merlin. Caroline was fascinated with superstitions and the supernatural, and had a collection of books on witches and ghosts in her library, so this is just possible.[28]

However, it is much more likely that the old woman accompanied the other striking female figure who stood nearby, clad in a short-skirted cotehardie, wearing a helmet topped with a plume of feathers, and carrying a spear and sword. She was described by visitors variously as Minerva, Britannia – 'Britain's Minerva' – or, more usually, as Britomart, the 'warlike Britonesse' from Spenser's *Faerie Queene*. Spenser presented Britomart as the protector of the Castle Joyeous against the unchaste Malecasta and the defeater of

73 *Britomart and Glauce Meet Merlin* by William Kent, pen, ink and wash, c. 1747, sketch for a plate in Edmund Spenser, *The Faerie Queene*, 1751. Victoria and Albert Museum, London

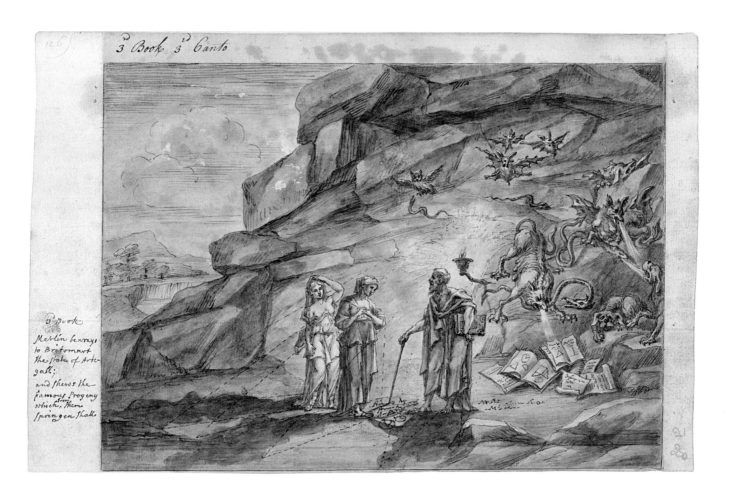

Radigund, the Amazonian ruler who questioned the right of women to govern. In this context, the little old woman should be identified as Glauce, Britomart's nurse. The last figure in the group was consistently identified as Elizabeth of York.

Mrs Salmon modelled the Queen's waxworks after people working in Caroline's household. The figure of Merlin was based on Mr Ernest, First Page to Frederick, Prince of Wales, and Merlin's secretary on Mr Kemp, who was one of Prince William Augustus's Grenadiers. Margaret Purcell, Caroline's Laundress, who accompanied her on early morning jaunts to Richmond Lodge, sat for the figure of Elizabeth of York, and a Miss Paget for Queen Elizabeth I. Mrs Poyntz, who was possibly a relative of one of Caroline's Maids of Honour, and a tradesman's wife from Richmond were models for the other two figures.

This was a project born of Caroline's passion for genealogical research, dating from when she was a young bride in Hanover. In this she had been encouraged first by Sophie Charlotte and later by the Electress Sophia, who had both fought their own battles to boost the fortunes of their dynasties by championing the distinction of their pedigree. Caroline would have been well aware that George I was regarded as 'foreign' and 'strange' by his new subjects. Even if he had been careful to make a distinction between the teams of advisors appointed to look after home policy and Hanoverian affairs, it appeared to many that he had surrounded himself with German friends, and this created tension within the Court in London. George II and Caroline early took practical measures to counteract such feelings: both had learnt English and they employed an exclusively English court. The Merlin's Cave waxworks, which celebrated the English royal line and at the same time explored its ancient connection to the House of Hanover, was intended as a contribution to the confirmation of the legitimacy of Hanoverian rule.

Sarah, Duchess of Marlborough, was one visitor who identified the text which brought all these strands together, writing to her granddaughter, Diana Spencer: 'I do not read romances but they say it is taken out of Spenser's *Fairy Queen*'.[29] The *Faerie Queene*, an epic allegorical poem written by Edmund Spenser in praise of Elizabeth I, makes connections between the Tudor dynasty and the legendary King Arthur and Merlin, his mentor. It was originally been published in two instalments, the first in 1590, the second in 1596.[30] Spenser celebrated Elizabeth as Gloriana, the female ruler supreme, as Belphoebe, the virgin queen, and as Britomart, the queen warrior. As inspiration this met many of Caroline's objectives. She had read the work, in an edition made by Hughes in 1715 (fig. 73).

Caroline's appropriation of Elizabeth as a model may have had political as well as personal resonance. She was, of course, a woman, and a monarch, which was the most obvious link, but in addition there were strands connecting to the early eighteenth-century political situation. Elizabeth was a champion of Protestantism and a star of the golden Tudor dynasty. The Tudors were the epitome of Englishness, occupying a solid, respectable and well-known part of the national historical narrative. They were romantic and just a little exotic – the celebration of Tudorism has been explored by recent historians.[31] Caroline, who had surrounded herself with a large collection of books about Elizabeth, may have become aware that she was one of a number of royal figures from history set up as heroes by Whig supporters of the Hanoverians.[32] Ironically, she was also revered by those disenchanted by George II's administration. As Caroline installed her waxwork in 1735, Lord Cobham, who in 1733 had disagreed with Sir Robert Walpole and left the mainstream Whig party, moved the bust of Elizabeth I by John Michael Rysbrack that he had

commissioned earlier, in 1730, from its first home, the Temple of Fame, in his garden at Stowe to a new monument, the Temple of British Worthies. This was intended as a pointed critique on the current political situation. Eventually in its niches there would be sixteen busts: the eight figures 'of action' were balanced by about 1737 with eight new busts by Peter Scheemakers of men whose ideas or actions could be read as opposing the policies of George II and Walpole. When Cobham lined up his 'Boy Patriots', a group of young Whig politicians, as well as several of his young nephews and nieces, it was to support Prince Frederick and not the King. It is not very likely that Caroline was aware that her Elizabethan iconography was being read so differently. She never visited Stowe – by the mid-1730s this would have been a political act too far. However, William Kent worked on both projects, and is very likely to have mentioned the work in a discussion at the palace. If that had been the case, it is entirely possible Caroline would have been content that she had appropriated the image of Elizabeth I to serve her ends, too (fig. 74).[33]

While the figure of Elizabeth I brought its own set of messages to Caroline's scheme, the group contained a waxwork of Elizabeth of York as well. It had been the marriage of Elizabeth, the daughter of King Edward IV, with Henry VII which had provided the link between the old and new houses after the Wars of the Roses, and paved the way for political stability in England in the early sixteenth century. Caroline may have delighted in the knowledge that both Elizabeth of York and Elizabeth I had resided at Richmond Palace, providing a local connection.[34]

The Welsh ancestry of the Tudor family may also have been an aspect which interested Caroline. As Princess of Wales, she had taken an interest in Welsh politics after being approached by the Society of Antient Britons, an association of Welshmen resident in London. It was founded in 1715, on 1st March, her birthday, and a copy of its statutes was lodged in her library. Not only was she concerned to honour the nation which provided her with her title, but Wales was closely linked to the Tudor history she held so dear. Henry VII, the first Tudor king, who wrested the throne from Richard III, head of the House of York, at the Battle of Bosworth in 1485, was Welsh born. His grandfather Owen Tudor, a nobleman from Anglesey, traced his family history back to Cadwalader, the seventh-century British king whose story had been included in Geoffrey of Monmouth's twelfth-century text *Historia Regum Britanniae*. The *Historia* also claimed King Arthur as part of the royal succession, and Henry VII had embraced this. An Arthurian connection would guarantee dynastic respectability, as well as a positive gloss on the regime change – Geoffrey of Monmouth had prophesied that a descendant of Cadwalader would sit on the English throne. Henry contrived that his first son, who was called Arthur, was born in Winchester, which Thomas Malory in *Morte d'Arthur* had identified as Camelot.

While the Arthurian imagery in the Merlin's Cave tableau was all suitably Gothic and picturesque enough to appeal to Caroline's and William Kent's taste, the legend of King Arthur would have been very familiar to her from her German upbringing. Since the early fourteenth century, when he had been one of the Nine Worthies chosen by Jacques de Longuyon, his image had been included in manuscript illustrations, tapestries and paintings, and provided inspiration for plays, pageants and romances throughout northern Europe.[35] He stood as one of the three Christian heroes and represented a Renaissance ideal of princeliness which was certainly appreciated in the Hanoverian duchy of

Brunswick-Lüneburg. In the early fifteenth century he featured in stained glass decorating the town hall in Lüneburg, one of the ducal capital cities.

Caroline recognised that the Arthurian legend had taken on its own political significance in contemporary England. After the accession of William and Mary in 1689, John Dryden had revived his opera *King Arthur*, originally written to mark the restoration of the monarchy in 1660, and this was followed by the publications of Sir Richard Blackmore's epic poems 'Prince Arthur' and 'King Arthur' in the 1690s. All celebrated the prophecy of Merlin that a new Arthur – for Dryden and Blackmore this was King William – would emerge to unite 'Britons, Saxons, as one people, with one common tongue, one common faith . . . in perpetual peace.' This was a chant that would be taken up by Whig supporters of the Hanoverian succession.[36]

And for members of the House of Hanover there was an additional association which was perhaps the most important of all those underpinning the setting up of Merlin's Cave. This had at its heart the claim that the House of Hanover had connections with the ancient English kings. In 1676 the Electress Sophia had employed Leibniz to undertake genealogical research to establish the validity of the long-held belief that the House of Hanover had its roots in the House of d'Este in northern Italy.[37] In the eleventh century this had split into two branches: the elder was known as the House of Welf-Este, usually referred to as simply the House of Guelph, or Welf, the younger as the House of Fulc-Este. The House of Guelph went on to produce the dukes of Bavaria, the dukes of Saxony and, significantly, the dukes of Brunswick-Lüneburg. However for Sophia, George I, and for George II and

74 *Queen Elizabeth I* by John Michael Rysbrack, stone, 1729–30. Temple of British Worthies, Stowe

Caroline, it was the discovery that Henry the Lion from the House of Guelph had in 1168 married Matilda, the daughter of the English king Henry II and Eleanor of Aquitaine, that was all-important.[38] Thus, Caroline's Hanoverian ancestors could claim English royal descent too. Some of the visitors to Caroline's waxworks recorded that the female figure with the plumed helmet was Bradamante, the heroine from Ariosto's *Orlando Furioso*, in which Merlin's prophecies are of glory for the House of Este.

Merlin's Cave was almost universally criticised by its visitors. Even if its neo-Spenserianism and neo-Elizabethanism was part of contemporary cultural and political currency, and the works of Ariosto had served as the inspiration for new, fashionable Italian operas in London, the messages at the heart of Caroline's project were muddled, and they were expressed in an unconventional way.[39] The satirical journal *The Craftsman*, linked to Lord Cobham's embryonic Patriot party, was quick to leap to the attack. They described the building dismissively as 'like an *old Haystack, thatch'd over*'.[40] Even as a theatrical experience it was judged to have failed. The Duchess of Marlborough wrote to her granddaughter in August 1735: 'it is too long to give you an account of a most curious comical description, which I had yesterday of what is called Merlin's Cave at Richmond, which they say is ten thousand times more ridiculous than what was done for the philosophers. Merlin, it seems, was a Welsh conjuror . . . and there are a great many strange puppets dressed up in it.'[41]

Caroline's choice of characters was far too esoteric for most visitors to untangle, and there was a plethora of explanations concerning their identity and the message that Caroline sought to convey. For some the message was party political. *The Craftsman*, in 1735, suggested that Merlin, the man of magic, 'begotten by a Daemon call'd Incubus upon the Body of an English Lady. . .' and derided as 'a Man or Devil', should be equated with Sir Robert Walpole, Caroline's wily political ally.[42] Commentators were now scornful that Caroline had chosen to celebrate King Arthur and Merlin, the heroes of myth and legend, in a monument to the antiquity and continuity of the British royal line; the Saxon King Alfred, with his undisputed historical pedigree, had become the royal hero of choice for a later generation of Whigs, taking his place, for example, in the pantheon at Stowe. They laughed at the equation made between Merlin and Duncan Campbell, whose reputation, after all, was for foretelling the names of future bridegrooms. Even George II heartily disapproved of the project. He called it 'childish silly stuff' and, on being informed that *The Craftsman* had abused it, said: 'it is the first time I ever knew the scoundrel in the right'.[43]

The gap between Caroline's European education and her English experience was exposed. In Europe there was a long and illustrious tradition of artists working in the wax medium and also constructing life-size tableaux. Tableaux can be found from the fifteenth century as a feature of the southern German crib tradition, and in terracotta, painted wood, plaster and wax in the Piedmontese and Marchese 'Holy Mountain' sanctuaries at Varello, Oropa, Orta and Varese (fig. 75). It was not unusual for members of European royal houses to commission works from artists in wax. Gilles Ménage in 1675 described his visit to the waxwork collection of the dukes of Tuscany in Florence which contained portraits of Cosimo III de' Medici, Grand Duke of Tuscany, with members of his family. In Copenhagen, Sophie Amalie, Queen of Denmark and Norway and the mother of Prince George, the husband of Queen Anne, included half-length wax figures of family members in her family portrait gallery from about 1670. Peter the Great, when visiting the Court of Louis XV at Versailles in 1717, noticed the wax portraits of members of the French royal

family which had been made in 1668 by Antoine Benoist, '*Peintre du Roi et son unique sculpteur en cire coloriée*'. He was determined to have his own likeness made and in 1719 invited Carlo Bartolomeo Rastrelli to St Petersburg from Paris to oversee the making of a full-length wax figure, which would eventually be dressed in clothes from his personal wardrobe.[44] The custom drifted into society, and it was not unusual in northern Europe when commissioning a funerary monument to elect for an image made in wax. The properties of wax, when worked and coloured by a skilled practitioner, allowed the creation of the appearance and texture of flesh, which meant that it was prized for the possibilities it provided for dramatic and theatrical representation. The wax portraits of members of the Danish royal family in Copenhagen have an almost photographic quality. Caroline gained direct experience of the medium in 1705 when, during her sojourn at the Court in Berlin, the life-size wax portrait of the Elector Frederick III, dressed in his own clothes and sitting in an armchair – commissioned sometime before 1699 – was moved into the newly arranged *Kunstkammer* in the Berlin palace (figs 76 and 77).[45]

In England, by contrast, waxworks were regarded as for popular entertainment: they were an established attraction at fairgrounds such as the Bartholomew Fair.[46] In a royal context, they were regarded as curious and inappropriate. Even the 'Ragged Regiment', which had included the surviving effigies traditionally carried as part of a royal funeral procession, had achieved status as a money-making crowd-pleaser at Westminster Abbey. These slightly vulgar connotations did not deter Caroline, and it was soon evident to her circle that she delighted in such curiosities. She continued to seek out waxwork exhibitions after her arrival in London; Miss Dyves, Maid of Honour to Princess Amelia, wrote to her aunt, Charlotte Clayton (later Lady Sundon), Caroline's Woman of the Bedchamber, in August 1725, reporting that 'the Prince of Wales and everyone but myself went last Friday

75 Tableau showing the Fall of Adam and Eve with painted terracotta statues by Jean de Wespin, called '*Il Tabacchetti*', 1595–99. Chapel on the pilgrim route up to the Holy Mountain at Varallo, Piedmont

76 *The Elector Frederick III,* German, waxwork, pre 1699. Hohenzollern Museum, Monbijou Palace, Berlin

77 *Queen Sophie Amalie of Denmark* by Antoine Benoist, French, waxwork, 1670. The Royal Danish Collections, Rosenborg Castle, Copenhagen

to Bartholomew Fair... and came home about five in the morning.'[47] In May 1733 Lord Wainwright informed Lady Sundon that he was sending 'the head of Henry the Seventh put up carefully in a box directed to you'. Wainwright had deduced that this head, made of wood, had once been part of the funerary effigy of Henry VII, from the Ragged Regiment, and that it would appeal to Caroline's taste.[48]

There was no obvious overarching intellectual story-line to link the sculptural programmes of Merlin's Cave and the Hermitage, and visitors who reported energetically on all the individual components of Caroline's garden did not make comparisons between the various elements. Much more sophisticated narratives had been built into Lord Cobham's garden at Stowe, Burlington's work at Chiswick and Pope's garden at Twickenham, which were established at about this time and were open to the same fashionable observers.[49]

In an attempt to address this, and cut through the confusion concerning the interpretation of her waxwork tableau, Caroline appointed the thresher-poet Stephen Duck as hermit-interpreter in 1735. Stephen Duck was an agricultural labourer from Charlton, near Pewsey in Wiltshire, who, as *The Gentleman's Magazine* reported in June 1736, had 'no other Teaching, than what enabled him to read and write *English*, and a little Share of Arithmetic' (fig. 78). However, his natural talent as a poet came to the notice of the local gentry, including the Earl of Tankerville, and Dr Alured Clarke, Caroline's Clerk of the Chamber. After the publication in 1730 of 'The Thresher's Labour', a poem which described the world of the farm labourer, and later the 'The Shunammite', which explored Duck's religious views, Clarke brought him to London and, through the auspices of his patron, Lady Sundon, he was introduced to Caroline. She was already aware of his work after Lord Tankerville had copies of the poems sent to Windsor, and they were read to her by Lord Macclesfield. She was greatly impressed, sent the verses on to Alexander Pope and in 1733 appointed Duck a Yeoman of the Guard and Keeper of Duck Island in St James's Park. In anticipation of

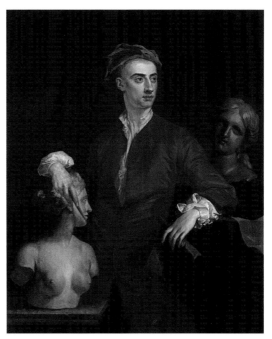

his subsequent appointment to Merlin's Cave, Dr Clarke and Lady Sundon put together a carefully selected library of books for Duck's inspiration and education.[50] Sarah Big, his new wife, would join him as the necessary woman, or cleaning lady.[51]

In the wake of so much criticism Caroline's last sculpture commission, another series of busts, followed a much more conventional pattern. It took the form of a 'line of kings' selected by Caroline for their particular contribution to the construct of British liberty and identity. The history of each of the subjects was well established. The commission, which was placed with John Michael Rysbrack, is first mentioned in June 1735 in *Old Whig, or The Consistent Protestant*: 'Her Majesty has ordered Mr Risbrack to make the Busto's in Marble of all the Kings of *England* from *William the Conquerer*, in order to be placed in her New Building in the Gardens at *Richmond*.' This suggests that the busts may originally have been intended as embellishment for the bookcases in the recently completed Merlin's Cave.[52] When Vertue visited Rysbrack's studio in Caroline's company and saw the busts in production a few months later, he noted simply that they were destined for 'some palace'. Rysbrack's project was, however, never completed and, after Caroline's death in November 1737, the terracotta modellos were returned to George II, at his request, and were later installed in the new library which William Kent had designed for Caroline at St James's Palace. Kent's first plan was to place them in niches at the end of each bookcase but this was abandoned, and in the final scheme they were arranged on brackets located high on the walls between each of the arched recesses.[53] By 1742 marble busts of George II and Queen Caroline, copies of the terracotta versions completed by Rysbrack in 1738 and 1739 respectively, were installed over the chimneypieces, to finish the scheme.[54]

Caroline probably encountered Rysbrack for the first time in about 1723 when he was working on a fine carved marble relief of the Roman Marriage, for an overmantel in the Cupola Room at Kensington Palace. A native of Antwerp, he had moved to London in

about 1720 with introductions both to James Gibbs and to the Duke of Marlborough. He quickly built up a substantial business carving portrait busts. George Vertue noted that sixty had been completed before 1732 and that by then George II had sat to him twice.

Perhaps it was because Caroline felt a loyalty to the Whiggish Lord Burlington that she had not used Rysbrack, the protégé of the Tory James Gibbs, for the sculpture she commissioned for the Hermitage. Burlington had brought Guelphi from Rome and the sculptor remained under his protection until 1734, when he returned home.[55] After Guelphi's departure it seems she was convinced by Kent that Rysbrack was much the most appropriate successor. Kent and Rysbrack had worked together not only on the decoration of the great rooms at Kensington but also since 1729 for Lord Cobham at Stowe. Caroline was still careful to check Rysbrack's credentials and, shortly before placing her first order, she visited his studio to view his equestrian statue of William III, later set up in Queen's Square in Bristol, and noticed there busts 'of Kings and Queens lately done by him'.[56]

The idea of decorating a library with sculpture had its origins in classical antiquity: Pliny the Elder stated in the first century: 'likenesses are set up in libraries in honour of those whose immortal spirits speak to us in these places'. The practice continued throughout the Middle Ages and by the sixteenth century humanist scholars such as Justus Lipsius, in his discussion on the classification of books, included a debate entirely devoted to the role of sculpture in a library.[57] He recommended, as later did the great librarians Gabriel Naudé and Claude Clement, that the worthies chosen should be selected as inspiration to the reader.[58]

The canon of subjects which began to emerge included classical authors such as Plato, Hippocrates, Homer, Aristotle, Pindar and Cicero, the fathers of the Church such as St Jerome and St Augustine, and St Gregory the Great, to which could be added more contemporary worthies. By the early eighteenth century the university libraries of Trinity College, Dublin, and Trinity College, Cambridge, and the Codrington Library in Oxford, were embellished with sculpted portraits, including those of Newton and Locke, as each institution sought to lay claim to important scientific discoveries and demonstrate its engagement with, and encouragement of, contemporary scientific and theological debate.

Amongst Caroline's circle there were several people who had constructed libraries and overseen their decoration, and this may have led to discussion at the royal palaces about the choice of subject for a sculptural series. Sir Andrew Fountaine had compiled a collection of painted worthies for the library in his house at Narford. It served to celebrate giants within the spheres of art, architecture and literature, as well as on the field of battle, and included images of Inigo Jones, Palladio, Rubens, Pope, Ben Jonson, Shakespeare, Gustavus Adolphus of Sweden, Prince Rupert, Dr Edward Pococke, Cardinal Mazarin and Sir Robert Cotton. Pope focussed on literary heroes, recording: 'I keep the pictures of Dryden, Milton, Shakespeare &c. in my chamber, round about me, that the constant remembrance of 'em may keep me always humble.'[59] One of Kent's designs for Caroline suggests there was an early plan to decorate the library with busts of ancient and contemporary writers and philosophers including Virgil, Shakespeare, Milton and Locke, which would be balanced across the room by those of Butler, Boyle, Spenser and Pope.[60] However for Caroline it was ultimately the patriotic agenda which won the day.

Only three busts survive from Caroline's commission. They are of Queen Elizabeth I (fig. 87), Edward, the Black Prince (fig. 81), and King Edward VI (fig. 80). The remainder

of the set was irretrievably damaged when the shelf on which they were stored collapsed in 1906; fortunately, photographs taken in the late nineteenth century provide information about the lost pieces. These indicate that Rysbrack's original order had included busts of King Edward III and Queen Philippa of Hainault, King Henry V (fig. 85) and his wife Catherine of Valois (fig. 86), King Henry VII and Elizabeth of York, King Alfred and Henry, Prince of Wales. If they were made for Caroline's new library, a building constructed with an eye to symmetry, it is surprising not to find that there were an even number. It is entirely possible that the set was once longer and that there were other, early losses. Alternatively, it is possible that Rysbrack had not started work on all the subjects when the commission was cancelled.

The roll-call reveals that Caroline, rather than choosing to make this a display of literary lions, decided instead to make a hall of ancestors, a feature of many European palaces. Her upbringing would have left her well aware of this tradition; it was through such a collection that the history of a family was revealed. This could be achieved by commissioning a series of sculptures, or by bringing together a collection of painted portraits. In some notable instances, as was the case in the sixteenth century with the Archduke Ferdinand of the Tyrol at Ambras Castle, a ruler would choose to do both. Caroline's intention was the same but, in contrast to many of her European counterparts, her choice of subjects for the series of busts was selective rather than strictly chronological.

Edward III and Henry V had established places in the Valhalla of royal British worthies and heroes. Both monarchs were noted for their valour, defending the honour and liberties of the nation at Crécy and Agincourt respectively. The Black Prince, the valiant soldier-hero who won his spurs at Crécy, was another obvious choice. They were subjects which had

80 *Edward VI* by John Michael Rysbrack, terracotta, 1737–38. The Royal Collection

81 *Edward, Duke of Cornwall, the Black Prince* by John Michael Rysbrack, terracotta, 1737–38. The Royal Collection

already been singled out for veneration by Caroline's predecessors, a fact which is likely to have reinforced her choices. In 1683 John Evelyn, visiting the new work undertaken for Charles II at Windsor Castle, reported: 'That which was new at Windsor since I was last there and was surprising to me was the incomparable fresco painting in St George's Hall, representing the legend of St George and the Triumph of the Black Prince, and his reception of Edward III. . . Verrio's work is admirable'.[61] Prince and king had both come to be particularly associated with the Hanoverian monarchy. William Talbot, Bishop of Oxford, had written to Lady Sundon in 1714: 'I see in the King [George I] and His Royal Highness [George Augustus] our glorious Edward and the Black Prince. . .'[62] Even though there had been an Anglo-French rapprochement since 1713, given the state of hostility which had existed persistently since 1689, making an analogy between members of the current royal family and their predecessors who had trounced the French had a special significance.

Caroline's decision to include King Alfred also fitted with this construct (fig. 82). Since her arrival in London she would have become aware of the Whig party's promotion of King Alfred as the perfect image of the medieval ruler, portrayed resplendent in his ermine-trimmed robes, famed for his wisdom and sense of justice. His role in the unification of the ancient kingdoms of Britain, described by Bede in *Historia Eccesiastica Gentis Anglorum* and Asser in his *Life of King Alfred* – both published in 1722 in new editions by John Smith and Francis Wise respectively – was in line with a growing awareness of a 'British' national identity which followed the Act of Union with Scotland in 1707.[63] The new order would gain increased legitimacy in the public consciousness by the association with this venerable predecessor – the quintessentially 'British' ruler, the embodiment of the nation's political identity, the defender of its liberties and the father of a united people.[64] Sir John Spelman's *Life of Alfred the Great*, published in 1709, as well as Sir Richard Blackmore's most recent royal tribute, *Alfred: An Heroic Poem in Twelve Books*, published in 1723, joined books on

82 *King Alfred* by John Michael Rysbrack, terracotta, 1737–38. Photograph of 1875, pasted into *Windsor Castle Inventory of Busts*, 1875. The Royal Collection

83 *King Alfred* by Peter Scheemakers, stone, c. 1737. Temple of British Worthies, Stowe

84 George Vertue, *Alfred the Great*, engraving, 1733. The Royal Collection

AELFREDUS MAGNUS.

contemporary archaeology in Caroline's library, making an interesting complement to her Arthurian collection.

After 1728 King Alfred was mainly compared with, and used to endorse, the character of Frederick, Prince of Wales. This must have made Caroline all the more anxious to draw the Saxon king into her own schemes as the two became passionate rivals in the sphere of artistic patronage. It is impossible to say whether Rysbrack started work on his bust of Alfred for Caroline before Frederick ordered his, also in 1736, for the Octagon Temple, a pavilion in the garden at Carlton House which he had begun to furnish two years earlier. He also commissioned a bust of the Black Prince, another of the subjects already selected by his mother. It comes as no surprise to find a bust of King Alfred occupying one of the niches in the Whig rebel Lord Cobham's Temple of British Worthies at Stowe. But in this instance Caroline without doubt won the race – Cobham's commission to Peter Scheemakers was not put in train until about 1737 (fig. 83).[65]

It is not surprising that Caroline's pantheon included a bust of Elizabeth I. As has been established, she had an important place within the list of English royal worthies; she was indisputably the most important female subject, celebrated for her courage, her political astuteness and her championing of the Protestant cause. Rysbrack's bust for Caroline is comparable to that made for Lord Cobham in about 1730, and is very similar to the version made by him for Mary Edwards which Hogarth later painted. The model seems to have been the effigy of Elizabeth I by Maximilian Colte in Westminster Abbey, and he had probably also seen the early seventeenth-century wax portrait which was on display as part of the Ragged Regiment there. It is possible that through his patron James Gibbs he could have had access to the great Ditchley portrait of Queen Elizabeth too.

85 *Henry V* by John Michael Rysbrack, terracotta, 1737–38. Photograph of 1875, pasted into *Windsor Castle Inventory of Busts*, 1875. The Royal Collection

86 *Catherine of Valois* by John Michael Rysbrack, terracotta, 1737–38. Photograph of 1875, pasted into *Windsor Castle Inventory of Busts*, 1875. The Royal Collection

Caroline may have included Henry, Prince of Wales, in the sequence as her ideal as promoter and encourager of the arts and sciences. This was a role often apportioned to the queen consort which, like him, she took very seriously. Prince Henry was a far more politically acceptable choice than King Charles I, who made such an important contribution to the royal collections of art. There are annotations in the inventories of her *Wunderkammer* and 'Gallery of the English', the collection of royal portraits she amassed, which suggest she was aware of Prince Henry's particular contribution.[66] He had been an early patron of Inigo Jones which also appealed to her.

The inclusion of women – Philippa the wife of Edward III, and Catherine, the wife of Henry V – is more unusual. One could argue that Caroline simply wished the busts of her male heroes to be balanced by those of their spouses, but it is interesting to discover in histories prepared in the early eighteenth century that there were stories of the exploits of both women which may have particularly captured her imagination. Philippa was said to have raised an army of twelve thousand men on her own initiative, while her husband was in France, in order to defend England against David, King of Scotland. She had not only ventured to approach the enemy but rode with the troops, exhorting each man to do his duty. There was a second connection: Queen Philippa was the founder of Queen's College in Oxford of which Caroline became patron in 1733.[67] It may have been her interest in Welsh history which caused Caroline to give Catherine of Valois a place in the series (fig. 86). Following the death of Henry V, Catherine had married Owen Tudor, thereby establishing the first Welsh link with the ruling house of England.[68] Philippa of Hainault and Catherine of Valois had both proved to be effective and respected queen consorts, and Caroline may have included their images in the scheme to demonstrate how important this role had always been in the dynastic succession.[69]

The models used by Rysbrack for the majority of the sculptures for Caroline were taken from engravings made by George Vertue and therefore provided indirectly by Caroline herself. As information began to circulate about her plans to re-order and add to the royal collection of paintings, and to draw together images of her royal predecessors, she found that several artists, including Vertue, applied to her for permission to use them as a resource. Vertue became a regular visitor to the royal homes, making a special study of 'pictures [which] are most useful for me to work after'. He was delighted to locate portraits of every monarch from Henry IV to Charles II as well as 'a Duke of Gloucester, and Lord Guildford.'[70]

The results of Vertue's research was gathered together and published in two sets of engravings which were used to illustrate Salmon's *The Chronological Historian*, and Paul de Rapin's *History of England*, published first in Paris in 1733, and later, in 1736, in London by Nicholas Tindal in *The Heads of the Kings of England, Proper for Mr Rapin's History*. It is very likely that the folio volume *Heads of the Kings and Queens of England*, which is listed amongst Caroline's books, is a copy of Vertue's work; Lord Egmont had sent her a copy through the good auspices of Lord Grantham.[71] The engraving of Edward III has a note recording that it was based on an 'ancient painting' at Windsor Castle, while Edward IV, Richard III and King Alfred were all described as based on paintings hanging in Kensington Palace. The sources for Henry VII and Elizabeth of York were given more ambiguously as from an 'original in oil colours in the royal collection' (figs 84, 88 and 89).

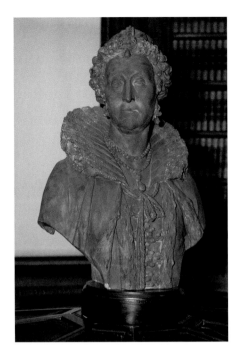

Caroline died before the fitting out of her library had been completed. It was her husband who retrieved the set of portrait busts from Rysbrack's studio and had them installed on their brackets as a tribute to her. Kent's grand room was never used in the way intended and the sculptural programme, which said so much about Caroline's dynastic politics and her approach to her role, and which almost certainly would have received popular acclaim, remained hidden from public view. It is her estranged son Frederick who is now associated with the imagery of King Alfred and the Black Prince, and there are few who know and appreciate that these had been the English royal heroes whom Caroline had researched so carefully for her own celebration of the English royal pedigree.

87 *Queen Elizabeth I* by John Michael Rysbrack, terracotta, 1737–38. The Royal Collection

88 *Edward IV 'from an antient Painting in the The Royal Collection now at Kensington Palace'* by George Vertue, engraving, 1735. National Portrait Gallery

89 *Richard III, 'from an antient original painting on board at Kensington Palace'* by George Vertue, engraving, 1735. National Portrait Gallery

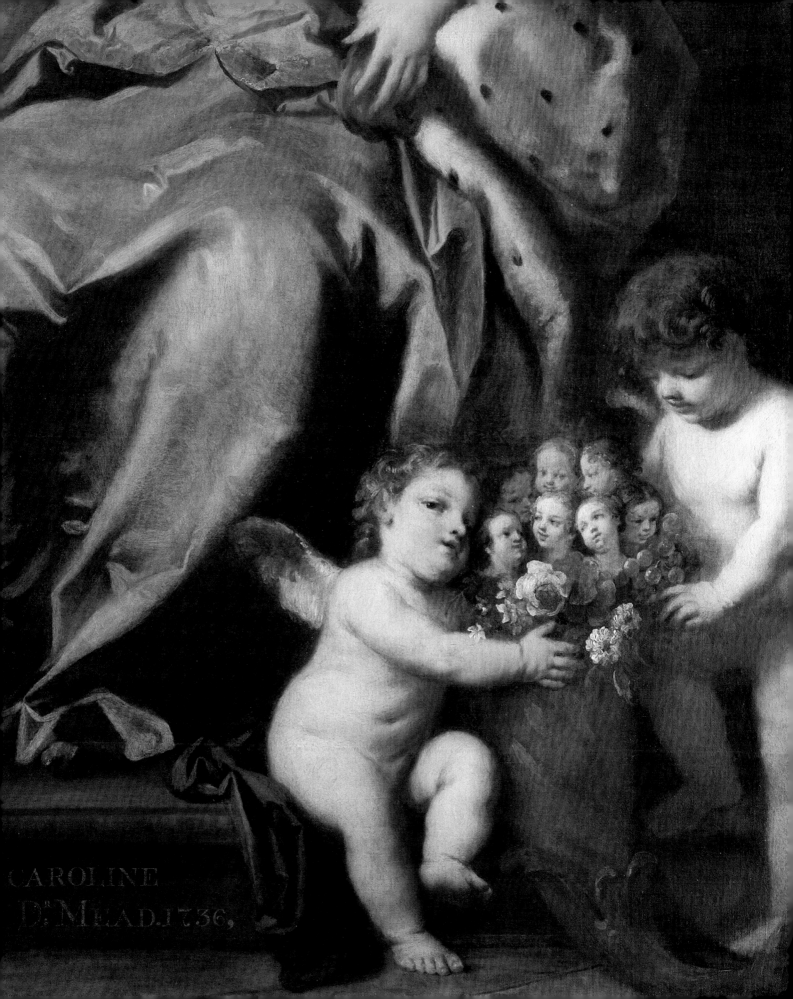

CAROLINE
D. MEAD 1736,

4

CAROLINE

and the Artists

In 1727, on the accession of George II, Caroline had her first real opportunity not only to explore the royal homes but also to evaluate the royal collection of art. There was much to delight her – and a few important surprises. The collection was another asset she would use to promote the new dynasty and celebrate its ancient royal pedigree. Importantly, it brought for her a lively engagement at first with the artists she drew into her salon and later with the wider artistic community in London.

Caroline, who was fiercely protective of the Hanoverian right to the throne, failed to locate a set of portraits to represent the line of English royal succession which she could display prominently. Her upbringing would have left her particularly aware of the tradition in Europe of acquiring portraits to illustrate the dignity and antiquity of the rulers' families. The electors of Saxony maintained an extensive *Kunstkammer* in Dresden and, although their collection of portraits never reached the encyclopaedic scale of that of Archduke Ferdinand of the Tyrol at Ambras Castle, it was still more than respectable.[1] When Caroline moved to Berlin in 1696 she had access to the important picture collection established by the Electress Sophie Charlotte, and the move to Herrenhausen in Hanover on her marriage enabled her to see the collection amassed and maintained by the Electress Sophia.

Opposite
Caroline of Ansbach by Jacopo Amigoni, oil on canvas, 1735. National Portrait Gallery (detail of fig. 118)

A List of The Books of Drawings and Prints in
The Buroe in His Majestys Great Closet at Kensington

no. 1. Drawings by Polidore, Julio Romano, Raphaell, Zuccaro,
 Daniell de Voltera, P. Ligorio, Jerom, Anniball Carracio,
 Taddio, L. Cangiagio, J. Pantorne, Penis, Jognon di Vincenza
 Barth Piperoto, J. Salviati, P. Farrinato, B. Bandinelli,
no: 2. By Defferent hands,
no: 3. x by Hans Holben, these fram'd & hang at Richmond
no: 4. by Paolo Farrinato,
no: 5.+ Prints by Hollar, Deliver'd to her Ma:ty Aug:t 1728 & by her
no: 6. Drawings by Leonardi de Vinci,
no: 7. by the Best hands,
no: 8. Prince Charle's Book with a few Drawings,
no: 9. Drawings by Julio Romano, M. Angelo, Raphaell,
no: 10. by Polydor, P. Veronese, Guido Rene, Titian,
no: 11. by Defferent hands,
no: 12 Prints of the Revelations of S.t Jhon by Albert Durer,
no: 13. Drawings by Leonardi di Vinci,
no: 14. A Book of Mathamaticall papers,
no: 15.x A Book with some Indian Pictures,
no: 16. A Cover with one Drawing by Cherubim Alberti,
no: 17. Drawings by Severall hands,
no: 18. by Severall hands,
no: 19x A Litle Book of Heads Drawn on Vellum,
no: 20. Another of Defferent Figures,
no: 21x Another by Parmesano,
no: 22. Another by the same hand,
no: 23 Another by the same hand,
 Seven Drawings Rolled together, of the Cartoons after Raphael
 a Drawing in a frame and Glass
 x five heads in Black frames unfinish'd by Cooper
 A tin Box with A Drawing the Triumphs of Trajan

90 'A list of the books of drawings and prints in the buroe in His Majesty's Closet at Kensington. Those marked with a cross were delivered for Her Majesty's use in ye year 1728.' British Library

Her half-sister Dorothea Friederike, who had married the heir to the obscure German state of Hanau-Lichtenberg, had a significant collection of family portraits, too, which was in her 'Little Cabinet' at the time of her death in 1731.[2]

In 1728 Caroline made a discovery which would provide a remedy for the situation. Tucked away in Kensington Palace she found a number of portfolios and volumes containing works of art on paper. George Vertue recorded the occasion: 'lately discovered in a bureau at Kinsington, which had not been opened in many years, many prints, drawings, medals of silver and brass etc; some drawings of Italian masters painted in body, some designs of Holben and one book of heads said to be King Henry VIII his Queens and Court etc, some with names, some without.'[3] The list that was immediately made of the collection indicates that the drawings fell into twenty-three groups (fig. 90).[4] Two of these comprised works by Leonardo da Vinci, and there were other groups of work by Raphael, Michelangelo, Giulio Romano and Annibale Carracci. There was a collection of prints by Wenceslaus Hollar and another of printed illustrations to the Revelation of St John by Dürer. Annotations to the first list show that Caroline's first act was to pick out five of the groups of drawings and take them off to Richmond Lodge, her private domain. The collection of prints by Hollar she lent to her friend Lady Burlington, who had recently been appointed Lady of the Bedchamber.

Caroline's greatest excitment was, however, reserved for the group of drawings, the 'designs' by Hans Holbein the Younger mentioned by Vertue. According to Lord Egmont there were sixty-three drawings in the collection, and they fell into two broad groups. The first dated from the period 1526 to 1528. This was during Holbein's first sojourn in London; he travelled from Basel armed with an introduction from Erasmus to his first great English patron, Sir Thomas More. The drawings are in black, white and coloured chalks on plain paper and record Erasmus's London friends and their families, including More, Sir Henry Guildford, William Wakeham, Archbishop of Canterbury, and John Fisher, Bishop of Rochester. The second set of drawings was made during Holbein's second London period, between 1532 and 1543. These are a little smaller in size and, though the artist continued to have links with the members of More's extended literary circle, which included Sir Thomas and Lady Elyot ('The Lady Eliot') and Sir Thomas Wyatt, they are principally of courtiers and their families. The later drawings were made on paper prepared with a pink primer, and the drawing in chalk was supplemented with a little line-work in ink or metal-point (figs 91, 92 and 93).

The lively detailed drawings would have served as Holbein's 'patterns' for his oil paintings. Once a drawing had been made from life, it was probably laid over another paper covered on the reverse with black chalk. Both sheets of paper were then placed on a prepared panel and, when Holbein traced over the main lines of the drawing with a sharp instrument, these would be transferred onto the panel below.[5] For Caroline not only were the drawings beautiful in their own right but each was carefully annotated with the name of the sitter and, though they did not exclusively record royal sitters, they stood as a startling record of the Tudor court Caroline admired so much. They held a particular association with Henry VIII, a quintessentially English royal hero, celebrated in the early eighteenth century as father of the sixteenth-century English Renaissance, a period when England saw a new unity and prosperity. He was another bright star of the Tudor dynasty which the House of Hanover claimed as its inspiration. The discovery of the drawings provided Caroline with a new impetus to research English royal history of this period. Her library would soon contain a great number of books about Tudor political and constitutional history as well as biographies of all the Tudor monarchs.[6] Eventually her research would be manifested in practical form in the waxwork tableau in Merlin's Cave and in Rysbrack's line of kings put together in the years that followed.

Until 1728 the Holbein drawings had been kept together in an album which can be traced in the royal collection back to 1547, when it is identified as the 'booke of paternes for phisioneamyes' in an inventory made at the time of the accession of King Edward VI.[7] When Edward died in 1553, the album was given to Henry FitzAllen, Earl of Arundel, who had served as Edward's Lord Great Chamberlain. Arundel in his turn presented it to his son-in-law Lord Lumley, and it is identified in his inventory of 1590 as 'a great booke of Pictures doone by Haunce Holbyn of certyne Lordes, Ladyes, gentlemen and gentlewomen in King Henry the 8; his tyme, their names subscribed by Sr John Cheke Secretary to King Edward the 6 wch booke was King Edward the 6.' When Lord Lumley died in 1609, the book was given as a gift to Henry, Prince of Wales, and so it was returned to royal hands.

Charles I inherited the Holbein volume on Prince Henry's death in 1612 and chose to present it to the Earl of Pembroke, who served as his Lord Chamberlain between 1627 and

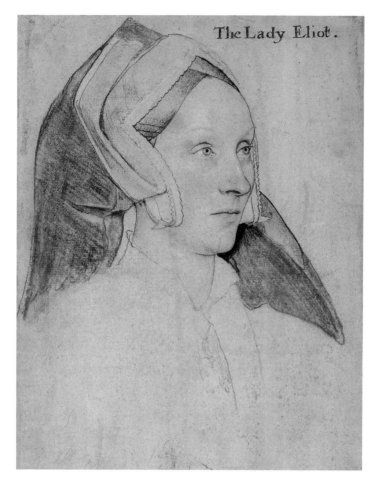

91 *'The Lady Eliot'* by Hans Holbein the Younger, c. 1532–34, black and coloured chalks, white bodycolour and black ink on pink prepared paper. The Royal Collection

92 *Henry Guldeford Knight* by Hans Holbein the Younger, 1527, black, white and coloured chalks with pen and ink. The Royal Collection

93 *'Reskemeer a Cornish Gent'* by Hans Holbein the Younger, c. 1532–33, black and coloured chalks and metalpoint on pink prepared paper. The Royal Collection

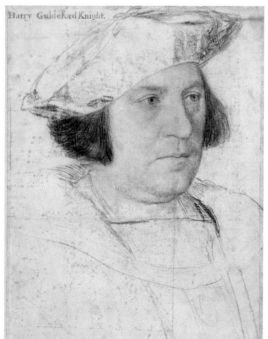

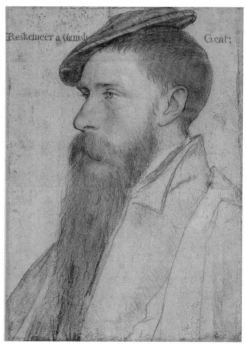

1641, in exchange for a painting by Raphael of St George and the dragon.[8] Lord Pembroke eventually passed the volume to his brother-in-law, Thomas Howard, Earl of Arundel, Earl Marshal to James I. Sometime before 1660 it was back in royal hands as John Evelyn recorded seeing it at Whitehall Palace.[9] For the next few decades it was regarded as a great treasure, to be shown only to the most favoured royal visitors, but after the fire which destroyed Whitehall Palace in 1698 references to it ceased.[10] It is likely that, together with the collections of Italian drawings, it was taken to Kensington for safekeeping and once stored away was forgotten.

After Caroline moved the drawings to Richmond she had them taken from the volume and framed up individually.[11] She was so proud of the collection that she urged her friends, including Lord Egmont, to come to admire this display of images of the Tudor court.[12] However, by 1734, with the building of the Hermitage completed and the construction of Merlin's Cave well underway, Caroline decided they should be moved to Kensington Palace, which she had come to use more regularly. There they would be set at the heart of a new and far more public enterprise, to create what Vertue would later claim was 'the greatest store of portraits of the English': in its own way it was her line of kings and another project to add to the message of Merlin's Cave – the notion of the 'Englishness', or 'Britishness', of the Hanoverians.[13]

The new picture closet was situated in the traditional province of the king, in a room which had earlier been William III's Little Bedchamber, to the west of the State Bedchamber.[14] It had windows looking on to a small internal courtyard and doors providing a link both to the public space of the State Drawing Room and to the intimate province of the King's Closet. Caroline found it simply furnished. The floor was covered with a fine 'French' fitted carpet lined with stout linen.[15] The upholsterer Sarah Gilbert had provided brown Holland spring-loaded sun blinds for the windows.[16] The room was hung with a few paintings: *Lucretia* then attributed to Annibale Carracci, *St Agnes* by Domenico Zampieri, called 'Domenichino', and a half-length portrait of Elizabeth I as a teenager, then attributed to Holbein, now attributed to William Scrots (fig. 96).[17]

By August 1735, as the project neared completion, Lord Egmont went to view the drawings in their new location: 'I saw in the Queen's Closet the famous collection of Holben's heads of eminent persons in Henry 8th reign. They are 63 in number, up to half sheets of paper and seem the sketches made for his portraits in oil.'[18] It is still possible to reconstruct the picture hang in every detail as Vertue, who seized every opportunity to explore the royal collection of art, was granted a warrant in 1743 from the Lord Chamberlain which gave him extended access to the picture closet and permission to 'copy or draw after those heads by Holbein' and to complete 'a scheme to show the nature, magnitude and disposition of them [the pictures] on the four sides of the room.'[19] He spent two or three days a week on his task, compiling *'An Exact and Intire Catalogue not only of those Paintings done by Holbein, but also all other Paintings, Limnings, Paintings small and large with the Carvings in Ivory and Miniatures, Enamels etc. in Frames, Cases etc. in that Closet'*, working from a little office in the palace provided for him by Henry Lowman, the housekeeper.[20] In about 1755 the catalogue was published in George Bickham's *Apelles Britannicus*, the first guidebook to Kensington Palace and Hampton Court Palace.[21] In 1758 it appeared in a collection of royal inventories published by William Bathoe.[22]

Vertue's catalogue indicates that as well as the Holbein drawings in their new black frames, hanging on the east wall in four tiers one above another, the picture closet still contained the painting of Lucretia attributed to Carracci and the half length of Queen Elizabeth I as a girl, both noted in the earlier inventory. To complete the scheme Caroline had selected many works by Holbein, including a painting of the Queen of Sheba and painted portraits of Holbein and his wife, Philip Melanchton and 'Reshemer, gentleman of Cornwall'; his drawing of the latter hung nearby. There were over four hundred other items.[23] Few were over half a metre in either dimension and most were less than twenty centimetres square. The only painting of any size was *The Salutation of the Virgin Mary,* painted on copper, which was hung over one of the doors.

While it was the collection of works by Holbein which dominated the room, there was also a considerable number of miniatures relating to Caroline's Brunswick and Brandenburg ancestry. The miniatures were in two series. The first was painted in about 1595 by an unknown miniature painter working at the Court of Brunswick-Lüneburg and comprised forty-nine miniatures, most of them of William the Younger, Duke of Brunswick-Lüneburg (fig. 97), his family and his most notable ancestors; the second, painted in Germany by an unknown artist at a similar date, comprised fanciful portraits of members of the House of Brunswick-Lüneburg from the thirteenth and fourteenth centuries. The figures were identified by their names, written in a Gothic script indicating that a romantic antiquarian approach had been part of their production. Four enamels, probably of Netherlandish origin and dating from about 1650, of the four daughters of Elizabeth of Bohemia, the Winter Queen – as the eldest daughter of James I, the pivotal figure in the Hanoverian succession – had also been included by Caroline.[24]

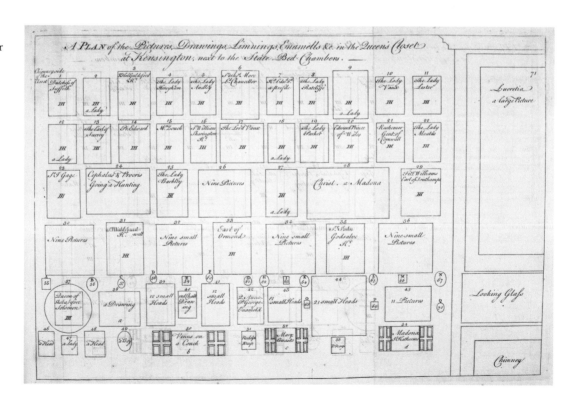

The remainder of the collection was a mixture of the ancient and the modern. There were discrete collections of miniatures by Isaac and Peter Oliver (fig. 101) and Samuel Cooper dating from the late sixteenth and early seventeenth centuries and a small number of Italian Old Masters, including a head of Christ crowned with thorns by Carlo Dolci and a painting of two mice by Raphael.[25] Contemporary artists were represented by an enamel of Queen Anne and Prince George of Denmark dated 1706 by Charles Boit, the Swedish miniature painter (fig. 99), a painting on copper of Frederick William I, King in Prussia, painted in 1733 by Theodore Gardelle from Switzerland, and two flower pieces by the Dutch artist Maria van Oosterwyck painted for William III in the late seventeenth century. There were a few amateur contributions, including a drawing of the Earl of Grantham, the Queen's Chamberlain, by Lady Burlington. Any space remaining on the walls was filled with heads and profiles carved in ivory and stone, a silk embroidery and a landscape in which the figures moved by clockwork.[26] The room was otherwise very simply furnished with a set of lacquer seat furniture which had been presented to Caroline by the British East India Company.

The making of the picture closet must be seen as the culmination of a larger project to reorganise the royal collection of paintings so it could better serve as a visual affirmation of the antiquity of the royal line. After the discovery of the Holbein drawings Caroline took a proprietary interest in all works by the artist, and they would occupy a special place

99 *Queen Anne and Prince George of Denmark* by Charles Boit, enamel, 1706. The Royal Collection

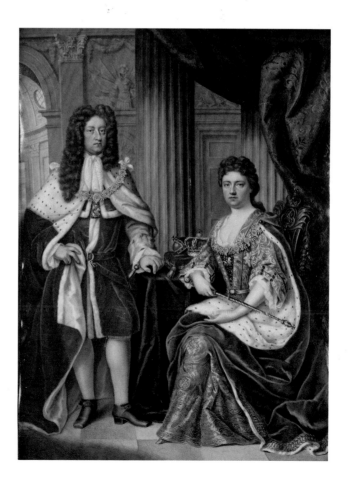

in her new plans. His paintings, as well as paintings by other artists associated with the Tudor dynasty, commissioned or collected by earlier generations of the royal family, were drawn together from all the royal homes and brought to Kensington Palace. The collection was soon boosted by purchases made by Caroline and presents she received from her friends.

When Henry Lowman made an inventory of the contents of Kensington Palace in about 1732, Holbein's portraits of Erasmus, Johann Froben, Erasmus's printer, and a *Noli me Tangere*, which showed Christ and St Mary Magdalene standing before the empty tomb, were already hanging in the State Apartments. In the Queen's private rooms on the floor below, portraits of Henry VII and Henry VIII with their queens had been placed over the chimney-piece in the private bedchamber, and there were eleven portraits on panel of early monarchs hanging in her dressing room next door. In the passage room nearby, a painting of the young Elizabeth I 'in ruff and red habit' hung alongside a 'head' of Queen Mary I 'in ruff and white habit when young', together with a picture described as an 'emblematic picture with Juno, Venus and Pallas with Queen Elizabeth, small life' (fig. 100). Caroline had also made an effort to bring together all the miniatures she could find dating from this same era. Many had survived in the royal collection because they had failed to sell at the public auctions held following the execution of Charles I in 1649 which resulted in the dispersal of most of the royal collection of art.[27]

100 *Elizabeth I and the Three Goddesses* by Hans Eworth, oil on panel, 1569. The Royal Collection

101 *Anne of Denmark* by Isaac Oliver, watercolour on vellum laid on a playing card (ace of clubs), c. 1611–12. The Royal Collection

While the impact of these sales on the royal collection had been dramatic, the process of rebuilding it had started soon after the restoration of the monarchy in May 1660. By the Act of Pardon, Indemnity and Oblivion, a committee was appointed to 'consider and receive information where any of the King's goods, jewels or pictures are; and to advise some course how the same may be restored to his Majesty'. Colonel William Hawley, Colonel William Anselm and Colonel Hercules Lowe were employed to research the whereabouts and to lay hold of any items they could find. The team made some progress; it was not long before Emanual de Critz and John Webb put together an inventory of items already retrieved, including 'twenty eight Kings and Queen's in small'.[28]

Charles II had played a part in rebuilding the collection by commissioning Jacob de Witt to produce a set of one hundred and eleven painted portraits of Scottish kings for the Palace of Holyroodhouse in 1685.[29] By 1697 William III had drawn together a small collection of portraits of members of the Tudor dynasty, among them works attributed to Holbein which he hung in his library, his Great Closet and 'Closet above stairs' at Kensington.[30]

It was this mass of small paintings in the king's closets at Kensington which proved the most fruitful source for Caroline as her picture closet project progressed. It was here that she found the miniatures by Isaac and Peter Oliver as well as the portrait by Jan Gossaert of Christian II of Denmark's children – the nephew and nieces of Anne of Denmark, the consort of James I – which can traced back to inventories made by Abraham van der Doort of the collection of Charles I.[31] Some of the miniatures were still in the black ebony cases with folding doors provided by their early Stuart collectors.

Yet compared with European models the line of kings Caroline was beginning to assemble in London was disorganised and patchy. In particular there was still a distinct shortage of medieval images. To complete the German story the two sets of miniatures were acquired and, so that early English monarchs were represented, she 'begged' Lord Cornwallis to sell her a series of paintings on panel in his collection, according to a story related by the Reverend James Granger, rector of Shiplake in Oxfordshire.[32] Even though the evidence for Granger's claim remains elusive, Lord Cornwallis of Eye was known to Caroline. He had been appointed Groom of the Bedchamber in 1721, before succeeding to the barony in 1722. The family had a long tradition of royal service which extended back to the sixteenth century. Thomas Cornwallis had been Steward of the Household to Prince Edward, later Edward VI, and by 1557 was Comptroller of the Household to Mary I. His son, Sir Charles Cornwallis, was Treasurer in the Household of Henry, Prince of Wales, from 1609. The Royal Collection has a number of paintings on panel which is likely to represent the Cornwallis purchase. The subjects are Edward III (fig. 102), Richard II, Henry IV, Henry V (fig. 103), Henry VI, Edward IV, Elizabeth Woodville and Lady Margaret Beaufort, as well as Henry VII, Elizabeth of York, Henry VIII, Katherine of Aragon, Anne Boleyn, Edward VI and Mary I.

To further fulfil her plan Caroline purchased any Tudor royal portraits she could locate. Her first discovery seems to have been the portrait of Mary I after Anthonis Mor van Dashorst, a version of the portrait made in 1554 which now hangs in the Prado in Madrid. Vertue first noticed it hanging 'at Richmond in the Princess's house' in about 1724 (fig. 104).[33] Sometime before 1729 she acquired a portrait of Henry IV and one of Elizabeth I, this last from 'Mr Coke', who was probably Christopher Cock, the auctioneer.[34]

102 *Edward III*, British
School, oil on panel,
c. 1550–1650. The Royal
Collection

103 *Henry V*, British School,
oil on panel, c. 1550–1600.
The Royal Collection

104 *Mary I* after Anthonis
Mor van Dashorst, oil on
panel, 1554–1650. The Royal
Collection

Triumphant at the discovery of the Holbein drawings, Caroline endeavoured to find further examples of his work with special zeal. She was evidently very successful in this mission and by 1743, when Vertue prepared his inventory of the 'store of portraits of the English', there were ninety-three drawings attributed to this artist; Caroline had already added thirty new examples. Most of these were gifts, as Vertue explained: 'indeed some few were added to their number by the late Queen Caroline, presented to her, who caused them all to be put in frames a little after she was Queen . . .'[35] Robert Clayton, Bishop of Killala in Ireland, was her most generous benefactor. He wrote to his kinswoman Lady Sundon: 'I searched for the remainder of those drawings which you were pleased to present to her Majesty and found that I had six more which I had not put in frames. I shall take care to send them to you by the first safe hand'.[36] On their receipt it seems Caroline felt sufficiently familiar with Holbein's working method to question the attribution of some of the drawings.

More presents followed. It was Sir Robert Walpole who gave Caroline the early eighteenth-century copies of the self-portraits made in 1543 of Holbein and his wife which later hung in the picture closet (fig. 106), as well as a sixteenth-century portrait of a woman now attributed to Hans Brosamer.[37] In about 1736 the Earl of Pomfret, Caroline's Master of the Horse, presented her with an important sixteenth-century painting, *The Memorial of Lord Darnley*, attributed to Livinus de Vogelaare.[38] To these Caroline added her own purchases. In about 1734, Vertue recorded that Holbein's painted portrait of Sir Henry Guildford, part of the collection of the Earl of Stafford until his death in 1719, had been purchased by 'the Crown', probably at Caroline's request. By 1735 it was hanging in the Privy Chamber at Kensington (fig. 105).[39]

Eventually there were dynastic portrait series throughout Kensington Palace to reinforce the message of the picture closet. In the State Apartments, the Privy Chamber contained

105 *Sir Henry Guildford* by Hans Holbein the Younger, oil on panel, 1527. The Royal Collection

106 *Portrait of the Artist* after Hans Holbein the Younger, oil on canvas, c. 1700–37. The Royal Collection

a collection of portraits of the Stuart dynasty which included Cornelius Johnson's *James I*, William Dobson's *Charles I*, William Wissing's *William III*, and Sir Peter Lely's *Queen Mary* and *Queen Anne*. In Caroline's gallery there was a set of full-length royal portraits hung in chronological sequence. It started with paintings of King Henry VIII, Queen Mary I and Queen Elizabeth I and ended with portraits of King George II and herself.[40] The Cornwallis panel paintings of medieval and Tudor monarchs adorned Caroline's private rooms. Many of these arrangements were still in place when James Stephanoff depicted the rooms in the early nineteenth century (fig. 107).

Kensington Palace may have received the most attention with respect to the arrangement of the royal collections but Caroline did not neglect the other royal palaces. In *Deliciae Britannicae* Bickham noted that at Hampton Court there was another Tudor, Stuart and Hanoverian full-length dynastic series, arranged around the walls of Caroline's Bedchamber. In her State Audience Room nearby, the five full-length portraits, then attributed to Holbein, were said to represent the Duchess of Brunswick, the Duke of Brunswick, the Marchioness of Brunswick, the Duchess of Lennox and Mary Queen of Scots. It is hard now to identify these paintings from the brief descriptions but it is likely that they included portraits of Princess Elisabeth of Brunswick-Wolfenbüttel, Duchess of Saxe-Altenburg, and a pair of portraits dated 1609, one of Christian, Prince of Brunswick, Duke of Brunswick-Lüneburg, and another of a woman, once part of Charles I's collection, both of which appear in later palace inventories. It is probable Caroline saw these subjects as

107 *The Queen's Private Dining Room, Kensington Palace* by James Stephanoff, watercolour over pencil, c. 1819. The Royal Collection

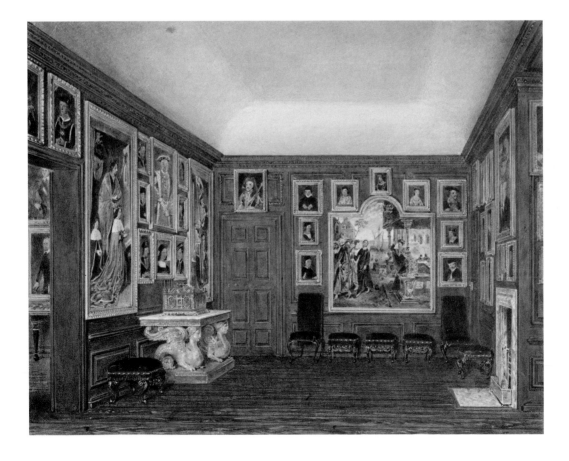

members of the Stuart family who were in some way important in the royal succession on the death of Elizabeth I, the last Tudor monarch, and who also had an association with the House of Brunswick. As such they would be considered very suitable for one of the Queen's principal rooms for entertaining.

At Windsor Castle Caroline drew together a group of portraits of royal women which included those of Henrietta Maria, consort of Charles I, Anne Hyde, Duchess of York, the first wife of James II, Mary Beatrice of Modena, the second wife and consort of James II, and Queen Mary II.[41]

If Caroline's first concern was to reassemble portraits to honour her royal forebears, her contemporary heroes were also honoured in a set of painted portraits that mirrored the subjects of the sculptural series in the Hermitage. Some were commissioned anew, such as the image of William Wollaston which is possibly by Charles Jervas after a Michael Dahl original, and that of Dr Samuel Clarke, which hung in commemoration at Kensington Palace after his death in 1729. The images of John Locke and Sir Isaac Newton were early eighteenth-century versions of portraits by Sir Godfrey Kneller. The final picture to make up the series, a portrait of Boyle by Johann Kerseboom, which had been purchased by George I, Caroline appropriated and hung in the room at Kensington in which she stored her collection of rarities.[42] It was the images of the stars of her salon, Clarke and Newton, together with that of Boyle – selected to preside over her pantheon – which Caroline chose to keep close to her at Kensington. Paintings of other of her salon *habitués* – 'the portraits of several poets, painters and philosophers' – were recorded later by Bickham, hanging together in Caroline's dressing room at Windsor (figs 108, 109 and 110).[43]

Caroline's fascination with genealogy, combined with her wish to be surrounded by images of the great minds of the age, led her to take part in the contemporary fashion for collecting printed portraits, or 'heads'.[44] This was a way in which those of moderate means could make an investment in antiquarianism: compiling a collection of engravings of

108 *William Wollaston* attributed to Charles Jervas after ?Michael Dahl, oil on canvas, 1730–35. The Royal Collection

109 *John Locke* attributed to Charles Jervas after Sir Godfrey Kneller, oil on canvas, 1704–30. The Royal Collection

110 *Sir Robert Boyle* by Johann Kerseboom, oil on canvas, 1689. The Royal Collection

British worthies allowed them to feel they were taking part in a small way in the contemporary debate about nationalism without the need for direct involvement on the political stage. There were ample opportunities for increasing the value of their collections by both purchase and exchange.[45]

The producers of prints rose to the challenge, and collections of images of members of the royal family and the great and the good were readily available from the early seventeenth century. *Baziliologia: A Booke of Kings Being the True and Lively Effigies of all our English Kings from the Conquest untill this Present with their severall Coats of Armes, Impresses and Devises, and a Brieff Chronologie of their Lives and Deaths*, in which the majority of the images were probably made by Renold Elstrack, was published for Compton Holland from 1618. This was a collection of plates showing octavo portraits of English kings with an introductory title page but no text. *Herologia Anglica* by Willem and Magdalena van de Passe, which appeared on the market in 1620, was a set of prints in a uniform format showing half-length portraits of English worthies, accompanied by an explanatory text.[46] Van Dyck's *Iconography*, published in Antwerp during the 1630s, comprises one hundred portraits of notable persons of the previous decade.[47] Later engravers such as Robert Vaughan made up careful chronological sequences to illustrate particular dynasties. He wrote in 1650 to Sir Owen Wynn of Gwydir: 'I only want the names of your ancestors from Owen Gwnedd to yourself, of which you are the 15th. For the faces I am at my own fancy till I come to Sir John Wyn your father, for the rest that are beyond him I think you have no true pictures of them extant.'[48]

By the later seventeenth century many great collections of prints had been compiled by among others Ralph Thoresby, who acquired the collections made earlier by the parliamentarian army officer Thomas Fairfax and by the antiquarian Elias Ashmole. Samuel Pepys had three volumes of engraved portraits in his library. In Caroline's circle, Lord Egmont was probably the most enthusiastic collector. Vertue noted that in the library of Charlton House, Egmont's house in Kent: 'many bustos, old pictures, and his printed collection of heads digested in near 40 large folio volumes neatly pasted and has dates to them etc making them curious and entertaining, also he has several large volumes of drawings of painters, their designs, sketches all regularly, but his collection of English heads are in London.'[49] Between 1731 and 1736 these volumes became a regular topic of discussion between Egmont and Caroline. They debated the respective skills of seventeenth-century engravers and Egmont's motivation in compiling his collection, as well as his approach to the presentation and preservation of individual works.[50] When Egmont suggested that he had made up the collection simply for his amusement, Caroline chided him, saying: 'I think it is a very useful thing' (fig. 111).

111 *John Perceval, 2nd Earl of Egmont* by John Faber Junior after Michael Zink, mezzotint, 1744. The Royal Collection

Eventually Caroline coaxed Egmont to lend her some of his volumes – some of them more than once – and she was quick to express her disappointment when eventually she had to give them back, saying that to look through them had given her 'a particular delight'.[51] On 21st April, 1735, she explained the reasons for her fascination: 'there is a particular satisfaction,' she said, 'to see the portraits of eminent persons dead and gone.' Lord Egmont encouraged her interest by sending her, through Lord Grantham, a copy of Knapton's recently published collection of prints of heads.[52] The volume joined many compendia of prints in Caroline's library, and these were consulted regularly.[53] In the record made of the movement of books between the royal palaces there is a note: '*Delivre aussy*

pour la reine le 20 Dec 1730 un grand foll ou iy avoit dedans plusiers figures et portraits persons de plusiers especes et couleurs porter a Richemont.[54] Caroline of course was to play her own particular part in furthering the fashion by allowing artists access to her extensive collection of portraits and, encouraged by Lord Egmont, she eventually agreed that engraved copies of the Holbein drawings could be made, another tremendous contribution to the art world. Fearing the originals might be damaged by the process, she required trials to be made on examples from Clayton's gift of drawings where she questioned the attribution to Holbein.[55]

It was not only Lord Egmont with whom Caroline could discuss matters art historical. Within her circle Lord Hervey (fig. 112), Sir Robert Walpole (fig. 113) and Sir Andrew Fountaine, who had so encouraged her in her architectural and gardening projects, became great allies too. *The Gentleman's Magazine* of August 1732 recounts the occasion when Caroline was entertained by Sir Robert in the 'Greenhouse' of his house in Chelsea where he had marshalled the best of his picture collection for her delectation.[56] A visit to see the 'rare cabinet of earthenware . . . and paintings by Raphael, Jul Romano, del Sarto and other famous masters of that age' in the collection of Sir Andrew Fountaine followed shortly afterwards.[57] The Duke of Richmond and Lennox, Lord of the Bedchamber to George II and later Master of the Horse, brought to Court another version of the painted *Memorial*

112 *John Hervey, 2nd Lord Hervey, Holding the Purse of Office as Lord Privy Seal* by Jean-Baptiste van Loo and Studio, oil on canvas, 1741. National Trust, Ickworth, Suffolk

113 *Robert Walpole, 1st Earl of Orford* by John Faber Junior after Sir Godfrey Kneller, mezzotint, 1733. National Portrait Gallery

114 *Memorial of Lord Darnley* by Livinus de Vogelaare, 1567. The Royal Collection

of Lord Darnley he had discovered at Aubigny – he was Duc d'Aubigné in the French peerage – so Caroline could compare it with the original in her collection (fig. 114).[58]

Just as Caroline had seized opportunities to travel from the royal palaces and explore the gardens of courtiers and connoisseurs during the King's absences in Hanover, she planned forays to inspect their collections of art too. In July 1732 she took the Prince of Wales and her three eldest daughters to view the new staircase painted by Jacopo Amigoni in Lord Tankerville's house in St James's Square.[59] On the way the party stopped to see a new painting by Charles Jervas at the Royal Hospital Chelsea. Visits to see the painting collections of Henry Pelham at Esher Place and that of his brother the Duke of Newcastle at Claremont followed shortly afterwards.[60] Sir Paul Methuen, the retired diplomat, was favoured with a visit in July 1733; when Caroline visited Lord and Lady Burlington at Chiswick House in 1735, she declared she was 'quite charm'd with the Beauties of the place'.[61]

In Caroline's wake the women in her household were inspired to make their own collections of art. Lady Sundon made a collection of paintings of contemporary worthies while Sarah, Duchess of Marlborough, included images of Sir Isaac Newton, Dr Samuel Clarke and John Locke amongst others.[62] Lady Sundon's friend Henrietta Louisa Jefferys, later Countess of Pomfret, also a Lady of the Bedchamber, emulated Caroline in her genealogical research and eventually compiled a large, beautifully illustrated volume which she named '*Heraldry ande Royal Household, the names and Arms of all those who have attended Her majesty Queen Caroline since her arrival in England Septer 11. 1714. Accounts with emblazoned coats of arms of Queen Caroline and Grooms of the Stole, Ladies of the Bedchamber, Maids of Honour and all dignitaries and servants*' (fig. 115).[63] Lady Burlington, an enthusiastic amateur artist so trusted by Caroline that she was allowed to borrow the set of prints by Wenceslaus Hollar found stored with the Holbein drawings, was given permission to copy

the double portrait after van Dyck of the Duke of Buckingham and Lord Francis Villiers at Kensington. One of her drawings was included in the picture closet and she made the last portrait of Caroline, showing her on her deathbed in 1737.[64]

George II distanced himself from any involvement in the royal collection. As long as Caroline kept the cost of her projects within sensible bounds, and as long as the arrangements of paintings in the rooms he used the most were left unchanged, he tolerated, even encouraged, her passion. The promotion of the arts was not an aspect of royal life in which he was interested, nor with which he was confident. But he would be aware of the importance of maintaining a style and elegance for court ceremonial and also for the appearance of the apartments in which state occasions were conducted. The visual aspects of monarchy could be used to instil confidence and gain respect. Caroline, herself, had proved more than competent at discharging the responsibility of engendering both.

On a few occasions Caroline would realise quickly that she had trespassed too far and upset her husband's sense of order. In 1735, while he was in Hanover, she removed some of the Italian pictures which hung in the King's Drawing Room at Kensington, including the large painting on panel by Giorgio Vasari of *Venus and Cupid* (fig. 116), and installed in their place splendid portraits of the Stuart royal family by van Dyck. The furious altercation when George returned was witnessed by Lord Hervey. Being close to Caroline, and very conscious of the benefit he derived from her motherly interest in his ambitions, Hervey's

115 *Heraldry ande Royal Household, the names and Arms of all those who have attended Her majesty Queen Caroline since her arrival in England Septer 11. 1714,* compiled by Henrietta Louisa Jeffreys (later Countess of Pomfret), 1730–50. Private Collection

record may be a little biased, but there is a ring of truth about it. He recounted how the King accused him of disrupting the picture hanging arrangements: 'I suppose you assisted the Queen with your fine advice when she was pulling my house to pieces. Thank God, at least she has left the walls standing! As for the Van Dycks, I do not care whether they are changed or no; but the picture with the dirty frame over the door, and the three nasty little children, I will have them taken away, and the old ones restored; I will have it done tomorrow morning before I go to London, or else I know it will not be done at all.'[65] Hervey asked: 'Would your Majesty have the gigantic fat Venus restored too?' The King replied: 'Yes, my Lord; I am not so nice as your Lordship, I like my fat Venus much better than anything you have given me instead of her.'[66] Caroline obeyed, and the van Dycks were returned to Windsor Castle, with the exception of the 'nasty little children'– the delightful portrait of the three eldest children of Charles I – which she kept at Kensington but moved to her own drawing room.

Caroline continued to make a few purchases of paintings to complement the sets with which George I had furnished the most formal of the State Rooms. The list includes Bartholomeus van Bassen's *King and Queen of Bohemia Dining*, *A Calm: An English Three-decker Drying Sails with Two Gallots near her* by Willem van der Velde the Younger, Carlo Maratti's *Annunciation* and, from the auctioneer Christopher Cock, Filippo Lauri's *The Rest on the Flight into Egypt*. In 1735 Vasari's *Venus and Cupid*, then attributed to Jacopo Pontormo, working after a sketch by Michelangelo, was offered for sale by raffle.[67] Mrs Jameson in 1842 recorded that Caroline pre-empted the raffle by offering £1000 for the work, and it must have been installed very promptly at Kensington for it to have caught George II's eye in the months before the quarrel about its removal.[68]

116 *Venus and Cupid* by Giorgio Vasari, oil on panel, 1543. The Royal Collection

It is possible that this list should have been much longer. In 1730 she sent Charles Jervas, who had been the King's Painter since 1723, on a mission to Italy to identify Italian paintings for the collection. In the event Jervas was taken ill and returned home without any treasures.

The new arrangements were soon attracting the attention of the artistic community in London, and Caroline in turn seems to have relished and nurtured the many contacts that resulted. In March 1727 Michael Rysbrack was given permission to make copies of Camillo Rusconi's 'four boys of the four seasons' in the King's Gallery.[69] From August 1728 the painter Jeremiah Davidson spent time in the State Apartments making copies of paintings by van Dyck and Titian. He was still working there in 1730 when Vertue arrived to make his own copy of van Dyck's painting of *Charles I with M. de St Antoine* in the King's Gallery. Both men were given rooms in the palace in which to work.[70]

Caroline paid visits to artists both in their studios and when they were working in the royal homes. In 1732 Vertue recorded: 'The Queen attended with several noblemen came from Kinsington one morning to view some pictures at Mr Jarvis's house in Cleveland Court.'[71] Later that year he described Caroline's visit to 'Mr Wootton's in Cavendish Square to see some horses lately painted by Mr Wotton where she viewed a portrait of Lord Malpas. While there she also noted a portrait of George II on horseback, a grey horse for Lord Hubbard, the face of the King by Mr Jarvis, all of the other parts by Mr Wotton.' He remarked that the Queen approved of the painting of the horse but was very disappointed with John Wootton's depiction of her husband.

It was not long before Caroline began to place her own commissions. Most were the private orders of a mother for portraits of her children as they grew up. In about 1728 she asked Charles Jervas to paint Prince William Augustus.[72] However, though Jervas held the coveted position of King's Painter, and was supported by powerful friends – he gave painting lessons to Pope and had made a portrait of Swift and others in Caroline's circle – his lack-lustre technique did not impress many. In 1731 and 1732 she turned to Christian Friedrich Zincke, first to paint her three eldest daughters and then to make portraits of herself and of her husband. In 1735 Jacopo Amigoni was asked to paint Princess Anne following her marriage to William Henry IV, Stadtholder of The Netherlands, and he later made companion portraits of her sisters.[73] Both these artists had been born abroad, Zincke in Dresden, Amigoni in Italy, but had established themselves in London. Zincke, a painter of miniatures on enamel, had a fine reputation, built up since 1706 when he first set up in practice. His jewel-like style might have appealed to Caroline, who took such delight in the historic miniatures from the royal collection. The pair of portraits commissioned in 1732 depict the King and Queen in their robes of state, and George Vertue recorded that, charmingly, the artist was given careful instructions by Caroline to make the King look youthful, and in turn George advised the artist that Caroline, who was then forty-nine, should look no more than twenty-eight years old.[74] Amigoni had arrived much more recently than Zincke; he had achieved a distinguished clientele and provided decorations for Covent Garden Theatre.

But these were the private art commissions. Royal portraiture was also a traditional and powerful mechanism for serving political ends. Both George and Caroline would have been aware that the Jacobite family in exile was producing a steady stream of images, replete with all the trapping of sovereignty, which in printed form were circulating widely and

117 *Caroline of Ansbach* by Joseph Highmore, oil on canvas, 1735. The Royal Collection

kept their interests in the public consciousness.[75] The Hanoverian family had to compete in the same way. English artists, or those with a long-established base in London, were given the commissions whenever possible, the earliest portraits, made in 1716 on their arrival in London, being painted by Sir Godfrey Kneller. Caroline is portrayed full length and dressed in her velvet ermine-trimmed coronation robes; her crown is displayed prominently on a table alongside. This was the format followed by Charles Jervas, Enoch Seeman, John Vanderbank and Joseph Highmore, who supplied a steady series of images until the late 1730s. Their work brought for the new regime dignity and authority by linking it to the portrait tradition of an earlier generation.[76] With the Jacobite threat ever present over these years, the image of monarchy needed to be commanding and enduring (fig. 117).

The other image that Caroline projected through her portrait commissions was as 'Mother of the Nation'. Sir James Thornhill, the King's Sergeant Painter, who had started the decoration of the Painted Hall at the Royal Naval College in Greenwich in 1708, following the accession of George I adapted his designs to integrate portraits of the Hanoverian family. The work was finished in 1727 and shows George II and Caroline as Prince and Princess of Wales surrounded by all their seven children. The message was loud and clear; it was through them that the royal succession would be guaranteed into the future. When Caroline sat for Herman van der Myn in the 1730s the image incorporated a portrait of Prince William Augustus.[77] Small portraits of all the children burst from a cornucopia

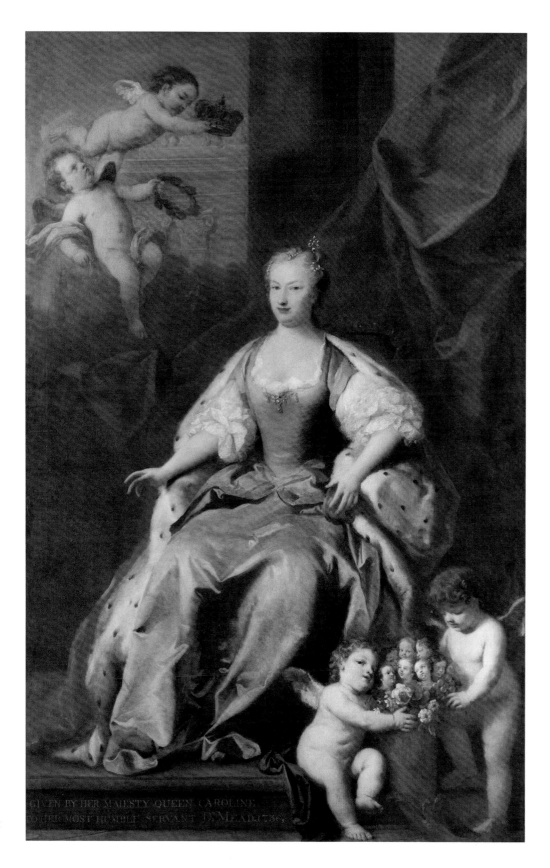

118 *Caroline of Ansbach*
by Jacopo Amigoni, oil on
canvas, 1735. National Portrait
Gallery

in a portrait by Amigoni showing Caroline seated in a stylised interior decorated with swags and cherubs in the Rococo manner. It was made in 1737 at the request of Dr Richard Mead, a sponsor and honorary physician of the Foundling Hospital in Bloomsbury. In a picture destined for a hospital for abandoned children, it may contain an allusion to Caroline as a protector of all children, and it served as a reminder that it was through Caroline and her family that the monarchy safeguarded its future (fig. 118).

It was not long before William Kent was drawn into Caroline's plans for the picture collection. At her 'express command', one of his first tasks for her in 1727 was 'for drawing the sides of the Drawing Room at Kensington Palace with all the pictures skitch'd in proper colours, designing and drawing the mouldings and ornaments for all the picture frames, glasses etc.' and 'the gallery with all the pictures sketch'd in proper colours, the frames drawn with ornaments at large and for the sconces and glasses'. For this he was paid £50.[78] The elevations record the picture hang, dominated by northern Italian works from the sixteenth and seventeenth centuries, which had been devised by George I but which he had not lived to see installed. Kent had designed new frames of a uniform design for all the paintings which gave these rooms an impressively unified appearance.

William Kent received one of Caroline's most interesting commissions for a set of pictures. In 1730, with the Holbein drawings still at Richmond Lodge and plans for the picture closet in their infancy, her research was already leading her towards medieval subjects, and he was asked to produce three paintings illustrating the life and achievements of the warrior king Henry V. The subjects selected were *The Battle of Agincourt*, *The Meeting between Henry V and the Queen of France* (fig. 119) and *The Marriage of Henry V*. The fact that Caroline paid for the paintings out of her Privy Purse indicates the personal nature of her order, and the paintings subsequently hung in her dressing room at St James's Palace, a well-used private space.[79] Henry V was later to be one of the subjects selected by Caroline for one of the sculptures commissioned from Michael Rysbrack for her library at St James's.

Given the small number of works of art to survive from the collections of her predecessors and Caroline's growing fascination with the 'antique', in his capacity as Surveyor and Examiner of his Majesty's Paintings Kent was called upon to maintain the collection in good order. With his colleagues Peter Walton, John Kin and Mr Sykes, he worked on the restoration of both the framed paintings in the royal collection and the painted murals which decorated several of the royal residences. In July 1732, Vertue recorded that Caroline took Frederick, Prince of Wales, Prince William Augustus and their five sisters to Somerset House, where they 'view'd Mr Walton's progress in cleaning and mending the Royal Pictures'.[80] John Kin was paid £45 in April 1735 for restoring a painting of the Duke of Buckingham introducing the sciences to Charles I and Queen Henrietta Maria by Gerrit van Honthorst; when Vertue came to Kensington to see *The Memorial of Lord Darnley*, it was Mr Sykes, working to conserve the piece, who helped him decipher the inscription on the painting.[81] In 1734 both George II and Caroline climbed the scaffolding erected in the Banqueting House to view Kent's work on the restoration of Rubens's ceiling paintings.

But Caroline's loyalty to Kent and her friendship with his patrons led her into tricky situations with artists whom Kent considered his rivals. William Hogarth sought and was granted permission through 'some lady about the Queen' to make a painting recording the wedding of Princess Anne, Caroline's eldest daughter, to William Henry IV, Stadholder of The Netherlands, in November 1734. When this permission was withdrawn and the

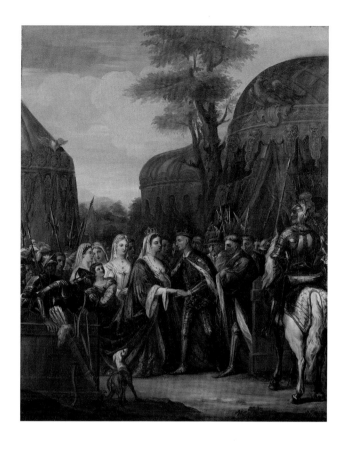

119 *The Meeting between
Henry V and the Queen of
France* by William Kent,
oil on canvas, 1730–31.
The Royal Collection

commission passed to Kent, Hogarth complained that this was not the first time access to the royal family had been denied at the eleventh hour.[82] In 1731 or 1732 he had been given permission to paint the royal family, achieved one sitting with Prince William Augustus and made two oil sketches before the commission was cancelled.[83] Kent and his supporters, including Lord Burlington, were evidently more than able to protect his interests at Court. Hogarth had a reputation for satire, which might have made Caroline cautious of involving herself with him, and it did not help that his friends and supporters were generally of the opposition party.[84] Hogarth's oil sketches both survive; in marked contrast to the greater body of portraiture of the Hanoverian royal family they show it gathered informally in an interior in one version and in the garden at Richmond in the other (figs 120 and 121).

William Kent was not however given the responsibility of providing painting tuition to the royal children. The three eldest princesses were instead taught by Philippe Mercier, born in Berlin and of French Huguenot extraction, who had followed the royal family from Hanover. After the rift between George I and his son, Mercier had joined the establishment of George Augustus and Caroline at Leicester House without hesitation. Bernard Lens, a miniature painter, gave lessons to the three younger children. All the princesses became gifted amateur artists.[85] In December 1733 Lord Egmont described being shown, at the Queen's order, copies after van Dyck, Titian and Carlo Maratti made by Princess Anne and claimed that they were 'as well done as I believe any other painter in London could have finished them'.[86] After the family's visit to van der Myn's studio, Prince Frederick encouraged Princess Anne to draw van der Myn's portrait herself, and *The Gentleman's*

120 *George II, King of England, and his Family* by William Hogarth, oil on canvas, c. 1732. National Gallery of Ireland, Dublin

121 *The Family of George II* by William Hogarth, oil on canvas, 1731–32. The Royal Collection

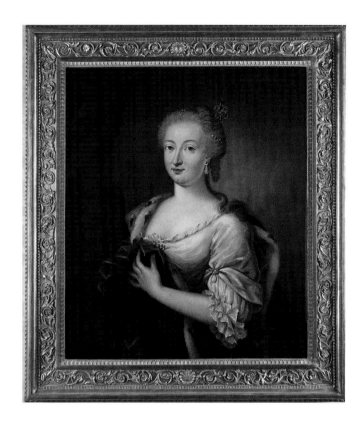

Magazine records that this was completed 'with a delicate and masterly execution and very like'.[87] Following her marriage, Anne packed up her paintings and took them with her to The Hague, where she continued to work; an inventory of the Dutch royal collections shows that by 1757 there were sixty-six paintings by the Princess hanging either at Huis ten Bosch or at Het Loo, her royal homes. A further thirty-two are noted in the list made the following year.[88] At least ten examples of Anne's paintings, including a number of flower pieces and a competent self-portrait, survive in the Royal Collection of the Netherlands in The Hague (fig. 122).[89]

Horace Walpole noted in his *Journals of Visits to Country Seats* that Princess Amelia's bedroom was decorated in 1728 with pictures painted by her younger sister, Princess Caroline, and several examples of Caroline's works survive. There is an oil painting of a shepherd and shepherdess after Mercier which she presented to Lady Susan Keck, her Lady of the Bedchamber, in the collection of the Earl of Wemyss, a drawing she made of a mezzotint of Lord Buckhurst and Lady Mary Sackville by John Smith after Kneller, given in 1732 to the Countess of Hertford, her mother's Lady of the Bedchamber (now in the collection of the Duke of Northumberland), and a copy of a painting by Jean-Baptiste Pater in the Royal Collection.[90]

Princess Mary's collection of landscapes, made in 1733 when she was ten years old, survive in Schloss Fasanerie at Fulda.[91] She also painted a portrait miniature of her sister Louisa, dressed as the character of Spring, which is now in the Royal Collection (fig. 123). The backing paper includes a note that the work was produced as a present for her mother, who subsequently stored it away carefully in a snuff box. Caroline remained an observer;

there seems to be no evidence of her making her own paintings. She was only prepared to do needlework – she sent a quilt and two cushions she had embroidered to Lady Elizabeth Smithson, the daughter of Lady Hertford.[92]

In her ten years as queen Caroline made a considerable contribution to the royal collection of paintings. The rediscovery of the Holbein drawings in the first year of her reign was critical. Caroline later did much to publicise the drawings, particularly through her encouragement of George Vertue in his project to reproduce the works. Through his agency they would be brought to an ever wider audience in the years immediately following the Queen's death. The drawings inspired her to explore the long history and importance of the English royal family through the royal collection of art. This led to the re-ordering of the royal pictures in all the royal palaces, the conservation of ancient treasures and the selective acquisition of new works. Her activities culminated with the establishment of the picture closet as her 'store of portraits of the English' at Kensington Palace.

The arrangement of the closet hints at Caroline's European roots. As a miniature 'Hall of Ancestors' it stood in the tradition of the great examples she would have come upon as a young woman in Dresden, Berlin and Hanover. It allowed her to indulge her youthful passion for genealogical research into the history of her family, learnt at the feet of her royal mentors in Germany, but saw this extend to the leading families of her adopted country. It provided a topic for discussion with members of her German family, just as much as for people within her immediate circle in the Court in London and in the artistic and intellectual community beyond. In a general way it helped to reinforce her reputation as an 'encourager' of the arts. However, the eclectic mixture of works she included meant that it remained essentially a private project, a little too individual and personal to serve any major propaganda role, except within Caroline's immediate circle. Public art generated by the regime, by contrast, followed strictly traditional lines in order to stress a dignified continuity of royal image-making.

123 *Princess Louisa in the Character of Spring* by Princess Mary, miniature, c. 1736. The Royal Collection

5

CAROLINE
and her Books

Early in 1737 Caroline decided to build a new library. It is possible that she saw this as somewhere to which she could draw together her former intellectual circle – her salon – once again. A library was a place set aside for academic purpose; a gathering held there would be seen as far less political than if held at the heart of the Court. Her first consideration was to settle on where it should be. To be seen as having a public benefit in any way, Hampton Court Palace and Windsor Castle were too far away from the centre of the Court. Richmond Lodge and Kensington Palace were regarded as royal retreats and therefore not appropriate either. St James's Palace, the most accessible of the palaces, where the royal family spent a significant length of time each year, was undoubtedly the best option.

The building, Caroline's most ambitious architectural project, was constructed with an eye to comfort and could have hosted small gatherings without difficulty. There was a walnut writing table, and Sarah Gilbert, Matthew Vernon and William Weekes upholstered couches and night-chairs with green mohair and trimmed them with silver lace.[1] Light was provided from gilt-wood sconces.[2] The cabinet-maker Benjamin Goodison was responsible for supplying the mahogany bookcases with doors of brass mesh.[3] With Caroline anxious to take possession, the final stages of the fitting-out became chaotic.

Opposite
Queen Caroline's Library,
St James's Palace by Charles
Wild, watercolour, c. 1815.
The Royal Collection
(detail of fig. 177)

In October 1737 Lord Hervey wrote angrily to Henry Fox, 'Neglecter of His Majesty's Works', to complain: 'which of all the devils in Hell prompted you to tell the Queen that everything in the library was ready for the putting up of her books? Thou abominable new broom that so far from sweeping clean, hast not removed one grain of Dirt and Rubbish. Bad night' (figs 124, 125 and 126).[4]

To the members of the artistic, literary, ecclesiastical and scientific communities in London whom she brought together in her salon, the number of subjects on which Caroline could talk with knowledge and enthusiasm was very impressive. Lord Egmont reported that she 'talked to me at least half an hour upon my collection of printed Heads, Dr Couraye, the history of France, gardening, painting, flattery and divers political and moral subjects', and that 'she reads and converses on a multitude of things more than [her] sex generally does.'[5] After overhearing their theological discussions, Jonathan Swift described Caroline and her friend Charlotte Clayton as 'freethinkers' – a term used from the late

124 *The Queen's Library* by Charles Wild, pencil on paper, c. 1815, City of Westminster Archives, London

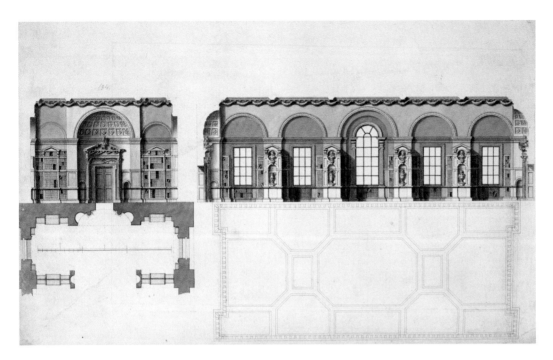

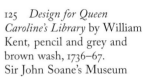

125 *Design for Queen Caroline's Library* by William Kent, pencil and grey and brown wash, 1736–67. Sir John Soane's Museum

126 *Design for Queen Caroline's Library* by William Kent, grey ink and grey wash, 1736–37. Sir John Soane's Museum

seventeenth century for those who sought to understand the nature of God, the universe, and the world and its working through an understanding of nature – a controversial label for a queen consort whose husband was the head of the Church of England.[6] For William Kent she was the embodiment of Minerva, the goddess of wisdom, the protector of art and science and, when he included an image of Minerva in his ceiling painting for the Privy Chamber at Kensington Palace as early as 1723, he may well have had Caroline in mind. He certainly incorporated the figure of Minerva into his design for a silver standish for Merlin's Cave, and the finial in his first design for candlesticks commissioned for the Leineschloss in Hanover is in the form of an owl, the attribute of the goddess.[7] Others made use of the symbolism too: on the obverse of the silver medal produced in 1736 by Henry Jernegan, to promote the lottery of a silver cistern, Minerva is depicted surrounded with the caption 'BOTH HANDS FILL'D FOR BRITAIN' and the Latin for 'George reigns'; the reverse has the image of Caroline watering plants with the words 'GROWING ARTS ADORN EMPIRE' and 'CAROLINE REIGNS' (fig. 127).

Caroline was more than aware of the pleasure and intellectual stimulation that a salon could provide. She had already played her part in the lively cultural gatherings over which Sophie Charlotte had presided at Lützenburg in Berlin and the Electress Sophia maintained in Hanover.

The young Caroline thrived at Lützenburg, taking part in the amateur theatricals and being party to lively political and philosophical discussion. Sophie Charlotte enjoyed the theatre and Italian opera, and, an enthusiastic musician, she often accompanied singers herself on the harpsichord. The composers Attilio Ariosti and Giovanni Battista Bononcini were at the centre of the circle she cultivated, but it also included philosophers, writers and clerics such as John Toland from Ireland and the French Huguenots Pierre Bayle, Isaac Beausobre and Isaac Jacquelot. The brightest star of all was Gottfried Wilhelm Leibniz (fig. 129).[8]

Leibniz was born in Leipzig in 1646, the son of a moral philosopher who taught at the University of Leipzig. By 1676, when he first arrived in Hanover, he had already impressed the Académie Royale des Sciences in Paris and the Royal Society in London with his invention of a calculating machine. This led not only to fruitful relations with their members for many years to come but also to his election to the Royal Society. While in Paris he had encountered the Dutch mathematician Christiaan Huygens and this led to his developing theories of both integral and differential calculus. His reputation as a philosopher was consolidated in the years that followed with the publication of a series of essays written, often, in response to the philosophical writings of others. In a criticism of John Locke's *Essay Concerning Human Understanding* which Leibniz wrote in 1690, he refuted Locke's major premise that the senses are the source of all understanding by adding 'except the understanding itself', and distinguished three levels of understanding: the self-conscious, the conscious, and the unconscious or subconscious. Leibniz's book *Essais de Théodicée sur la Bonté de Dieu, la Liberté de l'Homme et l'Origine du Mal*, published in 1699, was written in reply to an attack upon his views in the Huguenot Pierre Bayle's *Dictionnaire Historique et Critique* of 1697. In it Leibniz explored his ideas about the nature of God and the universe. His best-known contribution to metaphysics is his theory of monads, as exposited in his essay *La Monadologie*. He defined monads as the ultimate elements of the universe – individual percipient centres of possibility or force. Despite such

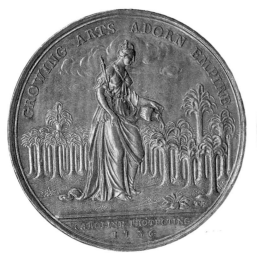

erudition he evidently possessed a courtier's wit, ease and diplomacy too, and was warmly welcomed into court gatherings.

Leibniz had been taken up by dynastically ambitious Sophia and her husband Ernest Augustus in 1676 – they had to coax him away from the household of Anton-Ulrich, Duke of Brunswick-Lüneburg-Wolfenbüttel, for whom he had served as librarian.[9] Once in Hanover he was drawn into their plan to achieve electoral status for the family. One aspect of their campaign was to establish the antiquity and dignity of the family pedigree; the genealogical research Leibniz undertook over the next few years in the archives in Modena, establishing a common ancestry between the House of Guelph and the English Planta-genets, was vitally important. As this information came together, Ernest Augustus and Sophia's continued their plans to consolidate the four dukedoms which comprised their family lands through marriage. Ernest Augustus's political and military support of the Holy Roman Emperor helped too. Eventually the plan worked: electoral status was awarded in 1692.

After Sophia's daughter Sophie Charlotte married Frederick III, Elector of Branden-burg, Leibniz lobbied hard for an introduction to the Court in Berlin where he had an ambition to make his mark on the arts and sciences. In 1699 Sophie Charlotte convinced her mother that he could serve as a discreet intermediary between the two courts and he soon become a regular guest at Lützenburg, advising Sophie Charlotte on her reading, and her architectural and gardening projects. Within a year he was appointed the first president of the Berlin Academy of Science. This is where Caroline would meet him for the first time; he was the only other person present at the sessions during which Father Orban sought her conversion. Leibniz's *Théodicée* which records conversations with Sophie Charlotte, would later be one of the books Caroline cited most frequently in her correspondence.

After Caroline's marriage to George Augustus in 1705, and her move to Hanover, she was quickly subsumed into the intellectual circle around the Electress Sophia – which served as the model for the Lützenburg salon. Sophia failed to establish a meaningful partnership with her husband. As her marriage disintegrated, she had to construct a *modus*

127 Lottery medal made by John Sigismund Tanner for Henry Jernegan, reverse and obverse, silver, 1736. British Museum

128 *Gottfried Wilhelm Leibniz*, German School, miniature, c. 1690. The Royal Collection

vivendi and role for herself which was fulfilling personally while being politically unthreat-ening for her family and connections. Sophia found her delight was in 'conversing with learned men, who, to their great reading and philosophy, had joined politeness and temper, or in writing letters in several languages, full of humanity, admirable wit, exquisite penetra-tion, and the strongest judgement, to her acquaintances or relations, and even many times to private persons, noted for their wisdom or probity.'[10] Her circle was international – she spoke 'five languages so well that by her Accent it might well be a Dispute which of 'em was her first', according to John Toland – and included philosophers, scientists, artists and musicians. Caroline immediately felt at home.

When Sophie Charlotte died in 1705, Leibniz lost his royal champion in Berlin and found his appointment at the Academy increasingly difficult to maintain. Sophia proved his saviour by inviting him back to Hanover, and this renewed his contact with Caroline. He picked up, once again, the genealogical research into the history of the House of Brunswick-Lüneburg-Wolfenbüttel he had been charged to undertake earlier. Sophia was to provide Caroline with the inspiration to organise philosophical debates on specific subjects which interested her. She had moderated two important exchanges on theological subjects herself; the first between Leibniz and Paul Pellisson-Fontanier, historiographer to Louis XIV, and the second between Leibniz and Jacques-Bénigne Bossuet, a French bishop and theologian who served as preceptor to the Dauphin, the eldest child of Louis XIV of France, and was considered by many to be one of the most brilliant orators of his time. Caroline also came to share Sophia's particular passion for genealogical research; an aware-ness of the political capital of a long and distinguished lineage was well established, and discovering the connections to the histories of other royal houses was far more than merely an interesting occupation.

It was Sophia who introduced Caroline to 'Liselotte', Elisabeth Charlotte, Duchess of Orléans (fig. 129). She also maintained a salon, and became something of a role model for Caroline, offering advice and support particularly during the tense months immediately after the accession in 1714, when Caroline was seeking to establish her place within the English court. Liselotte was Sophia's niece – the daughter of her eldest brother Charles Louis, the Elector Palatine. Between 1659 and 1663 Sophia had been entrusted with super-vising her education at the Leineschloss and this ensured they established a deep and enduring bond.[11] In 1671 Anna Gonzaga, the widow of Sophia's brother Edward and sister-in-law of Louis XIV, had encouraged Charles Louis, in the interests of consolidating French interests in the Palatinate, to marry Liselotte to the recently widowed Philippe d'Orléans, brother of Louis XIV. This was another disastrous royal marriage – the couple were incompatible and Liselotte, having successfully provided her husband with an heir, found her only real pleasure lay in collecting art and curiosities and conducting an extensive correspondence with her aunt as well as with men of science and letters.

After many years of hearing Caroline praised, first by Sophie Charlotte and later by Sophia, Liselotte wrote to her half-sister the Raugravine Louise from Marly: '*Je voudrais de grand coeur entrer en correspondence avec la princesse de Galles, car j'aime Sa Dilection bien cordialement.*'[12] With acquaintances in common, and many shared interests and experiences, there was an immediate empathy between the two women, despite the considerable dif-ference in their ages, and their correspondence continued until Liselotte's death in 1722. Caroline's letters were long and detailed – in April 1716 in a letter to Leibniz, Liselotte

ELISABETH CHARLOTTE DE BAVIERE (MADAME) DUCHESSE D'ORLÉANS

(Histoire du Palais Royal)

wrote: '*C'est la princesse de Galles qui est cause que j'ai tant tardé a vous répondre; car depuis notre commerce épistolaire a été engagé Sa Dilection me fait l'honneur de m'écrire à chaque poste; de plus elle m'écrit des lettres fort longues de huit à neuf feuillets; les moindres sont de cinq à six feuillets et pas une page laissée en blanc.*'[13] Leibniz, from the time of his appointment in Hanover, had conducted a lengthy long-distance correspondence with Liselotte too. Liselotte claimed he was a rare being, 'a learned man who knew how to behave and did not stink'.[14]

But Caroline's salon would always prove more than an amusement, an intellectual stimulant, even a distraction from private grief when separated from her children. The people she gathered together and the discussions which were held had a political import too. Having foresworn the Habsburg crown on religious grounds in 1703, Caroline was proud to be held up as a champion of the Protestant faith and took a particular interest in theology. George II seems to have handed to her the royal responsibility for church patronage – his name is rarely mentioned in correspondence relating to ecclesiastical matters. In this she achieved remarkable success and advanced the interests of many of her favourites (fig. 131); there is good evidence that she was able to influence eight out of thirteen episcopal appointments between 1727 and 1737 – to the great part these individuals, Whigs and Low-Churchmen, were well suited to the ministry, which sought to achieve a church loyal to the Hanoverians and supportive of arrangements achieved in 1689 in balancing the interests

129 *Elisabeth Charlotte, Duchess of Orléans* by Alphonse Léon Nöel after Rigaud, engraving, early eighteenth century. The Royal Collection

of Church and State.[15] On occasion she was thwarted and realised that she would have to tread with care. Despite her support of Dr Samuel Clarke, his views were considered just too controversial (figs 130, 131 and 132).[16]

The gatherings also brought together people from across the political divide. Lady Cowper noted in 1719 that Robert Walpole 'comes every day this winter, once if not twice' to Leicester House.[17] He joined other Whigs such as Philip Dormer Stanhope (later Earl of Chesterfield) and the Burlingtons with their circle of gardeners and artists. They mingled with Tories such as the Earl of Peterborough and a contingent from the Scriblerians Club, set up in the first decade of the eighteenth century expressly to counterbalance the influence of the Whig literary circle around Joseph Addison. Amongst the Scriblerians were Dr John Arbuthnot, who would serve Caroline as physician, and the writers Alexander Pope, John Gay, Jonathan Swift and Thomas Tickell.[18] The Venetian scientist-philosopher Antonio Conti, a protégé of George I's half-sister Sophia Charlotte von Kielmansegg (later created Countess of Darlington) would discuss his favourite topics – mathematics, theology, medicine, Descartes, Newton and Plato. Later participants, such as Lord Hervey were welcomed by Caroline simply for their wit and conversation. In an echo of the sculpture series commemorating such contemporary heroes, Caroline commissioned painted portraits of them, too, with which to adorn her apartments.

The unlikely encounters that Caroline engineered between this diverse group could prove very fruitful – it was the cleric William Wake who advised her that Samuel Clarke was the only person who could make a good English translation of Leibniz's *Théodicée*.[19] There was a notable theological colloquium between the cleric Clarke and Richard Bentley, the royal librarian.[20] But the most famous debate of all was between Leibniz and Sir Isaac Newton (fig. 133), and will be discussed in detail in the next chapter. Given the quality of

130 *William Wake* by George White after Thomas Gibson, 1715–20, mezzotint. National Portrait Gallery

131 *Thomas Sherlock* by Simon François Ravenet after Jean Baptiste van Loo, line engraving, 1756. National Portrait Gallery

132 *Dr Benjamin Hoadly* by Bernard Baron after William Hogarth, engraving, 1748. The Royal Collection

133　*Sir Isaac Newton* by
?Charles Jervas after Sir
Godfrey Kneller, oil on
canvas, 1689. The Royal
Collection

these conversations, it may seem curious that Caroline did not get more involved with academics at Oxford and Cambridge. In England, however, it had long been the case that universities were not dependent on royal favour and funds to guarantee their survival. Caroline was happy to contribute £1000 to Queen's College in Oxford to fund the building of a new quadrangle, acknowledging an ancient royal connection, but settled for nurturing and protecting her own private debating chamber.

But the salon of any female ruler or senior noblewoman could all too quickly become a honey-pot for those seeking promotion; in royal and aristocratic households, if there were appointments and commissions to be made, the female was often charged with the task. As an awareness of Caroline's interests and the extent of her influence became known, it was not long before writers, theologians, musicians, composers and painters began lobbying on their own behalf and on behalf of their protégés for jobs, protection and pensions – her attempt to act as patron was always going to be difficult, especially after she became queen.

The poet John Gay and Jonathan Swift, who championed him, courted Caroline's favour for many years. Their campaign included the dedication by Gay of his play *The Captives* to her in 1724 and his *Fables* to the infant Prince William Augustus the following year.[21] Charlotte Clayton and Dr Alured Clarke used the assemblies to introduce Stephen Duck, the naïve 'Thresher Poet', and William Somervile, the author of 'The Chace', to the Court. Viscount Tyrconnel, supported Richard Savage, who wrote the poem 'The Bastard', as a

Drawn by J. Harris Jun, from the Original at Blickling Norf.

134 *Henrietta Howard*
attributed to John Harris
after a painting attributed to
Thomas Gibson, watercolour,
c. 1715–25. National Portrait
Gallery

candidate for the post of Poet Laureate. Lord Egmont promoted the interests of Pierre-François le Courayer, the philosopher-historian who had recently fled from France. Dr Conyers Middleton, the author of a biography of Cicero, was drawn into the royal circle by Lord Hervey.[22]

The fact that Henrietta Howard, a Woman of the Bedchamber to Caroline – who had become George Augustus's mistress in about 1717 – established a rival intellectual circle was another concern. Clever, beautiful Henrietta had travelled with her husband to Hanover early in 1714, seeking advancement by securing positions at Court. Henrietta applied successfully for an introduction to the Electress Sophia, and wooed her with her cultivated manners and lively mind. An invitation to Sophia's salon followed and brought Henrietta into contact with members of the Electress's circle, among them John Gay. After the death of Queen Anne, Henrietta and her family followed the new royal family to London, where Henrietta must have been very pleased to secure, eventually, the coveted position in Caroline's household (fig. 134).

The brief sojourn in Hanover had shown Henrietta that she had not only the capacity but also the taste for intellectual debate, and it had provided her with exciting new friends – particularly in the literary world. Her amiable manner meant that these friendships flourished, and many, including Pope and Swift, were drawn from Caroline's gatherings to evening parties held in Henrietta's apartments at Hampton Court Palace and Richmond. Her relationship with George Augustus ensured plenty more sought her company in the belief that she might have the power to promote their interests with her paramour.

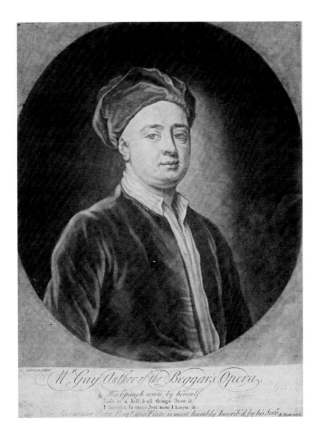

However magnanimous Caroline may have been about the fact that her husband took mistresses, finding one who had the potential to become a personal rival in the spheres of life she held dear must have been unsettling. Besieged at the same time by those lobbying for their advancement through her salon, she seems to have reassessed how the occasions should be managed. During the 1720s there was a gradual change of direction, particularly in her literary patronage, and by the time of the accession of her husband in 1727 the gatherings seem to have been largely abandoned. Cautiously, she offered John Gay an annual pension of £150 to serve as Gentleman Usher to the two-year-old Princess Louisa but he turned it down – it was too demeaning to be attached to the household of a baby (fig. 135). Pope, Swift and other literary lions found themselves sidelined.[23] Caroline's heroes would still be honoured but in a different, more passive way. In about 1731 she placed her order for the first series of portrait busts – of the great philosophers and scientists of her generation – for the Hermitage at Richmond. It was petitioners with a less public profile whom she would continue actively to encourage and support.

Through Caroline, Stephen Duck enjoyed many years of royal patronage. While Tyrconnel's championing of Richard Savage as Poet Laureate was unsuccessful, she supported the Countess of Hertford, her Lady of the Bedchamber, in the intercession for leniency when he was tried for murder after killing James Sinclair in a drunken fray in 1727.[24] She went on to furnish Savage with an annual pension of £50 in 1732 despite his association with the Jacobite cause. The refugee Le Courayer, was granted an annual pension of £200 and commissioned to undertake a translation of Thanaeus's history of his own times from Latin

135 *John Gay* Francis Kyte after William Aikman, mezzotint, 1730–40. The Royal Collection

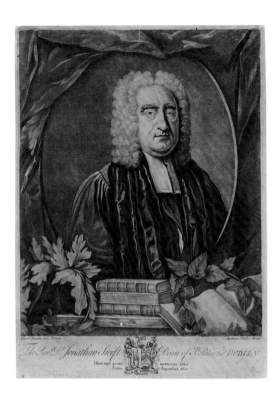

136 *The Reverend Jonathan Swift, Dean of St Patrick's, Dublin* by Andrew Miller after Francis Bindon, mezzotint, 1730–40. The Royal Collection

into English. She provided a pension of £50 for Deborah, the impoverished daughter of John Milton by his first wife.[25] Richard Steele, co-founder with Addison of *The Spectator*, and manager of the Theatre Royal, Drury Lane, received financial assistance as he became increasingly disabled.[26] In 1732, after reading the *Alciphron: Or the Minute Philosopher* written by the maverick philosopher George Berkeley, Caroline discovered he had resigned from his living as Dean of Derry to spend two years between 1729 and 1731 preaching in the provinces of Massachusetts, Connecticut and Rhode Island and Virginia on the east coast of north America. This had been with an ambition of raising funds for the establishing of a college for clergy in Bermuda. She immediately sent for him in order to discuss his American experiences with a view to encouraging interest in his work.[27] She promoted the work of the Welsh poet Jane Brereton, who wrote under the alias 'Melissa' and who had published verse praising Merlin's Cave. In this case there was additional dynastic advantage in allying the new Hanoverian rule with Britain's Celtic roots.

These actions led to much criticism. Gay's disappointment at failing to gain the court appointment he had desired for so long led his friends Swift and Pope to take their revenge. Pope wrote to the poet, not to commiserate but to say: 'I could find it in my heart to congratulate you on this happy dismissal from all court dependence.'[28] Pope, as a Roman Catholic, had no expectation of royal office for himself and congratulated Gay on achieving a similar status of 'Freeman'.[29] As he argued: 'you are nobodys servant, you may be anyones friend.'[30] Despite their many earlier contacts, and Caroline's discreet support of his gardening projects and promotion of his work, Pope declared himself vehemently and publicly against her, particularly through his work *The Dunciad*, first published anonymously in 1728. This is an epic poem in which he sets up the thesis that under the rule of the 'Goddess of

Dulness', and her cohort of dunces, the future of Great Britain will be dragged down by ignorance and the abuse of learning. It was an attack on the commercialism of literature, those who supported the mediocre, particularly in the world of publishing, and those who wrote to serve personal political ends. Even though the dunces were not identified explicitly, Colley Cibber, Sir Richard Blackmore, George Duckett, Lewis Theobald and Edmund Curll all responded, seeing the work as a personal attack on themselves and their work as writers or publishers biased towards the Whig party. Caroline was cast as the 'Goddess of Dulness' for her support of the work of some of these persons, for using her cultural patronage for political ends and for championing those whose work pandered to her personal ideas.[31] Swift's biting words were printed in *The Gentleman's Magazine*:

Lewis the living Genius fed
And rais'd the Scientific Head;
Our Q- , more frugal of her Meat,
Raises those heads which cannot eat.

Answered:
Our Q - n more anxious to be just
Than flatter'd rears the living Bust
To chosen Spirits, learned Tribe!
Whom Lewis like, she cannot bribe.
Her Majesty never shall be my exalter
And yet she would raise me, I know by – a halter.[32]

Swift went on to write more satirical verse about Caroline's Hermitage.[33] Lady Mary Wortley Montagu – another person ineligible for royal office, having married outside the nobility – despite their many meetings and delight in friends and interests in common, was quick to accuse Caroline of promoting only those she could maintain in her thrall (fig. 136).[34]

In fact, opinion about Caroline and her intellectual ability was mixed. There were plenty who suggested her grasp of contemporary science and philosophy was shallow – her husband was just one who made jest of her meddling, particularly in so many theological disputes. But it remains hard to discount the opinion of Lord Egmont, Leibniz and many others with whom she regularly debated in person or by letter. They were clearly very impressed by her, and she remained a muse for both male and female writers and poets.[35] There is also the evidence provided by the reading matter she acquired, and which by every account she devoured enthusiastically.[36]

On her death Caroline's love of reading was one of the traits singled out for particular commemoration. *The Gentleman's Magazine* printed a eulogy from Baron Pöllnitz, who claimed: 'The reading of choice authors was always one of her greatest pleasures; and her Majesty may be said to be one of the most learned Princesses in Europe'; he added: 'This great Queen, always the object of our love and admiration . . . to a great compass of knowledge, joined most polite address and the most easy and elegant manner of producing the sentiments of others, or conveying her own. She not only studied books, but infinitely better the nature and reason of things.'[37] Henrietta Howard had observed her in Hanover

many years earlier consulting Bayle's *Dictionnaire Historique et Critique*, an encyclopaedic text and exemplary work of critical methodology. As the author painstakingly compiled his facts, he questioned and compared, seeking to establish some degree of historical certainty.[38] In 1714 Lady Cowper reported that she 'went out to carry the Princess all my Lord Bacon's works, which she bade me get her', and later, 'in the morning at Court the Princess gave me a book to read to her; twas Madame Deshoulière's Works.'[39] Antoinette du Ligier de la Garde Deshoulières and her daughter Antoinette-Thérèse Deshoulières were French poets whose work had initiated a heated debate led by the French essayist and moralist La Bruyère about the status of women. Antoinette-Thérèse was a member of the Toulouse Académie des Jeux Floraux and, after presenting her work under a male alias, won prizes for it. According to Lord Hervey's mother, the Countess of Bristol, Caroline particularly enjoyed being read to first thing in the morning as she dressed. Her readers varied and included John Gay, who chose to read her *The Captives* in 1724.[40] Her opinion of any author was soon respected by many. Lord Tyrconnel wrote to Charlotte Clayton: 'The best judge of poetry, that I mean are the Queen and Mr Pope.'[41]

Caroline, raised in a European princely tradition, would have been aware that the maintenance of a library of books was seen as essential to a ruler. It was the final component within the Renaissance 'Museon' framework – the ideal structure for drawing together collections of art, literature, nature and science to allow a better exploration and appreciation of the contemporary world. Johann Daniel Major, who had been an important influence on the collections drawn up by the electors of Saxony, gave the library equal status to that of any other group of artefacts in his books *Kunst und Naturalienkammern*.[42] The small and scattered collections of books in London were very far from what was deemed necessary, and it is not surprising Caroline turned her thoughts to the creation of a single place in which to bring them all together – as befitting the English royal house.

Caroline had been made very aware how tenuous and vulnerable her connections were with the many new, articulate groups of people which existed in London outside the traditional court circle. She had read Lady Mary Wortley Montagu's *Roxana: Or, the Drawing-Room*, written in 1715, in which the author wickedly satirised the scramble for royal patronage.[43] She admired the cleverness of Swift's *Gulliver's Travels*, published in 1726, and Gay's *Beggar's Opera*, which played to packed houses at the Lincoln's Inn Theatre for an extraordinary sixty-two performances in 1728, even though both were critical of the political administration. Sir Robert Walpole had presented George II with a copy of Pope's *Dunciad*, but in fact Caroline already had her own copy, together with works by James Thomson, another of her critics.[44] With her ambitious son Frederick being courted by the disaffected Whig Lord Cobham, and his interests being championed by *The Craftsman*, the periodical which had become the organ of the political opposition, Caroline may have felt it was time to occupy a position at the heart of the intellectual life of the nation.[45] Perhaps she was given new confidence when Henrietta Howard finally fell from favour as the King's mistress in 1734 that she might now be able to coax the great minds she admired back into her circle. A new library might prove an appropriate place for gathering them together.

The concept of the 'universal library', which developed from the early seventeenth century, was grounded in the work of the Frenchman Gabriel Naudé, the keeper of Cardinal Mazarin's collections. Naudé was the author of *Advis pour Dresser une Bibliothèque*, published in 1627, which provided a new standard for the aspiring librarian. For him a

library should be a neutral resource for the scholar, allowing for a new and independent spirit of enquiry which could roam between disciplines, cultures and philosophies. It should embrace not only classic texts from antiquity but also works by contemporary authors.

Caroline's peripatetic early years had brought her into contact with some of the greatest European universal libraries of the late seventeenth and early eighteenth centuries. As a child her access to the Ansbacher and Saxon libraries would have been limited, but it is worth noting that it was her father, John Frederick, the Margrave of Brandenburg-Ansbach, who can take credit for compiling a great part of the library now surviving in the palace in Ansbach. And there are several books in this library with book plates bearing the name of Caroline's mother, Eleonore of Saxe-Eisenach.[46]

The library of the electors of Saxony in Dresden, where Caroline spent her early years, had been established under Augustus I and, when the first inventory of the collection of books was made in 1589, there were already more than ten thousand entries. In the seventeenth century the books were moved into their own new building and organised by categories as prescribed by Johann Daniel Major. It is interesting to find that Caroline's older half-sister, Dorothea Friederike, who shared some of her very early experiences, owned at least a hundred and ninety books when she died, suggesting the children were encouraged to explore literary culture.[47]

The first libraries that the young Caroline would have encountered were those established in the royal palaces in Berlin and in Hanover. The Brandenburg library, which contained twenty thousand books and over ten thousand manuscripts, had been established by the Great Elector. Frederick III, his successor, appointed Johann Casimir Kolbe, Graf von Wartenburg, as well as Freiherr Ezekiel von Spanheim, Freiherr Otto, later Graf, von Schwerin, Lorenz Berger and Maturinus Veyssière La Croze, some of the most distinguished librarians of the day, as its custodians and provided it with splendid new accommodation. Meanwhile, at Lützenburg Sophie Charlotte maintained her own book collection too.[48]

The Hofbibliothek, the royal library in Hanover, had been established in the 1660s in the Leineschloss by Johann Friedrich, the Electress Sophia's brother-in-law. In 1720, under George I, as Elector of Hanover, it was transferred to a new building and renamed the Königliche Öffentliche Bibliothek. Leibniz, formerly the librarian of another of the greatest European universal libraries – the Bibliotheca Augusta founded by the Dukes of Brunswick-Lüneburg at Wolfenbüttel – was charged to keep it in good order. George's own collection of books was incorporated into this library in two tranches – the first in 1718, the second in 1729. This was something he chose not to vest in England.[49] Nonetheless, his appreciation of the value of books led in 1713 to his gift of the thirty thousand volumes he had acquired from the library of John Moore, Bishop of Ely, a noted scholar and book collector, to the University of Cambridge. He later made a grant of £2000 to the university to fund the building of a library in which they could be housed. George II maintained his father's link with the Cambridge University library which, as Horace Walpole argued, allowed him to 'truly disculpate the King from the charge of neglecting literature' – although like his father his principal library would be maintained in Hanover.[50] He added over three thousand volumes to the collection there between 1729 and 1760.

On her arrival in London Caroline had begun to make her own collections of books rather than explore the existing royal library, probably because she had been unable to

locate it. Founded by Edward IV and, containing thousands of books and manuscripts, it had received a boost in October 1609 when Henry, Prince of Wales, acquired one of the greatest libraries of the Elizabethan age from his tutor, Lord Lumley.[51] The library had, however, been neglected during the Commonwealth and, when Dr Richard Bentley was appointed librarian to William III in 1694, he was dismayed to find it in very indifferent order. With the support of Mary II he promptly put forward a proposal that it should be taken in hand and developed as a national library backed by a parliamentary subsidy.[52] However, the death of Mary a few months later, and the upheaval in the royal accommodation following the destruction of Whitehall Palace in 1698, put paid to the ambitious plan.

By the early eighteenth century the majority of the royal books, together with Sir Robert Cotton's collection of manuscripts which had been acquired by the government, had been moved to Cotton House for safekeeping.[53] The collection was later divided up again and stored in a variety of locations including Westminster School, Essex House and Ashburnham House. When fire broke out at Ashburnham in 1731 a significant part of the collection was destroyed.[54]

The book collections Caroline would have been able to find more easily were at Kensington Palace and St James's Palace, and had been made by her recent royal predecessors. John Evelyn had been particularly impressed when in 1693 he visited Queen Mary's book room underneath her gallery in Kensington Palace and with King William's library, with its cases and presses embellished with carving by Grinling Gibbons, which he saw the following year.[55]

But when Caroline and George Augustus were banished from the royal palaces in 1718, access to these libraries, and any other royal book repository, was curtailed.[56] To make good this loss, as soon as the lease for Richmond Lodge was signed, plans were put in place to construct a new library wing there. This was a two-storey range, extending nine bays to the north of the main house. There is no record of the interior arrangements, but it may have been furnished with mahogany bookcases made in a style close to that of the cabinet-maker Benjamin Goodison.[57] A possible candidate survives in the Royal Collection, embellished with a small ivory plaque engraved with the number eighteen – indicating that it was once part of a long set of bookcases.

Caroline drew on the Richmond Lodge library for the small libraries which were established in the Hermitage and Merlin's Cave between 1731 and 1735.[58] With the education of her hermit, Stephen Duck, in mind, Alured Clarke and Charlotte Clayton, Duck's great supporters at Court, discussed the appropriate content. Dr Clarke wrote: 'I think he ought to have Chambers Dictionary, Danet's Dictionary of Antiquities and Bailey's Etymological Dictionary or books of that sort always by him ... I hope neither Swift, not Montaigne, nor South nor the works in the Dunciad controversy will fall into his hands.'[59] A few days later he added: 'as to Shakespeare, one would not confine him to three volumes ... I cannot meet with any satisfaction about a translation of Homer, and therefore I believe he must read Mr Pope's.' Caroline evidently had her own views too, as the libraries eventually contained miscellanies of the work of both Swift and Pope, as well as Pope's editions of *The Iliad* and *The Odyssey*, together with a collection of publications written by some of her friends and heroes such as Theophilus Cibber, Samuel Clarke, Locke and Wollaston.[60] Ariosto's *Orlando Furioso*, works by Lord Shaftesbury and Duncan Campbell's *Predictions*,

The Section of MERLIN'S CAVE *in the Royal Gardens at Richmond.*

as Design'd by M.ͬ Kent. I. Vardy *delin. et sculp.*

which had informed the iconography of the Cave and its setting, were also to be found on the shelves.[61] All the books were given uniform white vellum bindings and the titles were handwritten on the spines, 'in the neat plainness of Quakerism', indicating that there was an important aesthetic consideration (fig. 137).[62]

Caroline's choice of books for Merlin's Cave came in for just as much criticism as her display of waxwork characters drawn from the ancient mythical history of Britain. *Fog's Weekly Journal* on 6th December, 1735, recorded with some irony: 'The Reader having doubtless heard of a library provided for Merlin will be curious to know what authors it consists. It is not composed (as might be expected) of the works of the AEgyptian Hermes, Zorocaster, Xamolxis or Simon Magus which are now lost, much less of Albertus Magus, Cornelius Agrippa, Basilius Valentinus and Raymond Lully which were not then written, but of the Spectator, the Divine works of Dr Clarke' (fig. 138).

At the same time as the libraries in the garden at Richmond were being furnished, at Kensington Palace the 'little library', established by George I in the northeast pavilion, was appropriated by Caroline for use as her *Wunderkammer* and, according to Horace Walpole, as a repository for her rare or special books.[63] These included 'several books that had belonged to Charles I, a genealogical book on vellum of all the pedigrees of the King's of England, with their portraits and arms illustrated, drawn I think for Queen Elizabeth', as

137 *'The Section of Merlin's Cave in the Royal Gardens at Richmond'* by William Kent, a plate from John Vardy, *Some Designs by Mr Inigo Jones and Mr Wm Kent*, 1744. British Library

well as a 'curious little book of manuscript by Esther Inglis, 1613, and dedicated to King Charles I when Prince', which Walpole noted was famous for the smallness and neatness of the writing.[64] There was a large collection of atlases and folios of prints and drawings, possibly the residue of Caroline's great discovery in the King's Closet in 1727. The three volumes of engravings by Wenceslaus Hollar which appear in the original list of the discovery, and were later 'by her lent to Lady Burlington', were certainly later 'laid in the library at Kensington'.[65]

Several schedules survive recording a lively traffic of books between the book rooms in all the palaces. The process was managed by John Krahe, Herman Hobourg, John Shaw and Henry William Lawman, Pages of the Backstairs, with the assistance, on occasion, from Lady Charlotte Roussy, a member of Caroline's household, and Margaret Purcell.[66] In December 1736 Lord Hervey was asked if he would carry *The Designs of Inigo Jones* and *The Reign of Queen Elizabeth* from Kensington Palace back to St James's.[67] If such records provide ample evidence that the book collection was well used, it also indicates that the existing arrangements were not very practical (fig. 138).

If Caroline looked for models for her new library after her arrival in London, there were few in England which even began to approach the scale of those she had encountered in Europe. Before the 1720s a library had seldom been treated as a distinct architectural space in the house, even when a collection of books was in existence. One of the earliest examples was made by the Earl of Warrington at Dunham Massey, a project which started in about 1706. Sir Andrew Fountaine, tutor to Prince William Augustus, made a library at Narford

138 *Lord Hervey and his Friends* by William Hogarth, oil on canvas, 1738–39. National Trust, Ickworth

in about 1716 and was painted by Hogarth with his friends examining a painting presented by the auctioneer Christopher Cock, from whom Caroline purchased some of her books. Sir Robert Walpole, with whom Caroline discussed her art collection, had a library constructed in his new house at Houghton in Norfolk in the 1720s. But both these rooms were small.[68] Just a few women in Caroline's circle maintained their own book collections: Lady Burlington's collection was accommodated in rooms designed for her in the Link Building adjoining her husband's new villa at Chiswick, and Mary Lepell, one of Caroline's Maids of Honour, who married John Hervey in 1720, was responsible for the creation of the library at Ickworth (fig. 139).[69]

Reading the catalogues of her book collection, the scale of Caroline's ambition becomes apparent. The earliest of these, the *Catalogue of All the English Plays in Her Royal Highnes's* [sic] *Library*, was made in 1722. It lists hundreds of plays dating from the sixteenth to the eighteenth centuries and provides evidence of Caroline's interest in the theatre.[70] The next

139 *Conversation Piece. A Portrait of Sir Andrew Fountaine with Other Men and Women* by William Hogarth, oil on canvas, c. 1730–35. Philadelphia Museum of Art, The John Howard McFadden Collection, 1928

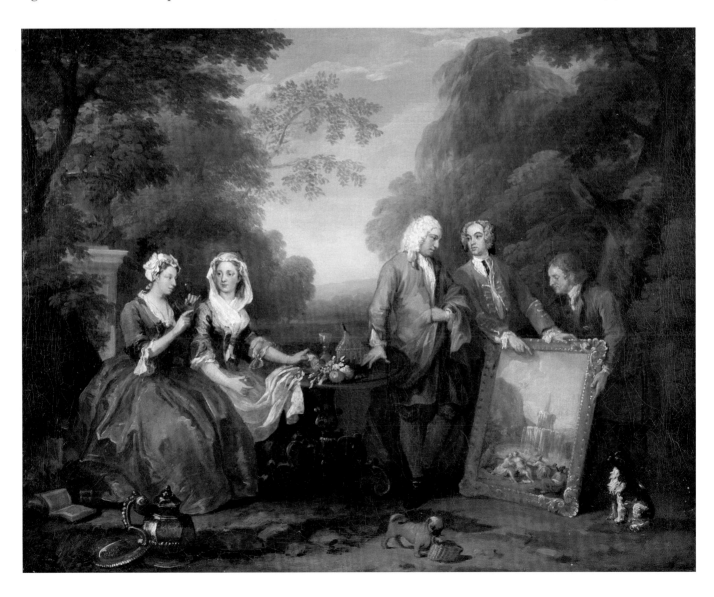

listing, *A Catalogue of the Royal Library of Her Late Majesty Queen Caroline Distributed into Faculties*, written up by professional scribes, was made under the auspices of Francis Say, who was appointed Caroline's librarian in March 1737, and John Hamilton, the 'Library Keeper'.[71] Completed in 1741, well after Caroline's death, it contains nearly three thousand titles carefully arranged by subject.[72]

The *Catalogue of the Royal Library* shows Caroline was ever the faithful pupil of Leibniz. Back in 1691 he had prepared a memorandum for his Hanoverian employers suggesting that a book collection, as well as being carefully organised and catalogued, should have a considered acquisition policy to build the collection and should be available to scholars.[73] Caroline's collection was universal and encyclopaedic, including many compendia, dictionaries and directories, so it could serve as a resource for the exploration of all branches of knowledge. It was cosmopolitan in that it contained publications in a wide range of languages and concerning many cultures.[74] Most of the books were written in French, the language in which Caroline found it easiest to converse, and in which she usually wrote, though there were still plenty written in English, which she spoke fluently.[75] There were smaller collections of books in Italian, German and Latin, and one or two titles in Spanish and Dutch. There were works in Latin, though Caroline would have had difficulty reading them. She had to ask her physician, Dr John Friend, for a translation of the Latin dedication to her in one of Sir Isaac Newton's books.[76] German titles were in the minority despite her facility with this language; after Latin, French was seen in the early eighteenth century as the language of intellectual exchange and German had a relatively low status. She may also have believed this to be evidence of her concern to promote English interests above all others.

The books were carefully arranged into classes echoing the practice of Leibniz in the libraries he had supervised in Wolfenbüttel and Hanover. Almost half the books related to historical subjects – the categories included classical history, ecclesiastical history, the history of individual European countries, and of the continents of Africa, America and Asia. As well as the substantial collection of plays, there were also collections of novels and poetry, and books on divinity, philosophy, music, medicine, art and architecture. It was a library overwhelmingly of contemporary literature – almost every book was published after the mid-seventeenth century. Many of the books were beautifully bound, and on occasion Caroline's coat of arms was painted on the fore-edge (fig. 140). This was to be the first library compiled by a member of the royal family in Britain on universal encyclopaedic principles, and it would certainly have contributed to making a very appropriate setting for cultural debate.[77]

140 *Histoire du théâtre italien depuis la décadence de la comédie latine* by Luigi Riccoboni, 1728. The Royal Collection

There were plenty of titles which provide an insight into Caroline's particular interests. Politically it was a library biased towards Whig philosophy, containing works by Joseph Addison, whom she had met in Hanover in 1706, as well as Richard Steele, Colley Cibber, Richard Blackmore and Nicholas Rowe.[78] Caroline subscribed to Steele's periodical *The Plebeian* in 1719, and described its attack on the Peerage Bill as 'delightful'.[79] There was a small collection of works by female authors such as Aphra Behn and Susanna Centlivre. There was a small collection of books concerning contemporary medicine, including Richard Holland's *Observations on the Small Pox*. She kept abreast of fashionable trends in gardening theory with Batty Langley's *New Principles of Gardening*. There was a copy of David Jones's *The History of the Most Serene House of Brunswick-Lunenburgh* [sic] as well as six copies of Leibniz's *Scriptores rerum Brunsvicensium*, the great genealogical research project he had undertaken for the Electress Sophia which had established the historical link between Brunswick and the royal family in Britain. It is interesting to find amongst such worthy tomes a small number of books concerning ghosts and angels, and a sensational work about the woman who had reputedly given birth to rabbits.[80] As with her cabinet of curiosities, an appraisal of the book collection will reveal that Caroline had a stake in both the traditional princely tradition of the Renaissance as well as the new world of the Enlightenment.[81]

There is plenty of evidence that Caroline sought out works by Newton, John Arbuthnot and William Somervile as well as from other writers who flocked to her salon, no doubt anxious to ensure she held her own in discussion. John Gay noted in August 1714 that 'The Princess and the Countess of Picbourg have both subscribed to Pope's *Homer*.'[82] Dr Arbuthnot wrote to Swift in 1726 on the publication of *Gulliver's Travels* to tell him that he 'had seen the Princess of Wales and found her reading the Travels and she was just come to the passage of the hobbling Prince, which she laughed at.'[83]

The book collections grew rapidly with Caroline's literary and academic interests. Within weeks of her arrival in London, authors were making their way to St James's Palace to present her with copies of their new publications. Samuel Clarke was amongst the first; Caroline read his books immediately and Lady Cowper reported shortly afterwards that her mistress announced: 'Dr Clarke shall be one of my favourites, his writings are the finest things in the world.'[84] On his death Caroline commissioned a fulsome epitaph from Benjamin Hoadly and had this added to her painted portrait of Clarke (fig. 141). John Gay followed hard on his heels to present her with *The Shepherd's Week* and returned in 1720 with *Poems on Several Occasions*.[85] Many publications dedicated to Caroline found their way into the collection. Nicholas Rowe's *Lady Jane Grey* was one of the first in 1715 and Mary Monk's book of poems, *Marinda: Poems and Translations on Several Occasions*, followed in 1716. Knowing her interest in the theatre, Colley Cibber in 1728 dedicated to her his work which completed Vanbrugh's *The Provok'd Husband* and, as previously mentioned, John Gay's work was well represented. While it is not surprising to find this practice adopted by writers such as Stephen Duck who were supported by Caroline's generosity, she also attracted admirers from wider international literary circles such as Voltaire, who dedicated *Henriade* to her in 1728.[86] There were also donations from organisations seeking to associate their activities with the new regime, such as the Society of Ancient Britons, which presented Caroline with a copy of their statutes.

SAMUEL CLARKE D.D.
Rector of S.t James Westm.
In every part of Usefull
Knowledge, and Critical
Learning; perhaps without
a Superior; In all united,
certainly w.thout an Equal;
In his Works, the Best Defen
der of Religion; In his Prac
tice, the Greatest Ornament
to It: In his Conversation,
Communicative; and in an
Uncommon manner, In-
structive; In his Preaching &
Writings, Strong, Clear, &
Calm: In his Life, High in the
Esteem of the Great, y.e Good,
& the Wise; In his Death,
lamented by Every Friend
to Truth, Virtue, & Liberty.
He died May 17, 1729, in
the 54.th year of his Age.

141 *Dr Samuel Clarke*
attributed to Charles Jervas,
oil on canvas, 1729–30.
The Royal Collection

Gifts of books flooded in from book collectors too. When it became known that she was interested in old romances, Lord Sunderland gave her a 'very scarce' example from his own library 'to the surprise of everybody who knew his passion for books'. The 3rd Duke of Argyll gave her 'an ancient' edition of *Amadis*, Sir Hans Sloane contributed volumes of military plans and Colonel Robert Dormer-Cotrell sent contributions unspecified from his library at Rousham.[87] A small volume which survives in the Royal Collection of Dorigny's engravings after Raphael's cartoons for the Acts of the Apostles tapestries was presented by Marie Maugis.

Caroline purchased books on her own account from booksellers such as James Roberts, John Jackson, Mr Knapton and Pierre Dunoyer. Paul Vaillant and his sons Paul and Isaac supplied her European titles.[88] On occasion she sought out second-hand books too: there is a reference to a play purchased from the collection of 'Mrs Of[e]ilds' – probably the actress Anne Oldfields, who had been drawn into Princess's circle at Leicester House – as well as various tomes from the library of the politician Thomas Sclater Bacon. For one rare though unspecified title she paid £115. 2s. 6d. to Christopher Cock, an auctioneer trading in Covent Garden.[89]

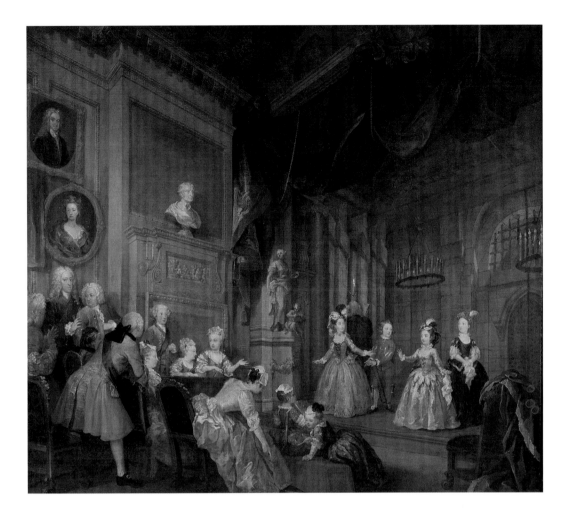

Also to be found on the shelves were books Caroline had a hand in commissioning herself, which might be seen as evidence of her intention to encourage the arts and sciences. These books were particularly calculated to benefit the education of her children. In 1716 Richard Bentley, the royal librarian, received instructions to make a new edition of classical works for the use of Prince Frederick. While the request came ostensibly from the Lord Chief Justice and George I, it is likely Caroline played her part too. She would later directly encourage Bentley to make a new edition of *Paradise Lost*, remarking 'that he had printed no edition of an English classic and urging him to undertake Milton'.[90] The royal children were intelligent and well educated, as demonstrated by their school exercise books which survive – Princess Anne's in the Royal Collection of the Netherlands and Prince William Augustus's in the British Library (figs 143 and 144).[91] As early as 1714 Lady Cowper recorded: 'The little princesses who are miracles of their ages, especially Princess Anne, who at five years old speaks, reads and writes both German and French to perfection, knows a great deal of history and geography, speaks English very prettily and dances very well.'[92] Lord Egmont recorded that Amelia was another able linguist.[93] All the children were introduced to the theatre when young. Hogarth depicted Prince William Augustus, Princess Louisa and Princess Mary in the audience of an amateur theatrical

142 *A Performance of 'The Indian Emperor or The Conquest of Mexico by the Spaniards'* by William Hogarth, oil on canvas, 1732–35. Private Collection

143 School book of
Princess Anne, c. 1720–30.
The Royal Collection of the
Netherlands

144 *The Original Exercise
Book of HRH The Duke
of Cumberland when a Boy,
in his own Handwriting,
28 Nov. 1727–25 March 1728.*
British Library

ISTORIA
DELLE RIVOLUTIONI
ACCADUTE
NELLA REPUBLICA ROMANA
VOL. II. LIB. V

performance which took place in the house of John Conduitt, Master of the Mint. The eminent moral philosopher Dr John Desaguliers acts as prompt for the young performers (fig. 142).

Members of Caroline's household were quickly caught up in her literary enthusiasms. Contemporary writing, including racy titles, circulated amongst her vivacious flock of Maids of Honour, often in manuscript. Lord Hervey wrote to his friend Stephen Fox in 1731 about Lady Deloraine, claiming she 'has taken of late into the sweet fancy to study philosophy and talks all day, and I believe dreams all night of a plenum and a vacuum. She declares of all philosophers Dr Clarke is her favourite and said t'other day if there was any justice in Heaven, to be sure he took place there of the twelve apostles.'[94] Charlotte Clayton's friend Henrietta Louisa Jeffrys (later Countess of Pomfret), a Lady of the Bedchamber, compiled her own family genealogy, inspired no doubt by Caroline's research interests. As noted earlier, it was Lady Hervey rather than her husband who was the great bibliophile in the family. Among these people and those with whom they came into contact, Caroline can be seen as the catalyst. At Court she maintained the balance between new, lively and libertine attitudes, with more measured tradition, encouraging writers from each camp in equal measure. As a member of the royal family she stood as a particularly potent example of how a confident, articulate woman, prepared to improve herself through enquiry and experience, could make her mark even within spheres traditionally regarded as that of a man. Caroline's salon served as model too. As has been mentioned, Henrietta Howard

145 *The 'Henry the Fifth Club' or 'The Gang'* attributed to Charles Phillips, oil on canvas, c. 1730–35. The Royal Collection

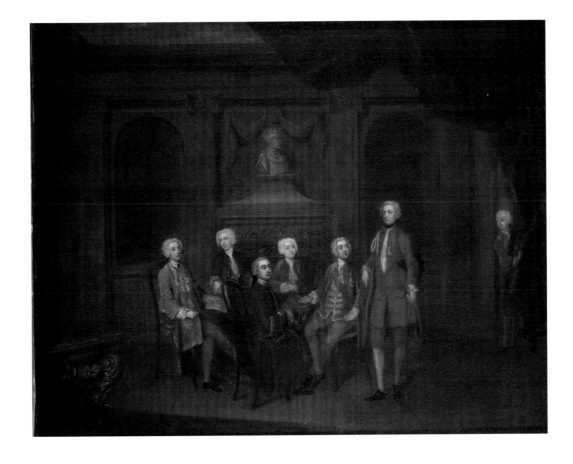

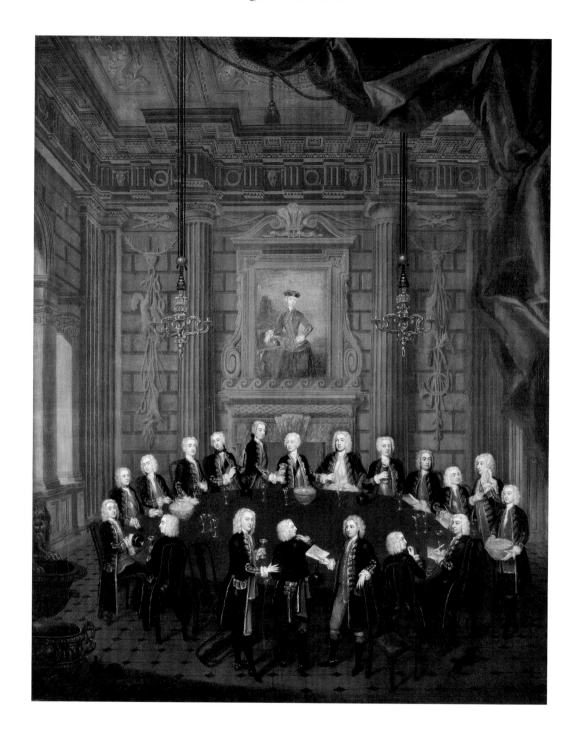

maintained a rival intellectual circle, and Caroline's son Frederick would work hard to draw together his own coterie. While this may have been motivated by his ambition to bolster his influence, the historically styled names given to his gatherings – The Round Table, and the Henry V Club – echo Caroline's interests and vision for the family (figs 145 and 146).

Caroline died before her great library was complete. It is impossible to say now whether it was intended to serve as the venue for a reconstituted salon. Of Britain's earliest royal universal library only a tantalising glimpse remains in the small number of books to survive from her collection, often re-bound by their later owners. It is nonetheless a rich mixture and includes an edition of Cerventes's *Don Quixote*, *Ancient Coins, Weights and Measures*, *Osteographia, or the Anatomy of Bones*, Richard Holland's *Observations on the Small Pox*, Ovid's *Metamorphoses*, *A View of Sir Isaac Newton's Philosophy*, the volume of Dorigny's engravings after Raphael's cartoons for the Acts of the Apostles tapestry series and the works of William Wollaston and Shakespeare.

146 *Frederick Prince of Wales, with the Members of 'La Table Ronde'* by Charles Phillips, oil on canvas, 1732. The Royal Collection

6

CAROLINE
and the *Natural Philosophers*

While Caroline's library contained many of the classic texts one might expect to find in the collection of a princess educated to traditional Renaissance notions of princeliness, the list of titles provides ample evidence that her interests extended into the realms of science and natural philosophy – the modern and the new.

Following her arrival in London, Caroline was drawn swiftly into the world of the natural philosopher. The most celebrated of the debates she organised and presided over was that between Leibniz and Dr Samuel Clarke, one of Caroline's protégés, and concerned Sir Isaac Newton's work on calculus. It was conducted through a series of letters which passed between Leibniz and Clarke and which Clarke prepared for publication between 1715 and 1716. At the heart of the exchange was the question who should be given credit for the discovery of calculus – or as Newton termed it, 'the method of fluxions and fluents'.[1]

Newton claimed his work on calculus had commenced in about 1666. However, apart from a short reference to it in *Philosophiae Naturalis Principia Mathematica* in 1687, it was not until 1693 that the research was published in part and not until 1704 in its final form. In the meantime Leibniz, who may have had the opportunity to examine some of Newton's work in manuscript while visiting London in 1676, had published his own version of

Opposite
147 Orrery made by
Thomas Wright, 1733.
Science Museum, London

149

differential calculus in 1684. While it is clear that Newton came by his calculation first, it is probable that Leibniz reached his conclusions independently and published his work in good faith. By 1711 they were engaged in a fierce dispute.

Caroline was initially an enthusiastic champion of Leibniz; she missed his company and from 1714 sought to bring him to London as historiographer to the new dynasty.[2] However, with the setting up of the salon in 1714, there was early acknowledgement that Newton was venerated as a national hero and it was clear that she would be wise to explore his theories too. After coaxing him to her drawing room in March 1716 she wrote to Leibniz: 'Tomorrow we will see the experiments with the colours, and the one that I have seen to prove the vacuum has nearly converted me.'[3] These experiments 'with the colours', using prisms to refract light, must have been extremely beautiful as well as interesting. Caroline was soon a much less neutral observer, and Clarke went on to arrange face to face discussions for her to explore Newton's 'system of philosophy'. Two months later she reported enthusiastically: 'I am in on the experiments, and I am more and more charmed by colours. I can't help being a little biased in favour of the vacuum.' Despite Leibniz enlisting Conti as his advocate in London, Caroline's allegiance had shifted and Leibniz would never receive a summons to join her in London.[4] If there was to be a new cultural energy at the heart of the Court, Newton was too important not to be involved (fig. 148).

Fired with new enthusiasm, Caroline and George Augustus began to attend lectures in experimental philosophy given by John Theophilus Desaguliers at the Royal Society, and

148 Title page from Sir Isaac Newton, *Opticks*, 1704. Wellcome Library, London

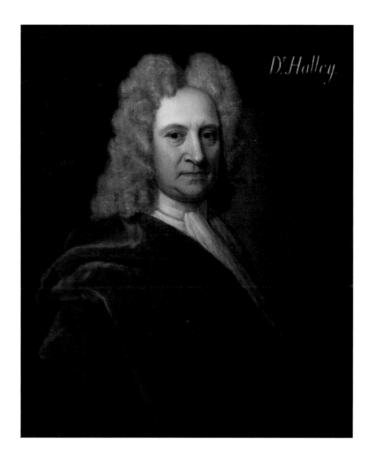

they became friends with Samuel Molyneux, the astronomer and performer of optical experiments.[5] Edmund Halley, the Astronomer Royal, was invited into her salon (fig. 149). After her visit to the Royal Observatory in 1729, when she learnt Halley had been a captain in the Navy, she obtained a warrant which allowed him to continuing drawing half pay until the end of his life. She would pay Thomas Wright £336 in 1733 for 'making all the Machinery and Wheel-Work to perform the Motions of all the planets and Co to the Great Orrery', which was a mechanical model of the solar system. When this was delivered to Kensington it was set up in splendour in the Queen's Gallery for all to admire (fig.147).[6]

Britain's active programme of commercial development and exploration overseas was another aspect of the national life that Caroline sought to promote. Lord Egmont recorded several conversations with Caroline concerning the early North American exploratory and trading missions managed by James Edward Oglethorpe, the army officer and founder of the colony of Georgia. On 1st August, 1734, according to *The Gentleman's Magazine*, Oglethorpe brought Tomochichi, chief of the Yamacraws, a branch of the Creek tribe of Native Americans, his wife Senauki and nephew Tooamokowli (Toonahowi), together with a small retinue from Georgia, to Kensington Palace to present eagle feathers as tribute to the royal family.[7] Lord Egmont was an excellent commentator on the occasion. He had found a good friend in Oglethorpe when in 1728 they were both members of a parliamentary committee investigating prison conditions, and in 1730 they both became part of an association that later became the Trustees for Establishing the Colony of Georgia in

149 *Sir Edmond Halley* by Richard Phillips, oil on canvas, before 1722. National Portrait Gallery

America. In 1732 George II had approved a charter for the colony, making Egmont president of the Georgia Trustees, and this ensured his determination to make the royal visit a success. There was considerable debate about the style of dress that the Yamacraws should wear. In the end a red frock-coat trimmed with gold galloon lace and rabbit fur was chosen for Tomochichi. The other men in his party wore a similar outfit but made in blue. All were cut long; Lord Egmont noted this was because 'they wore no breeches'. Senauki was provided with a 'scarlet Rosetti, in the make of our English wrappers'.[8] It must have made a very impressive scene in Kensington's Presence Chamber. The visitors arrived with their faces 'most hideously painted' in 'red and black, so thick that at a distance they looked like masks'. After the formal audience, Samuel Clarke recorded that Caroline called back the chief's young nephew to give him presents and to introduce him to Prince William Augustus, encouraging the two children to play together.[9] The delegation later had their portraits painted in their splendid new clothes (fig. 150).[10]

In her role as an encourager of trade and industry Caroline accepted in 1735 a length of organzine reeled by Piedmontese textile workers sent to Georgia in an attempt to encourage the embryonic silk industry there. The thread was later woven at Sir Thomas Lombe's Mill in Derby.[11] Wearing a dress made up from the new American silk, she was very vocal in her support of this initiative. Caroline also wore Irish textiles which she had acquired through the auspices of Jonathan Swift. He joked that the Queen and her daughters had become the toast of the Irish weavers.[12] In 1730 she bought lace goods from Mr Stockers

150 *Audience Given by the Trustees of Georgia to a Delegation of Creek Indians* by William Verelst, oil on canvas, 1734. Gift of Henry Francis du Pont. Winterthur Museum, Wilmington, Delaware

and Mr Reeds, lace manufacturers from Buckinghamshire and Bedfordshire, after their request that she support the local industry.[13]

Her interest in hygiene and medicine proved of particular benefit to her children. Caroline was a passionate advocate of regular bathing – a rather novel practice in the early eighteenth century. Between 1727 and 1737 at least twenty-four bath tubs were acquired for her family in various sizes. The tubs were made of wood bound round with iron hoops.[14] The larger examples had wheels underneath so they could be moved easily through the rooms in the royal homes. When not in use they hung against the wall from big hooks. To prevent damage to the fine floors in the State Apartments floor cloths were provided, some of them painted to resemble carpets. Members of the royal family each had their own set of linen and a little stool which they would place inside the bath to sit on as they bathed.

She took radical practical measures to protect her children from smallpox after Princess Anne caught the disease in 1720.[15] In 1714 Dr John Woodward had read to the Royal Society a paper written by Emanuel Timoni, a Greek physician, concerning the practice of inoculation he had encountered in Turkey. In 1717 the reading of a second paper on the subject by Giacomo Pylarini, an Italian doctor, coincided with the start of Lady Mary Wortley Montagu's campaign to promote its efficacy amongst her friends at Court. Lady Mary's husband was ambassador in Constantinople in Turkey and under the supervision of the embassy surgeon, Charles Maitland, she had Edward, her eldest child, inoculated in 1718. Her infant daughter Mary was submitted to the procedure in London in 1721.

At Caroline's request, though no doubt with the encouragement of the royal doctor Hans Sloane, George I commuted the sentences of six prisoners at Newgate Prison on the undertaking that they would take part in an inoculation experiment conducted by Charles Maitland.[16] Despite the success of this, before allowing her children to undergo the procedure, Caroline interviewed Dr Daniel Neal – the publisher of two tracts on inoculation research undertaken in New England – asked to meet Lady Mary's young son and initiated a second round of inoculation experiments. The experiments were conducted on five foundlings from the parish of St James's Piccadilly.[17] Eventually convinced of its safety, Caroline asked Claude Amyand, George I's surgeon, under the supervision of Maitland, to inoculate Amelia and Caroline in April 1722. Maitland later travelled to Hanover so that Frederick could be treated too.[18] Prince William Augustus and his youngest sisters were inoculated later.[19] Sloane was fulsome in his praise of Caroline for her part in promoting this advance in medical practice. James Jurin, Secretary to the Royal Society, physician at Guy's Hospital and disciple of Newton, dedicated his *Account of the Success of Inoculating the Smallpox in Great Britain* to Caroline in 1725 Jurin was quick to acknowledge the key role played by Maitland in the development of the process. Her initiative was widely reported in the press, sending powerful messages about the modern and enlightened nature of the new regime (fig. 151).

Further encounters with scientists and with technology were organised for the children as part of their lessons. At the recommendation of Newton, Robert Smith, a professor of astronomy, was engaged to teach William Augustus mathematics, while astronomy was taught by Sir Edmond Halley. A laboratory and a printing press were set up for his use in the cellar at St James's Palace and there, with the guidance of Mr Palmer, a local printer, and assisted by his sisters Mary and Louisa, he composed his own booklet entitled '*The*

(13)

The Number of Persons inoculated the last Year, as far as I have been able to collect it, is as follows, taking in four Persons inoculated the Year before, which came too late to Hand to be inserted in my last Account.

Inoculated in *London*,

By *Claudius Amyand*, Esq; Principal and Serjeant Surgeon in Ordinary to his Majesty, 11

By Mr. *Maitland*, Surgeon, (besides 9 inoculated at *Hanover*, not inserted in this Account,) 4

Mr. *Pemberton*, Surgeon, —— 3

Mr. *Cheselden*, Surgeon, by the Direction of Dr. *Plumptre*, 1

Mr. *Pawlett*, Surgeon, —— 1

At *Norwich*,

By Dr. *Howman*, —— 2

By Dr. *Offley*, —— 1

At *Ipswich*,

By Dr. *Beeston*, —— 3

At

151 Page from *An Account of the Success of Inoculating the Smallpox* by James Jurin, 1725. Wellcome Library, London

Laws of Dodge-Hare' in 1731.[20] There are several references to his 'model of the mines'.[21] Newton had made such an impression on six-year-old William Augustus that he insisted on attending Newton's funeral in 1727.

But despite so many schemes exploring new ideas about the world and its workings, it is very evident that Caroline still had a stake in an older realm of magic and superstition. She would continue the Renaissance tradition of creating a cabinet of curiosities – the physical embodiment and explanation of the world in miniature – just as Sophia, Sophie Charlotte and Liselotte had done before her.

In Berlin, as a young woman, Caroline saw the collection of rarities assembled by the electors of Brandenburg. During the last years of the seventeenth century there had been considerable investment in this collection, and material had been assimilated from collections made earlier by Erasmus Seidal and Gerrit Reynst in Amsterdam, by Hermann Ewich from Xanten and Christian Lorentzenen Aldershelm from Leipzig. The Prussian Admiral Raule contributed what might be described as 'naturalia' and ethnographic material from his travels in Asia. There would be an influx of antiquities from Rome following the purchase of the archaeologist Giovanni Pietro Bellori's collection.[22] In 1686 Lorenz Berger of Heidelberg, one of the greatest antiquarians of his day, had been appointed Councillor and Librarian by Frederick III, and Caroline was present in 1703 when under his supervision the Cabinet of Coins and Medals, the collection of antiquities, the *Kunst-und Naturalienkammer* and the library were moved to a suite of rooms newly fitted out on the third floor of the town palace in Berlin (fig. 152).

The Electress Sophia and Liselotte maintained cabinets of rarities too. The contents of the *Wunderkammer* made by the Electress Sophia, divided between the Leineschloss in Hanover and Herrenhausen, were recorded in an inventory completed in 1709. Written in

152 *Berliner Kunstkammer* by Samuel Blesendorf, a plate illustrating part of the collection of the Elector Frederick III in the Stadtchloss, Berlin, from *Thesaurus Brandenburgicus*, vol. I, 1696–1701

French, it includes sections for '*D'Argenterie*' and '*Des Vases et Coupes d'Agat et Cristal*' amongst other classes of objects. In the list of items made out of agate or crystal there are descriptions of '*8 petites coupes d'agat avec leurs pieds garnie d'agent doree*', '*2 petits coupes d'agat vermaille doree*' and '*4 vases forme de gondole de cristal de roche avec leurs pieds garnie d'or*'.[23] Liselotte's collections were also extensive. She collected coins and medals – an activity usually associated with men – with particular enthusiasm, and wrote to Caroline: 'in all I have four hundred and ten medals. I amuse myself by having learned men discuss them, and I have the inscriptions that are on the back translated for me. This interests me greatly. You are right in thinking that Hanoverian medals are incomparably finer than those of Nuremberg.'[24]

It is also possible that Caroline, as a child, encountered the collections made by the Saxon electors in Dresden. These were amongst the most extensive and sophisticated made either at a Court or in an academic circle anywhere in Europe. The *Kunstkammer* and *Wunderkammer* had been founded by Augustus of Saxony in about 1560 and they were in a series of attic rooms in the town palace in Dresden. When an inventory was made in 1587 the list of contents already ran to about ten thousand entries.[25] It was organised following rules laid down by Johann Daniel Major in his *Kunst- und Naturalienkammern* which in turn had derived from advice given in *Inscriptiones vel Tituli* by Samuel Quiccheberg, the most important museological text of the sixteenth century. This suggests that four classes of artefacts be included so that the collection could represent the whole universe. The first category was of sacred objects, paintings and other works of art; the second comprised works of art produced by man but made of natural materials; the third group was of organic material in its unaltered state; and the last category was of artistic works which could stand as a genealogical table.[26]

In choosing artefacts for their collection the Saxon electors had prized technical virtuosity above all else, and the list of their treasures contains many descriptions of carved cherry stones and ivory turnings, together with the magnifying glasses, lathes and other equipment used in producing them. The pieces of equipment were often given complicated and costly mounts to boost their status as exhibits. There were other specialist collections, including an armory, a treasury, a cabinet for coins and medals, and a novel *Anatomie-kammer* containing human and animal fossils and skeletons as well as a library. Despite their idiosyncrasy, the collections became a resource used by the scholars, scientists and craftsmen at the forefront of Saxony's industrial expansion. Caroline's half-sister, Countess Dorothea Friederike of Hanau-Lichtenberg, maintained a cabinet of curiosities too – evidence of a family expectation that this was an appropriate activity for her to pursue.[27]

In 1727 Caroline decided to make her own cabinet of curiosities. She chose Kensington Palace as her venue and found two rooms on the first floor of the north-east pavilion, used earlier by George I as a library, which she could clear.[28] A number of cabinets were installed, described variously as 'the glass cabinet', the 'wooden cabinet' and the 'other cabinet'. In the Royal Collection there is a large mahogany collector's cabinet dating from between 1730 and 1740 which may once have been part of this group. Carved with reliefs of Andrea Palladio and Inigo Jones – Caroline's architect heroes – it has three bays. The cupboards in the upper section are fitted with shelves. In the plinth the central bay is filled with thirty shallow drawers, the side cupboards with sixteen deep drawers.[29] In its design the cabinet is very reminiscent of the work of William Kent and can be compared with a library cabinet

now in the Victoria and Albert Museum.[30] There have been later alterations, but it is possible that it was made originally by one of Caroline's favoured cabinet-makers, either James Riorto or Richard Nix, who received payments from her Privy Purse (fig. 153).[31]

The most comprehensive list of Caroline's curiosities was made by Margaret Purcell, her Laundress, who served as the model for the waxwork of Elizabeth of York in Merlin's Cave and accompanied her on early morning jaunts to Richmond. It is a very practical document, noting when care should be taken while opening the drawers of one of the cabinets to prevent the contents jumping out.[32] Later, in 1763, Horace Walpole made some notes about the collection, in what he termed the 'little library', in the margin of his copy of Bathoe's *A Catalogue of Pictures Belonging to King James the Second*, stating that this had been 'fitted up (I believe) by Queen Caroline'. He returned the following year to make two longer and more detailed lists.[33]

153 English collector's cabinet, mahogany, 1730–40. The Royal Collection

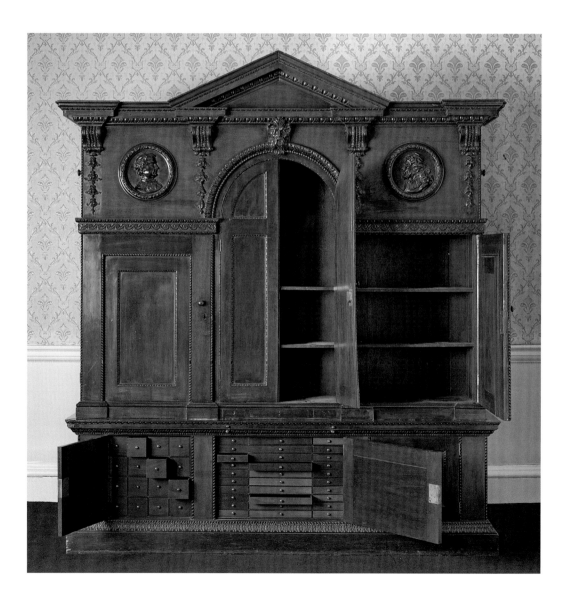

156

Caroline's collection comprised nearly two hundred gems, a hundred and twenty-six pieces of jewellery and over a thousand medals. There were twenty-three cups, five salts and four bottles, or ewers, made from shell, ivory, precious stones or metal. There were four pieces of coral set in jewelled mounts. Thirty natural history items included a loadstone, an ivory tusk, two 'unicorn horns' and bezoars – calculi or concretions found in the stomach or intestines of some animals when animal matter builds up around some foreign substance. Ethnographic material, to use a modern term, was limited: there were just ten weapons of Middle Eastern origin. Amongst the scientific instruments there was a sun dial and a 'burning glass'.

Although the collection was small when compared to the collections in Dresden and Berlin, Caroline, like her forebears, sought to draw together classes of artefacts to represent the world in microcosm, following the prescription of Quiccheberg. The 'crystal cup and cover, a humming bird in it', an 'agget Cup & cover set in silver gilt', a 'Green cup wrote wth figures & in it two branches of Correll' and 'a crystal shell and tryton set with jewells' would serve to demonstrate the skill and artistry of the maker. To show the ingenuity of man in mastering and manipulating natural materials there was agate, onyx and coral worked into elaborate artefacts such as 'a moco salt cellar', which was given an emerald rim, a 'shell with Hereglyflicks set in gold', 'flaggons of ivory carved', 'two ivory cups & covers with bas reliefs', 'a round ivory vase carved by Fiamingo' and lathe-turned ivories. There were natural curiosities in their unaltered state such as bezoars and 'unicorn horns'– in fact, the tusks of the Arctic narwhal. A collection of medals was arranged, as Horace Walpole noted in his inventories, to represent various royal dynasties (fig. 154).[34]

It may seem curious to find bezoars and 'unicorn horns' in Caroline's list. These traditional curiosities had been prized for centuries for their magical properties.[35] But such intellectual disjunction was typical of the time. Leibniz presented a similar conundrum to the contemporary historian. His pronouncements in articles written for the *Journal des Sçavans*, the *Acta Eruditorum* and the *Mémoires de l'Académie Royale des Sciences de Paris* between 1676 and 1716 extend from the nature of time and space to talking dogs, unicorns, monsters and genies. This eclecticism stands as evidence that in this era there were many curious commentators prepared to explore and concede the possibility of strange phenomena, with an assumption that they would eventually take their place within a more complete picture of the natural world once new contexts had been identified.[36]

Moreover, for Caroline, in its eclecticism the collection satisfied several additional purposes. Firstly it made a link with the European princely connoisseur milieu in which she had been raised and provided a home for gifts she received from family members. Secondly it could be a repository for the traditional curiosities she located and brought together from the Tudor and Stuart royal cabinets in celebration of her distinguished forebears, and allow it to become a complement to the 'store of portraits of the English'.

The greater part of Caroline's cabinet was indeed made up of material collected by her English royal predecessors. James I on his accession in 1603 had inherited an impressive collection of virtuoso metalwork and curiosities commissioned and collected by Henry VIII and Elizabeth I. It was already beginning to be considered a source of pride and an unalienable asset of the Crown, and after 1614 efforts were made to curb the practice of its being used as a source of diplomatic gifts (fig. 155).[37]

154 *Hercules*, North Italian, Saxon agate, late sixteenth century. The Royal Collection

155 English cameo carved with an image of Queen Elizabeth I, sardonyx, c. 1575–85, the mount early eighteenth century. The Royal Collection

James I was succeeded by Charles, his younger son, in 1619 and a catalogue made by Abraham van der Doort, curator to the new king, reveals that the collection he inherited was rich in cups, salts and other novelties made of crystal, agate, gold, silver gilt and silver, decorated with enamel and jewels.[38] There was a collection of natural history which included coral, ostrich eggs and three 'unicorns' horns. Ethnography was represented by items such as 'a mans head in brasse blackt over wth black vernish being soe big as life upon a black Tutchstone square Peddestall said to be an antiquity from Peru, Brought from Germany by Sir Henry Vane and given to yor Maty', also 'an eight square Eygptian stone table wth divers figures in reivo' and a 'conjuring Drum from Lapland'.[39] The collection of medals which he had inherited from his elder brother, Henry, Prince of Wales, and in which he took particular delight, was stored in drawers lined with white felt and fine leather in the Cabinet Room at Whitehall Palace (fig. 156).[40]

Following Charles I's execution in 1649 much of the metalwork was melted down, and other artefacts were dispersed through the series of sales of the royal collection which took place between 1649 and 1651. However, the trustees of the late king's estate stipulated that certain material should be retained to furnish Whitehall, Windsor, St James's, Somerset House and Theobalds. This included Charles's books, models, medals, globes, mathematical instruments and sculpture.[41]

When John Evelyn visited Whitehall Palace in 1660, following the restoration of the monarchy, he was delighted to find that the reserved items had been preserved in good

156 Italian cameo carved with the image a lady, possibly Mary, Queen of Scots, c. 1560, the mount eighteenth century. The Royal Collection

157 Roman cameo carved with a profile portrait of the Emperor Claudius, sardonyx, glass backing with colouring, 43–5 AD, the mount possibly seventeenth century. The Royal Collection

order and that other parts of the collection were already being rebuilt with the return of some of the items dispersed at the sales.[42] William and Mary would later add new collections of scientific instruments, ceramics and hardstone carvings from China, Japan and Korea.[43]

The inventories made of Caroline's cabinet by Horace Walpole show that it contained gems, cameos and a 'shock dog, marble; incomparable workmanship; I believe by Bernini', which had originally been part of Henry VIII's collection.[44] Abraham van der Doort's description made in the early years of the seventeenth century, of 'A Whitehall peece done in King Henry the 8ts tyme. Item a little shagged dogg scratching his head with his left hinder legg being carved in Alleblaster wch yor Maty had when you were Prince being don in King Hnery 8ts tyme' fits exactly with Horace Walpole's description over a hundred years later. In his annotation to Bathoe's guidebook he described the piece as 'A little shagged dog scratching his head with his left hinder foot, being carved in alabaster which the King had when he was Prince being done in King Henry VIII's time.' Mrs Purcell's list contains a description of a damaged cameo of the Emperor Claudius dating from c. 43–45 AD, once part of the collection of Henry, Prince of Wales. It had been broken by Lady Somerset during the time her husband served as Lord Chamberlain to James I. She also listed fifty-two rings set in iron which had come from Charles I's collection.[45] Even though there is not a detailed description of every medal – the collection numbered over a thousand examples – it seems likely that Caroline had located the entire medal collection of the early Stuart monarchs which had survived the Commonwealth. It is probable that following the fire which destroyed Whitehall Palace, this was another collection taken for safe storage to Kensington Palace, where it was rediscovered by Caroline, perhaps at the same time as she found the Leonardo da Vinci and Holbein drawings. Mrs Purcell's and Horace Walpole's lists, which have been uncovered in the British Library and the Royal Archives, are the first thorough records of the royal collections of virtuoso metalwork, coins, medals and curiosities following the lists made of the collection prior to the royal sales of mid-seventeenth century, nearly one hundred years earlier (fig. 157).

Presents from Caroline's relatives and friends could easily be accommodated in the cabinet of curiosities. There are numerous references in the correspondence with Liselotte to gifts of engraved stones and intaglios as well as two rings, one set with 'four tiny but genuine green diamonds', and another which had belonged to the Electress Sophia.[46] Liselotte sent coins and medals, despite the tradition that collecting such things has been generally considered a male activity. Liselotte's half-sister, the Raugravine Louise, one of Caroline's Ladies of the Bedchamber, seems frequently to have been the courier.[47] The arrival of the objects must have encouraged Caroline's interest in the very impressive collections she had inherited. She went on to acquire a large library of books on the subjects which would have ensured she was well informed, and the collections seem to have served as an easy topic of conversation within her male-dominated circle.[48] Interestingly, Caroline's half-sister, Dorothea Friederike, had collected medals too.[49]

Some of Liselotte's presents were extraordinary. It is probable that she was the donor of a very elaborate pendant composed of a seventeenth-century enamelled jewel set with a chalcedony cameo showing the biblical Joseph and his brothers around which was set a further twelve cameos. This survives in the Royal Collection. The way in which the piece was made and the gems set indicate that it was put together in France in the early

eighteenth century; it certainly does not appear in any existing inventory before those recording Caroline's collection (figs 158 and 159).[50]

Other special gifts were jewelled eggs and egg-shaped gemstones.[51] In 1717 Liselotte sent Caroline two 'eggs of tortoise' with a note saying: 'I hope this pleasantry will please, and it is likely she was also the donor of the most splendid egg of all, now in the Danish Royal Collection. It is composed of many intricate elements which are revealed as the egg is taken apart in the manner of a Russian doll. An ivory egg unscrews to reveal one of gold in which a vinaigrette is concealed at one end. A cap lifts off the other end of the golden egg to reveal an enamelled egg yolk set in egg white. This feature is the lid to an inner compartment containing a golden hen with enamelled feathers and diamond eyes sitting on a diamond and enamel nest. A hinged lid in the hen's back opens to reveal a golden crown set with pearls and diamonds. The crown is hinged in the centre and opens to reveal a ring which is set with a large diamond over the engraved cypher of two intertwined C's – which probably stand for Caroline and Elisabeth Charlotte – beneath a crown and an electoral hat (fig. 160).[52] The engraving of the electoral hat in conjunction with the crown is especially significant, and might be evidence of the link between this artefact and these two women; Liselotte wrote to Caroline: 'we are made of the same stuff – electoral children who have become royal.'[53]

158–9 French pendant with cameos, gold, enamel and semi-precious stones, early seventeenth century, cameos added eighteenth century. The Royal Collection

160 French egg, ivory and gold, decorated with enamels and precious stones, c. 1715–20. The Royal Danish Collections, Rosenborg Castle

As Caroline's interests became known there was an influx of presents from members of her circle and from artist-craftsmen in London. On 13th August, 1728, Lord Chesterfield wrote to Henrietta Howard: 'I have bought some china (which was brought by the last East India ship that came in) of a very particular sort, its greatest merit is being entirely new; which in my mind may be almost as well as being undoubtedly old; and I have got all there was of it, which amounts to no more than a service for tea, and chocolate with a basin and ewer. They are of metal enamelled inside and out with china of all colours. As I know the Queen loves china, I fancy she would like them.'[54] Mr Clay, 'Inventor of Machine Watches in the Strand', presented her with examples of his work.[55]

In 1730 the collection of medals received an important boost when Johann Heinrich Ott, a young cleric from Zurich – on the staff of Archbishop Wake, Caroline's spiritual adviser – presented Caroline with examples of the work of Jean Dassier, a medallist from Geneva (fig. 161). These were the first pieces of what would eventually be a very considerable sequence commemorating English kings from William the Conqueror onwards. A year later Dassier travelled to London and met Caroline to present this project to her in person, as well as to introduce a project for another set of medals he was preparing commemorating English worthies. This meeting was probably brokered by Wake, who was friend of the Genevan Jean-Alphonse Turrettini, a fellow Latitudinarian sympathiser, and one of Dassier's greatest champions.[56]

However Caroline was never a passive collector. The collection grew as she rounded up pieces from Hanover; in 1735 Lady Sundon noted in the margins of a list of Caroline's book purchases that she had taken receipt of a '*caisse remplie de grands verres qui sont venue de Hanover*' and '*une caisse de verres d'allemagne quelle a demande de la parte de la reine*'.[57] She made purchases including a '*peau blanche des Indes*' and '*six plats de cheney de couleur blanche et rouge et trois autres blan et bleu*', which were delivered to Mrs Purcell in 1733 and 1734 respectively.[58] In 1733 the *Daily Courant* newspaper recorded that Lady Deloraine, Lady Suffolk and Caroline went shopping for 'several fine curiosities in china' which had just

161 *Medals of the Kings and Queens of England* designed by Jean Dassier, bronze, c. 1731. British Museum

arrived from the Far East.[59] But particularly striking amongst the new additions was a collection of cameos. This included a set of sixteen made from onyx, probably in Milan – many had mounts that had possibly been provided, by Jean Vangol, the Flemish goldsmith who later worked in Paris. Horace Walpole recorded them in his inventory as 'small set in enamel as if designed for buttons'. There was also a spectacular cameo showing the Magi

presenting gifts to the Christ Child, another which Walpole claimed was a portrait of Mary, Queen of Scots, and a small cameo of Queen Elizabeth I. None of these items was recorded in the royal collection before turning up in Caroline's inventories (fig. 162).

Caroline began to place her own special commissions too.[60] These may well have included a pair of cameos set in early eighteenth-century mounts that are still part of the Royal Collection. They are carved in very low relief, which provides an unusual, almost stereoscopic, effect when they are held up to the light. One has an image of Henry VIII, the other a double portrait of Henry VIII and the young Prince Edward, later Edward VI. The likeness of Henry VIII is taken from the same source in both instances and that of Prince Edward has striking parallels with a cameo that was once part of Lord Burlington's collection and is now at Chatsworth House in Derbyshire. The reverse of the Chatsworth cameo is carved with the same double portrait of Henry and his son as on Caroline's example which suggests that they were from the same workshop.[61] Given the evidence of Caroline's rapport with Lord and Lady Burlington, it is very likely that they made purchases from the same maker (fig. 163).[62]

In just the same way as the royal paintings collection received her attention, Caroline was concerned to record the histories of her curiosities, and conservation was undertaken to keep things in good order. In 1727 the cabinet-makers Elizabeth Gumley and William Turing were paid £1. 10s. for 'repairing and cleaning a carved stone figure of a dog wth a new pedestal of fine wood to it' – the 'shock dog' from Henry VIII's cabinet.[63] In 1735 Benjamin Goodison repaired the glass cases made to protect an amber cabinet Caroline had received as a present from her kinsman Frederick the Great of Prussia.[64]

Echoing her exploration of the art collections made by her new countrymen, she was curious about their collections of rarities too, and made a series of forays – accompanied by her children – to see what they had. In 1732, while the King was away, and she was acting as regent, she travelled with her three eldest daughters to Gubbins, the house of Sir Jeremy Sambrook in Hertfordshire: *The Gentleman's Magazine* noted that the royal party viewed 'his fine gardens, waterworks, and his collection of curiosities'.[65] The Sambrook family had been in the East India Company's service since 1608, when an earlier Jeremy Sambrook was employed as an accountant. A description of the collection of rarities does not survive, but it is known that the family had the means to acquire artefacts of the highest

162 North Italian cameo with a design of the Adoration of the Magi, agate, sixteenth century, the mount c. 1700. The Royal Collection

163 English cameo carved with portraits of Henry VIII and Prince Edward after Hans Holbein the Younger, sardonyx, early eighteenth century. The Royal Collection

calibre, and it was sufficiently well known for others such as Lord Egmont to seek access to it (fig. 164).[66]

In 1734 Caroline took the children to see the treasures assembled by Sir Hans Sloane. He had been Physician in Ordinary to Queen Anne and George I, and in 1727 George II ratified his appointment once again, probably as a result of Caroline's urging.[67] On completion of his studies at Apothecaries' Hall, and later in France, Sloane, an Irishman, had seized the opportunity to travel to the West Indies for fifteen months in the service of the Duke of Albemarle where he collected ethnographic material and items of natural history.[68] On his return in 1689 this collection grew dramatically as he began to buy up groups of specimens which had been made by others. There were the natural history collections made by William Courten, Leonard Plukenet, Georg Joseph Kamel and James Cunningham, and the German traveller Engelbert Kaempfer's collections of artefacts from the Far East.[69] Sloane's became the most celebrated collection in London, though despite many scientific acquisitions, and a respectable quota of traditional curiosities it did not approach in scale the European models Caroline would have encountered. However there was much to intrigue, and the royal visit in 1734 led to a correspondence between Sloane and Caroline about the identification of an aquatic plant.[70] Sloane, who had recently purchased both Nehemiah Grew's seed bank and the herbarium made by James Petiver, replied promptly, providing her with the information requested, and for more detail referred her to Pliny's *Historia Naturalis*, a publication which already sat on the shelves in her library, amongst the other books on botany which included Mark Catesby's *The Natural History of Carolina, Florida, and the Bahama Islands* (fig. 165).[71]

On occasion a collection was brought by its compiler into one of the royal palaces for Caroline to view. As early as February 1716 Charlotte Clayton reported: 'when I got [to St

164 *'A Perspective View of the Canal at Gubbins in Hertfordshire, a seat of Sir Jeremy Sambrooke, Bart'* after Jean Claude Chatelain, engraving, 1748. The Royal Collection

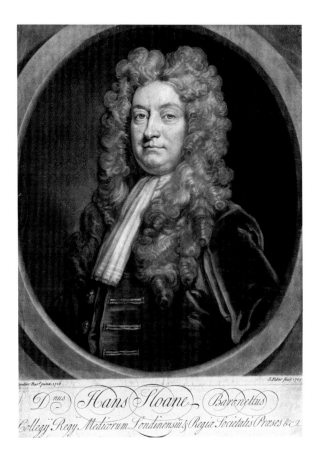

James's Palace] I found Sir John Germaine showing the Princess his rarities consisting of seals and reliefs. She had not Time to see them all this Evening so many of the Masquers came to show themselves.'[72] Sir John, a Dutch 'adventurer' who had arrived in England in the late seventeenth century, had made such an extensive collection that the next day the examination resumed: 'soon after the Princess called me in to see the Remainder of Sir John Germaine's Rarities. They were the collection of the late Earl of Peterborough ... amongst other things he showed us the dagger of King Henry VIII which he always wore and is pictured with.'[73]

There can be no doubt that Caroline knew her collection was conceived within a framework that was old fashioned. The collections made by members of her immediate circle were usually limited to a particular class of artefact: Sir Robert Walpole and Lord Burlington collected paintings and sculpture, and Sir Andrew Fountaine's most significant collection was of ceramics. Dr John Woodward, Professor of Physick at Gresham College, and the fashionable physician Dr Richard Mead, who were friends of Caroline's confidante Lady Sundon, and admirers of Caroline too, had made their own special collections – Woodward of antiquities, geology and books, Mead of manuscripts and works of art on paper. She would have observed when she visited Sloane's collection that side by side with the traditional rarities there was also significant natural history, ethnographic and archaeological content, and this last was an aspect which she found increasingly interesting.

It is perhaps revealing that this was the most private of her artistic programmes; there seems to have been no comment at Court about it, let alone any public debate, perhaps because she had personal experience of the scope and scale of some of the most impressive *Wunderkammern* in Europe and knew her collection would not bear comparison. And yet of all her projects it seems to have been the one which gave her particular delight. Gifts of rarities arrived on a regular basis from her kinsmen in Germany and France, presumably with the assumption they would give her pleasure, and it is the collection which was discussed most frequently in family correspondence.

Alongside their other studies. all the children were taught lathe-turning and gemstone-working, which were on the traditional list of skills thought appropriate for the off-springs of a European ruling house.[74] Twenty-four amber knife handles of Princess Anne's workmanship, one of which is set in gold, survive in The Hague.[75] Frederick the Great of Prussia sent her some amber, writing: '*Sachant que votre Altesse Royale se plâit quelque fois à s'amuser des ouvrages de l'ambre, je prens la liberté de lui envoyer quelques morceaux les meilleurs j'ai pu deterrer en Prusse.*'[76] Examples of Princess Louisa's ivory turning have been preserved in the Danish Royal Collection (figs 166 and 167).[77]

Perhaps Caroline's collection of curiosities, and her love of such costly toys, hints at a secret desire to retain a link with her European ancestry, and all that this represented. It drew her into a glittering and powerful family tree that linked most of the royal houses of central and northern Europe, and perhaps she wanted her children to be a little part of this exclusive company too. Lord Hervey, despite his admiration for her, accused her on several occasions of revealing a 'natural propensity to the interest of Germany'.[78]

But Caroline balanced her interests well. In the world of the early eighteenth-century connoisseur the purpose of collecting was becoming a subject for general debate. The painter and collector Jonathan Richardson was the first to suggest – in 'An Essay on the Whole Art of Criticism' and 'An Argument on Behalf of the Science of the Connoisseur', published in 1719 – that connoisseurship should be seen as a science. Joseph Addison's book *Dialogues upon the Usefulness of Ancient Medals*, published posthumously in 1721, took this thinking further by questioning the value of earlier classification systems, which had concentrated on establishing patterns to build up a picture of the order of things. He suggested instead that artefacts should be examined carefully for the information they contained

166 Turned miniature chandelier made by Princess Louisa, ivory, 1740–50. The Royal Danish Collections, Rosenborg Castle

167 Set of turned knife handles made by Princess Anne, amber, 1730–40. Royal Collection of the Netherlands

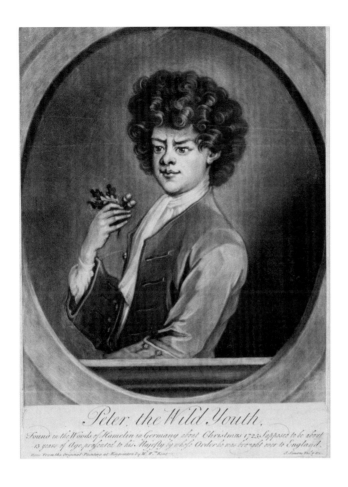

Peter the Wild Youth.

Found in the Woods of Hamelin in Germany about Christmas 1725, supposed to be about 13 years of Age, presented to his Majesty by whose Order he was brought over to England.

intrinsically. Horace Walpole's list of Caroline's rarities suggests that she may have sought to shift the focus of her own collecting. She certainly introduced a few objects of archaeological importance – 'three fair coins of English Kings before the Conquest, found at Cleeham in Rutlandshire' – indicating perhaps her growing interest in the origins of the English nation. As we have discussed earlier, she had become aware of the work of the antiquarian and archaeologist William Stukeley in about 1732 through her involvement with Henry Flitcroft and Andrews Jelfe, who were working on her Hermitage and Merlin's Cave.[79]

She also encouraged a change in attitudes to the nurturing of Peter the Wild Boy, a feral child brought from Hanover in 1726 to amuse George I. Initially he was seen as a curious novelty, coaxed to eat at table and to talk for the amusement of the company, but Caroline deputed Dr John Arbuthnot, a physician and scientist who had earlier attended her salon, to try and educate the child. When the experiment failed, and it became clear that he was mentally handicapped, a more enlightened approach was instituted. He was provided with a pension and lodged with a farming family in Berkhamstead in Hertfordshire. He enjoyed working on the land, became very attached to the family who looked after him and was much treasured in the neighbourhood. He would die of old age in 1785 (fig. 168).[80]

168 *Peter the Wild Boy. Protegé of King George I* by Jean (John) Simon after William Kent, c. 1735, mezzotint. The Royal Collection

169 *Queen Caroline on
her Deathbed* by Dorothy,
Countess of Burlington,
pencil on paper, 1737.
Devonshire Collection,
Chatsworth

Her children proved just as curious about the changing world in which they lived. In 1738, when Frederick the Great visited Princess Anne at the palace of Het Loo in The Netherlands, having promised to send her amber for her projects, he then recounted how deeply impressed he was by her knowledge of the work of Isaac Newton: '*J'ai beaucoup parlé de Newton avec la princesse; de Newton nous avons passé a Leibnitz, et de Leibnitz à la feue reine d'Angleterre*'.[81]

But, despite Caroline's increasing involvement with the scientific community in London, the main role of her cabinet of curiosities was to endorse the rich legacy of treasures left by earlier monarchs which contributed significantly to the celebration of the dignity and antiquity of the English royal pedigree. In drawing it together she had every right to be very pleased and proud. The four lists made of its contents can be set against John Evelyn's pessimistic account of Commonwealth dispersals and indicate that as well as the many medals, which had been kept back from the sale of the effects of Charles I, gems, jewels and many other treasures had in fact survived in good order, and it was she who had brought them back together again.

Caroline's engagement with the world of the natural philosopher was far more practically based and was grounded in the relationships she made through her salon and the other opportunities she organised for discussion. By bringing such men right into the heart of the Court, she gave them a new status and their research important publicity. For the Court, their presence served as a demonstration of the enlightened nature of the new monarchy. For her family – for the next generation – there were important consequences too. Her children received a very lively and imaginative education.

However all of this was to be cut short. On 9th November, 1737, when Caroline went to the library to inspect the final details of its installation, she was taken ill. Following the birth of her last child an umbilical hernia had developed. Long concealed, it had now become badly infected. Caroline struggled back to St James's Palace to attend the Drawing Room, but Lord Hervey immediately noticed her condition and urged her to retire: 'For God's sake, Madam, go to your own room. What have you to do here?' Anxious not to upset her husband, she managed to complete her duties before collapsing into bed. By the evening it was evident she was gravely ill.

Caroline's agony lasted for eleven days, during which she submitted to purges, cupping, blisters and eventually surgery. The King, thoroughly worried, sat by her side in tears, kissing her face and hands. When she realised there was no hope of recovery she took leave of her children. Frederick alone did not receive her blessing, though he sent message after message asking for permission to visit. Caroline died in the evening of 20th November, 1737 (fig. 169).

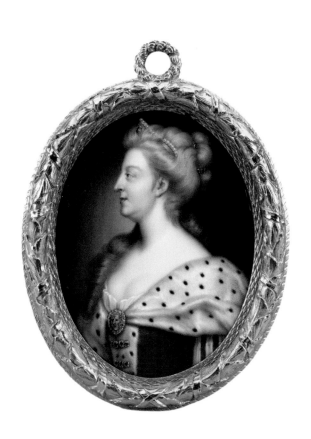

CONCLUSION

The role of queen consort in the early eighteenth century was multifaceted. As wife of the sovereign she was to be far more than helpmate to her husband; she was also to be his political confidante and principal supporter. She should become the Mother of the Nation in her nurturing of a large healthy family. She would do well to associate herself with philanthropic work and encourage the arts and sciences – roles traditionally considered to fall to a female, balancing that of the male royal to defend the realm and dispense justice. There were many dangers. A consort who was too bold and independent could be seen as politically dangerous to the monarch, and the penalty for this was at best isolation and at worst death. For the queen consort who was barren the situation was hardly better. Character, intelligence and ambition were all important to success in finding the equilibrium that had to be achieved. It would help if the consort had access to money and that the bond she was able to forge with her husband was good, following what was in most instances an arranged marriage (fig. 170).

Caroline was lucky. Her mentors, Sophie Charlotte, the Electress Sophia and Liselotte, had ensured she was aware that as a Hohenzollern princess she had dynastic capital as well as good looks. Marriage to George Augustus of Hanover, with its promise of the Hanoverian succession to the British throne, presented a particular and exciting challenge, one to which Caroline addressed herself assiduously. She had caught George's eye with her blonde

Opposite
170 *Queen Caroline*
by Christian Friedrich
Zincke, enamel, 1727.
The Royal Collection

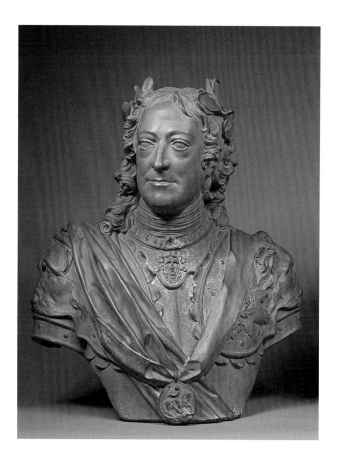

171 *George II* by John
Michael Rysbrack, terracotta,
1738. The Royal Collection

beauty, and without doubt they grew in affection for each other. George, despite his bluster, tolerated her projects and paid her bills. In the important things – particularly in political matters – she was clever enough to manage her husband and the situation sensitively. She stepped back quickly when she knew she had to. And she must have given him good advice. George trusted her and her judgement (fig. 171).

By 1727, and the accession of her husband as George II, there was no doubt that her role in the new order would be as an equal. In the ten years which remained of their married life together, George invariably left Caroline as regent when he travelled abroad. Her loyalty and toleration of his mistresses brought her his esteem. She had also been able to achieve a satisfactory relationship with her father-in-law, George I, despite his alienation from her husband. He seems to have respected her intellect and shared many of her interests. This allowed her to become confident and bold in pursuit of her goals, and she constantly pushed against the traditional assumptions concerning her role both as consort and as a woman. She sat at the centre of an intellectual circle dominated by men, she collected coins and medals – generally considered a male activity – and with her husband's blessing she assumed the role of royal patron of the Church.

There were some who questioned her intelligence, and criticised her for trespassing into intellectual debates and aspects of the national life they considered fell beyond her prerogative. But Caroline's position was unassailable, and it was only those who had nothing to lose who felt able to broadcast their views. Lady Mary Wortley Montagu said she possessed

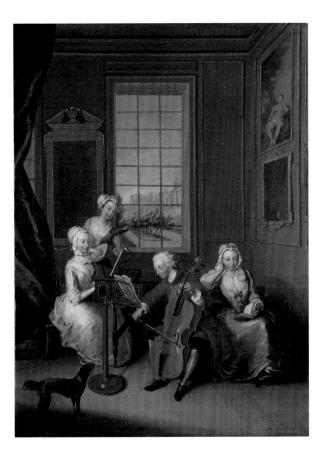

no more than 'low cunning' and that she lacked 'understanding enough that falsehood in conversation, like red on the face, should be used very seldom and very sparingly.'[1]

Alexander Pope in *The Dunciad* cast her as the 'Goddess of Dulness' for her promotion of writers he considered mediocre. James Thomson, a Scottish poet who had aligned his fortunes with those of Caroline's son Frederick – and wrote the words of 'Rule, Britannia' as part of the masque *Alfred*, staged at Cliveden in 1740 in Frederick's honour – satirised her in about 1733 in his poem 'The Castle of Indolence'. He cast her as 'The World's Imperial Queen' who, proud of her ancestry and her learning, sits surrounded by her collection of antique relics as the virtuosi flock to her feet.[2]

But there were many more who seem to have been impressed by her, including luminaries such as Leibniz and Voltaire, and who sought her favour. She was a colourful presence at Court, overcome with laughter at the English term 'round robin' and telling slightly risqué stories. One involved Mr Spence, who was taken by surprise by a visitor as he was taking a bath and, without hesitation, 'leapt up naked as he was and waited on him to the very street door'.[3] Caroline did make mistakes, but in these instances she seems to have adjusted her ambition rather than feeling obliged to abandon her ideas. When ordered by George II to undo one of her new picture hangs, she quietly continued with her plans, knowing that in other matters it was he who was dependent on her. It helped that she had success in producing a large, lively family, which was the key to ensuring a solid Protestant dynasty (figs 172, 174 and 175).

172 *The Music Party. Frederick Prince of Wales and his Three Eldest Sisters* by Philippe Mercier, oil on canvas, 1733. The Royal Collection

There is ample evidence that George II was devastated by Caroline's death. Horace Walpole reported in a letter to Sir Horace Mann in August 1749 that the King 'has locked up half the palace [Kensington] since the Queen's death so he does at St James's' and ordered that none of her possessions be moved. When Walpole returned in 1758 he noticed that even the wood laid in her bedroom hearth on the day she died was still in place.[4] The order to change nothing had implications for the royal collection of art too. In March 1748,

173 *George II* after Robert Edge Pine, oil on canvas, c. 1801–16. The Royal Collection

174 *Frederick and Augusta,
Prince and Princess of Wales*
by Gaetano Manini,
miniature, 1758. The Royal
Collection

when Stephen Slaughter, the Surveyor of the King's Pictures, was asked to assess the condition of some of the paintings at Kensington Palace, he was given strict instructions from the Lord Chamberlain: 'I am also to acquaint you that you are not to remove any pictures out of the palace.'[5] In 1750, when George Vertue visited in the company of Prince Frederick to prepare a new inventory, the record he made shows that the arrangements had survived unaltered for nearly twenty years (fig. 173).[6]

But despite so much that was favourable, there has been little lasting perception of the role Caroline played in the promotion of the arts in early Georgian England and how she used this intelligently and imaginatively to achieve dynastic ends. One reason for this is that the records chronicling her projects are disparate and in many instances incomplete. She enjoyed just ten brief years as queen which meant that she left her gardens in their infancy, and none of her other schemes had achieved their final form. The scale of each endeavour was circumscribed by the relatively limited funds available to her – though she regularly overspent her allowance. On her death the combination of family quarrels, and ambivalence about some of the initiatives which had not received a popular reception, led to their being abandoned. Despite the intention behind many of the projects that they contribute to the anglicization of the dynasty, the way in which they were cast betrayed Caroline's European roots, which was not always welcomed by observers, and, on occasion, the messages were so complex that they were difficult to decipher.

Visitors to Kew Gardens in Richmond now have to look very hard to find any trace of Caroline's 'Trianon'. Her groves and avenues, the mound and river terrace, and all the buildings, were swept away by Lancelot 'Capability' Brown when he transformed the

175 *The Children of Frederick, Prince of Wales* by Barthélemy du Pan, oil on canvas, 1746. The Royal Collection

garden for Caroline's grandson George III and his wife, Charlotte of Mecklenburg-Strelitz. When Merlin's Cave was dismantled there was gentle lament. William Mason wrote 'An Heroic Epistle':

> To Richmond come, for see, untutor'd Brown
> Destroys those wonders which were once thy own.
> Lo, from his melon-ground the peasant slave
> Has rudely rush'd, and level'd Merlin's Cave;
> Knock'd down the waxen Wizard, seiz'd his wand,
> Transform'd to lawn what late was Fairy land;
> And marr'd with impious hand, each sweet design
> Of Stephen Duck, and good Queen Caroline.[7]

The waxworks had long since disappeared by then, though George II continued to pay a pension to Stephen Duck, who remained 'Librarian of the Queen's Select Library' at Richmond until he took holy orders, was appointed chaplain to the Brigade of Dragoon Guards and moved to a living at Byfleet. After he committed suicide in 1755, his royal pension was paid to his daughter.

By the early nineteenth century just a few pieces of masonry from the Hermitage remained. Caroline's busts of contemporary worthies had long since been absorbed into the royal collection of sculpture.

By the mid-eighteenth century the garden at Kensington was seen increasingly as an amenity for the residents of the burgeoning village of Kensington and the new suburbs of Marble Arch, Knightsbridge and later Bayswater which developed along its boundaries. Access which had originally been limited to set times and days of the week, and only to those neatly dressed, was extended to the general public in the 1830s.[8] The trees and shrubs growing over the prospect mount had eventually so completely obscured its form that it had been levelled, and the summer house dismantled by about 1784. By the early nineteenth century the Queen's Temple was being used as a tool-shed and, though the proposal in 1835 to convert it into a 'Mohamedan' temple came to nothing, it was renamed Temple Lodge and used as a gardener's house until it was damaged by a bomb in 1944.[9] It was restored to its original appearance in 1977. In the early nineteenth century the ha-ha and bastion wall dividing Kensington Gardens from Hyde Park were dismantled.[10]

The breaking up of the picture closet began swiftly after the death of George II in 1760; George III bought Buckingham House – later to be called Buckingham Palace – as his principal residence, and the distinguished collection at Kensington was an obvious source from which to select pictures for its new rooms.[11] The Holbein drawings, still in their black lacquer frames, were amongst the first objects to be moved; by 1774 they had been gathered together in two volumes and were in the King's Library. These volumes were retained by George IV when he presented his father's library to the British Museum in the 1820s, and were taken to Windsor Castle for a new royal library which would be established there. On the instructions of Albert, the Prince Consort, the drawings were taken out of the volumes and provided with the first of a series of mounts. The drawings survive in the Print Room at Windsor, now held between two thin sheets of acrylic set into double-sided mounts. In June 1783 Horace Walpole when visiting Buckingham House noticed 'six large frames glazed over red damask' containing 'a vaste quantity of enameled pictures, miniatures & cameos amongst six or eight at least of Charles I', remarking that these were 'the best of those that were in Queen Caroline's Closet at Kensington'.[12] Many of the Tudor portraits and the miniatures by Cooper and Oliver are still easy to trace in the Royal Collection. Some paintings remained at Kensington into the early years of the nineteenth century. When the artist James Stephanoff recorded the arrangements in the Queen's Gallery in 1815, the collection of full-length portraits of English monarchs was still in place (fig. 176).

However, not every piece found a new royal home; there were some dispersals. A reference to Raphael's 'Two Mice' is found in the inventory of the Duchess of Portland's Museum compiled on her death in 1785. It was amongst the small collection of artefacts which formed the bequest to her friend Mrs Delany.[13] Several pictures, and perhaps the waxes, textiles and more unusual items from the closet, made their way to Queen Charlotte's apartments in Buckingham House and on Charlotte's death a portrait of 'Charles I very old embroidery in coloured silk', and 'four portraits modeled in wax', which sound very similar to some of the descriptions in Vertue's catalogue, were included in the sale of her effects.[14] In the 1830s the Duchess of Kent, the widow of George III's son Edward, had the room used for the 'store of portraits of the English' converted into a bathroom for her daughter, the future Queen Victoria.

176 The Queen's Gallery, Kensington Palace by James Stephanoff, watercolour over pencil, c. 1819. The Royal Collection

The greater part of the cabinet of curiosities was preserved intact until 1760, though George II presented Caroline's friends with a few items as mementoes after her death: Horace Walpole mentioned to his friend Sir Horace Mann in January 1784 that his father, Sir Robert Walpole, had received a 'crystal hunting bottle with a gold stopper and cup', and it was probably Princess Mary who received Liselotte's golden egg which is now preserved in Amalienborg Palace in Copenhagen.[15] According to Walpole, on the accession of George III the greater part of the collection was packed up and in March 1764 it was probably sent to the recently remodelled Buckingham House.[16] William Vile, the cabinet-maker, was asked to supply cabinets to house one thousand six hundred medals for the young king between 1761 and 1762, and then, between 1766 and 1767, arrangements were made to accommodate one thousand three hundred and eighty-five more. It is probable that this included Caroline's collection of medals and means that when George III's collection was acquired by the British Museum in 1825, Caroline's medals and the Stuart legacy she had marshalled left the royal collection.[17]

Other rarities from Caroline's collection can be traced through the lists prepared by Benjamin Jutsham between 1806 and 1816 recording goods moving between Buckingham House and Carlton House at the behest of George IV.[18] This flamboyant monarch with a discerning eye and interest in his Stuart ancestors seems to have picked out some of the items she had drawn from Charles I's cabinet for the decoration of his newly furnished residence.[19] This included 'portrait of a dog in stone in a laying posture scratching his ear, upon a rosewood plinth, under the plinth is burnt the Crown & initials GP', which can probably be identified as Henry VIII's 'shock dog'. 'The Emperor Maximilian & Mary of Burgundy; bas relief on stone', as described by Walpole in Caroline's list, is found too, as 'a stone sculpted with the head of the Emperor Maximilian and on the reverse side the head of the Duchess of Burgundy. Each with Latin inscription. A metal frame gilt with a swivel top'; the 'small vase made of horn, mounted in silver with chimera handles. 4 unicorn feet & gilt cover' must be Walpole's 'vase made of unicorns horn & supported by unicorns'.[20] Jutsham's 'small jewel coffer made of agate' may be Mrs Purcell's 'one aggett trunk', and he found the 'Branch of Red Corall on a silver foot' and 'branch of white corell on a gilt pedestal' she recorded in her list as well as the 'crystal cup and cover, a humming bird in it'; the humming bird had later become detached and was noted as a separate item.[21] References to the collection of bezoars Caroline had received from Liselotte lingered. Described in 1820 as 'small stones, the one like a nut & the other resembling the private parts of a man. Query petrifactions', they emerge again in an inventory made in 1837 as five 'amber balls'.[22]

During the nineteenth century the steady stream of precious metalwork leaving the royal collection continued. In Christie's sale catalogue of Queen Charlotte's effects there are lots described as a 'small bust of Charles I carved in rock crystal. Unique and very fine', a 'crystal shell & triton set with jewells' and a 'round ivory vase, carved with boys by Fiamingo', all of which had been described in either Mrs Purcell's or Walpole's inventories. It is hard to believe that the 'small equestrian figure of the Emperor Charles V in silver, his armour silver gilt, on an ebony pedestal with festoons of silver chasing', 'a broach in the shape of a carduceus of brilliants with the cameo head of William III in onyx in the centre' and 'ten convex pieces of very old English carving in two black frames a portrait of Inigo Jones, and ditto of Pope carved in ivory' were not survivals from the collection too. In 1830 William IV sold to the jewellers Rundell and Bridge the '52 antique rings set in iron', once part of the collection of 'one hundred & twenty one rings and sealls but with heads on different stones & 53 of them set in iron' described by Mrs Purcell.[23]

The library was another casualty. With its encyclopaedic collection of books, classified to reflect all branches of knowledge, it served to underpin the collection of curiosities and support the collections of paintings and sculpture celebrating the English royal dynasty. Its creation was ambitious, even radical, within an early eighteenth-century English context. But the Queen died before the project was completed, and to establish whether she intended it to double as a debating chamber is now impossible to discover. George II cancelled the commission she had placed for sculpture with Michael Rysbrack but did retrieve the terracotta modellos which had already been completed, and eventually these were installed on brackets between the bookcases. He went on paying the salaries of the librarian and library keeper; when Francis Say, the librarian, died in 1748, he appointed a successor, Archibald Bower, and continued to deposit books in the library, though its rate

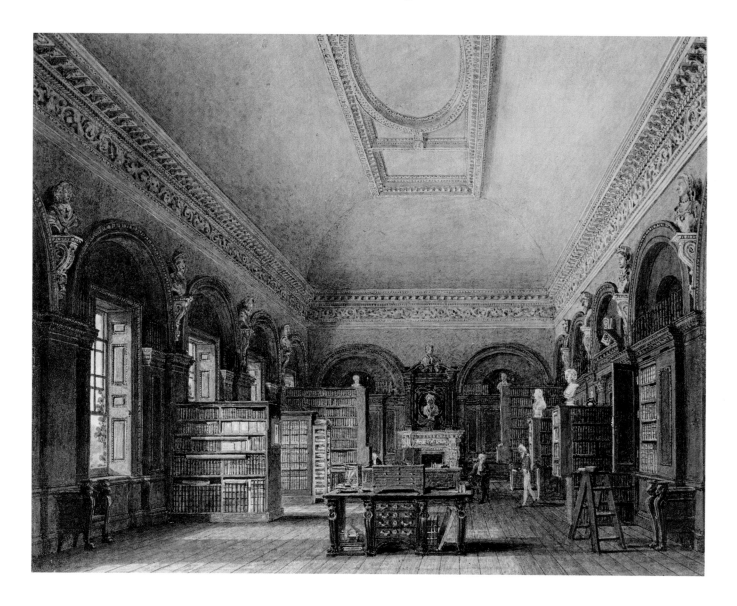

177 *Queen Caroline's Library,
St James's Palace* by Charles
Wild, watercolour, c. 1815.
The Royal Collection

of growth dwindled rapidly.[24] In 1764 some of the bookcases were appropriated and 'adapted with many additions' for the 'Great Library' which William Chambers was constructing for George III in the new southern extension of Buckingham House.[25] This left Caroline's library by 1805 little more than a 'lumber room' according to Thomas Tennant, who described it in *Some Account of London*, though it did enjoy a brief period of glory when the library of Frederick, Duke of York and Albany, was moved there in 1815.[26] However, in 1825 the building was demolished and the busts were moved to store where, sadly, the majority were later accidentally destroyed (fig. 177).

When the contents of the old royal library were donated to the British Museum – then at Montagu House – in 1757, Caroline's collection of books does not appear to have been included in great quantity. Only a handful can be identified with certainty in the King's Library and Department of Manuscripts, though the situation is complicated by the fact that some of the volumes have been rebound by later owners. A few books can be found

in the Royal Library and Print Room at Windsor Castle.[27] The collection at Windsor includes the two volumes of Dorigny engravings after Raphael which were probably moved there with other folios and precious books which sat alongside Caroline's curiosities at Kensington Palace.[28] The other small book library at Kensington was dismantled in 1764 and the contents moved to join the new library at Buckingham House.[29]

The remaining two volumes associated with Caroline in the Royal Library came from the library of her son, William Augustus, Duke of Cumberland, which he established at Cumberland Lodge. In the 1830s this was combined with a number of other royal libraries by William IV to form a new resource at Windsor to compensate for the second large transfer of royal books to the British Museum in 1823.[30] It is possible that some books passed to Caroline's other children, and there is also an annotation to the undated catalogue of her book collection in the Royal Library that 'All the duplicates found in this catalogue were sent to the Library in Hannover by his Majesty's order.'[31] This library, at the University of Göttingen, was drawn up on lines recommended by Leibniz and had by the mid eighteenth century developed into one of Europe's most important research libraries.

But there were great legacies too. Caroline's schemes had been informed by her experience at some of the most magnificent and cultivated courts of Europe and enriched by advice garnered from her distinguished mentors. They may have been tempered and revised subsequently by local British custom and contemporary fashion, but it would still have been clear to all that there was a new cultural ethos at Court.

One can only speculate as to how each of her programmes, which had often been put together quickly, might have developed had Caroline lived longer. Even in her lifetime projects were recast. That the controversial waxworks exhibition celebrating the mythical

178 *'Summer Hermitage. Winter Hermitage'*, a plate from Paul Decker, *Gothic Architecture Decorated*, 1759. Yale Center for British Art

origins of the English nation was overtaken by a sedate 'line of the kings' is no surprise, and this rethinking is comparable to her development of the cabinet of curiosities, into which artefacts retrieved in archaeological excavations were inserted amongst traditional treasures such as bezoars and 'unicorns horns' – any appraisal of Caroline's contribution to the shaping of the early Hanoverian monarchy would rate this extraordinary.

She had developed a new relationship between the various royal residences, and used the rooms in each of them in an imaginative and sometimes innovatory way, arranging them so as to create a series of experiences ranging from the intimate and theatrical to the grandiose and awe-inspiring. For visitors they had been given a new splendour, with decorations which celebrated all that was English. In the scale of her initiatives, whether it was creating a garden or building a library, she quickly surpassed the efforts of her royal predecessors since 1689 and the Glorious Revolution.

Caroline, the gardener, brought together the greatest gardeners and garden theorists of her era. If her gardens have now been lost, in their own time they were prestigious projects and influenced the creation of many others. Merlin's Cave, architecturally a product of Caroline's interest in the Gothic, which extended into the sphere of the Gothick and more generally picturesque, was imitated up and down the country for several decades. In 1737 Mrs Delany, as she would become, was boasting about her 'thatched temple', and in 1743 Paul Decker included in his *Gothic Architecture Decorated* designs for both summer and winter hermitages – both round structures with conical thatched roofs resembling those of the Cave (fig. 178).[32] An example dating from the 1740's survives at Brocklesby Park in Lincolnshire.

In the course of Caroline's projects she assembled, appraised and conserved the remnants of the Tudor and Stuart collections of paintings and drawings, of jewels, metalwork and medals, which had survived the Commonwealth dispersals. She expended tremendous effort and money on the identification and acquisition of many new objects and thereby made a significant contribution to the campaign to anglicize the House of Hanover. Caroline showed herself to be actively promoting an understanding of English history and seeking ways in which it could be chronicled. Her efforts have bought great benefit to future generations since a significant number of the items from Caroline's 'store of portraits of the English' and her cabinet of curiosities still exist; her interest in conservation ensured that items were kept in good order. The list of pictures which had received attention from a restorer, encouraged by her, includes the wonderful portrait by Holbein of Henry Guildford and Livinus de Vogelaare's extraordinary *Memorial of Lord Darnley*. Amongst the curiosities are the 'Onex of the Adoration of the Kings' listed by Mrs Purcell, her 'Bust with a cap set with jewels, one out, the shoulders amethest, the plate gold', the 'large onyx cameo of one of the Caesar's', the broken cameo of the Emperor Claudius and a small bust of Hercules carved in agate mounted on a gilt-metal socle, which must be the 'Bust of Hercules in agate' described by Walpole.[33] The Armoury still has weapons which may be those noted by Mrs Purcell, and the collection of medals in the British Museum, despite later rationalisation, almost certainly includes items which were Caroline's (figs 179–80).[34]

Caroline did much to promote knowledge about the royal collections to a wider English public. The discussion which followed her rediscovery of the Holbein drawings brought the work of Holbein to an interested audience; George Vertue noted enthusiastically in 1741 that Lady Betty Germaine owned four drawings which related to Caroline's and

spotted four more being offered for sale in 1745.[35] In 1736 Caroline allowed a set of engravings to be made by Vertue which ensured they were exposed to a wider audience. This first initiative was followed by the publication in 1776 of 'Nine Historical Portraits representing King's, Queen's, Prince's etc of the Tudor Family', and in the 1790s John Chamberlaine and Francesco Bartolozzi made a set of engraved reproductions of the drawings.[36] The widespread circulation of Bickham's guidebooks to Kensington Palace, Hampton Court and Windsor Castle in the 1750s brought the contents of all the palaces to greater public notice. The books ensured that, while access to Kensington Palace remained difficult, Caroline's collection – particularly of medieval and Tudor portraiture – became sufficiently well known for it to be used as a point of reference for all those with an interest in sixteenth- and seventeenth-century history (fig. 181).

Caroline's passionate interest in the Tudors was to persist amongst those in her circle. Elizabeth Robinson – who later married Edward Montagu and was known as a hostess and bluestocking – when sitting for her portrait by Zincke in 1740 chose a costume shown in a portrait of Anne Boleyn, who was not only a glamorous figure from the Court of Henry VIII but held up as a Protestant heroine. It also continued to be a powerful inspiration for the Whig politicians disenchanted with the then Hanoverian regime. Lord Cobham and his 'Boy Patriots' would use Elizabethan iconography in their efforts to promote the interests of Prince Frederick, and his wife Augusta. In 1742, writing to Elizabeth Montagu, Mrs Donnellan described Princess Augusta dressed for a ball in 'a vast number of jewels' and that she was in 'Queen Elizabeth's dress'.[37] The Arthurian legend, which Caroline had found so compelling, and which had also been appropriated by Whig agitators in the early eighteenth century, left its mark not only on political iconography but also on popular

179–80 French and English, comesso pendant, gold, with carnelian and precious stones, the reverse enamelled, 1550–60. The Royal Collection

entertainment: in 1739 Frederick and Augusta, visited the Crown Coffee House to see a representation of 'Merlin in Miniature' in his cave and 'were extremely delighted with the surprising performance of that curious piece' (figs 124 and 125).[38]

Caroline's active involvement in her projects, though very much following the approach adopted by her female mentors, would have seemed very unusual in English royal circles. She regularly visited artists, and travelled to view collections in the houses of her friends; it is arresting to imagine her in middle age, wearing a mantua, petticoat and slippers, climbing the scaffolding tower erected in the Banqueting House to review progress on the conservation of Rubens's ceiling canvases. There were a number of women who were encouraged, inspired and emboldened to follow Caroline's example. Some were of Caroline's age, others were from the following generation, but whose lives had been touched by the nature of the court culture which Caroline had established (figs 182–4).

Some of these women would make their own collections of pictures: Sarah, Duchess of Marlborough, wrote to her granddaughter describing the collection of portraits – a set of worthies and heroes – made by Lord and Lady Sundon: 'There are eight square pieces in two rows on the side of Lady Sundon over her head the first is Dr Freind, Dr Clarke, Sir Isaac Newton, the Archbishop of Canterbury, Dr Tillotson, Locke and three other great philosophers whose I cannot remember. And the eight which is nearer to my Lady Sundon in the same row with these philosophers is drawn rich as the Queen's but in a familiar way.'[39] Lady Mary Wortley Montagu in 1738 noted: 'I had some thoughts of establishing a set of pictures of some meriticious ladies.'[40] Others, such as Henrietta Howard and Lady Cowper, established their own salons, and Margaret Cavendish, Duchess of Portland, sat not only at the heart of an intellectual circle but also compiled her own museum. Lady Sundon, Lady Mary Wortley Montagu and Mrs Delany were simply encouraged to take confidence in their intellectual gifts and sought to pursue their own journeys into the

182–4 Gold box with painted portraits by Christian Friedrich Zincke of Margaret Cavendish, Duchess of Portland; Elizabeth Montagu; Mary Howard, Lady Andover; and Mary Pendarves, c. 1740. Private Collection

worlds of the scientist, philosopher, artist and writer inspired by Caroline's example. For others it was the more practical aspects of the Queen's activities which proved influential. In Caroline's wake a scattering of aristocratic women gardeners emerged. While Mary II had established important gardens around some of the royal homes, her position at the very apex of court society had been of such short duration that knowledge of her projects was limited. It was Caroline's gardens which were discussed and admired and it was she who made such ventures respectable.

Although it proved to be a delicate and potentially controversial task, Caroline managed to introduce a European vision of princely responsibility to the post-Restoration English monarchy (fig. 185).[41] Taking inspiration from Sophia, Sophie Charlotte and Liselotte, she promoted a stable of young artists, artists and gardeners, as well as writers, scientists and thinkers, bringing a new confidence and enthusiasm for the arts and sciences to members of the royal family and the wider court circle. Her salon, so much the product of her experiences in Berlin and Hanover, brought together the broadest of intellectual communities and set a new model for scholarly debate in England. Her ambition to create a universal library in the heart of London had the potential to introduce the European philosophies of Samuel Quiccheberg, Johann Daniel Major and Leibniz to her new countrymen and set a standard in the ordering of knowledge. Her children received an enlightened education on a model of which even the great Leibniz would have approved, and each developed a strong personality which enabled them in later years to survive the vagaries of diplomatic marriages. Frederick and Anne went on to establish lively intellectual circles of their own.

Caroline was well aware of the precariousness of the new Hanoverian dynasty. Her patronage may have been conditioned by her European upbringing, assisted by her relatives abroad and spurred on by international rivalries, but it underpinned her principal aims – to celebrate and promote the monarchy, to stress the dignity and antiquity of the royal line and to demonstrate that the present members of the House of Hanover and their heirs could take their places worthily and legitimately in the royal succession. When her initiatives received adverse comment, or the patriotic messages they contained proved too opaque for the contemporary English audience, she made strenuous attempts to bring her schemes in line with the expectations of her new compatriots. As a result Caroline contributed in an imaginative and important way to the anglicization of the new ruling house, and she should be seen as a significant contributor to – and facilitator of – early eighteenth-century Enlightened debate.

Opposite
185 *Queen Caroline as Britannia, receiving the gifts of the Earth(?)* by William Kent, pen and brown ink and grey and brown wash, over graphite, 1685–1748, British Museum

NOTES

INTRODUCTION

1 John Hervey, Baron Hervey, *Lord Hervey's Memoirs: Edited from a Copy of the Original Manuscript in the Royal Archives at Windsor Castle*, ed. Romney Sedgwick, London, 1952, p. 112. G. W. Leibniz, *Die Werke von Leibniz*, series 1, ed. O. Klopp, 1864–84, vol. XI (*Correspondez mit Caroline*), pp. 14–15, quoted in Paul Lodge, ed., *Leibniz and his Correspondents*, Cambridge, 2004, p. 264. Voltaire, *Letters Concerning the English Nation*, introduction. Charles Whibley, London, New York, Toronto, 1926, p. 375.

2 *The Craftsman*, 1727, cited in R. L. Arkell, *Caroline of Ansbach: George the Second's Queen*, London, 1939, p. 149.

3 Egmont, John Percival [Perceval], Earl of, *Manuscripts of the Earl of Egmont: Diary of Viscount Percival, Afterwards First Earl of Egmont, 3 vols*, Historical Manuscripts Commission, London, 1879–1923, vol. II, p. 458.

4 Caroline was baptised Wilhelmina Karoline.

5 George Stepney, Agent to the Brandenburg court, and from 1693 Commissary and Deputy to the Saxon court, provides useful information about the marriage between Eleanore of Saxe-Eisenach and John George IV. For his despatches see TNA S.P.81/87.

6 Karl Ludwig von Pöllnitz, [*La Saxe Galante*] *The Amorous Adventures of Augustus of Saxony . . . Translated from the French by a Gentleman of Oxford*, London, 1929, p. 14.

7 George Stepney was entertained by Caroline and her mother in Dresden on 5th August, 1695, see TNA S.P.150/50, cited in Tony Sharp, *Pleasure and Ambition: The Life, Loves and Wars of Augustus the Strong, 1670–1707*, London, 2001, pp. 113–14.

8 Following the death of her stepfather, Caroline seems to have maintained her links with the Saxon court. Augustus the Strong, John George's brother and successor, sent her a wheelchair as she became infirm. Berlin Dep. XI, 73, Convolut, 54 (Reichenbach's despatch). Windsor Oct 15/26, 1728), cited in Arkell, op. cit., p. 229. John Hervey, Baron Hervey, *Lord Hervey and his Friends, 1720–1738: Based on Letters from Holland House, Melbury and Ickworth*, ed. Earl of Ilchester, London, 1950, p. 182.

9 Hanover MS. Y.46c.XI. f.61, quoted in Arkell, op. cit., p. 7.

10 Hanover MS. Y.46c.XI.f.77, quoted in Arkell, op. cit., pp. 10–11.

11 Liselotte wrote to her aunt Sophia, Sophie Charlotte's mother, from Versailles in November 1704. Elisabeth Charlotte, Duchesse d'Orléans, *Correspondance de Madame, Duchesse d'Orléans*, trans. E. Jaeglé, 3 vols., Paris, 1890, vol. II, p. 14.

12 M. Kroll, *Sophie, Electress of Hanover: A Personal Portrait*, London, 1973, p. 215.

13 George Augustus declared: 'I have not one drop of blood on my veins dat is not English,' see W. Coxe, *Memoirs of the Life and Administration of Sir Robert Walpole, Earl of Orford*, 4 vols., London, 1816, vol. II, p. 205.

14 F. Harris, *A Passion for Government: The Life of Sarah, Duchess of Marlborough*, Oxford, 1991, pp. 204–205.

15 RA Add. MS. 17/75.

16 Armoisin was a stout plain woven silk. Mantua was a plain weave silk a little heavier than a taffeta.

17 Mary Glanville, Mrs Delany, *The Autobiography and Correspondence of Mary Glanville, Mrs Delany*, ed. Lady Llanover, 6 vols., vol. I, 1861, p. 220.

18 Mary, Countess Cowper, *Diary of Mary, Countess Cowper: Lady of the Bedchamber to the Princess of Wales, 1714–1720*, ed. Hon. C. S. Cowper, London, 1964, pp. 10–11.

19 Henrietta Howard, Countess of Suffolk, *Letters to and from Henrietta, Countess of Suffolk, and her Second Husband, the Hon. George Berkeley, from 1712 to 1769*, ed. J. W. Croker, 2 vols., London, 1824, vol. I, pp. 208–18

20 M. Hinton and O. Impey, ed., *Kensington Palace and the Porcelain of Queen Mary II*, London, 1998.

21 E. Corp, 'Catherine of Braganza and Cultural Politics' in C. Campbell Orr, ed., *Queenship in Britain, 1660–1837: Royal Patronage, Court Culture and Dynastic Politics*, Manchester, New York, 2002, pp. 53–73.

22 *The Political State of Great Britain*, vol. VIII, 1714, p. 357.

23 *Dawks's News Letter*, 18th March, 1715.

24 Andreas Gottlieb Bernsdorf, Hans Kasper von Bothmer and Jean de Roberthon served as advisers to George I on his German policy. There were other Germans friends who had travelled with the royal party to London, such as Augustus Shütz, Philip von Hattorf and the Countess of Bückeburg, but they were kept discreetly in the background. The Baroness von Gemmingen, who had served as governess to the elder princesses, was replaced by Lady Portland on the order of George I.

25 Ragnhild Hatton, *George I: Elector and King*, London, 1978, pp. 198–201.

26 Caroline missed her eldest son Frederick tremendously, as evidenced by a poignant trail of letters to courtiers and friends travelling to Hanover which ask for news of him, see Historical Manuscripts Commission, *Report on the Manuscripts of Lord Polwarth Preserved at Mertoun House, Berwickshire*, London, 1910, vol. I, p. 112.

27 Leicester House was earlier the residence of Elizabeth of Bohemia, and later an embassy. George Augustus and Caroline paid £6000 for their new home.

28 Koninklijk Huisarchief, The Hague, A17/470, i–iii.

29 W. Michael, *Englische Geschichte im XVIII Jahrhundert*, 5 vols., Hamburg, 1896–1955, vol. II, pp. 58–59.

30 Mary, Countess Cowper, *Diary*, op. cit., p. 132.

31 BL Egerton MS., 1717.f.78.

32 In 1751 George II said: 'I know I did not love my children when they were young: I hated to have them running into my room; but now I love them as well as most fathers', see H. Walpole, *Memoirs of the Reign of King George the Second: Edited from the original MSS. with a Preface and Notes*, ed. Lord Holland, 3 vols., London, 1846, vol. I, pp. 227–28.

33 Stephen Philpot, *An Essay on the Advantages of a Polite Education Joined with a Learned One*, London, 1747, pp. 26–27.

34 BL Add. MS. 16941, *The Original Exercise Book of HRH the Duke of Cumberland when a Boy in his own Writing, 28th Nov. 1727–28*. Hervey was to remark of Sir Andrew Fountaine: 'Lord Burlington could not make a better ragoust of paintings, statues, gilding and virtu.' See Hervey, *Lord Hervey and his Friends*, op. cit., p. 74.

35 John Chamberlayne, *The Present State of Great Britain*, London, 1735–36.

36 Reference to Philip Mercier as drawing master of the elder princesses can be found in George Vertue, 'Note Books III', *Walpole Society*, vol. 22, 1934, p. 72. '4 January, 1732. Mr Bernard Lens for his lodging at Hampton Court last summer to teach the Duke, Princess Mary and Princess Louisa to draw. £62.18.00', see TNA LC5/ 160. '1 November 1737. Mr Bernard Lens, painter in enamel, drawing master to ye young princesses at Hampton Court last summer. £18.19.0', see TNA LC5/20. All the princesses were provided with painting desks for their apartments, see: 'Richmond 23 December, 1732. a walnutree table with drawers and casters with a leather cover for Princess Royal to draw on', see TNA LC5/3f.91r. 'Kensington Two boxes of drawers with partitions to hold colours. Two mahogany stands to paint on', see TNA LC9/166 22r.

37 The evolution of the literary salon is discussed in the following publications and articles: Katherine R. Goodman, *Amazons and Apprentices: Women and the German Parnassus in the Early Enlightenment*, Rochester, N.Y., Woodbridge, 1999. Merry E. Wiesner, *Women and Gender in Early Modern Europe*, Cambridge, 2000. Dena Goodman, *The Republic of Letters: A Cultural History of the French Enlightenment*, Ithaca, London, 1994. Julie Sanders, 'Caroline Salon Culture and Female Agency: The Countess of Carlisle, Henrietta Maria and Public Theatre', *Theatre Journal*, vol. 52, no. 4, December 2000, pp. 449–64. Katherine B. Clinton, 'Femme and Philosophe: Enlightenment Origins of Feminism', *Eighteenth-Century Studies*, vol. 8, no. 3, Spring 1975, pp. 283–99. Gregory Brown, 'Leibniz's Endgame and the Ladies of the Court', *Journal of the History of Ideas*, vol. 65, no. 1, Jan. 2004, pp. 75–100.

38 Hertfordshire Record Office D/EP.F205, f.12v, quoted in S. Taylor, 'Queen Caroline and the Church', in S. Taylor, R. Connors and C. Jones, ed., *Hanoverian Britain and Empire: Essays in Memory of Philip Lawson*, Woodbridge, 1998, p. 85.

39 Francis Hare, Dean of St Paul's and Bishop of Chichester, John Potter, Archbishop of Canterbury, and Thomas Secker, Bishop of Bristol, also received invitations to Caroline's salon.

40 Henrietta Howard, Countess of Suffolk, *Letters*, op. cit., vol. II, p. 46.

41 J. M. Beattie, *The English Court in the Reign of George I*, Cambridge, 1967. Ragnhild Hatton, *George I: Elector and King*, London, 1978. B. Arciszewska, *The Hanoverian Court and the Triumph of Palladio: The Palladian Revival in Hanover and England, c. 1700*, Warsaw, 2002. R. O. Bucholtz, *The Augustan Court: Queen Anne and the Decline of Court Culture*, Stanford, Calif., 1993. H. Smith, *Georgian Monarchy: Politics and Culture, 1714–1760*, Cambridge, 2006.

42 Christine Gerrard, 'Queens-in-waiting: Caroline of Anspach and Augusta of Saxe-Gotha as Princesses of Wales', in Campbell Orr, ed., *Queenship in Britain*, op. cit., pp. 143–61. Andrew Hanham, 'Caroline and the 'Anglicisation' of the House of Hanover', in C. Campbell Orr, ed., *Queenship in Europe, 1660–1815: The Role of the Consort*, Cambridge, 2004, pp. 276–99.

43 S. Taylor, R. Connors and C. Jones, ed., *Hanoverian Britain and Empire*, op. cit., pp. 82–101.

44 L. Colley, *Britons. Forging the Nation, 1707–1837*, New Haven, London, 1992.

45 B. Simms and T. Riotte, ed., *The Hanoverian Dimension in British History, 1714–1837*, Cambridge, 2007.

46 A. C. Thompson, *George II: King and Elector*, New Haven, London, 2011.

47 W. H. Wilkins, *Caroline the Illustrious*, 2 vols., London, 1901. P. Quennell, *Caroline of England: An Augustan Portrait*, London, 1939. Arkell, *Caroline of Ansbach*, op. cit.

48 John Walters, *The Royal Griffin: Frederick, Prince of Wales, 1707–51*, London, 1972. Kimerly Rorschach, *Frederick, Prince of Wales (1707–1751) as a Patron of the Visual Arts: Princely Patriotism and Political Propaganda*, PhD. thesis, Yale, 1985. Kimerly Rorschach, 'Frederick, Prince of Wales (1707–1751) as a Patron and Collector', *Walpole Society*, vol. 55 (1990), pp. 1–76. Frances Vivian, *A Life of Frederick Prince of Wales, 1707 1751: A Connoisseur of the Arts*, ed. Roger White, Lewiston, N.Y., Lampeter, 2006.

1 CAROLINE AND THE GARDENERS

1 R. L. Brett, *The Third Earl of Shaftesbury: A Study in Eighteenth-Century Literary Theory*, London, 1951, pp. 165–207.

2 Anthony Ashley Cooper, *Second Characters*, London, 1778, vol. I, pp. 4–7.

3 J. Thorne, *Handbook to the Environs of London*, 2 vols., 1876, vol. II, p. 493. Victoria County History. *Surrey*, vol. III, p. 536.

4 *Calendar of Treasury Books and Papers, 1702–1707*, p. 115, p. 212. The leasing arrangement for Ormonde Lodge was terminated in 1715 when Ormonde was declared a traitor, after his defection to the Jacobite cause. Four years later the estate was offered for sale by the Commissioners of Forfeited Estates and caught the eye of the Prince and Princess of Wales, from their temporary lodgings.

5 Nicholas Hawksmoor claimed riding charges on several occasions for visiting the lodge to supervise work commissioned by William III, see TNA Works 6/2. For the furnishings of the lodge see TNA AO1/2482/296–97.

6 Christopher Clark, *Iron Kingdom: The Rise and Downfall of Prussia, 1600–1947*, London, 2006.

7 The remodelling of Lützenburg was complete by 1702 to designs by the Swedish architect Johann Friedrich Eosander.

8 A. C. Wimmer and M. Schaefer, 'Die Bedeutung Simon Godeaus für die deutsche Gartenkunst', in Gerd Bartoschek, et. al., *Sophie Charlotte und ihr Schloss*, Munich, 1999, pp. 130–40.

9 Sophia of Hanover, *Memoirs of Sophia: Electress of Hanover, 1630–1680*, trans. H. Forester, London, 1888, pp. 3–4.

10 Ibid., p. 6.

11 John Frederick, Ernest Augustus's elder brother, who died in 1679, had already inherited the property of another brother, Christian Louis, who had died in 1665.

12 It is possible that Caroline may have encountered the work of Benson at Lützenburg in Berlin. In 1704 Sophie Charlotte in her correspondence with Hans von Bothmar confirmed his presence there, though whether he was engaged on garden projects is not clear. Discussed in C. Hussey, 'Wilbury Park, Wiltshire', *Country Life*, 3 Dec., 1959, p. 1014.

13 T. Mowl, *Gentlemen and Players: Gardeners of the English Landscape*, Stroud, 2000, p. 80.

14 T. Richardson, *The Arcadian Friends: Inventing the English Landscape Garden*, London, 2007, pp. 66–69.

15 Stephen Switzer, *Ichnographia Rustica: Or, the Nobleman, Gentleman, and Gardener's Recreation*, London, 1718.

16 See Ophelia Field, *The Kit-Cat Club: Friends who Imagined a Nation*, London, 2008.

17 John Harris, *The Palladian Revival: Lord Burlington, his Villa and Garden at Chiswick*, New Haven, London, 1994, pp. 42–43.

18 *The Guardian*, no. 173, quoted in Mavis Batey, *Alexander Pope: The Poet and the Landscape*, London, 1999, p. 21.

19 Antonio Pellegrini's fine decorative cycle installed in the saloon at Narford, Sir Andrew Fountaine's country seat in Cambridgeshire, was almost certainly the gift of Lord Burlington.

20 In June 1725 Sir Andrew Fountaine served as proxy for Prince William Augustus on his installation as a Knight of the Order of the Bath.

21 The Temple of Modern Virtue stands in the Elysian Fields, part of the garden that Cobham developed at Stowe from 1733, after his break with Sir Robert Walpole. Conceived as a shambling ruin, the temple was intended by Cobham as a derogative comment on corruption in Walpole's government.

22 Letter from Alexander Pope to Lord Bathurst, 13 September, 1719, quoted in Alexander Pope, *The Works of Alexander Pope*, ed. J. W. Croker, intro. and notes W. Elwin and W. J. Courthorpe, 10 vols., London, 1871–89, vol. VIII, *Correspondence III*, 1872, pp. 327–29.

23 Horace Walpole, Earl of Orford, *Anecdotes of Painting in England; With some Account of the Principal* Artists, ed. Rev. J. Dallaway, 3 vols., London, 1848, vol. III, pp. 800–801.

24 John Harris, 'The Bicentenary of Kew Gardens. I: Fate of Royal Buildings', *Country Life*, vol. CXXV, 28 May, 1959, p. 1182, quoted in P. Willis, *Charles Bridgeman and the English Landscape Garden*, Newcastle upon Tyne, 2002, p. 102.

25 Lady Mary Wortley Montagu, *The Letters and Works of Lady Mary Wortley Montagu*, ed. Lord Wharncliffe, 2 vols., London, 1837, vol. II, p. 184. R. Halsband, *The Life of Lady Mary Wortley Montagu*, London, 1956, p. 106.

26 Egmont, John Percival [Perceval], Earl of, *Manuscripts of the Earl of Egmont. Diary of Earl of Egmont: Afterwards First Earl of Egmont*, Historical Manuscripts Commission, London, 1920, vol. I, p. 101. The diary is hereafter referred to in the text as 'Lord Egmont's diary.

27 The image was engraved by Nicolas-Henri Tardieu in 1733, and later circulated widely.

28 TNA Works 32/312, TNA Map Room h.258.

29 TNA Works 4/3 10 April 1725. TNA Works 6/15, pp. 94–95. TNA LC5/158, p. 361.

30 TNA Works 4/3, 17 March, 11 May 1725, 18 May, 14 June, 16 August, 1726. TNA Works 4/3, 25 October, 24 November, 8 December, 1726. TNA LC5/158, p. 488. TNA T. 1/141.

31 TNA T. 29/26, p. 279. TNA T.52/36, pp. 479–80.

32 TNA Works 6/114 f.30.

33 TNA Works 6/114 ff. 20–21v.

34 TNA Works 6/114 f.19v.

35 TNA Works 6/114 f. 26v. *The London Evening Post*, 29 April–1 May, 1731, p. 534.

36 *Memoirs of Charles-Lewis, Baron de Pöllnitz*, 3rd ed., 5 vols., London, 1745, vol. V, pp. 223–24.

37 *Gentleman's Magazine*, vol. III, April 1733, p. 206.

38 *A Companion to Every Place of Curiosity and Entertainment in and about London and Westminster*, London, 1767, p. 185.

39 Kensington Gardens are described in 1786 by Sophie von la Roche, see Sophie von la Roche, *Sophie in London 1786: Being the Diary of Sophie von la Roche*, London, 1933, p. 135.

40 Egmont, *Diary*, op. cit., vol. II, p. 138.

41 A short chapter in Ray Desmond's history of Kew Gardens is devoted to the Richmond garden, and this garden is also

discussed briefly in the works of Timothy Mowl, Mavis Batey and Tim Richardson. Ray Desmond, *Kew: The History of the Royal Botanic Gardens*, London, 1995. Mavis Batey, *Alexander Pope: The Poet and the Landscape*, London, op. cit., Timothy Mowl, *Gentlemen and Players*, op. cit., Tim Richardson, *The Arcadian Friends*, op. cit. Peter Willis includes a discussion of Bridgeman's work at Richmond, and also at Kensington, amongst information about the many other gardens with which he was involved, see P. Willis, *Charles Bridgeman*, op. cit. The contribution made to these gardens by the architect/artist/ designer William Kent in the 1730s is covered amongst his other garden projects in works by John Dixon Hunt, Michael Wilson and John Harris. John Dixon Hunt, *William Kent: Landscape Garden Designer*, London, 1987. Michael I. Wilson, *William Kent: Architect, Designer, Painter, Gardener, 1685–1748*, London, 1984. John Harris, *William Kent, 1685–1748: A Poet on Paper*, London, 1998.

2 CAROLINE AND THE ARCHITECTS

1 *The English Traveller Giving a Description of . . . England and Wales, etc.*, 3 vols., London, 1746, vol. III, pp. 145–46.

2 Vanburgh proposed a grand new palace to replace St James's Palace.

3 The development of a Hanoverian court style of architecture has been researched by Barbara Arciszewska, see B. Arciszewska, *The Hanoverian Court and the Triumph of Palladio*, op. cit.

4 George Vertue, 'Note Books I', Walpole Scoiety, vol. 18, 1930, pp. 100–101.

5 Thomas Coke was Earl of Leicester, fifth creation (1697–1759).

6 See Althorp MS. B8, 1733.

7 John Harris, *William Kent*, op. cit., John Dixon Hunt, *William Kent*, op. cit., and Timothy Mowl, *William Kent: Architect, Designer, Opportunist*, London, 2006.

8 For a description of the condition of the King's Staircase see TNA T.56/18, p. 352. For a description of the work undertaken by Kent in 1730: 'Repair'd the cracks and restoring fifteen ceilings and one of the King's Staircases from the top to the bottom', see TNA Works 4/4, 7 July, 1730. Further accounts relating to conservation projects undertaken by Kent are found in *Calendar of Treasury Books and Papers*, 1729–30, p. 402, *Calendar of Treasury Books and Papers*, 1731–34, pp. 63, 65, 89. TNA AO1/2453/164, TNA AO1/2453/165, TNA Works 4/4 April 1731 and TNA Works 4/7 July 1736.

9 TNA Works 4/4 16 Dec 1727 contains the first reference to conservation work undertaken by Kent in St George's Chapel. He was paid £300. Further work was undertaken in 1732 according to *The Gentleman's Magazine*, April 1732, p. 720, 'The curious Representation of our Lord's Supper, over the Altar of the Cathedral of *Windsor*, having been much damaged by being buried in the Earth, during the Usurpation of *Oliver Cromwell*, the Dean and Prebendaries of *Windsor* agreed with an eminent Painter to clean and beautify it.' Kent's conservation of the frescoes by Verrio is recorded in TNA Works 6/16, p. 44, TNA Works 4/7, July1, 1736, and TNA AO1/2455/170.

10 Following the report he presented in May 1734, Kent was paid £450 in 1735 for the conservation of the Queen's Staircase at Hampton Court Palace. He had written that the 'staircase leading to the Queen's great apartment at Hampton Court was never yet completely finished & the wainscot there is much out of repair . . . it would be advisable to take away the wainscot & embellish the walls and ceiling of the said staircase which are at present only whitewashed with ornaments painted of canvas in chiaroscuro', see TNA Works 5/141, 1735.

11 For the conservation of the painting by Rubens on the Banqueting House ceiling see TNA Works 4/3, 25 October 1726 and TNA Works 6/15, pp. 172–73. Caroline and George II's visit to the site is recorded by Kent at the end of a manuscript of Ovid's *Metamorphoses* in the British Library, see BL MS. Rawlinson, D540.

12 Burlington had financed a translation of Pliny's text which described the Villa Tuscum and Villa Laurentinum from Robert Castell, see R. Castell, *The Villas of the Ancients*, London, 1728.

13 Hervey, *Memoirs*, ed. Romney Sedgwick, op. cit., pp. 16–64.

14 John Hervey, *Letter-Books of John Hervey, First Earl of Bristol*, 3 vols., Wells, 1894, vol. III, p. 7.

15 *Political State of Great Britain*, vol. XXXVIII, August 1729, p. 191.

16 *Gentleman's Magazine*, July 1732, p. 874.

17 P. Willis, *Charles Bridgeman*, op. cit., pp. 86–87.

18 Lady Elizabeth Finch to Lady Burlington, 25 May, 1735, see Chatsworth Papers 212.2.

19 P. Willis, op. cit., p. 48.

20 TNA Works 4/6.

21 TNA AO1/2455/169. The Queen's Temple survives as a garden store.

22 Information on the construction of the mount seat is found in TNA Works 4/6, 22 October, 3 December, 1734, 4 September, 1735. TNA Works 6/16, f.35v. TNA Works 6/16. TNA Works 5/105 and *The Daily Gazetteer*, no. 31, 4th August, 1735.

23 The mount seat is illustrated on Rocque's plan of Kensington Gardens published in 1745. There is also a drawing by Bernard Lens. The detail in the drawing by Bernard Lens has been used as evidence that a drawing by William Kent without identification, published by John Vardy in 1744, is of the mount seat.

24 *London in Miniature*, London, 1755, p. 283

25 F. Kielmansegge, *Diary of a Journey to England in the Years 1761–62*, London, 1902, pp. 36–39.

26 Quoted in R. King, *Royal Kew*, London, 1985, p. 51.

27 The locations of all the new temples at Richmond are noted on Bridgeman's undated plan of the estate which can be found in the Topographical Collections at the British Library, and his first map in the National Archives, see BL King's Topographical Collections, XLI, 1613 and TNA Map Room 696. The eventual layout of the garden with illustrations of all the buildings can be found in John Rocque's plan, 'The Exact Plan of the Royal Palace Gardens and Park at Richmond' published in 1734, see John Rocque, *The Exact Plan of the Royal Garden and Park at Richmond 1734*, BL Maps K. Top. 41.16.F. A second version was made in 1754, see John Rocque, *The Exact Plan of the Royal Palace, Gardens and Park at Richmond 1754*, BL Maps K. Top. 41.16.h.

28 The first building accounts for the Hermitage date from 1730. Work started on the temples of Modern Virtue and Venus at Stowe in 1731.

29 Sir John Soane's Museum Adam vol. 56, folios 25, 33 and 34. RIBA Adam volume folios 11 and 12. See also John Vardy, *Some Designs of Mr Inigo Jones and Mr Wm Kent*, London, 1744, Pl. 33. The Holkham Hall illustrations are discussed in C. Sicca, '"Like a shallow cave by nature made . . ." William Kent's Natural Architecture at Richmond', *Architectura*, vol. 16, 1986, pp. 68–82.

30 A drawing of the Hermitage by Bernard Lens, entitled 'A Prospect of Her Majestys Hermitage in ye Gardens at Richmond in Surey 1733', survives in the collection of the Museum of London.

31 The interior of the Hermitage is illustrated in drawings in Sir John Soane's Museum, see Adam vol. 56/33.

32 These illustrations can be found in RIBA Adam volume, fol. 11 and RIBA Adam volume fol. 12.

33 The building accounts for the Hermitage are found in TNA Works 4/4, 5 November, 1730. After the main bills had been paid a few arrived late, totalling an extra £130. 8s. 6d. Only a short series of Privy Purse accounts from July 1731 to September 1733 survives in the Royal Archives at Windsor Castle, but happily these identify the contractors working on the Hermitage.

34 The book was passed marking the completion of the building of Merlin's Cave on 1st August, 1735, see TNA Works 4/6, 1 August, 1735.

35 The thatching of Merlin's Cave is detailed in TNA Works 4/4 December 22, 1730. The financial records recording the building of Merlin's Cave are limited but a series is found in TNA Works 5/59, dating from June 1735.

36 J. Dryden, *Merlin: Or, the British Inchanter. And King Arthur, the British Worthy*, London, 1736. The engraved illustration is associated with T. Bowles.

37 E. Curll, *The Rarities of Richmond: Being Exact Descriptions of the Royal Hermitage and Merlin's Cave, with his Life and Prophesies*, London, 1736.

38 H. Walpole, *Anecdotes of Painting in England: With some Account of the Principal Artists*, ed. Dallaway, op. cit., vol. III, pp. 778–79.

39 John Harris, 'William Kent and Esher Place', in G. Jackson-Stops, ed., *The Fashioning and Functioning of the British Country House*, Washington, D.C., Hanover, London, 1989, pp. 13–26. John Harris, 'Esher Place, Surrey', *Country Life*, 2 April, 1987, pp. 94–97. M. Symes, 'The Landscaping of Esher Place', *Journal of Garden History*, 1988, vol. 8, no. 4, pp. 63–96.

40 A capriccio dating from about 1731 by Kent in the British Museum includes in a single image views of both Hampton Court Palace and Esher Place, see British Museum accession number 1927-7-21-5.

41 The thatched cottage in the park at Esher is illustrated on Rocque's plan for Esher published in 1737.

42 John Harris, 'William Kent and Esher Place', op. cit., pp. 23–24. The Gothick style of architecture later became associated with the 'Patriots', a group of Whigs deeply disenchanted with the policy of the Sir Robert Walpole, the Whig prime minister. Garden buildings in a Gothick style constructed at Stowe for Cobham, at Painshill for Charles

Hamilton, at Hagley for Charles Lyttelton, and at Wroxton for the Earl of Guilford are indications of their Patriot affiliation.

43 Bodleian Library, Maps 40, f.6v, f.7v.

44 The catalogue of Caroline's library (BL Add. MS. 11511) includes the title 'William Stukeley, *Itinerarium Curiosum, or an Account of the Antiquitys and Remarkable Curiositys in Nature or Art, Observ'd in Travels through Great Britain*', London, 1724'. For contemporary discussion on the formation of national identities see R. Sweet, *Antiquaries: The Discovery of the Past in Eighteenth-century Britain*, Hambledon, London, 2004. G. Newman, *The Rise of English Nationalism: A Cultural History, 1740–1830*, London, 1987. L. Colley, *Britons: The Forging of a Nation, 1707–1832*, 1992, op. cit. C. Kidd, *British Identities before Nationalism: Ethnicity and Nationhood in the Atlantic World, 1660–1800*, Cambridge, 1999. Murray G. H. Pittock, *Celtic Identities and the British Image*, Manchester, 1999.

45 Timothy Mowl and Brian Earnshow have made a compelling case that John Wood the Elder (1704–54), the architect most associated with his work in Bath, in the train of Stukeley became fascinated by the prehistoric sites on Lansdown Hill above the city. His interest was passed to his son, John, and the form, proportion and decorative detail employed in John Wood the Younger's work on the Circus, and the Grand Crescent, may reflect contemporary thinking about ancient Druidical structures. See T. Mowl and B. Earnshaw, *John Wood: Architect of Obsession*, London, 1988.

46 John Toland's *History of the Druids* was published in 1726.

47 A dancing lawn was laid out in front of Alfred's Hall, in Lord Bathurst's garden at Cirencester.

48 The festivities at Hampton Court are recorded in *The Political State of Great Britain*, London, 1716, pp. 139–40. There are accounts of Caroline taking part in country dances in Mrs Delany, *The Autobiography and Correspondence of Mary Granville, Mrs Delany*, ed. Lady Llanover, series I, vol. I, London, 1861, pp. 191–92, Sarah Churchill, *Letters of a Grandmother: Being the Correspondence of Sarah, Duchess of Marlborough with her Grandaughter Diana, Duchess of Bedford*, ed. G. S. Thomson, London, 1943, pp. 171–72, and C. Gerrard, 'Queens-in-waiting: Caroline of Anspach and Augusta of Saxe-Gotha as Princesses of Wales', in C. Campbell Orr, ed., *Queenship in Britain*, op. cit., p. 148.

49 Lodged in Caroline's library of gardening books was Batty Langley's *New Principles of Gardening*, originally published in 1727, and *Pomona: or, the Fruit Garden Illustrated*, originally published in 1728, as well as books of plans of the gardens at Versailles, and about grottoes and mazes. Caroline also owned d'Argenville's *La Théorie et la Pratique du Jardinage*, in the edition published in 1713 under the synonym LSAU DA.

50 Sir John Soane's Museum Adam vol. 56/25.

51 Quote from Horace Walpole, *On Modern Gardening*, London, 1782, from *Anecdotes of Painting*, ed. Dallaway, op. cit., p. 801. Lord Hervey recorded that the Queen remarked of England: 'Your island might be a pretty thing in that case for Bridgeman and Kent to cut into gardens', giving both men credit as gardeners. See Hervey, *Memoirs*, ed. Romney Sedgwick, op. cit., p. 151.

52 J. Gwynn, *London and Westminster Improved, etc. A Facsimile of the Edition of 1766*, Farnborough, Hants, 1969.

53 Lord Egmont visited the Queen's garden at Richmond on 25th August, 1730, see Egmont, *Diary*, op. cit., vol. I, p. 101. Lord Egmont described a second visit to the Richmond garden on 7th August, 1735, see Egmont, *Diary*, op. cit., vol. II, p. 190.

54 'Richmond Garden', *The London Magazine and Monthly Chronologer*, vol. VII, 1738, pp. 38–39.

55 E. Curll, *The Rarities of Richmond*, op. cit., p. 7.

56 Walter Harrison, *A New and Universal History, Description and Survey of the Cities of London and Westminster*, London, 1775, p. 573, and Egmont, *Diary*, op. cit., vol. II, p. 190.

57 H. Colvin and M. Craig, ed., *Architectural Drawings in the Library of Elton Hall by Sir John Vanbrugh and Sir Edward Lovett Pearce*, Roxburghe Club, 1964, plates 74–76.

58 Descriptions of the making and the display of the model of the new palace are found in TNA Works 4/15, TNA AO 1/2455/170, and *The London Daily Post and General Advertiser*, 15 September, 1735.

59 William Kent's model for the new palace survives in the Royal Collection.

60 John, Baron Hervey, *Some Materials towards Memoirs of the Reign of King George II*, ed. Romney Sedgwick, London, 3 vols., 1931, vol. III, p. 681. While Hervey was not an impartial commentator on Hanoverian royal family politics, there is every indication that Frederick's relationship with his parents was very difficult.

61 T. Borman, *Henrietta Howard: King's Mistress, Queen's Servant*, London, 2007.

62 A. C. Thompson, *George II*, New Haven, London, 2011, pp. 113–14.

63 Hervey, *Memoirs*, ed. Romney Sedgwick, op. cit., p. 312.

64 TNA Works 1/1, p. 44.

65 The collection of drawings in Sir John Soane's Museum collection shows alternative plans for the Queen's library, as well as various worked-up details. Vol. 147/194, an alternative design, is drawn by an unknown draughtsman in grey and brown wash. It comprises a detailed plan of the first of the book alcoves, an elevation, the entrance apse and a sectional elevation of the window wall looking onto the park. Vol. 147/196 is an enlarged plan and section of the entrance bay. Vol. 147/198 is another alternative plan for the library with windows arranged down both sides of the room, and having bookcases projecting into the room at right angles to the walls. Vol. 147/195 is a partial plan for the ceiling with some of the plasterwork details worked up. Vol. 147/193 is an elevation of the window wall of the library and is a close variant of the plan Vol. 147/198 but with sketchy details added for a scheme for the ceiling. Vol. 147/192 is an enlarged plan and section of the fireplace and its flanking bookcases for one end of the library. The exhibition of drawings by Kent in Sir John Soane's Museum in 1998 included an engraving from a private collection, captioned 'Her Majesty's Library in St James's Park . . . Finished Octr 29th 1737/Designed by W Kent . . . *Gulielmus Kent Archit:et Pict. Invenit et Delin . . . P Fourdrinier Sculpt.*' It shows the fireplace at the end of the library flanked with bookcases arranged in arched recesses under a richly carved cornice and deep coved ceiling ornamented with scrolling foliage, enclosing cartouches containing painted royal portraits, see J. Harris, *William Kent*, op. cit., p. 23.

66 See Sir John Soane's Museum, vol. 147/197. The design is in pencil, pen and ink with a sepia wash.

67 The design for the ceiling takes inspiration from ceilings at the Palazzo del Tè in Mantua, and the Palazzo Borghese in Rome which Kent had the opportunity to visit during his Italian sojourn.

68 A design for the ceiling is found in Sir John Soane's Museum, vol. 147/192–98.

69 The library cost Caroline £1618. 0s. 8<1/2>d. The accounts are found in TNA Works 5/59 July 1736–Sept 1737 and TNA Works 5/105, Debt Book 1730–68, vol. 2.

70 The watercolour of the Queen's Library was made by Charles Wild in 1819. The drawing by Wild is in the City of Westminster Library and Archive.

3 CAROLINE AND THE SCULPTORS

1 *Gentleman's Magazine*, August, 1733, p. 421.

2 Guelphi was paid £10. 2s. as a first instalment for the busts in June 1731 and in September 1731 there was a second payment of £42 for 'Four busts in stone'. The commission for the bust of Robert Boyle followed a little later, in June 1732, and cost Caroline £22. 14s. The payments are recorded in TNA Works 5/58.

3 Vertue, 'Note Books III', op. cit., vol. 22, p. 51. Even though *The Gentleman's Magazine*, vol. III, August 1733, pp. 421–22, provides a confusing reference to Michael Rysbrack as the sculptor of the Hermitage busts of worthies, the business accounts for the project indicate that they should be attributed to Giovanni Battista Guelphi, listing no other artist. A contemporary publication of the attribution to Rysbrack led to such confusion that Rysbrack himself intervened and, in a discussion with Sir Edward Littleton in 1756, he declared: 'Sir. I did not make the bust of Dr Clarke in the Hermitage; it was done by Mr Guelphi, an Italian, who is dead', see M. I. Webb, 'Busts of Sir Isaac Newton', *Country Life*, vol. CXI, Jan. 25, 1952, pp. 216–18.

4 The busts are now supported on circular socles, made later in the style associated with Sir Francis Chantrey. The busts are not signed or dated.

5 Guelphi made another bust of Newton for Alexander Pope which he bequeathed to Lord Mansfield, and is now in the collection at Scone Palace. This is very close in style to the example in the Hermitage.

6 The arrangement of the bust of Robert Boyle is described in *The Gentleman's Magazine*, April 1733, p. 208.

7 E. Curll, *Rarities of Richmond*, op. cit., p. 16.

8 Cowper, *Diary*, op. cit., p. 74.

9 BL Add. MS. 11511, which lists Caroline's books, includes the following titles by Sir Isaac Newton: '*Observations upon the Prophesies of Daniel & ye Apocalypse of St John*'; '*Philosophiae Naturalis Principia Mathematica*, 3rd ed., London, 1726. 2 copies'; '*Traité d'Optique sur les Réflexions, Réfractions, Infuxions et les Couleurs de la Lumière*, 2 vols., trans. Mr Coste, Amsterdam, 1720'; and '*Recueil de Diverse Pièces sur la Philosphie, la Réligion Naturelle, l'Histoire, les Mathématiques par Mss Leibnitz, Clarke, Newton et les Auteurs celebres*, 2 vols., Amsterdam, 1720'. There were also several books that discussed Newton's work, including: '*A View of Sir Isaac Newton's Philosophy*, by Henry Pemberton, London, 1728'; '*A Demonstration of some of the Principal Sections of Sir Isaac Newton's Principles of Natural Philosophy in which his Particular Method of Treating that Useful Subject, is Explained, and Applied to some of the Chief Ph<ae>nomena of the System of the World*, by John Clarke DD., London, 1730'.

10 M. C. Jacobs, *The Newtonians and the English Revolution, 1689–1720*, Hassocks, 1976.

11 Clarke's first Boyle lecture entitled 'Demonstration of the Being and Attributes of God' was given in 1704. The second, 'A Discourse Concerning the Unchangeable Obligations of Natural Religion, and the Truth and Certainty of the Christian Revelation', was given in 1705.

12 Cowper, *Diary*, op. cit., p. 14.

13 Ibid., p. 17.

14 BL Add. MS. 11511, which lists Caroline's books, includes the following titles by Dr Samuel Clarke: '*A Paraphrase of the Four Evangelists, with Critical Notes*, London, 1714'; '*A Discourse Concerning the Being and Attributes of God: The Obligations of Natural Religion and the Truth and Certainty of the Christian Revelation*, London, 1711, 3 copies'; '*Three practical Essays, viz. On Baptism, Confirmation, Repentance*, London, 1699; *The Scripture-doctrine of the Trinity*, London, 1712, 3 copies'; '*A Collection of Papers which Pass'd between the Late Learned Mr Leibnitz and Mr Clarke in the Years 1715 and 1716 Relating to the Principles of Natural Philosophy and Religion*, London, 1717, 2 copies'.

15 Quoted in P. Lodge, ed., *Leibniz and his Correspondents*, Cambridge, 2004, p. 269.

16 The argument that Caroline's choice of worthies for the Hermitage demonstrates her belief that science and religion could be mutually reinforcing is discussed in Nigel Aston, *Art and Religion in Eighteenth-Century Europe*, London, 2009.

17 Egmont, *Diary*, op. cit., vol. I, p. 281.

18 See S. Taylor, 'Queen Caroline and the Church' in S. Taylor, R. Connors and C. Jones, *Hanoverian Britain and Empire*, op. cit., pp. 82–102.

19 The Temple of Fame was also called the 'Gibbs Building'.

20 The winning entries to the poetry competition were published in *The Gentleman's Magazine*, June 1733, p. 317, July 1733, pp. 369–71, August 1733, pp. 429–31, and October 1733, pp. 541–42.

21 *Gentleman's Magazine*, August 1733, p. 421.

22 Viscountess Sundon, *Memoirs of Viscountess Sundon: Mistress of the Robes to Queen Caroline, Consort of George II*, ed. A. T. Thomson, 2 vols., London, 1847, vol. II, p. 139.

23 *Gentleman's Magazine*, vol. V, August 1735, p. 498. Confusingly, Curll also included, with his text, an engraving showing the figures arranged in pairs in niches within the blind tracery around the walls. Curll, *The Rarities of Richmond*, op. cit., p. 80.

24 *The Spectator*, 5 April, 1711. Mrs Salmon's exhibition later moved to Fleet Street. There is a reference in *Reed's Weekly Journal or British Gazetteer*, August 2nd, 1735, issue 539, to suggest that Rysbrack was involved in the sculpting of the figures for Merlin's Cave. This is hard to verify; it may be that he was involved in the early stages of the production of the waxworks, or in an earlier plan for the decoration of the Cave.

25 Zacharias Conrad von Uffenbach, *London in 1710: From the Travels of Z. C. von Uffenbach*, ed. W. H Quarrell and Margaret Mare, London, 1934, pp. 92, 118. George Vertue noted that Mrs Salmon employed Thomas Benière, an artist in wax, to run her studio. Benière was of Huguenot ancestry and had experience in making anatomical models. His brother-in-law Abraham Simmonds also worked with wax, specialising in portraiture.

26 In 1725 Mrs Goldsmith, who operated from Green Court in the Old Jury, made full-length figures of William III and Mary II, and Queen Anne. These were set up in Westminster Abbey alongside her wax effigy of the Duchess of Richmond and Lennox which had been commissioned in 1703 by the Duchess herself. These formed part of what came to be known as the 'Ragged Regiment'. Caroline was certainly aware of the Westminster Abbey effigies. The Lord Chamberlain paid for repairs to railings at Westminster Abbey, in 1735, and there is every possibility that Caroline had involved herself in the project. Lord Hervey reported: 'My Lord Rochester carried us to Westminster Hall to show us a pair of old brass gates to Henry VII's chapel which were formerly overrun with rust and turned quite black but are now new cleaned and bright as when first made, and the finest things of the kind I ever saw in my life . . . and the Queen asked many questions about them and seemingly extremely pleased with the description, the king stopped the conversation short by saying "My Lord, you are always putting some of these fine things in the Queen's head, and then I am plagued with a thousand plans and workmen". Then turning to the Queen he said "I suppose I shall see a pair of these gates to Merlin's cave to complete your nonsense there."' The railings were subsequently used as models for the gilded railings which barred the entrances to her Hermitage. See Hervey, *Memoirs*, ed. Romney Sedgwick, op. cit., pp. 162–63.

27 D. Defoe, *The History of the Life and Adventures of Mr Duncan Campbell: Gentleman who tho' Deaf and Dumb, Writes Down any Stranger's Name at first Sight . . .* London, 1728.

28 BL Add. MS. 11511, which lists Caroline's books, includes the following titles relating to the supernatural: '*Le Monde Enchanté ou Examen des Communs Sentimens Touchant les Esprits, leur Nature, leur Pouvoir, leur Administration et leurs Operations*, par Balthazar Bekker, traduit du Hollandois, Amstr. 1694 4 vol.'; '*De la Demonomanie des sorciers*, par J. Boudin, Paris, 1586'; '*Discours des Spectres ou Visions et Apparitions d'Esprits comme Anges, Demons, et Ames, se Monstrans Visibles aux Homes*, par 'Pierre le Loyer, Paris, 1608'; '*Saducismus Triumphatus: Or, Full and Plain Evidence Concerning Witches and Apparitions: In two parts. The first Treating of their Possibility, the second of the Real Existence*, by Joseph Glanvil, The third edition with additions. Lond. 1700'; '*An Historical Essay Concerning Witchcraft with Observations upon Matters of Fact, Tending to Clear the Texts of the Sacred Scriptures and Confute the Vulgar Errors about that Point: And also Two Sermons, one in Proof of Christian Religion, the other Concerning Good and Bad Angels*, by Francis Hutchinson, DD. 1718'.

29 Sarah Churchill, *Letters to a Grandmother*, op. cit., pp. 171–72.

30 BL Add. MS. 11511, which list Caroline's books, includes '*The Works of Mr Edmund Spenser: With a Glossary Explaining the Old Obscure Words pub. by Mr Hughes*, London, 1715'.

31 The notion of Tudorism, 'a post Tudor mobilisation of any and all representations, images, association, artefacts, spaces and cultural scripts that either have, or are supposed to have, their roots in the Tudor era,' is explored in T. String and M. Bull, ed., *Tudorism: Historical Imagination and the Appropriation of the Sixteenth Century*, Proceedings of the British Academy, no. 170, 2011.

32 BM Add. MS. 11511 includes reference to William Camden's *History of Elizabeth*, as well as '*Regni Anglie sub Imperio, Reginae Elizabetho, Religio et Gubernano Ecclesiastica ex autographo Johannis Cosini, Episcopo Dunelmen, editi Gul. Wesket Lond, 1729*', and '*The Journals of all the Parliaments during the Reign of Queen Elizabeth both of the House of Lords and House of Commons* collected by Sr Simon D'Anvers, London 1682', and many more books relating to Queen Elizabeth I.

33 See C. Gerrard, *The Patriot Opposition to Walpole: Politics, Poetry and National Myth, 1725–42*, Oxford, 1994.

34 William Kent's illustrations to Thomas Birch's edition of *The Faerie Queene* can be found in the Department of Word and Image at the Victoria and Albert Museum.

35 *Les Voeux de Paon* was written by Jacques de Longuyon in about 1310, at the behest of Thiébaut de Bar, Bishop of Liège. It concerns principally the story of the siege of Ephesus and the exploits performed there by a group of knights in fulfilment of vows they had made to a peacock. It includes a panegyric of the nine worthies which served to introduce them into future popular literature. A copy of *Les Voeux de Paon* can be found in Lambert le Tort, *The Romances of Alexander: A Collotype of MS. Bodley 264*, intro. M. R. James, Oxford, 1933.

36 Caroline owned not only a copy of Dryden's play and the two epic poems by Blackmore but also the manuscript of a work entitled '*King Arthur or Merlin the British Inchanter*' by Henry Gissard.

37 BL Add. MS. 11511, which lists Caroline's books, includes 'Leibniz, *Mantissa cordis Juns Gentium Diplomatici Hanoverae*, 1700, 4 sets'.

38 The new opera house in the Leineschloss opened in 1689 with a production of *Enrico Leone* based on the history of Henry the Lion, the great hero from Hanoverian family history. For further discussion of Handel and his association with the Hanoverian regime see R. Smith, *Handel's Oratorios and Eighteenth-Century Thought*, Cambridge, 1995.

39 The Italian opera *Alcina* by G. F. Handel is based on Ludovico Ariosto's *Orlando Furioso*. It was first performed at Covent Garden Theatre in 1735.

40 *Gentleman's Magazine*, vol. V, Sept. 1735, pp. 532–33.

41 Sarah Churchill, *Letters of a Grandmother*, op. cit., pp. 171–72.

42 *The Craftsman*, vol. 14, no. 480, September 1735, pp. 110–11.

43 Hervey, *Memoirs*, ed. Romney Sedgwick, op. cit., p. 163.

44 The figure of Peter the Great in the St Petersburg Academy was described in great detail by Mr Stahlin-Storcksburg in 1725. See J. von Staehlin-Storcksburg, *Original Anecdotes of Peter the Great: Selected from the Conversation of Several Persons of Distinction at Petersburgh and Moscow*, London, 1788, p. 367.

45 The figure of Frederick III survived until 1945, and in the twentieth century was displayed in the Hohenzollern Museum in Monbijou Palace. Caroline had moved away from Dresden, her childhood home, before Augustus the Strong, Elector of Saxony and King of Poland, commissioned a life-size, full-length wax portrait of himself and had it set up dressed in heroic dress and holding replicas of the regalia of his electorate and kingdom.

46 The incidence of waxworks as entertainment was not just a phenomenon of the early eighteenth century. Visitors to St Bartholomew's Fair as early as 1647 described figures being exhibited as novelties. In 1685 the Lord Mayor's Book recorded that Jacob Schalek was given permission to take his waxwork exhibition round the City of London. An exhibition compiled by Miss Mills, which included figures of Charles II, William II and Mary II 'in full stature', was advertised in *The Postman* in 1696. In 1710, von Uffenbach was impressed and surprised at 'more than a dozen' full-length wax figures prepared by Mr de Puy and installed in his house in London as an adjunct to his collection of rarities. They were deemed 'all made excellently and most natural'. The display included 'Cleopatra lying on a couch, clasping the asp to her bosom. Opposite was a quite incomparable representation of her maid weeping. Her eyes were all swollen as if she had been crying them out, and tears were coursing down her cheeks, while she wrung her hands most piteously. Nearby was Mark Antony stabbing himself. There was also the whole of the well known story of the madness of Rosamond, the mistress of one of the English kings. She was represented kneeling before Queen Elionor, who was offering her rival either the dagger or the poisoned cup. The wounded King was

near her, lying on the ground with a gash on his forehead. There was also Princess Sophia of Hanover, Heiress of England, when still young, sleeping by a table. On the side was Queen Anne, well made but flattered. There was a waiting woman and by the door a yeoman of the bodyguard who looked, most natural.' Uffenbach, *London in 1710*, op. cit., pp. 80–85.

47 Sundon, *Memoirs*, op. cit., vol. I, p. 121.

48 Sundon, *Memoirs*, op. cit., vol. II, pp. 106, 279–80. The Abbey series contained many of the characters – Edward II and Catherine of Valois, Elizabeth of York and Henry VII, Elizabeth I and Henry, Prince of Wales – whom Caroline selected as subjects for the line of kings in her new library.

49 In 1727 Lord Cobham set up seven full-length sculptures by Rysbrack of the Saxon deities who gave their names to the days of the week and which also celebrated the Germanic roots of the English nation. Caroline was probably aware of the programme.

50 'I think he ought to have Chamber's Dictionary, Danet's Dictionary of Antiquities, and Baily's Etymological Dictionary, or books of the same sort . . . I hope neither Swift, not Montaigne, nor South, nor writers in the Dunciad Controversy, nor even Cowley, will fall into his hands . . . and if her Majesty will allow me the honour of spending a few hours in her Library at Richmond when I come to town, I will endeavour to pick out the most useful things I can . . .' Dr Alured Clarke to Mrs Clayton, 19th Sept., 1730. See Sundon, *Memoirs*, op. cit., vol. I, pp. 189–92.

51 Stephen Duck was treated very well in his role as hermit. The hermit recruited by The Hon. Charles Hamilton in the 1730s and 1740s to live in the Hermitage in his garden at Painshill, while enjoying a reasonable salary, was supplied with just a Bible, a pair of glasses, a mat, a hassock and an hourglass.

52 *Old Whig, or The Consistent Protestant*, issue 16, 26 June, 1735. *Reed's Weekly Journal or British Gazetteer*, 3 July, 1736, issue 591.

53 In the two nineteenth-century illustrations made of Caroline's library, the last set of sculpted worthies can be seen still placed on their brackets, set up high between each of the arched recesses.

54 'Mr Risbrack's' bill be passed for 'the bustoes in the Queen's Library at St James's and ordered that he be writ to to send to the Office (there to be kept) the models of the faces he made for working after', see TNA Works 4/7, 11 Jan., 1737–38.

'I am ordered by the Surveyor General and the rest of the commissioners of the Board of Works to acquaint you that they will allow you the price you charged them for the bustoes in the Queen's library but expects you will send them to the office (there to be lodged) the modellos of the faces you made for working after', see TNA Works 1/2, p. 7, 23 Jan., 1737–38.

55 Guelphi had been trained by Camillo Rusconi, a pupil of Ercole Ferrate, in whose work the influences of both Algardi and Bernini may be seen.

56 For Caroline's visit see *The Daily Journal*, 11th June, 1735. *The General Evening Post*, 10th–12th June, 1735. While in the studio she remarked of the bust of James I, 'il me semble a une Boureau, I won't have that done', see Vertue, 'Note Books III', op. cit., vol. 22, p. 75. She returned on 30 July, 1736, see *The Daily Gazetteer* (London edition) 31 July, 1736, issue 342. There is a note in *The Daily Gazetteer* (London edition) 3 July 1736, issue 617, to suggest Caroline had also commissioned from Rysbrack four busts to represent the seasons for Merlin's Cave.

57 Justus Lipsius, *De Bibliothecis Syntagma*, Antwerp, 1602.

58 Gabriel Naudé, *Avis pour Dresser une Bibliothèque*, 1627, and Claude Clemens, *Musei sive Bibliothecae*, 1635.

59 Pope's comment was made in 1711, see Alexander Pope, *The Works of Alexander Pope*, intro. and notes W. Elwin and W. J. Courthope, op. cit., vol. VI, Correspondence I, 1871, p. 145.

60 This proposal is described in Thomas Pennant, *Some Account of London*, 4th ed., London, 1805. This plan is reflected in a drawing by William Kent in 147/198, in Sir John Soane's Museum.

61 John Evelyn, *The Diary of John Evelyn*, intro. and notes Austin Dobson, 3 vols., London, New York, 1906, vol. III, p. 96–97.

62 Sundon, *Memoirs*, vol. I, op. cit., p. 66.

63 The Venerable Bede, *Historiae Ecclesiasticae Gentis Anglorum, Libri Quinque*, ed. J. Smith, Cambridge. 1722. Assar, *Annales Rerum Gestarum Aelfredi Magni: Auctore Asserio Menevensi*, ed. F. Wise,Oxford, 1722.

64 David Wilkins had dedicated his edition of the corpus of Anglo-Saxon legislation to George I in 1721.

65 Hogarth's portrait of the heiress Mary Edwards, which includes busts of both Elizabeth I and King Alfred, was not made until 1742. She is shown as a 'Patriot' princess, see S. Keynes, 'The Cult of King Alfred' in *Anglo-Saxon England*, no. 28, 1999, pp. 225–356.

66 See RA, Add. MS. 16, and the Royal Collection inventory bought in 1942 from Mr Francis Harper.

67 Caroline gave £1000 to Queen's College, in 1735, to fund the building of a new quadrangle.

68 Sir John Wynn, *The History of the Gwydir Family*, Llandysul, 1937, p. 69.

69 Rev. J. Granger, *A Biographical History of England*, 5th ed., 6 vols., London, 1825, vol. I, p. 13 (Philippa of Hainault), p. 20 (Catherine of Valois).

70 George Vertue, 'Note Books IV', *Walpole Society*, vol. 24, 1936, p. 65.

71 BL C120.h.6(6), which records the movement of Caroline's books between various royal residences, includes the reference 'Mr Tide a envoyé à la bibliothèque . . . the *Heads of the Kings and Queens of England* . fol.' Her library catalogue (BL Add. MS. 11511) includes the title '*The Heads of the Kings and Queens of England* fol.' Perhaps this is the volume sent to Caroline from Lord Egmont, see Egmont, *Diary*, op cit., vol. II, p. 299.

4 CAROLINE AND THE ARTISTS

1 Archduke Ferdinand of the Tyrol's collection in the Spanischen Saal at Ambras Castle eventually contained over a thousand portraits. They recorded, chronologically, rulers of the House of Habsburg from the time of its ancient founders.

2 Caroline's half-sister's inventory is recorded in StA. Marburg Best. 81, A, Reg. Hanau Nr. 8, transcribed in Uta Löwenstein's unpublished article 'Apartment of the Countess Dorothea Friederike von Hanau-Lichtenberg at her Death in the Year 1731', pp. 1–32. The Electress Sophia, just like Caroline, prized the unusual. They both had pictures with moving parts in their cabinets.

3 In the early 1730s Vertue's thoughts returned to the collection of Holbein drawings, and he recorded for the second time his account of their discovery: 'of late (about a year or two) the present Queen met with in the library at Kinsinton many pictures, drawings (in a book) from the life done by Hans Holbein. The pictures of persons living in the time and courts of Henry VIII and Edward VI. These pieces have been long buried in oblivion . . .' Vertue, 'Note Books II', *Walpole Society*, vol. 20, 1932, pp. 45, 83.

4 BL Add. MS. 20101 f.28, ff.58–59.

5 For a discussion of the Holbein drawings see Jane Roberts, *Holbein and the Court of Henry VIII*, Edinburgh, 1993, and Susan Foister, *Holbein in England*, London, 2006.

6 BL C120.h6 (7), which records the movement of books between various royal homes, notes: '*le 9 dec 1736 recu de la part de Milord Hervey pour la Reine les livres suivans. The Reign of Queen Elizabeth . . .*'

7 It is possible that this book was referred to in Henry VIII's inventory made in 1542. Jane Roberts, *Holbein and the Court of Henry VIII*, op. cit., p. 20.

8 'Abraham van der Doort's Catalogue of the Collections of Charles I', ed. with intro. Oliver Millar, *The Walpole Society*, vol. 37, 1960, p. 79.

9 'I waited on my Brother and Sister Evelyn to Court . . . I was also showed divers rich jewels and crystal vases . . . two incomparable heads by Holbein . . . This in the closet.' Evelyn, *Diary*, op. cit., vol. II, p. 155.

10 In June 1690 Constantijn Huygens took his friends Berghesteyn and Sonnius to Whitehall where 'in rooms underneath the King's Closet . . . we saw four or five books with drawings amongst others Holbeins and Leonardo da Vincis.' He returned on 31st August when 'The Queen [Mary II] sent for me saying she wanted me to put the books with the King's Drawings in good order'. On the following day, 'in the morning at nine o'clock when I was still in bed the Queen sent for me again and together we went through the whole of the book by Leonardo da Vinci and one by Holbein.' Constantijn Huygens '*Journal van Constantijn Huygens van zoon*' in *Handschrift van de Koninklijke Akademie van Wetenschappen*, Utrecht, 1876, pp. 277, 325–26.

11 BL Add MS. 20101 f.28. Vertue, 'Note Books II', op. cit., vol. 20, p. 45.

12 Lord Egmont received his invitation 'to see the drawings of Holben, which are those of Henry the 8th, his Queens and Courtiers' in June 1732, see Egmont, *Diary*, op. cit., vol. I, p. 281.

13 George Vertue, 'Note Books V', *Walpole Society*, vol. 26, 1938, p. 23.

14 During George I's occupancy this room was referred to simply as the 'Passage Room'.

15 See TNA LC9/166 f.17r. In the 1830s as part of the Duchess of Kent's refitting of the King's State Bedchamber to provide accommodation for herself and her daughter, Princess Victoria, the northern access to the State Drawing Room was blocked off, and the room was subdivided into two rooms with a connecting passage leading to the King's Gallery Backstairs. It seems that one of the rooms served as a bathroom, the other as a dressing room.

The partition walls were removed and the doorway to the State Drawing Room reinstated during a restoration project at Kensington Palace which took place between 1995 and 1998.

16 Furnishing accounts for the picture closet can be found in TNA LC9/12/no. 20, TNA LC9/168 121r, TNA LC9/168 204r, TNA LC9/289 203v, TNA LC9/169 121r, TNA LC9/289/204, no. 21.

17 Henry Lowman's *A Catalogue Taken of the Pictures which are in the Publick and Private Lodgings of the Palace of Kensington*, c. 1732, The Royal Collection, The Office of the Surveyor of the Queen's Pictures inventory. The inventory is listed as number 29 in Sir Oliver Millar's bibliography of royal inventories in his *Tudor, Stuart and Early Georgian Pictures in the Collection of Her Majesty the Queen*, 2 vols., London, 1963, vol. I, p. 38. In 1732 Henry Lowman was, in fact, no longer the housekeeper at Kensington Palace. However, references in the inventory to Queen Caroline, the Prince of Wales, the Princess Royal and Princess Mary suggest that it has to have been made after 1727, and there are later annotations recording changes in the picture hang dated between 1734 and 1736, which suggest that the date cannot be wildly inaccurate.

18 Egmont, *Diary*, op. cit., vol. II, p. 190.

19 In 1739, a short time after Caroline's death, Vertue returned to Kensington Palace and took the opportunity to view 'the new closet of pictures, call'd the Queen's closet'. Amongst the items which caught his eye were 'several large heads limnings by Cooper, only heads not finisht at his death I suppose . . .' He also remarked on 'the number of heads begun by Holbein: I wish I had the Names of them; some I know that has not the names.' Vertue, 'Note Books IV', op. cit., vol. 24, 1936, p. 176. On a second visit later that year he viewed once again 'a little room not far from the State Drawing Room in which hung the collection of Holbeins, Coopers and others called the Queen's Closett, pictures lately brought from Richmond.' Ibid., pp. 159–60. Ibid., pp. 65–67. During a third visit made in the company of Frederick, Prince of Wales, he spent at least three hours viewing all the pictures both in the public and private apartments at Kensington. Vertue, 'Note Books V', op. cit., vol. 26, p. 21.

20 Vertue, ibid., p. 26. An incomplete manuscript survives in the British Library with annotations indicating that while the catalogue of the picture closet was completed after Caroline's death, the

project may have been at her personal request, see BL Add. MS. 15752 ff.35–43. For the reference to Henry Lowman providing a room for painters see TNA LC5/161 p. 139.

21 G. Bickham, *Apelles Britannicus, Book 1: The Royal Palace of Hampton Court; Book 2: The Royal Palace of Kensington*, London, 1741. G. Bickham, *Deliciae Britannicae: Or the Curiosities of Hampton Court and Windsor Castle*, London, 1742.

22 W. Bathoe, *A Catalogue of Pictures Belonging to King James the Second (Copied from a ms. in the Library of the Earl of Oxford): To which is Appended a Catalogue of the Pictures, Drawings, Limnings, Enamels, Models in Wax and the Ivory Carvings etc. at Kensington in Queen Caroline's Closet, next the State Bedchamber*, London, 1758.

23 An incomplete inventory of the picture closet made in 1743 survives in the British Library. BL Add MS. 15752 ff. 35–43. It is titled *'An Exact and Intire Catalogue not only of those Paintings done by Holbein but also all other Paintings, Limnings, Paintings small and large with the Carvings in Ivory and Miniatures, Enamels etc in Frames, Cases, etc.'* It contains two hundred and seventeen entries, some of which are frames or cases containing up to a dozen separate miniatures. Number 125 is used twice.

24 Two thirds of the eighty-eight miniatures survive in the Royal Collection, though Caroline's gatherings have now been broken up. For more information see Royal Collection inventory *A Catalogue of the Miniatures in the Possession of Her Majesty the Queen*, 1851. This was probably compiled by John Glover. The Royal Collection of miniatures is discussed in G. Reynolds, *The Sixteenth- and Seventeenth-Century Miniatures in the Collection of Her Majesty The Queen*, London, 1999.

25 George Vertue singled out nine drawings by Cooper for comment following his visit in 1739: 'Several large heads limnings by Cooper, only heads not finisht at his death I suppose; Queen Katherina, Duke of Monmouth young, Lady Castlemain, Gen Monke', see Vertue, 'Notebooks IV', op. cit., vol. 24, p. 176. In Bathoe, the Cooper drawings are numbered 60, 62, 64, 65, 67, 104, 107, 108 and 213, in the inventory of the picture closet. The small collection of Cooper drawings was part of the discovery made by Caroline in the bureau in the King's Closet at Kensington.

26 W. Bathoe, *A Catalogue of the Pictures Belonging to King James the Second*, op. cit., nos. 119, 120, 142, 143, 162, 191, in the inventory of the picture closet.

27 One frame described in Henry Lowman's inventory contained miniatures by Isaac Oliver of the early Stuart family which had failed to sell at the sale of goods from the collection of Charles I. They can be traced through *An Inventory of all his Maties Pictures in White-hall* made in about 1666–67 and William Chiffinch's *Inventory of His Majesty's Goods* of 1688 before turning up in Caroline's cabinet. The 1666–67 inventory, *An Inventory of all his Maties Pictures in White-Hall*, is now held in the Office of the Surveyor of the Queen's Pictures. The inventory is listed as number 16 in Sir Oliver Millar's bibliography of royal inventories in his *Tudor, Stuart and Early Georgian Pictures in the Royal Collection*, op. cit., vol. I, pp. 38–39. There is another copy in the British Library, see BL MS. Harley 1890, and it is also included in Bathoe's compendium of royal inventories published in 1758. Bathoe, *A Catalogue of the Pictures Belonging to King James the Second*, op. cit.

28 The new line of kings and queens was installed in the Privy Gallery at Whitehall.

29 At least ten of the twenty-six portraits of Scottish kings, which had been painted in 1633 by George Jameson for the Council in Edinburgh, to mark the visit of Charles I to the city, were used as models for the line of kings at Holyroodhouse.

30 BL Harley MS. 7025 ff.189–94. 'A List of his Majesty's Pictures as they are now Placed in Kensington House 1697.'

31 Bathoe, *A Catalogue of Pictures Belonging to King James the Second*, op. cit., no. 50, in the inventory of the picture closet reads: 'Peter Oliver after Titian, in a black ebony case with folding doors, a limning of Venus lying on a couch', and see also nos. 52, 54, 145, 149 in the same inventory.

32 Granger, *A Biographical History*, op. cit., vol. I, p. 17.

33 Vertue, 'Note Books V', op. cit., vol. 26, pp. 22–23.

34 The purchases are noted in BL Add. MS. 20101, f.56 and Vertue, 'Note Books I', op. cit., vol. 18, p. 133. Vertue. 'Note Books II', op. cit., vol. 20, p. 431.

35 Vertue, 'Note Books V', op. cit., vol. 26, p. 45.

36 Sundon, *Memoirs*, op. cit., vol. II, pp. 11–12.

37 The donor of the painting by Hans Brosamer is described in handwritten

annotations by Horace Walpole to his copy of Bathoe's *A Catalogue of Pictures Belonging to King James the Second*, op. cit. Initially these paintings hung in Caroline's Supper Room at Kensington Palace.

38 Vertue, 'Note Books IV', op. cit., vol. 24, p. 124. The painting by Livinus de Vogelaare was recorded by Sir John Clerk as part of Lord Pomfret's collection on 31 March, 1727. This information is given in a note by Addison in Royal Collection inventory *VR. Inv. 24 Feb. 1866.*

39 Vertue noted that the portrait of Sir Henry Guildford was hanging in Tart Hall in 1726, see Vertue, 'Note Books II', op. cit., vol. 20, p. 19. See Vertue, 'Note Books IV', op. cit., vol. 24, p. 40 and the Royal Collection inventory *The Collections of Pictures Paintings etc at Kensington, Hampton Court and in the Castle of Windsor* made by George Vertue in 1750, for information that the painting was hanging at Kensington Palace after about 1736. The 1750 inventory is listed as number 30 in Sir Oliver Millar's bibliography of royal inventories in his *Tudor, Stuart and Early Georgian Pictures in the Collection of Her Majesty the Queen*, op. cit., vol. I, p. 38. It is not listed in the Lowman inventory annotated with picture movements in the palace to about 1736.

40 The full-length royal portraits were still in place when James Stephanoff recorded them in the Queen's Gallery at Kensington Palace in about 1815.

41 Bickham, *Delicae Britannicae*, Book II, op. cit., pp. 171–86.

42 BM Stowe MS. 567 includes a note of the picture hanging arrangements under George I. For Queen Caroline's rehang see Henry Lowman's *A Catalogue Taken of the Pictures which are in the Publick and Private Lodgings of the Palace of Kensington*, op. cit.

43 Bickham, *Deliciae Britannicae*, op. cit., p. 87.

44 The Queen told Lord Egmont 'she had a concern' in the collecting of 'heads'. Egmont, *Diary*, op. cit., vol. I. p. 311.

45 For more information about the collecting of prints see M. Pointon, *Hanging the Head: Portraiture and Social Formation in Eighteenth-Century England*, New Haven, London, 1993, and Antony Griffiths, ed., *The Print in Stuart Britain, 1603–1689*, London, 1998.

46 The texts for the engravings were prepared by Henry Holland.

47 Discussed in A. Griffiths, *The Print in Stuart England*, op. cit., pp. 50–52.

48 A. M. Hind, *Engraving in England in the Sixteenth and Seventeenth Centuries*, 3 vols., Cambridge, 1952–64, vol. III, 1964, p. 49.

49 Vertue, 'Note Books V', op. cit., vol. 26, pp. 55–56.

50 Egmont, *Diary*, op. cit., vol. I, p. 311 and vol. II, p. 138. Caroline agreed with Egmont that the most appropriate way to organise a collection was chronologically.

51 Ibid., vol. II, p. 51.

52 Ibid., vol. II, p. 299.

53 The compendia of prints in Caroline's library included '*The Heads of the Kings and Queen's of England*', two books entitled '*Portraits des Hommes Illustres*' by Jean Morin and by M. Perrault, '*Les Tombeaux des Personnes Illustres*' by Jean le Laboureau, '*Esprit des Hommes Illustres, Emereurs, Roys, Capitaines, Philosophes etc, Anciens et Modernes dans leurs Bons Mots et leurs plus remarquables pensees. Delle Lettere di Tredici Huomini Illustri*', given as being published in Venice in 1554, and two copies of '*Esprit des Hommes Illustres, Emereurs, Roys, Capitaines, Philosophes etc, Anciens et Modernes dans leurs Bons Mots et leurs plus remarquables pensees*' published in The Hague in 1683. There were also two volumes of engravings made by Nicolas Dorigny after Raphael's cartoons for the Acts of the Apostles tapestries which hung at Hampton Court Palace. These contained one hundred and fifty engraved 'heads'. The engravings were made as part of a project initiated by Simon Gribelin. These two volumes survive in the Royal Library, one dedicated by Marie Maugis to Caroline as Princess of Wales in 1722; the other, without dedication, may be the volume presented by Dorigny. Both of the Dorigny volumes can be identified in the Queen's library lists. Caroline's collection of books on art and architecture ensured that she was kept abreast of contemporary art-historical debate. Some publications related to the royal collections specifically, such as the Dorigny compendiums, but there were also titles which related to the collections of her friends and art advisers. Her standard art-historical texts were Vitruvius, and Benevuto Cellini, as well as '*The Painting of the Antients in Three Parts by Franciscus Junius, Histoire de la Peinture Ancienne. Extraite de l'Histoire Naturelle*' the text by Pliny, and '*The Art of Painting by C. A de Fresnoy* bound with an essay by Mr Dryden concerning parallels between painting and poetry'. By the name 'Fresnoy' Caroline's bibliographer probably was referring to C.-A. Dufresnoy.

54 BL C120 h6 (6).

55 Lord Egmont recorded: 'I desired her Majesty to give leave that her fine heads of King Henry the 8 Court, drawn by Holbein, might be engraved. She said she was unwilling lest they should be spoiled in the copying, but however, she would allow one of them to be copied as a trial, a Bishop of Killaloo, which she doubted whether done by Holbein or not.' Killaloo was the diocese adjacent to that of Killala where Robert Clayton was bishop, see Egmont, *Diary*, op. cit., vol. II, p. 297.

56 *Gentleman's Magazine*, August, 1732, p. 926. The visit to Walpole's London home is also recorded by Joseph Farington in his *Anecdotes of Walpole*, see Horace Walpole, *The Yale Edition of Horace Walpole's Correspondence*, ed., W. S Lewis, Charles H. Bennett, Andrew G. Hoover, 48 vols., New Haven, London, 1937–1983, vol. 15, 1952, p. 333.

57 Lord Hervey described Sir Andrew Fountaine's collection as 'the prettiest trinket I ever saw. My Lord Burlington could not make a better ragoust of paintings, statues, gilding and virtue!' see Earl of Ilchester, ed., *Lord Hervey and his Friends*, op. cit., p. 74. Lord Hervey, the eldest child of the 1st Earl of Bristol, was appointed Vice-Chamberlain and thus a Privy Counsellor in 1730. He began writing his Memoirs in 1733.

58 D. Jacques, *A Visit to Goodwood: The Seat of the Duke of Richmond*, Chichester, 1822, p. 27.

59 Vertue, 'Note Books III', op. cit., vol. 22, 1934, pp. 61–62.

60 The visit to Henry Pelham's home was made on 13th June and the visit to the Duke of Newcastle on 26th June, 1732, see *The Gentleman's Magazine*, June, 1732, p. 874. The visit to see Sir Andrew Fountaine's collection is recorded by Vertue, see Vertue, 'Note Books V', op. cit., vol. 26, p. 120.

61 Lady Elizabeth Finch to Lady Burlington, 25th May, 1735, see Chatsworth Papers 230.5.

62 Churchill, *Letters of a Grandmother*, op. cit., p. 155.

63 Lady Pomfret's volume later sold as Lot 296 in the sale of the Fermor-Hesketh Library from Easton Neston on 15th December, 1999.

64 Trustees of the Chatsworth Settlement. Chatsworth. Kent/Burlington House 26/69/76.

65 Hervey, *Memoirs of the Reign of George the Second*, op. cit., vol. II, pp. 152–53.

66 As the painting by Vasari of Venus and Cupid did not arrive at Kensington Palace until early in 1735, just a short time before the quarrel, there is an argument that the 'Fat Venus' was another painting, already part of the picture hang in the King's Drawing Room. Lowman's inventory for the room, made from about 1732, as well as including the entry 'Mich Angelo – Venus and Cupid, large life', has the entry, 'Titian – Naked Venus and a Woman looking into a Trunk'. This is very likely to be one of the two versions of the *Venus of Urbino* by Titian in the Royal Collection (see RCIN 406162). One of these paintings, which appears in the inventory of the collection of James II, had been part of the picture hang established by William III in the King's Gallery at Kensington, and was still hanging there under Queen Anne's occupation and was part of George I's picture scheme. See 'A List of his Majesty's Pictures as they are now placed in Kensington House, 1797'. BL Harley MS. 7025, ff.189–94, and 'A list of Pictures in Kensington House', BL Add. MS. 20013, ff.1–13. For George I's inventory for the King's Gallery see BL Stowe MS. 567, Temp. George I. This inventory written in French is likely to date from the early years of the King's reign, before the refurnishing programme for the room was initiated in the early 1720s. It would seem that the version of the *Venus of Urbino* moved to the King's Drawing Room during the course of these works.

67 Raffle at Essex House, The Strand, 29th March, 1735, 'Raffle of a Painting of Venus and Cupid said to be Painted by the highest Colourist of that Age, the famous Jacopo da Puntormo, upon the Original Out Line, or Sketch of the great Michael Angelo Buonaroti.' The raffle was managed by Robert Browne, Charles Margas and Gerard van der Gucht. A pair of raffle tickets survives in the collection of the British Museum.

68 A. Jameson, *Handbook to the Public Galleries of Art in and near London*, 2 vols., London, 1842, vol. II, p. 362. The history of this painting is discussed in L. Whitaker and M. Clayton, *The Art of Italy in the Royal Collection: Renaissance and Baroque*, London 2007, p. 75.

69 TNA LC5/158, p. 492 and TNA LC5/159, p. 1.

70 For the arrangements made at Kensington Palace to accommodate artists see TNA LC5/160, p. 93. Vertue records his own experience, see Vertue, 'Note Books IV',

op. cit., vol. 24, p. 65. He observed 'Davison, an ingenious young painter' also at work there, see Vertue, 'Note Books II', op. cit., vol. 20, pp. 88–89. In 1735 he was also allowed to make a drawing from van Dyck's portrait of Charles I at Hampton Court, see Vertue, 'Note Books IV', op. cit., vol. 24, p. 74.

71 Vertue, 'Note Books III', op. cit., vol. 22, pp. 61–62.

72 Ibid., p. 17.

73 The miniatures by Zincke of Anne, the Princess Royal, and of Princess Louisa later hung in Queen Caroline's picture closet, see Bathoe, *A Catalogue of Pictures Belonging to King James the Second*, op. cit., no. 103, in the inventory of the picture closet. The portrait of Princess Anne by Amigoni Caroline later presented to Lord Hardwick along with two portraits of herself. The commission to Amigoni is recorded in TNA AO.1.415, vol. 169.

74 The exchange between the royal couple is recorded by Vertue, see Vertue, 'Note Books III', op. cit., vol. 22, p. 58. *The Gentleman's Magazine* of May 1732, p. 773, records that a portrait of the Queen in robes of state by an artist unspecified was commissioned by the King for him to carry with him while travelling abroad.

75 E. Corp, *A Court in Exile: The Stuarts in France, 1689–1718*, Cambridge, 2004.

76 John Vanderbank's portrait survives at Goodwood House in Sussex. Joseph Highmore's portrait is discussed by George Vertue, see Vertue, 'Note Books III', op. cit., vol. 22, p. 54. The Highmore portrait survives and is in the Royal Collection.

77 The portrait of Caroline and Prince William Augustus by Herman van der Myn is on display at Orleans House Gallery, London Borough of Richmond upon Thames.

78 TNA Works 6/15, pp. 168–69.

79 Horace Walpole noticed the history paintings by Kent, hanging in Caroline's dressing room, see Horace Walpole, 'Walpole's Journal of Visits to Country Seats', ed, Paget Toynbee, *The Walpole Society*, vol. 16, Oxford, 1928, p. 16. Their frames are likely to have been supplied by William Waters, who was paid £211. 13s. 3d. in the same quarter year that the paintings were completed and paid for, see RA Add. MS. 53993, Accounts, 5th May, 1730–25th May, 1731.

80 Vertue, 'Note Books III', op. cit., vol. 22, p. 61.

81 Vertue, 'Note Books IV', op. cit., vol. 24, p. 124.

82 Vertue, 'Note Books III', op. cit., vol. 22, p. 68.

83 Ibid., vol. 22, p. 68. One of the oil sketches survives in the Royal Collection, the other is in the National Gallery of Ireland, Dublin.

84 The portrait of Prince William Augustus is in the collection of the Yale Center for British Art, New Haven, Connecticut.

85 Jane Roberts, *Royal Artists: From Mary Queen of Scots to the Present Day*, London, 1987.

86 Egmont, *Diary*, op. cit., vol. I, p. 466.

87 *Gentleman's Magazine*, April 1734, p. 216. Vertue later recorded Mercier's comment that Anne, who 'never drew or painted any peece without his being witness – never drew from the life at any time tho' she had drawn & coppyd many several copies in Oyl painting done by her', on this occasion had in fact just touched a brush to the canvas to satisfy van der Myn, see Vertue, 'Note Books III', op. cit., vol. 22, p. 72.

88 Koninklijk Huisarchief, The Hague, The Netherlands, A17/415, *Inventaris der mobelen . . . op 't Huys D'Orange. . .op den 28 September 1758*, cited in S. Drossaers, et al., *Inventatissen van de Inboedels in de Verblijven van de Oranjes (1567–1795)*, The Hague, 1974, p. 185. The Princess made many paintings at the request of her relatives. They were presented as gifts to Frederick the Great and Frederick, Prince of Wales, amongst others. See Koninklijk Huisarchief A17/430 for a letter from Frederick the Great, 16th April, 1740, thanking Anne for sending him one of her paintings, and KH A17/430, for a letter from Frederick, Prince of Wales, 12th May, 1745, asking Princess Anne for a painting of her daughter Caroline for his collection. These are quoted in Richard G. King, 'Anne of Hanover and Orange', in Campbell Orr, *Queenship in Britain*, op. cit., pp. 183–85.

89 Mauritshuis, The Hague, The Netherlands, cat. 504.

90 Walpole, *Visits to Country Seats*, op. cit., p. 17.

91 Princess Mary's drawings are preserved in the Kurhessischen Hausstiftung Archiv, Schloss Fasanerie, Fulda.

92 Roberts, *Royal Artists*, op. cit., pp. 53. Elizabeth's husband was later created 1st Duke of Northumberland. The quilt made by Caroline is preserved in the collection at Syon House. The princesses were also competent needlewomen. In 1736 a 'walnutree chair, the seat stuffed and the cover to be of Princess Mary's own embroidery' was prepared for the Prince of Wales's closet at St James's. Princess Anne made a design for embroidery to be worked by her sister Caroline in 1747, see Koninklijk Huisarchief, The Hague, The Netherlands, A17/430, cited in Richard G. King, 'Anne of Hanover and Orange' in Campbell Orr, *Queenship in Britain*, op. cit., p. 184.

5 CAROLINE AND HER BOOKS

1 TNA LC5/73 f.165v, TNA LC9/167 f.16v and TNA LC9/289 f.128v. f.143ov.

2 TNA LC9/289 f.16ov.

3 TNA LC9/167 f.28v. f.31v.

4 BL Add. MS. 51396 f.185.

5 Egmont, *Diary*, op. cit., vol. II, p. 138.

6 Sundon, *Memoirs*, op. cit., vol. I, pp. 95–96.

7 E. M. Alcorn, 'A Chandelier for the King. William Kent, George II and Hanover', *The Burlington Magazine*, vol. 139, Jan. 1997, pp. 40–43, and Vardy, *Some Designs by Mr Inigo Jones and Mr Wm Kent*, op. cit., p. 31.

8 John Toland's *Letters to Serena* were dedicated to Sophie Charlotte, see G. Bartosch et al. *Sophie Charlotte und ihr Schloss*, op. cit. pp. 258–60.

9 In 1699 Anton-Ulrich brokered a marriage between his son Friedrich-August and Sophia Dorothea, Sophia's niece, the daughter of George William, Duke of Brunswick-Lüneburg by his morganatic wife Eléonore d'Olbreuse. The boy died three months after the engagement. Sophia Dorothea later married Sophia's son George Louis, later George I.

10 F. E. Baily, *Sophia of Hanover and her Times*, London, 1936, p. 211. Sophia's intellectual circle replicated that of her elder sister Elisabeth, Abbess of Herford. In 1147 Herford was granted *Reichsunmittelbarkeit*, or Imperial immediacy. This made it an independent territory within the Holy Roman Empire, and its abbesses became Imperial princesses who sat in the *Reichstag* in the College of Prelates of the Rhine. It became a Lutheran establishment in 1533 under the electors of Brandenburg. Elisabeth maintained a long correspondence with René Descartes.

11 Liselotte's governess, Katharina Uffeln, who later married Ferdinand von Harling, Sophia's Master of the Horse, went on to serve as governess to Sophia's daughter Sophie Charlotte.

12 Orléans, *Correspondance*, op. cit., trans. Jaeglé, vol. II, p. 231.

13 Orléans, *Correspondance*, op. cit., trans. Jaeglé, vol. III, p. 174.

14 Arkell, op. cit., p. 144.

15 S. Taylor, 'Caroline and the Church' in S. Taylor, R. Connors, C. Jones, *Hanoverian Britain and Empire: Essays in Memory of Philip Lawson*, op. cit., p. 92.

16 Lord Egmont revealed that while Caroline was prepared to champion Samuel Clarke as a future archbishop of Canterbury, she appreciated that this would not meet with universal approval, and did not eventually push his interests forward. Egmont, *Diary*, op. cit., vol. I, p. 99.

17 Cowper, *Diary*, op. cit., p. 134.

18 Jonathan Swift's *Gulliver's Travels* first published in 1726, as well as John Gay's *Beggar's Opera* of 1728, were written as critiques of Sir Robert Walpole's England.

19 Clarke turned down the commission to make a translation of Leibniz's *Theodicée* because he saw that it would draw him into politically dangerous territory. Leibniz sought to enter English scientific circles with the expectation of Caroline's protection. This was not forthcoming.

20 R. Bentley, *The Correspondence of Richard Bentley*, 2 vols., London, 1842, vol. I, p. 152, vol. II, pp. 52–69.

21 Alexander Pope, *The Correspondence of Alexander Pope*, ed. G. Sherburn, 5 vols., Oxford, 1956, vol. I, p. 287.

22 Le Courayer took refuge in England in 1728. In 1736 he published *Histoire du Concile de Trente*, a French translation of Paolo Sarpi's work, widely seen as an anti-Catholic and possibly deist work. It was dedicated to Caroline, from whom he later received a pension of £200 a year, see Egmont, *Diary*, op. cit., vol. I, pp. 7, 32, 101, 102, 179, 197, and Lewis Melville, *Maids of Honour*, London, 1927, p. 151. Lord Hervey described how he promoted the interests of Dr Middleton, see Hervey, *Memoirs of the Reign of George II: From his Accession to the Death of Queen Caroline*, ed., J. W. Croker, 3 vols., London, 1884, vol. II, p. 218–19.

23 Borman, *Henrietta Howard*, op. cit., pp. 152–53.

24 Melville, *Maids of Honour*, op, cit., p. 223.

25 J. Mitford, ed., *The Poetical Works of John Milton*, Boston, 1838, p. xcv.

26 Sundon, Memoirs, op. cit., vol. II, pp. 57–58.

27 Sundon, *Memoirs*, op. cit., vol. II, p. 171.

28 Pope to Gay, 16th October, 1727, see Sherburn, ed., *The Correspondence of Alexander Pope*, op. cit., vol. II, pp. 453–54.

29 Gay and Pope to Swift, 22nd October, 1727, see Pope, *The Correspondence of Alexander Pope*, ed. Sherburn, op. cit., vol. III, p. 455. Pope wrote to Swift on 27th Jan., 1727: 'Courts I see not, Courtiers I know not, King's I adore not, Queen's I compliment not, so am never like to be in fashion, nor in dependance', see Sherburn., ed., *The Correspondence of Alexander Pope*, op. cit., vol. II, p. 469. Pope was at this time working independently on his translation of *The Iliad*.

30 Pope to Gay, 16th October, 1727, see Sherburn, ed., *The Correspondence of Alexander Pope*, op. cit., vol. II, pp. 453–54.

31 Christine Gerrard, ed., *A Companion to Eighteenth-Century Poetry*, Oxford, 2006, p. 17.

32 *Gentleman's Magazine*, April 1733, p. 206. H. Williams, ed., The Poems of Jonathan Swift, 3 vols. London 1958, vol. II, pp.662–63.

33 Pope and Swift, as well as Gay, remained faithful in their alliance with Henrietta Howard, and Caroline would have to live with the tension this created until 1734, when George Augustus finally tired of Henrietta as his mistress.

34 Lady Mary Wortley Montagu, *Essays and Poems; and Simplicity: A Comedy*, ed. R. Halsband and I. Grundy, Oxford, 1977, pp. 83–94.

35 For the record of a discussion Egmont had with Caroline concerning St Augustine, Erasmus, Luther, Calvin and Melancthon, see Egmont, *Diary*, op. cit., vol. II, pp. 259–60.

36 In a letter sent to Leibniz on 13 September, 1715, Caroline recounted that she is reading and enjoying the exchanges between John Locke and Bishop Stillingfleet about the nature of the Trinity, see D. Bertolini Meli, 'Caroline, Leibniz and Locke', *Journal of the History of Ideas*, vol. 60, no. 3, July 1999, pp. 469–86.

37 Eulogy published in the *Gentleman's Magazine*, December 1737, p. 753.

38 Delia K. Bowden, *Leibniz as a Librarian: And, Eighteenth-Century Libraries in Germany*, School of Library, Archive and Information Studies, Occasional Publications 15, University College, London, 1969. Pierre Bayle's *Dictionnaire Historique et Critique* together with his *Dissertation Concernant le Livre d'Etienne Junius Brutus*, in two volumes, published in Rotterdam in 1697, was still in Caroline's library at her death.

39 Cowper, *Diary*, op. cit., pp .12–13.

40 Horace Walpole, *Reminiscences*, op. cit., p. 115.

41 Sundon, *Memoirs*, op. cit., vol. II, p. 241.

42 Johann Daniel Major's works include *Vorstellung etlicher Kunst und Naturalienkammern in Africa an den Gränzen Europae, Vorstellung etlicher Kunst und Naturalienkammern in America und Africa* and *Vorstellung etlicher Kunst und Naturalienkammern in Italien, zu Neapol und Alt Rom*. Samuel Quiccheberg in *Inscriptiones vel Tituli* recommended that a cabinet of curiosities should be drawn together with the purpose of collecting information about every field of knowledge, and suggested this would complement other collections of art, science, technology and natural history. This is discussed in Eva Schultz, 'Notes on the History of Collecting and of Museums in the light of selected literature of the sixteenth to the eighteenth century', *Journal of the History of Collections*, 2, no. 2, 1990, pp. 205–18. In *Gesta Grayorum*. published in 1594, Francis Bacon wrote: 'First, the collecting of a most perfect and general library, wherein whosoever the wit of man hath committed to books of worth . . . may be made contributory to your wisdom.'

43 I. Grundy, *Lady Mary Wortley Montagu* Oxford, 1999, pp. 93–94.

44 George II and Caroline were presented with copies of *The Dunciad* on 12 March, 1729. See C. H. Timperly, *A Dictionary of the Printer and Printing: With the Progress of Literature, Ancient and Modern*, London, 1839, p. 640. Caroline's library catalogue shows she owned a copy of James Thomson's *The Seasons*.

45 By 1731 each edition of *The Craftsman* had a circulation of 9000, with each copy read by up to forty people. See M. Harris, *London Newspapers in the Age of Walpole: A Study of the Origins of the Modern English Press*, Rutherford, N.J., 1987, p. 189. I. Kramnick, *Bolingbroke and his Circle: The Politics of Nostalgia in the Age of Walpole*, Cambridge, 1992, p. 19.

46 Gunthe Schuhmann, '*Ansbacher Bibliotheken vom Mittelalter bis 1806*', in *Schriften des Instituts fur Frankischen Landesforschung und der Universitat Lassleben*, 1961, pp. 90–96, discussed in Emma Jay, 'Queen Caroline's Library and its European Contexts', *Book History*, vol. 9, 2006, pp. 31–55, 32.

47 Uta Löwenstein, 'Apartment of the Countess Dorothea Friederike von Hanau-Lichtenberg', op. cit. pp. 1–32.

48 In 1704 Sophie Charlotte wrote to Leibniz to say that she had started reading John Locke's *Essay Concerning Human Understanding*, see Bartoschek, etc., *Sophie Charlotte und ihr Schloss*, op. cit., p. 100.

49 Kim Sloan, 'The Universal Museum', in Kim Sloan, ed., *Enlightenment: Discovering the World in the Eighteenth Century*, London, 2003, pp. 10–58.

50 H. Walpole, *Memoirs of King George II*, ed. John Brooke, 3 vols., New Haven, London, 1985, vol. III, p. 119.

51 Lord Lumley's collection of books amounted to two thousand eight hundred volumes.

52 Richard Bentley, *A Proposal for Building a Royal Library, and Establishing it by Act of Parliament*, London. 1697, discussed in Emma Jay, 'Queen Caroline's Library', op. cit., pp. 35–36.

53 Act of 12 Will. III. This is discussed in Kim Sloan, ed., *Enlightenment*, op. cit., pp. 38–45.

54 In 1754 George II donated the entire Royal Library to the British Museum.

55 Evelyn, *Diary*, op. cit., vol. III, p. 303. Bishop Burnet recorded that Mary owned books in French and Dutch as well as in English, see Gilbert Burnet, Bishop of Sarum, *An Essay on the Memory of the Late Queen*, London, 1695, p. 38. The cabinet-maker Gerrit Jensen made the elegant looking-glasses and seat furniture upholstered in green velvet for William III's library, see TNA Works 5/50 f.384v, TNA LC9/377 f.1, f74, f.55, f.49, BL Add. MS. 20013 ff.1–13. For other furnishings in the library, see BL. Add. MS. 20013, ff. 1–13, 'A List of the Pictures at Kensington House', TNA LC9/280 f.236, TNA LC11/5 f.178 no. 52, TNA LC9/282 f.214, f.278, f.229 and TNA LC9/380 no. 45.

56 In about 1718 George I gave instructions for the collection of books to be moved to rooms in the northeast pavilion at Kensington. The cost for taking down the presses, altering them, re-erecting them in the new library, 'making good the wainscot in the old library' and 'other necessary work' was estimated at £40. It actually cost just 2s. 8d. less. A few repairs were undertaken to some of the furnishings in 1721 and 1725, see TNA Works 6/7, p. 152, TNA LC9/282 f.148, f.137, f.140, f.162, TNA T54/25, p. 407, TNA AO.1/2450/154.

57 One of the bookcases in the Royal Collection, bearing an ivory plaque engraved with the number eighteen, may now be the sole survivor of the bookcases once installed in the library at Richmond Lodge. Its number suggests that it once had many companions.

58 Letter from the Rev. Alured Clarke to Mrs Clayton, Sept. 19th, 1730, cited in Sundon, *Memoirs*, op. cit., vol. I, pp. 189–91. In the Hermitage one of the rooms flanking the central octagonal room was fitted out with bookshelves. There was a similar arrangement at Merlin's Cave. This is illustrated in Vardy's *Some Designs of Mr Inigo Jones and Mr Wm Kent*, op. cit.

59 Letter from the Rev. Alured Clarke to Mrs Clayton, Sept. 19th, 1730, cited in Sundon, *Memoirs*, op. cit., vol. I, pp. 191–93.

60 'Her Majesty has ordered also a choice collection of English books to be placed therein, and appointed Mr Stephen Duck to be cave and library keeper and his wife necessary woman there', *Gentleman's Magazine*, vol. V, August 1735, p. 498. For more information about Stephen Duck, see Rose Mary Davis, *Stephen Duck, The Thresher Poet*, University of Maine, series 2, no. 8, vol. XXIX, 1927, pp. 90–98. For discussion of Stephen Duck's pension, see p. 37; for discussion of Mr and Mrs Duck's appointments at Richmond see pp. 69–70. There is a touching reference in one of Lady Hervey's letters to her husband, who was then absent from Court, to a conversation she had with Caroline. The Queen, who was missing their conversations, said she would give him Merlin's Cave, but 'you are to be locked up there, and the Queen keep the key'.

61 The last consignment of books delivered by John Jackson for the Richmond pavilions was not made until July 1736, see BL C120.h6 (6), f.6, f.8, f.16, f.17.

62 Curll, *The Rarities of Richmond*, op. cit., p. 80. The new books were paid for from Caroline's private Privy Purse. They cost £155. 2s. 6d.

63 Walpole made a note that 'in an adjacent chamber are more books' in the margins of his copy of Bathoe, *A Catalogue of Pictures Belonging to King James the Second*, op. cit.

64 Ibid. The inventory includes a list of other books, as well as the curiosities Walpole found in these rooms at Kensington Palace.

65 Hervey, *Letter-Books*, op. cit., vol. III, p. 37.

66 H. Walpole, *Reminiscences Written by Mr Horace Walpole in 1788 for the Amusement of Miss Mary and Miss Agnes Berry: Now First Printed in Full from the Original MS.*, ed. Paget Toynbee, Oxford, 1924, p. 120.

67 BL C120.h.6. (6).

68 Sir Matthew Decker, who visited Houghton in 1728, noted that the room was lined with bookcases, and contained 'many valuable books, bound and so neatly and well placed that it makes a perfect picture'. For a description of Sir Andrew Fountaine's library, see Vertue, 'Note Books IV', op. cit., vol. 24, pp. 10, 61 and 'Note Books V', op. cit., vol. 26, p. 120.

69 Lady Hervey's interest in books is touched on in a letter to the Rev. Edmund Morris, cited in Lewis Melville, *Maids of Honour*, op. cit., p. 190. For information about

Lady Burlington and her collections, see Mark de Novellis, *Pallas Unveil'd: The Life and Art of Dorothy Savile, Countess of Burlington (1699–1758)*, London, 1999.

70 BL King's, MS. 308, 1722. The list of plays has additions made in 1729. Caroline's Privy Purse accounts show that substantial payments were made regularly to theatrical entrepreneurs in London including Theophilus Cibber, Robert Wilkes and John Rich.

71 Francis Say, Caroline's librarian, received a salary of £100 per annum, see TNA Treasury Papers, T52/40, p. 35. He is likely to have been recommended to Caroline by Dr Samuel Clarke. Previously he had been secretary to Thomas Green, Bishop of Ely, and Green's two immediate predecessors, William Fleetwood and John Moore. Moore was a member of the network of men, including Dr Samuel Clarke and William Whiston, whom Caroline admired and whose company she sought. Say was given a deputy, a 'Library Keeper', John Hamilton, who was paid £40 annually. The Huguenot, Francis Vallotton, who had served as Page of the Presence to Caroline, and after her death to Princesses Amelia and Caroline, and later Queen Charlotte, would succeed Hamilton as Library Keeper.

72 Two early drafts of Caroline's library catalogue survive, see BL Add. MS. 11511, BL C.120.h.6 (6) and BL c.120.h.6 (7). A second fine copy dating from 1743 was annotated with information about later additions made to 1760, see Royal Library, Windsor Castle, RL 102893.a, *A Catalogue of the Library of Her Late Majesty Queen Caroline Distributed into Faculties*, 1743.

73 Leibniz's vision for a universal library became a reality in Hanover with the establishment in 1737 of a new library in Göttingen, the seat of the national university of the Hanoverian electorate. It sat at the heart of teaching programmes, and received regular and generous funding. This ensured it could maintain an acquisition policy which drew together publications from many parts of Europe through the agency of the Hanoverian foreign policy. The official inauguration of the university took place in 1737, though lectures had been held since 1734.

74 P. Fara, *Pandora's Breeches: Women, Science and Power in the Enlightenment*, London, 2004, pp. 75–80.

75 Arkell, *Caroline of Ansbach*, op. cit., p. 34.

76 Caroline to Mrs Clayton, see RA Geo. Add. MS. 28/2 and Egmont, *Diary*, op. cit., vol. I, p. 102. Lord Egmont in 1730 recorded that the Queen asked his opinion about how proper names should

be translated into Latin, and suggested that the French pronunciation should be replicated because in her opinion 'that is the language most generally known'.

77 A universal library of a similar size was created by Lovisa Ulrika of Prussia, sister of Frederick the Great, who married Crown Prince Adolf Fredrik of Sweden in 1744. Her library was built at Drottningholm in about 1760. Lovisa Ulrike also created a museum in an adjacent chamber for her collection of coins, minerals and natural history.

78 Nicholas Rowe, dramatist, poet and writer, was appointed Poet Laureate in 1715.

79 Caroline to Mrs Clayton, March 1719, see RA Geo. Add. MS. 28/53.

80 Sir Richard Manningham, *An exact Diary of what was Observ'd during the Close Attendance upon Mary Toft: The Pretended Rabbet-breeder of Godalming in Surrey . . . Together with an Account of her Confession of the Fraud*, London, 1726.

81 Emma Jay, 'Queen Caroline's Library and its European Contexts', op. cit., pp. 31–55.

82 John Gay, *The Letters of John Gay*, ed. C. F. Burgess, Oxford, 1966, p. 12.

83 John Fuller, ed., *John Gay: Dramatic Works*, 2 vols., Oxford, 1983, vol. I, p. 344. Caroline attended the opening night of Gay's *Captives* at Drury Lane Theatre, see Hervey, *Letter-Books*, op. cit., vol. III, p. 37, and Stephen Gwynn, ed., *The Life and Friendships of Dean Swift*, London, 1933, pp. 260–61.

84 Cowper, *Diary*, op. cit., pp. 14, 17.

85 BL C120.h.6 (7).

86 Caroline and Voltaire conducted a lively correspondence and he fêted her in his *Letters Concerning the English Nation*, published in 1733.

87 BLC.120.h.6 (6)

88 For book repairs and for new bindings the Queen used the services of John Brindley, see RA Add. MS. Geo/54000.

89 RA Add. MS. Geo/54000.

90 Joseph Towers, *British Biography: Or, An Accurate and Impartial Account of the Lives and Writings of Eminent Persons*, 7 vols., London, 1766–72, vol. II, 1766, pp. 244–55. In 1726 Bentley went on to dedicate his edition of Terence and Phaedrus to Prince Frederick.

91 BL Add MS. 16941, *The Original Exercise Book of HRH The Duke of Cumberland when a Boy in his own Handwriting, 28 Nov. 1727–25 March 1728*, Lord Wentworth wrote to Lord Stafford that William Augustus possessed 'the scholars learning with the courtier's ease', see BL Add. MS. 22227 f.167.

92 Cowper, *Diary*, op. cit., p. 38.

93 Egmont, *Diary*, op. cit., vol. I, p. 466.

94 Hervey, *Lord Hervey and his Friends*, op. cit., p. 131.

6 CAROLINE AND THE NATURAL PHILOSOPHERS

1 The correspondence of Leibniz and Clarke, which took place between 1715 and 1716, was published by Clarke in 1717 with a dedication to Caroline, see Samuel Clarke, *A Collection of Papers, which Passed between the late Learned Mr. Leibniz and Dr. Clarke, in the Years 1715 and 1716: Relating to the Principles of Natural Philosophy and Religion*, London, 1717. A copy was to be found amongst the books in Caroline's library.

2 George I did not agree to the appointment of Leibniz as Historiographer Royal. Leibniz had been appointed to undertake similar research in Hanover but had tried the Elector's patience with his moon-lighting at the Court of the Emperor Karl VI in Vienna.

3 *Die Werke von Leibniz*, vol. XI, p. 93, quoted in Paul Lodge, ed., *Leibniz and his Correspondents*, op. cit., p. 278.

4 *Die Werke von Leibniz*, vol. XI, p. 112, quoted in Paul Lodge, ed., *Leibniz and his Correspondents*, ibid., pp. 274–75, 280–81. Cowper, *Diary*, op. cit., p. 74.

5 The Ordinary meetings of the Royal Society took place once a week, and lasted between one and three hours. Caroline's library contained the texts of Desaguliers's 'Physico-Mechanical' lectures, a description of Hawksbee's air-pump, and a selection of books by John Flamsteed on astronomy.

6 TNA LC5/19 f.55.

7 *Gentleman's Magazine*, August 1734, pp. 449–50.

8 Egmont, *Diary*, op. cit., vol. II, p. 117.

9 Sundon, *Memoirs*, op. cit., vol. II, pp. 264–65.

10 Lord Egmont recorded his visit to the studio of the artist William Verelst to have his portrait made. This would be incorporated eventually into the large conversation piece which shows a meeting of the Common Council of the Georgia Trustees at the time of the Yamacraws' visit. See Egmont, *Diary*, op cit., vol. II, p. 258.

11 Egmont, *Diary*, op. cit., vol. II, p. 191 and Georgia Historical Collections, *Selected Eighteenth Century Manuscripts: Collections of the Georgia Historical Society*, vol. XX, ed. A. S. Britt Jnr. and A. R. Dees, Savannah, 1980, pp. 110–11.

12 Jonathan Swift, *The Correspondence of Jonathan Swift, D.D.*, ed. F. Elrington Ball, 6 vols., London, 1910–1914, vol. III, pp. 354, 357, 360, 364, 371, 374. Alexander Pope, *The Works of Alexander Pope*, op. cit., vol. VII, Correspondence III, p. 90.

13 *Daily Courant*, 2 Feb., 1730. RA Add. MS. 17/75.

14 TNA LS1/73, 76, 79, 80, 81, 82.

15 Caroline herself had survived smallpox in 1707. Catherine Vezian, a milliner, was later paid 6d. each for 'papers' of silk patches for Caroline. Patches were supplied in small quantities attached to a little slip of paper to prevent them being damaged in handling. The patches would be pasted onto the face and help cover scars. See RA Add. MS. 17/75.

16 Sir Hans Sloane, *An Account of Inoculation*, *Philosophical Transactions*, vol. XLIX, pt. II, 1756. The account was written in 1736 though not published by the Royal Society until 1756.

17 Daniel Neal, *A Narrative of the Method and Success of Inoculating the Small-pox in New England. By Mr Benj. Colman. With a Reply to the Objections Made against it from Principles of Conscience. In a Letter from a Minister at Boston [Rev Wm Cooper] to which is now Prefixed an Historical Introduction*, London, 1722. See also Genevieve Miller, *The Adoption of Inoculation for Smallpox in England and France*, Philadelphia, 1957.

18 BM Sloane MS. 4034 ff. 9. seq. for discussion for Maitland's inoculation experiments. BM Add. MS. 34327 f.7 records Maitland was paid £1000 for inoculating the eldest royal children.

19 'Last Saturday Night the Princess Mary was inoculated for the smallpox,' reported in *Brice's Weekly Journal*, 8 April, 1726, p. 3. 'The three princesses dansed,which is a signe they had got over their inoculating well,' reported Sarah Osborn, see Sarah Osborn, *Political and Social Letters of a Lady of the Eighteenth Century, 1721–1771*, ed. E. F. D. Osborn, London, 1890, p. 23.

20 The Lords of the Treasury later required the laboratory be moved to Richmond in the interests of public safety, see *Calendar of Treasury Books and Papers*, vol. 3. 1735–38, ed. William A. Shaw, pp. 509–15. Item 139, 17th October, 1738.

21 TNA LC9/166 f.19v. 'Benjamin Goodison. 1736. For a glass of the model of the mines and fixing it.' TNA LC5/73 f.134v. 'A glass for the model of the mines at St James's.'

22 Major acquisitions were made for the Brandenburg *Wunderkammer* in 1642, 1680 and 1685. Later additions included the *Naturalienkammer* of Christian

Lorentzenen Aldershelm of Leipzig, which was presented to the Elector Frederick III in 1687, and a significant collection of African artefacts in 1688 from Admiral Raule, who engaged the services of a Dutch army officer called Polemann, stationed in Batavia, to procure Asian weapons, lacquer-work, ivory and porcelain. See C. Theuerkauff, 'The Brandenburg Kunstkammer in Berlin' in O. Impey and A. MacGregor, ed., *The Origins of Museums: The Cabinet of Curiosities in Sixteenth- and Seventeenth-Century Europe*, Oxford, 1980, pp. 110–14.

23 Inventory of the Electress Sophia of Hanover, 1709. Hanover Archives, Dep. 103, XXIV, Nr. 2487.

24 Charlotte Elisabeth, Duchess of Orléans, *Life and Letters of Charlotte Elizabeth, Princess Palatine, 1652–1722*, London, 1889, p. 165. The collection in Hanover contained presents to Sophia from Liselotte including nodding buddhas decorated with jewels.

25 See J. Menzhausen, 'Elector Augustus's *Kunstkammer*: An Analysis of the Inventory of 1587', in O. Impey and A. MacGregor, ed., *The Origins of Museums*, op. cit., pp. 69–75.

26 Samuel Quiccheberg. *Inscriptiones vel Tituli Theatri Amplissimi*, Munich, 1565, discussed in Eva Schultz,. 'Notes on the History of Collecting and of Museums', op. cit. pp. 206–10

27 Inventory of the Electress Sophia of Hanover, 1709, op. cit., and inventory of Dorothea Friederike of Hanau-Lichtenburg, St. A. Marburg Best., 81A. Regierung Hanau 45, Nr.8, cited in Uta Löwenstein, 'Apartment of the Countess Dorothea Friederike von Hanau-Lichtenberg', op. cit., pp. 6–22. Dorothea Friederike's collection contained artefacts made of ivory, agate and coral, a large collection of jewelled *objets de vertu*, mostly taking the form of miniature birds and animals, and a sizable collection of coins and medals.

28 In May 1724 three back stools and an easy chair were purchased for the new rooms, see TNA Works 19/48/1, pp.11–13, and TNA LC9/286 f.131. In April 1720, hangings were removed from a corner closet in the Audience Room and were re-erected in the room adjacent to the Library, see TNA LC9/286 f.107.

29 The reliefs decorating the collector's cabinet derive from the same model used by Michael Rysbrack for his full-length sculptures of Palladio and Jones which had stood outside the Bagnio in Lord Burlington's garden in Chiswick back in 1717, as well as a pair of busts also made for Lord Burlington in the 1730s or 1740s. These busts are now part of the collection at Chatsworth House. It is probable that the main arched recess within the cabinet was originally left open. The doors to the bays either side may have been fixed, and glazed, with access through doors at the sides of the cabinet.

30 There is a Kentian bookcase in the Victoria and Albert Museum, illustrated in Michael Wilson, *William Kent*, op. cit., p. 122.

31 The cabinet-maker James Riorto was paid £400 19s. 6d. in 1731, and £52. 3s. in 1733. There is also record of a payment of £73 in 1733 to George Nix for furniture, see RA Add. MS. 53993–54005, May 1730–Mar. 1731 and RA Add..MS. 54015–54023, Sept. 1731–Sept. 1733. James Riorto was recorded living in the parish of St Giles in the Fields in 1718. He received royal commissions from the 1730s, principally from Frederick, Prince of Wales. George Nix was another cabinet-maker working in Lord Burlington's circle and is often associated with projects undertaken by William Kent.

32 BM Add. MS. 20101, f. 60. There is a careful note that the author was 'Mrs Pursell' and that she had delivered the document to the housekeeper.

33 Horace Walpole's volume of Bathoe is owned by the Royal Collection. RA Geo. Add. MS. 16 is another listing of the curiosities made by Walpole, and there is an additional manuscript list made by Walpole which Owen Morshead, a former royal librarian, purchased for the Royal Archives from Francis Harper, a dealer. Even though in the 1760s Walpole identified the cabinet as belonging to George II, there is a substantial weight of evidence in correspondence, contemporary newspaper reports and manuscript notes containing references to the acquisition and movement of rarities to indicate that Caroline was the originator.

34 Horace Walpole noticed the series of Roman silver medals was arranged 'from Julius Caesar to the end of Marcus Aurelius', indicating that Caroline may have followed a collecting plan.

35 Bezoars had been prized since the sixteenth century as evidence of the irrationality of nature. The unicorn had for many centuries been the magical creature associated with the Virgin Mary and its horn was attributed with apotropaic qualities.

36 See R. Ariew, 'Leibniz on the Unicorn and various other Curiosities', *Early Science and Medicine*, vol. 3, no. 4, 1998, pp.267–88.

37 H. N. Nicholas, ed., *The Privy Purse Expenses of King Henry the Eighth*, London, 1824, pp. 51, 84–89, 96–99. A. Jefferies Collins, ed., *Jewels and Plate of Queen Elizabeth I: The Inventory of 1574*, London, 1955, pp. 247–253, 268–301.

38 Abraham van der Doort. '*Abraham van der Doort's Catalogue of the Collections of Charles I*', op. cit. pp. 127–28, 221–25.

39 'Inventory and Valuations of the King's Goods, 1649–1651', ed., Oliver Millar, *The Walpole Society*, vol. 43, 1972, pp. 26–47, 121, 426, 429.

40 Inner Temple MS. 538/17 f.425 discussed in Roy Strong, *Henry, Prince of Wales and England's Lost Renaissance*, London, 1986, pp. 196–98.

41 The Library Keeper, Patrick Young, listed the artefacts reserved from Charles I's collections before they were moved to Whitehall, see 'Inventories and Valuations of the King's Goods', op. cit., p. XVIII. Charles I's collection of coins and medals is discussed in H. W. Henfrey, 'King Charles the First's Collection of Coins', *Numismatic Chronicle*, new series, no. 14, 1874, p. 100, and A. MacGregor ed., *The Late King's Goods: Collections, Possessions and Patronage of Charles I in the Light of the Commonwealth Sale Inventories*, London, Oxford, 1989.

42 John Evelyn's account makes mention of the 'unicorn' horn beaker with a mount in the form of three unicorns. This can also be identified in the earlier inventory made by van der Doort along with clocks and 'divers jewels and crystal vases and exquisite pieces of carving, two unicorns horns etc.'. Even though Evelyn noted 'a vast number of agates, onyxes and intaglios especially of Caesar as broad as my hand', when writing to Samuel Pepys in 1689 he was still of the opinion that many parts of the collection had been irretrievably lost. In particular he suggested that most of the Stuart collection of medals had not survived the Commonwealth dispersals and lamented their loss: 'For thus has a cabinet of ten thousand medals, not inferior to most abroad & far superior to any at home . . . been imbeziled and carried away during our late barbarous Rebellion, by whom & whither none can or is likely to discouer'. Cited in Roy Strong, *Henry, Prince of Wales*, op. cit., p. 198, and J. Evelyn, *Diary*, op, cit., vol. II, p. 155.

43 M. Hinton and O. Impey, ed., *Kensington Palace and the Porcelain of Queen Mary II*, op. cit., pp. 49–59.

44 The 'shock dog', which was described by Abraham van der Doort, was believed to have belonged to Henry VIII originally, see 'Abraham van der Doort's Catalogue', op. cit., p. 96. On p. 212 there is a second description: 'A little shagg dogg scratching his upper lipp with his left hinder foote carved in Allabaster – Auncient and very curious work.' It is interesting to note that John Evelyn describes 'an antique of a dog in stone scratching his ear; very rarely cut, and comparable to the greatest curiosity I had ever seen of that kind for the accurateness of the work' in the collection of Signor Rugini in Venice on 29th September, 1645. J. Evelyn, *Diary*, op. cit., vol. I, p. 311. The sculpture of the 'shock dog' is mentioned in Horace Walpole's annotations, made in 1757, to his copy of Bathoe. Against the entry which reads 'A little shagged dog scratching his head with his left hinder foot, being carved in alabaster which the King had when he was Prince being done in King Henry VIII's time', Walpole writes: 'at Kensington, a Whitehall piece done in K Hen VIII's time.'

45 Elias Ashmole had taken wax impressions from the iron rings in 1660. The impressions survive in the Ashmolean Museum, Oxford.

46 The gems were described as '*gegrabene, nachge . . . stein*', see A. F. von Veltheim, *Anecdoten von Franzosischen Hofe vorzugliche aus den zeiten Ludewigs des XIV und des Duc Regent, aus den Briefen der Madame d'Orléans, Charlotte Elisabeth, Herzog Philipp I von Orléans*, Strabourg, 1789, letters 727, 734, 739 and 741. See also Charlotte-Elisabeth, Duchesse d'Orléans, *Secret Memoirs of the Court of Louis XIV and the Regency*, London, 1895.

47 See M. Trusted, *Catalogue of European Ambers in the Victoria and Albert Museum*, London, 1985. p. 14. The Raugravine Louise, who had served as Lady of the Bedchamber to Caroline when Princess of Wales, between 1715 and 1717, in 1717 sent her a medal. Caroline replied, thanking her for the gift, and declared: 'it gave me great pleasure, I have Dr Luther in gold and silver now', see Charlotte-Elisabeth, Duchesse d'Orléans, *Life and Letters of Charlotte-Elisabeth: Princess Palatine and Mother of Philippe d'Orléans, Regent of France, 1652–1723*, London, 1889, p. 246.

48 Caroline discussed the relative quality of German medal makers with Liselotte, see Charlotte-Elisabeth, Duchesse d'Orléans, Ibid., p. 165. Caroline's library contained the following titles, '*La Science des Medailles Antique et Moderne*', Amsterdam, 1717', '*Medailles du Cabinet du Roy*', and '*Suite de Medaillons du Cabinet du Roy*'.

49 Uta Löwenstein, 'Apartment of the Countess Dorothea Friederike von Hanau-Lichtenburg' op. cit. p. 6.

50 BL Add. MS. 20101 describes 'A hanging Jewell of onexes containing 12 heads and a piece of figures in the middle.' RA Geo. Add. MS. 16 describes 'A large cameo set round with several others.'

51 Caroline's collection contained an egg made of 'chyrstal'. The inventory of Liselotte's curiosities, made on her death in 1722, also contains references to several eggs – '*un oef*' at entry 136, and entry 215 reads '*trois oeufs*' of silver gilt, see E. de Barthélemy, '*Inventaire du Mobilier de la Duchesse d'Orléans, Mère du Regent, après son Decès en 1722, Bulletin du Comité des Travaux Historiques*', Paris, 1883.

52 The ivory and golden egg was presented to the Danish Royal Collection in 1900 as part of the bequest from Wilhelmine, to her 'beloved brother and sister-in-law, the King and Queen of Denmark, and the heirs to the Danish throne'. Wilhelmine was the daughter of King Frederick VI of Hesse-Kassel and had been presented with the piece in 1828, on her marriage to Prince Frederick, later Frederick VII of Denmark. In the box containing the egg was a note in Wilhelmine's hand which recorded: 'The costly egg which I received from my beloved mother when she was still alive was a gift from the Duchess of Orléans to the Queen of England, my mother's Great Grandmother. My mother inherited from her grandmother, the Landgravine of Hesse née Princess of England.' The Landgravine was Mary, one of Caroline's younger daughters. There are three other eggs of this type known, all thought to be of French workmanship. One is in the Kunsthistorisches Museum in Vienna. Another from the *Grünes Gewölbe* collection of Augustus the Strong was returned to the House of Wettin in 1924. A third egg is known from the inventory made in 1733 of the collection of the effects of the Margravine Sibylla Augusta of Löwenburg (1675–1733). It remained in the House of Baden until sold to Louis Philippe d'Orléans in 1775. The presence of a variety of cyphers and mottoes in both French and German,

together with the incorporation of specific portraits, shows that they were produced to special commission.

53 Charlotte-Elisabeth, Duchesse d'Orléans, *Briefe der Herzogin Elisabeth Charlotte van Orléans*, ed., W. L. Holland, Stuttgart, 1871, cited in Mogens Bencard, *The Hen in the Egg*, Copenhagen, 1999, p. 23. Letter 831, from Liselotte to Caroline, accompanied a gift of a pair of Easter eggs. In Letter 707 Liselotte wrote of her search to find French treasures that might please Caroline. In her turn, Caroline often chose a curiosity as a gift for a family member or friend. In 1716 Liselotte received 'a bezoar stone of Goa'. In 1716 Liselotte received a gold knife in a box and a sealskin case containing slides for a microscope, see Charlotte-Elisabeth, Duchesse d'Orléans, *The Letters of Madame: The Correspondence of Elisabeth Charlotte of Bavaria, Princess Palatine, Duchess of Orleans, 1661–1708*, trans. and ed., G. S. Stevenson, 3 vols., New York, 1924, vol. II, p. 84. In 1733 Caroline gave her daughter Princess Amelia '*une casete avec l'argenterie et Emagne*' and the following year Prince William Augustus received a '*petite statue de Bronze ou Bras Mercury*', see BL C120.h.6 (6).

54 Henrietta Howard, Countess of Suffolk, *Letters to and from Henrietta, Countess of Suffolk*, op. cit., vol. I, p. 304.

55 Mr Clay brought his new musical clock to Kensington Palace, see *Daily Post and General Advertiser*, 1st Sept., 1736. The clock was to be sold by raffle. Caroline brought £50 worth of tickets.

56 In 1733 Caroline sent a gold medal by John Crocker and John Tanner as a present to the Calvinist Jean-Alphonse Turrettini as a mark of esteem for his support of the Protestant Vaudois from Piedmont who had sought refuge in Switzerland, see William Eisler, *Les Médailles des Dassiers de Genève*, Milan, 2010. Since the 1680s there had been an attempt to bring together the Church of England and European Calvinists.

57 BL Add. MS. 11511 contains a reference to a book called '*L'Art de la Verrerie*' by M. Handicquer de Blancourt, published in Paris in 1697.

58 BL C120.h.6 (6). In 1716 Lady Cowper recorded: 'The Princess told me she had sent for amber out of Germany for the boxes for her ladies, but as she loved and esteemed me a hundred times more than any of the rest, she would make a distinction and so pulled out of a drawer a fine gold box . . .', Cowper, *Diary*, op. cit., p. 79

59 *Daily Courant*, issue 5525, 21st December, 1733.

60 As early as 1715 Caroline joined three hundred guests at the wedding of the daughter of Daniel Quare, a celebrated watchmaker from Change Alley in London, see J. Francis, *Chronicles and Characters of the Stock Exchange*, London, 1849, p. 46.

61 The images used of Henry VIII and Prince Edward in both the Royal Collection and the Chatsworth jewels are related to images by Holbein known in the eighteenth century. Henry VIII is based on the cartoon for the Whitehall painting celebrating the Tudor dynasty. A copy of this by Leemput was copied in watercolour by George Vertue in 1737. Prince Edward is based on a drawing that survives in the Royal Collection. It was one of the drawings re-discovered by Caroline and would also have been known by Vertue. See Vertue 'Note Books II, op. cit., pp. 90–91 for a reference possibly to these gems. ,

62 The craftsman who made the cameos is not known. However Vertue noted that the gemstone carver Charles Christian Reisen (1680–1725) was working in London. Uffenbach in 1710 visited Jacob Hempel and Wesenbeck,'a native of Augsburg',who made cameos and seals, as well as Francisco Benedetti of Lucca, a dealer in these objects, operating in London. See Uffenbach, *London in 1710*, op. cit., pp, 150, 170, 160.

63 TNA LC9/287 f.150v.

64 'two new glasses to an amber cabinet for the Queen at Kensington, 28 Sept.,1735', see TNA LC5/73 f.132v.

65 *Gentleman's Magazine*, July 1732, pp. 874–75. Sir Jeremy Sambrooke, who acquired the property in 1728, made great changes to the grounds, introducing a series of garden pavilions designed by James Gibbs, including a dovecote, temple and a folly arch in the Gothic taste, see BL Add. MS. 3250, ff.143–146 and Ashmolean MS, vol. III,87,IV.40.

66 Lord Egmont visited Gubbins in 1739, see BL Add. MS. 47013A. f.99.

67 Sloane was employed as Physician in Ordinary, 'having been before constant employ'd about the whole Royal Family & always honour'd with the esteem & favour of the queen Consort', see TNA LC3/64 f.109. William Stukely noted on 14th June, 1720: 'The young princesses dine'd with Hans Sloan', see *The Family Memoirs of the Rev. William Stukeley M.D.*, 3 vols., Publications of the Surtees Society, 17, 76, 80, Durham, 1880–87, vol. I, p. 73.

68 George II later chose not to acquire the collections made by Sloane when they were offered to him on Sloane's death. Sloane's *Voyage to the Islands Madera, Barbados, Nieves, S. Christophers and Jamaica . . . with the Natural History of the . . . last of those Islands* was published in 1707, with a second edition in 1725.

69 John Evelyn visited Sloane's 'Repository' of ethnography and naturalia at 4 Bloomsbury Place in 1691. J. Evelyn, *Diary*, op. cit., vol. III, p. 284. Sir Hans Sloane owned fifty-three bezoars at the time of his death.

70 'Epigram on Caroline's visit to Sloane's Museum' by John Thomas de Woolhouse, see BL Sloane MS. 3516.f.4, f.79. For information about the visit by the princesses to Sloane's collection see *The Gentleman's Magazine*, 7 March, 1734 p. 159. Prince William Henry of Orange visited Sloane's collection on 4th September, 1734, while in London for his wedding, see BL. Sloane MS. 3516.

71 BL Sloane MS. 1968.f.72.

72 *Notes and Queries*, series 8, no. VI, 7 July, 1894, p. 14.

73 Cowper, *Diary*, op. cit., p. 69, pp. 71–72.

74 *Gentleman's Magazine*, Feb. 1731, p. 79. There is a notable collection of ivory turnings made by members of the royal family in the Danish Royal Collection.

75 Marten Loonstra, *Uit Koninklijk Bezit: Honderd jaar Koninklijk Huisarchief de verzameling van de Oranjes*, Zwolle, 1996, p. 110, cited in Richard R. King, 'Anne of Hanover and Orange (1709–59) as Patron and Practitioner of the Arts', in Campbell Orr, *Queenship in Britain*, op. cit., p. 184. Anne's work in amber survives in the Dutch Royal Collection.

76 'April 30 1740. Finding that your Royal Highness takes pleasure sometimes in working amber, I take the liberty of sending to her several pieces of the best I was able to locate in Prussia', Letter from Frederick the Great of Prussia to Anne of Hanover. Personal communication. Marten Loonstra, Koninklijk Huisarchief, The Hague.

77 De Dansk Kronologiske Samling på Rosenborg, Copenhagen, Denmark. Accession numbers 4001, 4002, 4016.

78 Hervey, *Memoirs*, op. cit., pp. 103–104.

79 Leibniz presents a similar conundrum to historians today. For discussion of the breadth of Leibniz's interests see Ariew, op. cit., pp. 272–85.

80 L. Worsley, *Courtiers: The Secret History of Kensington Palace*, London, 2010, p. 85–111 and M. S. Newton, *Savage Girls and Wild Boys: A History of Feral Children*, London, 2002.

The Gentleman's Magazine records that on another occasion a small dwarf was brought from Denmark in May, 1732, to be introduced as a curiosity to the royal family: 'He stood under the arm of the Duke of Cumberland to the amusement of the company', see *The Gentleman's Magazine*, May 1732, p. 771.

81 Quoted by Richard. G. King, 'Anne of Hanover and Orange', in Campbell Orr, *Queenship in Britain*, op. cit., p. 162.

CONCLUSION

1 Lord Wharncliffe, ed., *The Letters and Works of Lady Mary Wortley Montagu*, op. cit., vol. I, p. 13.

2 C. Gerrard, 'The Castle of Indolence and the Opposition to Walpole', *The Review of English Studies*, new series, vol. 41, no. 161, Feb. 1990, pp. 45–64.

3 Egmont, *Diary*, op. cit., vol. I, p. 279.

4 Walpole, *Correspondence*, op. cit., vol. IV, p. 88, and Walpole, 'Journal of Visits to Country Seats', op. cit., p. 16. The most cursory examination of the Lord Chamberlain's and Lord Steward's records reveals the impact Caroline had had on many aspects of royal life, well away from the artistic sphere. The management of Princess Mary's trousseau on her marriage in 1740 to Frederick II, Landgrave of Hesse-Kassel, was left to Margaret Purcell, Caroline's Laundress. The regular payments for supplies for the bathroom stop abruptly on her death; it seems that it was only Caroline's interest in science and medicine that had ensured the most thorough programme of personal and household hygiene was maintained within the Court. George II did not use Hampton Court Palace after 1737 and had never cared for Windsor Castle.

5 TNA LC5/161, p. 283.

6 Vertue was given a copy of the inventory made by Lowman in about 1732 for reference, see Vertue, 'Note Books I', op. cit., vol. 18, pp. 12–13. The inventory he prepared was called 'The Collections of Paintings etc at Kensington, Hampton Court and in the Castle of Windsor', 1750.

7 William Mason, *An Heroic Epistle to Sir William Chambers*, 2nd ed., London, 1773.

8 Leigh Hunt, *The Old Court Suburb*, London, 1902, p. 196

9 E. Walford, *Old and New London*, London, 1877, vol. V, p. 39.

10 The Treasury passed estimates for £161 for this work, see TNA Works 16/663.

11 *The London and Westminster Guide* of 1768 states: 'some of the apartments which were capable of it were kept up in a real state of magnificence during the late King's reign and possessed of many excellent pictures, but they have been grabbed for the Queen's Palace.'

12 As early as 1761 it seems that 'a batch of miniatures and a chest of enamelled pictures' had been moved from Kensington Palace to Buckingham House. See BL Add. MS. 20101, f.53 and Walpole, 'Visits to Country Seats', op. cit., pp. 78–80.

13 'To her friend Mrs Delany She bequeathed ... & also Raphael's Mice from the Royal Collection ...', see Horace Walpole, *The Duchess of Portland's Museum*, intro. W. S. Lewis, New York, 1936, p. 9. The name of the person who had passed the painting to the Duchess is not recorded.

14 Walpole, 'Visits to Country Seats', op. cit., pp.78–79 records of the treasures: 'they are taken from Kensington to Buckingham House for Queen Charlotte'. Queen Charlotte's sale was held at Christie's, see Christie, Manson and Wood, *A Catalogue of a Superbe Assemblage of Jewels, Trinkets ... which will be sold by Mr Christie*, 17–18 May, 1819.

15 Even though the information given in Mrs Purcell's inventory is sketchy and difficult to reconcile with certainty with Horace Walpole's lists made in the 1760s, she almost certainly saw many more items. For gifts to Sir Robert Walpole see Walpole, *The Yale Edition of Horace Walpole's Correspondence*, op. cit., vol. XXIII, p. 464.

16 The bookcases were transferred to Buckingham House on 22nd March, 1764.

17 The manuscript inventories of the collection of medals by 1825 contained over fifteen thousand items. Amongst the group were many which Charles Combe, its cataloguer, considered to be false and of poor quality, see Charles Combe, CATALOGUE of the Several Series of *Modern Medals & Coins in His Majesty's Collection*, 1771, rev. 1814, and CATALOGUE of the Ancient Coins in His Majesty's Collection, 1814. It is revealing that in the descriptions of Caroline's items recorded by Horace Walpole, he used the terms 'which appear to me to be false', 'not many & some false' and 'very indifferent'.

18 RA Jutsham's receipts, F12/13, 16B.

19 For George IV's admiration of King Charles I, see S. Parissien, *George IV: The Grand Entertainment*, London, 2001, pp. 202–206.

20 RA Add. MS. 16. RA Jutsham's receipts, F12/13, p. 121, no.7. RA Jutsham's receipts, F12/13. p. 125, no. 29. Horace Walpole note about the unicorn beaker is found in his annotations to Bathoe.

21 RA Jutsham's receipts, F12/13, p. 123, no. 17. RA Jutsham's receipts, F12/13, p. 125, nos. 30, 31. RA Jutsham's receipts, F12/13, p. 125, no. 28: 'A crimson colour vase carved in ovals & squares lined with gold and gold enamel cover & feet. 7 1/4 inches high ornamented with light blue beads'. RA F12/13, p. 127, no. 42 'A broken hummingbird to be found in vase no. 28'.

22 Jutsham's receipts, F12/13, p. 128. Jutsham indicated that the collection of weapons. together with the 'shock dog', was later sent to the Armoury.

23 Royal Collection, *Inventory Taken of Sundry Jewels etc. at Windsor Castle 16 Sept. 1830, and the Following Days by Messrs. Bridge in the Presence of Major General Wheatley, Major General Stephenson and Sir Frederick Watson*, p. 33.

24 Between 1741 and 1760 just 323 volumes were added to Caroline's library.

25 TNA LC9/307, Bill 56, qtr to midsummer 1762 discussed in Hugh Roberts, 'Metamorphosis in Wood: Royal Library Furniture in the Eighteenth and Nineteenth Centuries', *Apollo*, June 1990, p. 383–90.

26 See Thomas Pennant, *Some Account of London*, London, 1805, p. 118, Edgar Sheppard, *Memorials of St James's Palace*, 2 vols., London, 1894, vol. I. pp. 385–87 and H. M. Colvin, ed., *The History of the King's Works*, 6 vols., London, 1963–82, vol. V, 1976, p. 43.

27 Jay, 'Queen Caroline's Library', op. cit. There were sales of books considered duplicates from the British Library in the late eighteenth and early nineteenth centuries. These were generally conducted by Sotheby's, which traded initially under the name S. Baker and G. Leigh, and later as Leigh and Sotheby. I have checked the catalogues of the sales of duplicate books which took place on 4th April, 1769, 6th March, 1788, 21st April, 1805, 18th May, 1818, and 19th February, 1819, but none of these seems to contain books from Queen Caroline's collection. It is possible that some books escaped from royal hands as there is one volume in the British Library, acquired in 1897, with the annotation that the book was believed to have once belonged to Caroline.

28 Even though the Dorigny volumes can be identified in the book movement lists, they are not included in the lists for the main library and possibly were never lodged there. Both of the volumes were noted in the two manuscript inventories made of the Print Room collections in the reign of George III, see Print Room Inv. A. Print Room Inv. B

29 RA Geo. Add. MS. 16.

30 In 1765 the book collection of Prince William Augustus, Duke of Cumberland, passed to George III.

31 See annotation to the title pages of RL 1028932.

32 Delany, *Autobiography*, op. cit., series 1, vol. II, p. 5.

33 Royal Collection, *An Inventory of Sundry Articles of Jewellery etc. Belonging to Her Majesty in the Strong Closet in Windsor Castle Taken July 1837 by Rundell Bridge & Co. Jeweller to Her Majesty*, p. 7.

34 Royal Collection, Armoury Catalogue, no. 3008, 'An ancient powder horn mounted in silver', no. 3006, 'An Indian dagger in a crimson velvet case', and no. 3007, 'A Malay dagger in a silver sheath'.

35 Vertue, 'Note Books V', op. cit., vol. 26, p. 21.

36 Vertue's tracings of thirty-four of the Holbein drawings survive in the collection of Sudeley Castle. They had been sold by the auctioneer Mr Ford as lot 83 at George Vertue's sale in 1757 as 'A portfolio with thirty five drawings taken by permission from the original heads of eminent persons painted by Hans Holbein in the Royal Collection at Kensington Palace by Mr Vertue.' The lot was bought by Horace Walpole for £18. 2s. 6d. On 17 May, 1842, they were sold on again as lot 32 on the 20th day of Horace Walpole's sale at Strawberry Hill as 'An interesting series of 34 Portraits of remarkable personages of the Court of Henry VIII. They are tracings on oil paper by Vertue and Muntz from the original drawings by Holbein in the Royal Collection at Buckingham House in black and gold frames.' The collection sold for £36. 10s.

37 *Elizabeth Montagu, the Queen of the Blue-Stockings: Her Correspondence from 1720 to 1761*, ed. E. J. Climenson, 2 vols., London, 1906, vol. I, p. 47.

38 *Daily Post*, 15th June, 1739.

39 Churchill, *Letters of a Grandmother*, op. cit., pp. 155–56.

40 R. Halsband, *The Life of Lady Mary Wortley Montagu*, op. cit., p. 168.

41 Lord Hervey claimed Caroline had to
 work hard to align attitudes and interests
 conditioned by her German ancestry and
 experience with the responsibilities that
 came with her new royal office in Great
 Britain. Lord Hervey's comment was
 written in 1734: 'There are local prejudices
 in all people's composition, imbibed from
 the place of their birth, the seat of their
 education, and the residence of their
 youth, that are hardly ever quite
 eradicated, and operate much stronger
 than those who are influenced by them
 are apt to imagine; and the Queen
 [Caroline], with all her good sense, was
 articulated by these prejudices in a degree
 nothing short of that in which they biased
 the King.' Hervey, *Memoirs*, op. cit., p. 103.

BIBLIOGRAPHY

PRIMARY SOURCES

THE NATIONAL ARCHIVES (TNA)

Audit Office Papers
AO1, AO3

Calendar of Treasury Books and Papers

Lord Chamberlain's Papers
LC2, LC5, LC9, LC11

Lord Steward's Papers
LS1, LS13, LS58

Treasury Papers
T1, T27, T29, T52, T54, T56

Works Papers
Works 1, Works 4, Works 5, Works 6, Works 32

THE ROYAL ARCHIVES (RA)

Papers and correspondence. Queen Caroline
RA Add. MS. 52760–6
RA Add. MS. 52773
RA Add. MS. 5.2824
RA Add. MS. 52895–52900
RA Add. MS. 52936
RA Add. MS. 17/75
RA Geo Add. MS. 16
RA Geo Add. MS. 28/2–18
RA Geo Add. MS. 54000
RA Geo Add. MS. 1/49
RA Geo Add. MS. 2
Accounts. Queen Caroline
RA Add. MS. 53993–54005,
 May 1730–March 1731
RA Add. MS. 54006–54014,
 May 1731–Sept. 1731
RA Add. MS. 54015–54023, Sept. 1731–1733

ROYAL LIBRARY (RL)

Catalogue of the Royal Library of Her Late Majesty, Queen Caroline Distributed into Faculties, 1743.

THE OFFICE OF THE SURVEYOR OF THE QUEEN'S PICTURES

An Inventory of Sundry Articles of Jewellery etc. Belonging to Her Majesty in the Strong Closet in Windsor Castle Taken July 1837 by Rundell Bridge & Co. Jeweller to Her Majesty.

Bathoe, W., *A Catalogue of Pictures Belonging to King James the Second (Copied from a ms. in the Library of the Earl of Oxford): To which is Appended a Catalogue of the Pictures, Drawings, Limnings, Enamels, Models in Wax and the Ivory Carvings etc. at Kensington in Queen Caroline's Closet, next the State Bedchamber*, London, 1758.

Illustrations by George Vertue. Handwritten inventory of Caroline's cabinet of curiosities by Horace Walpole, c. 1760.

Combe, Charles, CATALOGUE of the Several Series of Modern Medals & Coins in His Majesty's Collection, 1771, rev. 1814.

Combe, Charles, CATALOGUE of the Ancient Coins in His Majesty's Collection, 1814.

Doort, Abraham van der, A Catalogue and Description of Charles the First's Capital Collection of Pictures, Limnings, Statues etc. Contributions by Horace Walpole and George Vertue, 1756.

Glover, John (probably), A Catalogue of the Miniatures in the Possession of Her Majesty the Queen, 1851.

Inventory Taken of Sundry Jewels etc. at Windsor Castle 16 Sept. 1830, and the Following Days by Messrs. Bridge in the Presence of Major General Wheatley, Major General Stephenson and Sir Frederick Watson.

Jutsham, R. D., An account of Furniture etc received and deliver'd by Benjamin Jutsham on account of His Royal Highness The Prince of Wales at Carlton House, 1806–1820.

Lowman, Henry, A Catalogue Taken of the Pictures which are in the Publick and Private Lodgings of the Palace of Kensington, c. 1732.

Royal Collection inventory VR Inv. 24 Feb. 1866.

Vertue, George, The Collections of Pictures, Paintings etc at Kensington, Hampton Court and in the Castle of Windsor, 1750. With handwritten annotations.

BRITISH LIBRARY
DEPARTMENT OF MANUSCRIPTS (BL)

BL Add. MS. 15752
BL Add. MS. 11511
BL Add. MS. 20101
BL Add. MS. 51396
BL Add. MS. 16941
BL Add. MS. 20013 ff.1–13, A List of Pictures at Kensington House, c. 1710.
BL C120.h.6 (1–7)
BL Stowe MS. 567, Inventory of Pictures at Kensington, Hampton Court, Windsor and St James's, c. 1720.

BL Sloane MS. 4034
BL Egerton 1717
BL Maps K. Top. 16
BL Maps H. 258
BL Sloane MS. 4068
BL Sloane MS. 1968
BL Sloane MS. 3516
BL Sloane MS. 567

CHATSWORTH HOUSE, DERBYSHIRE

Chiswick & Chatsworth & Miscellaneous Drawings, 46 and 50
Chatsworth. Kent/Burlington House 26/69/76
MS. 212/2
MS. 127/6
MS. 230/5

ALTHORP HOUSE, NORTHAMPTONSHIRE

MS. B8

SIR JOHN SOANE'S MUSEUM

Adam vol. 56/25, 33–34
Adam vol. 147/192–198

ROYAL INSTITUTE OF BRITISH
ARCHITECTS (RIBA)

Adam, Robert, Sketchbook, c. 1750

BODLEIAN LIBRARY, OXFORD

Bodleian Maps 40

THE ROYAL BOTANIC GARDEN, KEW

Rocque, John, An Exact Plan of the Royal Palace Gardens and Park at Richmond, 1734
Rocque, John, An Exact Plan of the Royal Palace Gardens and Park at Richmond, 1754

VICTORIA AND ALBERT MUSEUM

Kent, William, Preparatory drawings for The Faerie Queene, V&A E.871–1928 –E.885–1928

PREUSSISCHES STAATSARCHIV, HANOVER

Specification D'Argenterie de S. A. Madame l'Electrice. Inventer 1709, HStA Hanover Dep. 103, XXIV, Nr. 2487 (Marianburg)

KONINKLIJK HUISARCHIEF, THE HAGUE
(ROYAL COLLECTION OF THE NETHERLANDS)

A17/470
A17/430

CONTEMPORARY NEWSPAPERS AND JOURNALS

Daily Courant
Daily Gazetteer
Daily Journal
Daily Post
Dawks's News Letter
Free Briton
General Evening Post
Gentleman's Magazine
London Daily Post and General Advertiser
London Magazine and Monthly Chronologer
London Journal
The Political State of Great Britain
The Spectator

SECONDARY SOURCES

BOOKS

Adamson, J., ed., The Princely Courts of Europe: Ritual, Politics and Culture under the Ancien Régime, 1500–1750, London, 1998.

Anon, An Enquiry how the Wild Youth, Lately taken in the Woods near Hanover (and now brought over to England) could be there Left, and by what Creature he could be Suckled, Nursed and Brought Up, London, 1726.

Anon, possibly Swift, Jonathan, It never Rains but it Pours: Or London Strow'd with Rarities, 2 vols., London, 1726.

Arbuthnot, J., Mr Maitland's Account of Inoculating the Small Pox Vindicated, London, 1722.

Arciszewska, Barbara, The Hanoverian Court and the Triumph of Palladio: The Palladian Revival in Hanover and England, c. 1700, Warsaw, 2002.

Arkell, R. L., Caroline of Ansbach: George the Second's Queen, Oxford, 1939.

Asch, Ronald G., and Birke, Adolph M., *Princes, Patronage and Nobility: The Court at the Beginning of the Early Modern Age, c. 1450–1650*, London, Oxford, 1991.

Baily, F. E., *Sophia of Hanover and her Times*, London, 1936.

Baker-Smith, V. P. M., *A Life of Anne of Hanover, Princess Royal*, Leiden, 1995.

Bartoschek, Gerd, et. al., *Sophie Charlotte und ihr Schloss: Ein Musenhof des Barock in Brandenburg-Preussen*, Munich, 1999.

Batey, M., *Alexander Pope: The Poet and the Landscape*, London, 1999.

Bathoe, W., *A Catalogue of Pictures Belonging to King James the Second (Copied from a ms. in the Library of the Earl of Oxford): To which is Appended a Catalogue of the Pictures, Drawings, Limnings, Enamels, Models in Wax and the Ivory Carvings etc. at Kensington in Queen Caroline's Closet, next the State Bedchamber*, illus. George Vertue, London, 1758.

Bayley, Peter, ed., *Spenser, The Faerie Queene: A Casebook*, London, 1977.

Beattie, John M., *The English Court in the Reign of George I*, Cambridge, 1967.

Bencard, M., *The Hen in the Egg*, Copenhagen, 1999.

Bentley, R., *A Proposal for Building a Royal Library, and Establishing it by Act of Parliament*, London, 1697.

Bentley, R., *The Correspondence of Richard Bentley*, 2 vols., London, 1842.

Bickham, G., *Apelles Britannicus, Book I: The Royal Palace of Hampton Court; Book II: The Royal Palace of Kensington*, London, 1741.

Bickham, G., *Deliciae Britannicae: Or the Curiosities of Hampton Court and Windsor Castle*, London, 1742.

Bindman, D., *Hogarth and his Times: Serious Comedy*, London, 1997.

Biographia Britannica: Or, the Lives of the Most Eminent Persons who have Flourished in Great Britain and Ireland from the Earliest Ages, down to the Present Times, Collected from the Best Authorities . . . 6 vols., London, 1747–66.

Birch, T., *Heads and Characters of Illustrious Persons of Great Britain with their Portraits Engraven by Mr. Houbraken and Mr. Vertue: With their Lives and Character*, 2 vols., London, 1743.

Blanning, T. C. W., *The Culture of Power and the Power of Culture: Old Regime Europe, 1660–1789*, Oxford, 2002.

Borman, T., *Henrietta Howard: Queen's Servant*, London, 2007.

Bowden, Delia K., *Leibniz as a Librarian: And, Eighteenth-Century Libraries in Germany*, School of Library, Archive and Information Studies, Occasional Publications 15, University College, London, 1969.

Bredekamp, H., *The Lure of Antiquity and the Cult of the Machine: The Kunstkammer and the Evolution of Nature, Art and Technology*, trans. Allison Brown, Princeton, 1995.

Brett, R. L., *The Third Earl of Shaftesbury: A Study in Eighteenth-Century Literary Theory*, London, 1951.

Brewer, John, *The Pleasures of the Imagination: English Culture in the Eighteenth Century*, London, 1997.

Brewer, John, and Porter, Roy, ed., *Consumption and the World of Goods*, London, 1993.

Brinkley, Roberta Florence, *Arthurian Legend in the Seventeenth Century*, Baltimore, London, 1932.

Britt, A. S, Jnr., and Dees, A. R., ed., 'Selected Eighteenth Century Manuscripts', *Georgia Historical Society Collections*, vol. XX, Savannah, 1980.

Brown, Stuart, ed., *British Philosophy and the Age of Enlightenment*, Routledge History of Philosophy, vol. 5, London, 1996.

Brownell, M. R., *Alexander Pope and the Arts of Georgian England*, Oxford, 1978.

Browning, J. D., ed., *Education in the 18th Century*, New York, London, 1979.

Bucholz, R. O., *The Augustan Court: Queen Anne and the Decline of Court Culture*, Stanford, Calif., 1993.

Butterfield, H., *The Whig Interpretation of History*, London, 1931.

Campbell Orr, Clarissa, ed., *Queenship in Britain, 1660–1837: Royal Patronage, Court Culture and Dynastic Politics*, Manchester, 2002.

Campbell Orr, Clarissa, ed., *Queenship in Europe, 1660–1815: The Role of the Consort*, Cambridge, 2004.

Casley, D., *Catalogue of the Manuscripts of the King's Library: An appendix to the Catalogue of the Cottonian Library, together with an account of the books burnt or damaged by a late fire . . .* London, 1734.

Cassirer, Ernst. *The Philosophy of the Enlightenment*, trans. Fritz C. A. Koelin and James P Pettegrove, Princeton, 1951.

Chenevix Trench, C., *George II*, London, 1973.

Chesterfield, Philip Dormer Stanhope, Earl of, *Lord Chesterfield's Letters*, ed. and intro. D. Roberts, Oxford, 1992.

Chesterfield, Philip Dormer Stanhope, Earl of, *The Letters of Philip Dormer Stanhope, Earl of Chesterfield: Including Numerous Letters now first Published*, ed. with notes by Lord Mahon, 5 vols., London, 1845–53.

Christie, Manson and Wood, *A Catalogue of a Superbe Assemblage of Jewels, Trinkets . . . which will be sold by Mr Christie*, 17–18 May, 1819.

Christie, Manson and Wood, *A Catalogue of the Remaining Part of a Valuable Collection of Curiosities, which will be sold by Auction by Mr Christie, Monday May 24, 1819 and the following days.*

Churchill, Sarah, *Letters of a Grandmother: Being the Correspondence of Sarah, Duchess of Marlborough with her Granddaughter Diana, Duchess of Bedford*, ed., G. S. Thomson, London, 1943.

Clark, Christopher, *Iron Kingdom: The Rise and Downfall of Prussia, 1600–1947*, London, 2006.

Clarke, Dr Alured, *An Essay towards the Character of Her Late Majesty Caroline, Queen-Consort of Great Britain*, London, 1738.

Clarke, G., Marsden, J., Wheeler, R., Bevington, M., and Knox, T., *Stowe Landscape Gardens*, The National Trust, London, 1997.

Clarke, G. B., ed., *Descriptions of Lord Cobham's Gardens at Stowe, 1700–1750*, Buckingham Record Society, no. 26, 1990.

Colley, Linda, *Britons: Forging the Nation, 1707–1837*, New Haven, London, 1992.

Colman, Benjamin, *A Narrative of the Method and Success of Inoculating the Small-Pox in New England. By Mr Benj. Colman. With a Reply to the Objections Made against it from Principles of Conscience. In a letter from a Minister at Boston [Rev Wm Cooper] to which is now Prefixed an Historical Introduction*, intro. Daniel Neal, London, 1722.

Colvin, H. M., *The History of the King's Works*, 6 vols., London, 1963–82.

Cooper, Anthony Ashley, 3rd Earl of Shaftesbury, *Charactersticks of Men, Manners, Opinions, Times . . .* 3 vols., London, 1711.

Cooper, Anthony Ashley, 3rd Earl of Shaftesbury, *Second Characters: Or the Language of Forms*, 3 vols., London, 1778.

Corp, E., *A Court in Exile: The Stuarts in France, 1689–1718*, Cambridge, 2004.

Cowper, F. T. de Grey, Earl Cowper, *The Manuscripts of the Earl Cowper, KG, Preserved at Melbourne Hall, Derbyshire . . .* 12th Report, Royal Commission on Historical Manuscripts, Appendix pt. 1–3, 1888–89.

Cowper, Mary, Countess, *Diary of Mary, Countess Cowper: Lady of the Bedchamber to the Princess of Wales, 1714–1720*, ed. Hon. C. S. Cowper, London, 1864.

Coxe, W., *Memoirs of the Life and Administration of Sir Robert Walpole, Earl of Orford*, 4 vols., London, 1816.

Curll, E., *The Rarities of Richmond: Being Exact Descriptions of the Royal Hermitage and Merlin's Cave, with his Life and Prophesies*, London, 1736.

Dann, Uriel, *Hanover and Great Britain, 1740–1760: Diplomacy and Survival*, Leicester. 1991.

Davis, Mary Rose, *Stephen Duck: The Thresher Poet*, University of Maine Studies, series 2, no. 8, vol. XXIX, 1927.

Dean, Christopher, *Arthur of England: English Attitudes to King Arthur and the Knights of the Round Table in the Middle Ages and the Renaissance*, Toronto, 1987.

Debioggi, C., *Il Sacro Monte di Varallo*, Varallo Sesia, 1998.

Defoe, Daniel, *The History of the Life and Adventures of Mr Duncan Campbell: A gentleman, who, tho' Deaf and Dumb, Writes Down any Stranger's Name at first Sight . . .* London, 1728.

Delany, Mrs, *The Autobiography and Correspondence of Mary Granville, Mrs Delany*, ed. Lady Llanover, series I, 3 vols., London, 1861, series II, 3 vols., London, 1862.

Desmond, R., *Kew: The History of the Royal Botanic Gardens*, London, 1995.

Dezallier d'Argentville, Antoine Joseph, *The Theory and Practice of Gardening*, trans. John James, Farnborough, 1969.

Dodington, George Bubb, *The Diary of the Late George Bubb Dodington, Baron of Melcombe Regis . . . now first published by Henry Pennruddocke Wyndham*, London, 1784.

Dryden, J., *Merlin: Or, the British Inchanter. And King Arthur the British Worthy*, London, 1736.

Eger, E., and Peltz, L., *Brilliant Women: 18th–Century Bluestockings*, London, 2008.

Egmont, John Percival [Perceval], Earl of, *Manuscripts of the Earl of Egmont: Diary of Viscount Percival. Afterwards First Earl of Egmont*, 3 vols, Historical Manuscripts Commission, London, 1879–1923.

Einberg, E., and Jones, R., ed., *Manners & Morals: Hogarth and British Painting, 1700–1760*, exh. cat., Tate Gallery, London, 1987.

Eisler, William, *Les Médailles des Dassiers de Genève*, Milan, 2010.

Eustace, Katharine, *Michael Rysbrack: Sculptor, 1694–1770*, Bristol, 1982.

Evans, E. D., *A History of Wales, 1660–1815*, Cardiff, 1976.

Evans, Joan, *A History of the Society of Antiquaries*, Oxford, 1956.

Evelyn, John, *The Diary of John Evelyn*, intro. and notes Austin Dobson, 3 vols., London, New York, 1906.

Fara, Patricia, *Pandora's Breeches: Women, Science and Power in the Enlightenment*, London, 2004.

Fauchier-Magnan, Adrien, *The Small German Courts in the Eighteenth Century*, trans. Mervyn Savill, London, 1958.

Field, Ophelia, *The Kit-Cat Club: Friends who Imagined a Nation*, London, 2008.

Findlen, Paula, *Possessing Nature: Museums, Collecting and Scientific Culture in Early Modern Italy*, Berkeley, London, 1994.

Foister, Susan, *Holbein in England*, London, 2006.

Ford, Mr [Auctioneer], *George Vertue: Sale of Library*, 18–19 March, 1757.

Ford, Mr [Auctioneer], *George Vertue: Sale of Pictures, Coins and Drawings*, 17–19 March, 1759.

Franklin, Colin, *Lord Chesterfield: His Character and Characters*, Aldershot, 1993.

Franklin, Julian H., *John Locke and the Theory of Sovereignty: Mixed Monarchy and the Right of Resistance in the Political Thought of the English Revolution*, Cambridge, 1978.

Frey, Linda, and Frey, Marsha, *Frederick I: The Man and his Times*, New York, 1984.

Gay, J., *John Gay: Dramatic Works*, ed. John Fuller, 2 vols., Oxford, 1983.

Gay, J., *Poems on Several Occasions*, 2 vols., London, 1762.

Gay, J., *The Letters of John Gay*, ed. C. F. Burgess, Oxford, 1966.

Gerrard, C., ed., *A Companion to Eighteenth-Century Poetry*, Oxford, 2006.

Gerrard, C., *The Patriot Opposition to Walpole: Politics, Poetry, and National Myth, 1725–1742*, Oxford, 1994.

Goodman, Dena, *The Republic of Letters: A Cultural History of the French Enlightenment*, Ithaca, London, 1994.

Goodman, Katherine R., *Amazons and Apprentices: Women and the German Parnassus in the Early Enlightenment*, Rochester, N.Y., Woodbridge, Suffolk, 1999.

Gordon, Peter, and Lawton, Denis, *Royal Education: Past, Present and Future*, London, 1999.

Granger, Rev. J., *A Biographical History of England*, 5th ed., 6 vols., London, 1825.

Griffiths, Antony, ed., *Landmarks in Print Collecting: Connoisseurs and Donors at the British Museum since 1753*, London, 1996.

Griffiths, Antony, ed., *The Print in Stuart Britain, 1603–1689*, London, 1998.

Grundy, Isabel, *Lady Mary Wortley Montagu: Comet of the Enlightenment*, Oxford, 1999.

Gwynn, Stephen, *The Life and Friendships of Dean Swift*, London, 1933.

Hallett, Mark, *The Spectacle of Difference: Graphic Satire in the Age of Hogarth*, London, New Haven, 1999.

Halsband, Robert, *Lord Hervey: Eighteenth-Century Courtier*, Oxford, 1973.

Halsband, Robert, *The Life of Lady Mary Wortley Montagu*, London, 1956.

Harmsen, T. H. B. M., *Antiquarianism in the Augustan Age: Thomas Hearne, 1678–1735*, Oxford, 2000.

Harris, F., *A Passion for Government: The Life of Sarah, Duchess of Marlborough*, Oxford, 1991.

Harris, J., *The Palladian Revival: Lord Burlington, his Villa and Garden at Chiswick*, New Haven, London, 1994.

Harris, J., *The British Hero: Or, a Discourse . . .* London, 1715.

Harris, J., *William Kent, 1685–1748: A Poet on Paper*, London, 1998.

Hatton, Ragnhild, *George I: Elector and King*, London, 1978.

Hawkins, E., ed., *Medallic Illustrations of the History of Great Britain and Ireland to the Death of George II*, London, 1885.

Hervey, John, Baron Hervey, *Lord Hervey and his Friends, 1726–1738: Based on Letters from Holland House, Melbury and Ickworth*, ed. Earl of Ilchester, London, 1950.

Hervey, John, Baron Hervey, *Lord Hervey's Memoirs: Edited from a Copy of the Original Manuscripts in the Royal Archives at Windsor Castle*, ed. Romney Sedgwick, London, 1952.

Hervey, John, Baron Hervey, *Memoirs of the Reign of George the Second: From his Accession to the Death of Queen Caroline*, ed. J. W. Croker, 3 vols., London, 1848.

Hervey, John, Baron Hervey, *Some Materials towards Memoirs of the Reign of King George II*, ed. Romney Sedgwick, London, 1931.

Hervey, John, Baron Hervey, *Letter-Books of John Hervey, First Earl of Bristol*, 3 vols., Wells, 1894.

Hervey, Mary, Lady Hervey, *Letters of Mary Lepel, Lady Hervey: With a Memoir, and Illustrative Notes*, ed. J. W. Croker, London, 1821.

Hesse, Carla, *The Other Enlightenment: How French Women Became Modern*, Princeton, 2001.

Hind, A. M., *Engraving in England in the Sixteenth and Seventeenth Centuries*, 3 vols., Cambridge, 1952–1964.

Hinton, M., and Impey, I., ed., *Kensington Palace and the Porcelain of Queen Mary II*, London, 1998.

Howard, Henrietta., Countess of Suffolk, afterwards Berkeley, Hon. Mrs George, *Letters to and from Henrietta, Countess of Suffolk, and her Second Husband, the Hon. George Berkeley, from 1712 to 1767*, ed. J. W. Croker, 2 vols., London, 1824.

Huddleston, R., ed., *A New Edition of Toland's History of the Druids*, Montrose, 1814.

Hunt, John Dixon, ed., *The Oxford Book of Garden Verse*, London, 1993.

Hunt, John Dixon, *William Kent: Landscape Garden Designer*, London, 1987.

Hunt, John Dixon, and Willis, P., ed., *The Genius of the Place: The English Landscape Garden 1620–1820*, London, 1975.

Hyde, Melissa, and Milam, Jennifer, ed., *Women, Art and the Politics of Identity in Eighteenth- Century Europe*, Aldershot, 2003.

Impey, O., and MacGregor, A., ed., *The Origins of Museums: The Cabinet of Curiosities in Sixteenth- and Seventeenth-Century Europe*, Oxford, 1980.

Jackson-Stops, Gervase, ed., *The Fashioning and Functioning of the British Country House*, Washington D.C., Hanover, London, 1989.

Jackson-Stops, Gervase, ed., *The Treasure Houses of Britain: Five Hundred Years of Private Patronage and Art Collecting*, London, New Haven, 1985.

Jacob, Margaret C., *The Newtonians and the English Revolution, 1689–1720*, Hassocks, 1976.

Jardine, Lisa, *Ingenious Pursuits: Building the Scientific Revolution*, London, 1999.

Jenkins, G. H., *The Foundations of Modern Wales*, Oxford, 1987.

Joeres, R. E. B., and Maynes, M. J., *German Women in the Eighteenth and Nineteenth Centuries: A Social and Literary History*, Bloomington, 1986.

Jones, Inigo, *The Designs of Inigo Jones: Consisting of Plans and Elevations for Publick and Private Buildings: Published by William Kent with Some Additional Designs*, 2 vols., London, 1770.

Kelley, Donald R., and Sacks, David H., ed., *The Historical Imagination in Early Modern Britain: History, Rhetoric and Fiction, 1500–1800*, Cambridge, 1997.

Kidd, Colin, *British Identities before Nationalism: Ethnicity and Nationhood in the Atlantic World, 1600–1800*, Cambridge, 1999.

King, J. N., *Spenser's Poetry and the Reformation Tradition*, Princeton, 1990.

King, R., *Royal Kew*, London, 1985.

Kliger, S., *The Goths in England: A Study in Seventeenth and Eighteenth Century Thought*, Cambridge, Mass., 1952.

Kroll, Maria, *Sophie, Electress of Hanover: A Personal Portrait*, London, 1973.

Langley, Batty, *Gothic Architecture Improved, by Rules and Proportions in Many Grand Designs . . .* London, 1747.

Langley, Batty, *New Principles of Gardening: Or, The Laying out and Planting Parterres . . .* London, 1728, Farnborough, 1971.

Lawrence, Cynthia, ed., *Women and Art in Early Modern Europe: Patrons, Collectors and Connoisseurs*, University Park, Pennsylvania, 1997.

Lees-Milne, J., *Earls of Creation: Five Great Patrons of Eighteenth-Century Art*, London, 1962.

Levey, Michael, *The Later Italian Pictures in the Collection of Her Majesty the Queen*, Cambridge, 1964.

Levine, J. M., *Humanism and History: Origins of Modern English Historiography*, Ithaca, London, 1987.

Lipking, Laurence, *The Ordering of the Arts in Eighteenth-Century England*, Princeton, 1970.

Lloyd, C., *The Queen's Pictures: Royal Collectors through the Centuries*, London, 1991.

Lodge, P., ed., *Leibniz and his Correspondents*, Cambridge, 2004.

Lord, George deForest, ed., *Some Poems composed upon the Occasion of the Publication of the First Volume of Poems on Affairs of State: Augustan Satirical Verse, 1660–1714*, New Haven, London, 1963.

MacGregor, A., ed., *Sir Hans Sloane: Collector, Scientist, Antiquary, Founding Father of the* British Museum, London, 1994.

MacGregor, A., ed., *The Late King's Goods: Collections, Possessions and Patronage of Charles I in the Light of the Commonwealth Sale Inventories*, London, Oxford, 1989.

Marples, Morris, *Poor Fred and the Butcher: Sons of George II*, London, 1970.

Mason, William, *An Heroic Epistle to Sir William Chambers*, 2nd ed., London, 1773.

McCarthy, Michael, *The Origins of the Gothic Revival*, New Haven, London, 1987.

Melville, Lewis, *Lady Suffolk and her Circle*, London, 1924.

Melville, Lewis, *Maids of Honour*, London, 1927.

Merriman, James Douglas, *The Flower of Kings: A Study of the Arthurian Legend in England between 1485 and 1835*, Lawrence, Kansas, 1972.

Millar, Sir O., *The Tudor, Stuart and Early Georgian Pictures in the Collection of Her Majesty The Queen*, London, 1963.

Miller, Genevieve, *The Adoption of Inoculation for Smallpox in England and France*, Philadelphia, 1957.

Milton, John, *The Poetical Works of John Milton*, ed. J. Mitford, 2 vols., London, 1851.

Montagu, Elizabeth, *Elizabeth Montagu, the Queen of the Blue-Stockings: Her Correspondence from 1720 to 1761*, ed. E. J. Climenson, 2 vols., London, 1906.

Montagu, Elizabeth, *The Letters of Mrs Elizabeth Montagu*, ed. M. Montagu, 4 vols., London, 1809–13.

Montagu, Lady Mary Wortley, *Essays and Poems; and Simplicity: A Comedy*, ed. R. Halsband and I. Grundy, Oxford, 1977.

Montagu, Lady Mary Wortley, *The Complete Letters of Lady Mary Wortley Montagu*, ed. Robert Halsband, Oxford, 1965–67.

Montagu, Lady Mary Wortley, *The Letters and Works of Lady Mary Wortley Mo ntagu*, ed. Lord Wharncliffe, 2 vols., London, 1837.

Moore, A. W., ed., *Houghton Hall: The Prime Minister, the Empress and the Heritage*, Norwich, 1996.

Moore, A. W., *Norfolk and the Grand Tour: Eighteenth-Century Travellers Abroad and their Souvenirs*, Norwich, 1985.

Moore, Lucy, *Amphibious Thing: The Life of Lord Hervey*, London, 2000.

Morris, Robert, *An Essay in Defence of Ancient Architecture: Or, a Parallel of the Ancient Buildings with the Modern . . .* London, 1728.

Morton, Alan Q., and Wess, Jane A., *Public and Private Science: The King George III Collection*, Oxford, 1993.

Mowl, T., *Gentlemen and Players: Gardeners of the English Landscape*, Stroud, 2000.

Mowl, T. *William Kent: Architect, Designer, Opportunist*, London, 2006.

Mowl, T., and Earnshaw, B., *John Wood: Architect of Obsession*, London, 1988.

Murdoch, Alexander. *British History, 1660–1832: National Identity and Local Culture*, London, 1998.

Myrone, M., and Peltz, L., ed., *Producing the Past: Aspects of Antiquarian Culture and Practice, 1700–1850*, Aldershot, 1999.

Newman, Gerald, *The Rise of English Nationalism: A Cultural History, 1740–1830*, London, 1998.

Newton, Isaac, *Opticks: Or, a Treatise of the Reflexions, Refractions, Inflexions and Colours of Light*, London, 1704.

Newton, Sir Isaac, *The Chronology of Ancient Kingdoms Amended*, London, 1728.

Newton, M., *Savage Girls and Wild Boys: A History of Feral Children*, London, 2002.

Nokes, D., *John Gay: A Profession of Friendship*, Oxford, 1995.

Novellis, Mark de, *Pallas Unveil'd: The Life and Art of Dorothy Savile, Countess of Burlington, (1699–1758)*, London, 1999.

Nussbaum, Felicity A., *Torrid Zones: Maternity, Sexuality, and Empire in Eighteenth-Century English Narratives*, Baltimore, 1995.

Oresko, Robert, Gibbs, G. C., and Scott, Hamish, ed., *Royal and Republican Sovereignty in Early Modern Europe: Essays in Memory of Ragnhild Hatton*, Cambridge, 1997.

Orléans, Charlotte-Elisabeth, Duchesse d', *Briefe der Herzogin Elisabeth Charlotte von Orléans*, ed. W. L. Holland, Stuttgart, 1871.

Orléans, Charlotte-Elisabeth, Duchesse d', *Secret Memoirs of the Court of Louis XIV and of the Regency*, London, 1895.

Orléans, Charlotte Elizabeth, Duchesse d', *Life and Letters of Charlotte Elizabeth, Princess Palatine and Mother of Philippe d'Orléans, Regent of France, 1652–1722*, London. 1889.

Orléans, Elisabeth Charlotte, Duchesse d', *Correspondance complète de Madame, Duchesse d'Orléans*, trans, M. G. Brunet, 2 vols., Paris, 1857.

Orléans, Elisabeth Charlotte, Duchesse d' *Correspondance de Madame, Duchesse d'Orléans*, trans. E. Jaeglé, 3 vols., Paris, 1890.

Orléans, Elisabeth Charlotte, Duchesse d', *Letters from Liselotte: Elisabeth-Charlotte, Princess Palatine and Duchess of Orleans, 'Madame', 1652–1722*, ed. and trans. Maria Kroll, London, 1970.

Orléans, Elisabeth Charlotte, *The Letters of Madame: The Correspondence of Elisabeth Charlotte of Bavaria, Princess Palatine, Duchess of Orleans, 1661–1708*, trans. and ed. G. S. Stevenson, 3 vols., New York, 1924.

Osborn, Sarah, *Political and Social Letters of a Lady of the Eighteenth Century, 1721–1771*, ed. E. F. D. Osborn, London, 1890.

Outram, Dorinda, *Panorama of the Enlightenment*, London, 2006.

Owen, A. L., *The Famous Druids: A Survey of Three Centuries of Literature on the Druids*, Oxford, 1962.

Paas, Sigrun, ed., *Liselotte von der Pfalz: Madame am Hofe der Sonnenkönigs*, exh. cat. Heidelberger Schloss, 21 Sept. 1996–26 Jan. 1997, Heidelberg, 1996.

Parissien, S., *George IV: The Grand Entertainment*, London, 2001.

Perrone, S. S., *Guida al Sacro Monte di Varallo*, Turin, 1995.

Phillips, Nicholas, and Skinner, Quentin, ed., *Political Discourse in Early Modern Britain*, Cambridge, 1993.

Philpot, Stephen, *An Essay on the Advantage of a Polite Education Joined with a Learned One*, London, 1747.

Piacenti, Kirsten Aschengreen, and Boardman, John, *Ancient and Modern Gems and Jewels in the Collection of Her Majesty The Queen*, London, 2008.

Piggott, S., *Ancient Britons and the Antiquarian Imagination: Ideas from the Renaissance to the Regency*, London, 1989.

Piggott, S., *William Stukeley: An Eighteenth Century Antiquary*, Oxford, 1985.

Pittock, Murray G. H., *Celtic Identities and the British Image*, Manchester, 1999.

Plumb, J. H., *Sir Robert Walpole: The King's Minister*, 2 vols., London, 1972.

Pocock, J. G. A., *Virtue, Commerce and History: Essays on Political Thought and History, chiefly in the Eighteenth Century*, Cambridge, 1985.

Pöllnitz, Carl Ludwig von [*La Saxe Galante*], *The Amorous Adventures of Augustus of Saxony . . . Translated from the French by a Gentleman of Oxford*, London, 1929.

Pöllnitz, Carl Ludwig, *The Memoirs of Charles-Lewis, Baron de Pöllnitz*, 5 vols., London, 1745.

Pointon, Marcia, *Hanging the Head: Portraiture and Social Formation in Eighteenth-Century England*, New Haven, London, 1993.

Pope, Alexander, *Selected Poetry and Prose*, ed. W. K. Wimsatt., New York, 1972.

Pope, Alexander, *The Correspondence of Alexander Pope*, ed. G. Sherburn, 5 vols., Oxford, 1956.

Pope, Alexander, *The Works of Alexander Pope*, ed. J. W. Croker, intro. and notes W. Elwin and W. J. Courthope, 10 vols., London, 1871–89.

Porter, Roy, *English Society in the Eighteenth Century*, London, 1982.

Porter, Roy, *Enlightenment: Britain and the Creation of the Modern World*, London, 2000.

Preuss, J. D. E., ed., *Œuvres de Frédéric le Grand*, 31 vols., Berlin, 1846–57.

Pyke, E. J., *A Biographical Dictionary of Wax Modellers*, Oxford, 1973.

Quennell, Peter, *Caroline of England: An Augustan Portrait*, London, 1939.

Rapin de Thoyras, M., *The History of England . . . translated into English with additional notes . . . by N. Tindal*, 21 vols., London, 1757–63.

Reid, Margaret J. C., *The Arthurian Legend: Comparison of Treatment in Modern and Medieval Literature: A Study in the Literary Value of Myth and Legend*, London, 1938.

Reynolds, Graham, *The Sixteenth- and Seventeenth-Century Miniatures in the Collection of Her Majesty the Queen*, London, 1999.

Richardson, T., *The Arcadian Friends: Inventing the English Landscape Garden*, London, 2007.

Roberts, Jane, *Holbein and the Court of Henry VIII*, Edinburgh, 1993.

Roberts, Jane, *Holbein and the Court of Henry VIII: Drawings and Miniatures from the Royal Library, Windsor Castle*, Edinburgh, 1993.

Roberts, Jane, *Royal Artists: From Mary Queen of Scots to the Present Day*, London, 1987.

Roberts, Jane, *Royal Treasures: A Golden Jubilee Celebration*, London, 2002.

Robin, George [Auctioneer], *Catalogue of the Classic Contents of Strawberry Hill Collected by Horace Walpole*, 25th April–21st May, 1842.

Robinson, John Martin, *Temples of Delight: Stowe Landscape Gardens*, London, 1994.

Roche, Sophie von la, *Sophie in London, 1786: Being the Diary of Sophie von la Roche*, trans. C. Williams, foreword G. M. Trevelyan, London, 1933.

Ross, Angus, ed., *The Correspondence of Dr John Arbuthnot*, Munich, 2006.

Sambrook, James, *The Eighteenth Century: The Intellectual History and Cultural Context of English Literature, 1700–1789*, London, 1993.

Savage, Richard, *The Poetical Works of Richard Savage*, ed. Clarence Tracy, Cambridge, 1962.

Schuhmann, Gunther, *Die Markgrafen von Brandenburg-Ansbach:Eine Bilddokumentation zur Geschichte der Hohenzollern in Franken*, Ansbach, 1980.

Scott, Hamish, ed., *The European Nobilities in the Seventeenth and Eighteenth Centuries*, 2 vols., London, 1995.

Seymour, Frances, Duchess of Somerset, *Correspondence between Frances Countess of Hertford (afterwards Duchess of Somerset) and Henrietta Louisa, Countess Pomfret between the years 1738 and 1741*, ed. W. Bingley, 2nd ed., 2 vols., London, 1805.

Sharp, Tony, *Pleasure and Ambition: The Life, Loves and Wars of Augustus the Strong, 1670–1707*, London, 2001.

Shearman, John, *The Early Italian Pictures in the Collection of Her Majesty The Queen*, Cambridge, 1983.

Simms, Brendan, and Riotte, Torsten, ed., *The Hanoverian Dimension in British History, 1714–1837*, Cambridge, 2007.

Simon, Edith, *The Making of Frederick the Great*, London, 1963.

Sloan, Kim, ed., *Enlightenment: Discovering the World in the Eighteenth Century*, London, 2003.

Smiles, Sam, *The Image of Antiquity: Ancient Britain and the Romantic Imagination*, New Haven, London, 1994.

Smith, H., *Georgian Monarchy: Politics and Culture, 1714–1760*, Cambridge, 2006.

Society of Antiquaries of London, *A Description of Nine Historical Prints, Representing Kings, Queens, Princes, etc. of the Tudor Family, Selected, Drawn and Engraved from the Original Paintings, by George Vertue, late Engraver to the Society of Antiquaries of London*, London, 1776.

Sophia of Hanover, *Memoirs of Sophia: Electress of Hanover, 1630–1680*, trans. H. Forester, London, 1888.

Spence, J., *Anecdotes, Observations and Characters of Books and Men: Collected from the Conversation of Mr Pope . . .* ed. S. W. Singer, London, 1820.

Spencer, S. I., *French Women and the Age of Enlightenment*, Bloomington, 1984.

Spenser, Edmund, *The Fairy Queen*, ed. D. Brooks-Davies, London, 1996.

Staehlin-Storcksburg, J. von, *Original Anecdotes of Peter the Great: Selected from the Conversation of Several Persons of Distinction at Petersburgh and Moscow*, London, 1788.

Stirling, A. M. W., *Coke of Norfolk and his Friends*, London, 1908.

Stone, B., trans. and intro., *King Arthur's Death: Alliterative Morte Arthure and Stanzaic le morte Arthur*, London, 1988.

String, T. C., and Bull, M., ed., *Tudorism: Historical Imagination and the Appropriation of the Sixteenth Century*, Proceedings of the British Academy, no. 170, 2011.

Strong, Roy, *Henry, Prince of Wales and England's Lost Renaissance*, London, 1986.

Stukeley, William, *Itinerarium Curiosum, or an Account of the Antiquitys and Remarkable Curiositys in Nature or Art, Observ'd in Travels thro' Great Britain*, London, 1724.

Sundon, Viscountess, *Memoirs of Viscountess Sundon: Mistress of the Robes to Queen Caroline, Consort of George II*, ed. A. T. Thomson, 2 vols., London, 1847.

Sweet, Rosemary, *Antiquaries: The Discovery of the Past in Eighteenth-Century Britain*, Hambledon, London, 2004.

Swift, Jonathan, *The Correspondence of Jonathan Swift, D.D.*, ed. F. Elrington Ball, 6 vols., London, 1910–14.

Switzer, S., *Ichnographia Rustica: Or, the Nobleman, Gentleman, and Gardener's Recreation*, London, 1718.

Taylor, S., Connors, R., and Jones, C., ed., *Hanoverian Britain and Empire: Essays in Memory of Philip Lawson*, Woodbridge, 1998.

Tennant, C. M., *Peter the Wild Boy*, London, 1938.

Thomas, P. D. G., *Politics in Eighteenth-Century Wales*, Cardiff, 1998.

Thompson, A. C., *George II*, New Haven, London, 2011.

Uffenbach, Zacharias Conrad von, *London in 1710: From the Travels of Z. C. von Uffenbach*, trans. and ed. W. H. Quarrell and Margaret Mare, London, 1934.

Vardy, John, *Some Designs of Mr Inigo Jones and Mr Wm Kent*, London, 1744.

Vivian, Frances, *A Life of Frederick Prince of Wales, 1707–1751: A Connoisseur of the Arts*, ed., Roger White, Lewiston, N.Y., Lampeter, 2006.

Voltaire (pseud. for François-Marie Arouet), *Letters Concerning the English Nation*, intro. Charles Whibley, London, New York, Toronto, 1926.

Wagstaffe, William, *A Letter to Dr Friend, showing the Danger and Uncertainty of Inoculating the Small Pox*, London, 1722.

Walpole, Horace, Earl of Orford, *A Selection of the Letters of Horace Walpole*, ed. W. S. Lewis, London, 1926.

Walpole, Horace, Earl of Orford, *Aedes Walpolianae: Or, a Description of the Collection of Pictures at Houghton Hall in Norfolk, the Seat of the Right Honourable Sir Robert Walpole, Earl of Orford*, London, 1752.

Walpole, Horace, Earl of Orford, *Anecdotes of Painting in England: With some Account of the Principal Artists*, ed. Rev. J. Dallaway, 3 vols., London, 1848.

Walpole Horace, Earl of Orford, *Horace Walpole: Memoirs and Portraits*, ed. M. Hodgart, London, 1963.

Walpole, Horace, Earl of Orford, *Letters of Horace Walpole*, selected and ed. C. D. Yonge, 2 vols., London, 1891.

Walpole, Horace, Earl of Orford, *Memoirs of King George the Second*, ed. John Brooke, 3 vols., New Haven, London, 1985.

Walpole, Horace, Earl of Orford, *Memoirs of the Reign of King George the Second: Edited from the original MSS. with a Preface and Notes*, ed. Lord Holland, 3 vols., London, 1846.

Walpole, Horace, Earl of Orford, *Reminiscences Written by Mr Horace Walpole in 1788 for the Amusement of Miss Mary and Miss Agnes Berry*, ed. Paget Toynbee, Oxford, 1924.

Walpole, Horace, Earl of Orford, *The Duchess of Portland's Museum*, intro. W. S. Lewis, New York, 1936.

Walpole, Horace, Earl of Orford, *The Yale Edition of Horace Walpole's Correspondence*, ed. W. S. Lewis, Charles Bennett, Andrew G. Hoover, 48 vols., New Haven, London, 1937–83.

Walters, John, *The Royal Griffin: Frederick, Prince of Wales, 1707–51*, London, 1972.

Ware, I., *Designs of Mr Inigo Jones and Others*, London, 1735.

Ware, I., *The Plans, Elevations, and Sections, Chimney Pieces, and Ceilings of Houghton in Norfolk, the Seat of Sir R, Walpole*, engraved Foudrinier, London, 1735.

Watkins, John, *Memoirs of Her Majesty Sophia Charlotte, Queen of Great Britain*, London, 1819.

Watkins, John, *Representing Elizabeth in Stuart England: Literature, History, Sovereignty*, Cambridge, 2002.

Webb, M. I., *Michael Rysbrack: Sculptor*, London, 1954.

Whately, M., *Observations on Modern Gardening*, Dublin, 1770.

Whitaker, L., and Clayton, M., *The Art of Italy in the Royal Collection: Renaissance and Baroque*, London, 2007.

Whitaker, Muriel, *The Legends of King Arthur in Art*, Cambridge, 1990.

Whitworth, R., *William Augustus, Duke of Cumberland: A Life*, London, 1992.

Wiesner, Merry E., *Women and Gender in Early Modern Europe*, Cambridge, 2000.

Wilkins, W. H., *Caroline the Illustrious*, 2 vols., London, 1901.

Williams, Basil, *The Whig Supremacy, 1714–1760*, Oxford, 1952.

Willis, Peter, *Charles Bridgeman and the English Landscape Garden*, Newcastle upon Tyne, 2002.

Wilson, M. I., *William Kent: Architect, Designer, Painter, Gardener, 1685–1748*, London, 1984.

Wittkower, R., *Palladio and English Palladianism*, London, 1974.

Woolf, D. R., *Reading History in Early Modern England*, Cambridge, 2000.

Worsley, L., *Courtiers: The Secret History of Kensington Palace*, London, 2010.

Young, Sir George, *Poor Fred: The People's Prince*, Oxford, 1937.

PERIODICALS

Addison, Joseph, 'The pleasures of the Imagination', *The Spectator*, nos. 411–21, 21 June–3 July, 1712.

Alcorn, E. M., 'A Chandelier for the King: William Kent, George II and Hanover', *The Burlington Magazine*, vol. 139, Jan.1997, pp. 40–43.

Arciszewska, B., 'A Villa fit for a King: The role of Palladian Architecture in the Ascendancy of the House of Hanover under George I', *Canadian Art Review*, XIX, 1992, pp. 41–112

Ariew, R., 'Leibniz on the Unicorn and various other Curiosities', *Early Science and Medicine*, vol. 3, no. 4, 1998, pp. 267–88.

Barthélemy E. de, '*Inventaire du Mobilier de la Duchesse d'Orléans, Mère du Régent, après son Decès en 1722*', *Bulletin du Comité des Travaux Historiques*, Paris, 1883.

Bertolini Meli, D., 'Caroline, Leibniz and Locke', *Journal of the History of Ideas*, vol. 60, no. 3, July 1999, pp. 469–86.

Bignamini, Ilaria, 'George Vertue, Art Historian and the Art Institutions of London', *Walpole Society*, vol. 54, 1991, pp. 1–48.

Bowett, Adam, 'George I's Furniture at Kensington Palace', *Apollo*, Nov. 2005, pp. 37–46.

Brown, Gregory, 'Leibniz's Endgame and the Ladies of the Court', *Journal of the History of Ideas*, vol. 65, no. 1, Jan. 2004, pp. 75–100.

Carré, J., 'Lord Burlington's Garden at Chiswick', *Garden History*, vol. I, no. 3, 1973, pp. 23–30.

Clinton, Katherine B., 'Femme and Philosophe: Enlightenment Origins of Feminism', *Eighteenth-Century Studies*, vol. 8, no. 3, Spring 1975, pp. 283–99.

Colton, J., 'Kent's Hermitage for Queen Caroline at Richmond', *Architectura*, no. 2, 1974, pp. 181–91.

Colton, J., 'Merlin's Cave and Queen Caroline: Garden Art as Political Propaganda', *Eighteenth-Century Studies*, vol. X, no.1, 1976. pp. 1–20.

Corder, Jim, 'Spenser and the Informal Eighteenth-Century Informal Garden', *Notes and Queries*, 204, 1959, pp. 19–21.

Cornforth, John, 'Houghton Hall, Norfolk I', *Country Life*, April 30, 1987, pp. 124–29.

Cornforth, John, 'Houghton Hall, Norfolk II', *Country Life*, May 7, 1987, pp. 104–108.

Cornforth, John, 'Kensington Palace, London', *Country Life*, Jan 5, 1995, pp. 32–37.

Cornforth, John, 'The growth of an Idea: The Making of Houghton's Landscape', *Country Life*, May 14, 1987, pp.162–68.

Doort, Abraham van der, 'Abraham van der Doort's Catalogue of the Collections of Charles I', ed. and intro. Oliver Millar, *Walpole Society*, 37, London, 1960.

Eichholz, Jeffrey P., 'William Kent's Career as Literary Illustrator', *Bulletin of the New York Public Library*, 70, 1966, pp. 620–46.

Fabianski, M., 'Iconography of the Architecture of the Ideal: *Musaea* in the Fifteenth to Sixteenth Centuries', *History of Collections*, vol. 2, no. 2, 1990, pp. 95–134.

Findlen, P., 'The Museum: Its Classical Etymology and Renaissance Genealogy', *Journal of the History of Collections*, vol. 1, no.1, 1989, pp. 59–78.

Gerrard, C., 'The Castle of Indolence and the Opposition to Walpole', *The Review of English Studies*, new series, vol. 41, no. 161, Feb. 1990, pp. 45–64.

Gutfleish, B., and Menzhausen, J., '"How a Kunstkammer should be formed": Gabriel Kaltemarckt's Advice to Christian I of Saxony on the Formation of an Art Collection', *Journal of the History of Collections*, vol. 1, no.1, 1989, pp. 3–32.

Harris, John, 'Esher Place, Surrey', *Country Life*, April 2, 1987, pp. 94–97.

Harris, John, 'The Bicentenary of Kew Gardens I. Fate of Royal Buildings', *Country Life*, vol. CXXV, May 28, 1959, p. 1182.

Hessler-Cable, Mabel, 'The Idea of a Patriot King in the Propaganda of the Opposition to Walpole 1735–1739', *Philosophical Quarterly*, 18, 1939, pp. 124–30.

Heusinger, Christian von, 'Duke Anton Ulrich as Collector of Prints and Drawings', *Apollo*, March 1986, pp. 190–95.

Hunt, John Dixon, 'A Silent and Solitary Hermitage', *Annual Report of the York Georgian Society*, 1970, pp. 47–61.

Jansen D. J., 'Antiquarian Drawings and Prints as Collectors Items', *Journal of the History of Collections*, vol. 6, no. 2, 1994, pp. 181–88.

Jay, Emma, 'Queen Caroline's Library and its European Contexts', *Book History*, vol. 9, 2006, pp. 31–55.

Keynes, Simon, 'The Cult of King Alfred', *Anglo-Saxon England*, no. 28, 1999, pp. 225–356.

Löwenstein, Uta, '*So Hält der Engel Hand die Cron aus Engelland. Feierlichkeiten bei der Hochzeit des Landgrafen Friedrich von Hessen-Kassel und der Prinzessin Maria von Grossbritannien*', *Hessische Heimat*, 44 Jahrgang, vol. 4, 1994, pp. 135–39.

Löwenstein, Uta, unpublished article 'Apartment of the Countess Dorothea Friederike von Hanau-Lichtenberg at her Death in the Year 1731', pp. 1–32.

Marschner, J. M., 'Baths and Bathing at the Early Georgian Court', *Furniture History*, vol. XXXI, 1995, pp. 23–28.

Marschner, J. M., 'Queen Caroline of Ansbach: Attitudes to Clothes and Cleanliness, 1727–1737', *Costume*, no. 31, 1997, pp. 28–37.

Mazingue, E., 'Duke Anton Ulrich and the Theatre', *Apollo*, March 1986, pp. 196–99.

Roberts, Hugh, 'Metamorphosis in Wood: Royal Library Furniture in the Eighteenth and Nineteenth Centuries', *Apollo*, June 1990, pp. 383–90.

Rorschach, Kimerly, 'Frederick Prince of Wales (1707–1751) as Patron and Collector', *Walpole Society*, vol. 55, 1990, pp. 1–76.

Julie Sanders, 'Caroline Salon Culture and Female Agency: The Countess of Carlisle, Henrietta Maria and Public Theatre', *Theatre Journal*, vol. 52, no. 4, Dec. 2000, pp. 449–64.

Schuhmann, Gunthe, 'Ansbacher Bibliotheken vom Mittelalter bis 1806', *Schriften des Instituts fur Frankischen Landesforschung und der Universitat Lassleben*, 1961, pp. 90–96.

Schulz, E., 'Notes on the History of Collecting and of Museums in the Light of Selected Literature of the Sixteenth to the Eighteenth Century', *Journal of the History of Collections*, vol. 2, no. 2, 1990, pp. 205–18.

Schutte, R. A., 'The Kunst- und Naturalienkammer of Duke Anton Ulrich of Brunswick-Luneburg at Scloss Salzdahlum: Cabinet Collections, Literature and Science in the First Part of the Eighteenth Century', *Journal of the History of Collections*, vol. 9, no.1, 1997, pp. 79–115.

Sicca, C., '"like a shallow cave by nature made …": William Kent's Natural Architecture at Richmond', *Architectura*, vol. 16, 1986, pp. 68–82.

Symes, M., 'The Landscaping of Esher Place', *Journal of Garden History*, 1988, vol. 8, no. 4, pp. 63–96.

Vertue, George, 'Vertue Note Books I–VI', *Walpole Society*, vols. 18, 20, 22, 24, 26, 30, 1930–50.

Walpole, Horace, 'Walpole's Journals of Visits to Country Seats', ed. Paget Toynbee, *Walpole Society*, 16, Oxford, 1928.

Webb, M. I., 'Busts of Sir Isaac Newton', *Country Life*, Jan 25, 1952, pp. 216–18.

Wilson, M. I., 'A Taste for the Strange: William Kent's Book Illustrations', *Country Life*, Nov. 7, 1985, pp. 1396–98.

Wittkower, R., 'Lord Burlington and William Kent', *Archaeological Journal*, vol. CII, 1946, pp. 760–61.

Woodbridge, Kenneth, 'William Kent as Landscape-Gardener: A Re-appraisal', *Apollo*, vol. 100, Aug. 1974, pp. 126–37.

Worsley, G., 'Houghton Hall, Norfolk', *Country Life*, March 4, 1993, pp. 50–53.

INDEX